JAVA GRAPHICS PROGRAMMING LIBRARY

Concepts to Source Code

JAVA GRAPHICS PROGRAMMING LIBRARY

Concepts to Source Code

Oswald Campesato

CHARLES RIVER MEDIA, INC.
Hingham, Massachusetts

Acquisitions Editor: Brian Sawyer
Production: Paw Print Media
Cover Design: The Printed Image
Cover Images: Oswald Campesato

CHARLES RIVER MEDIA, INC.
20 Downer Avenue, Suite 3
Hingham, Massachusetts 02043
781-740-0400
781-740-8816 (FAX)
info@charlesriver.com
www.charlesriver.com

This book is printed on acid-free paper.

Oswald Campesato. *Java Graphics Programming Library: Concepts to Source Code.*
ISBN: 1-58450-092-1

Library of Congress Cataloging-in-Publication Data

Campesato, Oswald.
 Java graphics programming library / Oswald Campesato.
 p. cm.
 ISBN 1-58450-092-1 (paperback with CD-ROM : alk. paper)
 1. Computer graphics. 2. Java (Computer program language) I. Title.
 T385 .C357 2002
 006.6'633--dc21
 2001008584

Printed in the United States of America
02 7 6 5 4 3 2 First Edition

CHARLES RIVER MEDIA titles are available for site license or bulk purchase by institutions, user groups, corporations, etc. For additional information, please contact the Special Sales Department at 781-740-0400.

Requests for replacement of a defective CD-ROM must be accompanied by the original disc, your mailing address, telephone number, date of purchase and purchase price. Please state the nature of the problem, and send the information to CHARLES RIVER MEDIA, INC., 20 Downer Avenue, Suite 3, Hingham, Massachusetts 02043. CRM's sole obligation to the purchaser is to replace the disc, based on defective materials or faulty workmanship, but not on the operation or functionality of the product.

I'd like to dedicate this book to my family, especially to my parents, whose many sacrifices over the years helped me attain my goals.

CONTENTS

ACKNOWLEDGMENTS

I would like to express my appreciation to Farid Sharifi and Laurie Dresser, both of whom have always given me sound advice. Among other things, Farid eased the mind-numbing *ennui* of living in a ghastly humid subtropical climate. Although I've lost track of the number of times that we barbecued in his backyard in Longwood, I remember that his mother once asserted that our chicken kabobs were "tastier than any sold on the streets in my home town." Alas, we always used a random measure of spices and herbs, so we could never reproduce one singular taste. I'm happy to say that Farid is now a master of writing memos, even to members of his own family. Meanwhile, Laurie helped me relocate to California, and I feel indebted toward her (to this very day) for having done so. She appreciated not only my helping her with English grammar, but also recognized the humor in the mantra-like chanting of "no backlog, no real-time," which provoked stentorian peals of laughter in so many people. *Primus inter pares* and *sui generis* are two of the accolades that I associate with Laurie. Her tremendously hard work paid off. Laurie earned her position as a director and many people could learn a great deal about management from Laurie's wisdom; she is a naturally gifted leader.

Over the years, other people have had varying degrees of influence on me, sometimes without having realized that they did so: Keith Swartz, with his dazzling intellect; Chris Tanabe, a modern-day renaissance man; Marcio Soares, who makes me yearn for Brazil again; Alex Pakalniskis, who has a heart of gold and a wickedly funny sense of humor; Barbra Trivisonno, who taught me much about compassion; Cherryl Thomas, a truly classy woman with fine qualities. I would be remiss if I did not thank Brian Sawyer and Dave Pallai of Charles River Media, whose support and guidance made this book possible.

INTRODUCTION

THE GOAL

The goal is simple: to provide the reader with a library of Java code that can be easily tailored to fit specified needs. In this book, there are literally hundreds of pages of Java code that leverage the power of Java graphics. The provided plethora of Java code covers a broad spectrum of graphics, ranging from simple polygons to three-dimensional objects. As a Java programmer, you have most likely experienced a number of occasions when you needed a specific graphic but didn't have the time or expertise to create it. This library of Java code provides an enormous selection of ready-to-use graphics that will save you hours of programming time.

WHY BUY THIS BOOK?

Before launching into a description of what this book contains, why would anyone be interested in buying a Java book about graphics? This is a valid question, and there are several reasons.

First, there's an aesthetic aspect of writing graphics-related code. The subject matter is intrinsically interesting because results are attained quickly. The eye-catching graphics and feedback from other people sustain my desire to write ever-more sophisticated Java code. You'll know that your code is of professional caliber when people ask you what software package you used in order to generate your graphics! Second, this vast collection of Java code can be extended or modified in an assortment of ways. The Java code on the CD-ROM contains many variations of the code presented in this book. Third, writing graphics code is fun, especially when you can produce exotic eye-candy that does not require complex algorithms or a Ph.D. in mathematics.

WHAT DOES THIS BOOK COVER?

This book has three main objectives. First, the Java code provided can be used immediately. Many Java classes are only two or three pages, and the most classes are less than four pages in length. Second, the code can be enhanced in order to create custom extensions and modifications. Third, the techniques in this book for rendering graphics reinforce underlying mathematical concepts. How quickly the concepts and techniques are learned will depend on a variety of factors. Prior experience with graphics is not mandatory, but it will obviously shorten the learning curve. Moreover, having previously written code in other languages (e.g., C or C++), will undoubtedly facilitate the transition to writing graphics code in Java.

You'll find that your programming discipline will also improve as you master the Java code. Graphics problems that initially seem difficult because they require significant effort become easier. With sufficient time and effort, you might eventually be able to visualize graphics code in your mind as you type the physical code at the keyboard!

The Java code developed in this book is available on the accompanying CD-ROM, along with many other additional examples that are variations of the Java code presented in this book.

ON THE CD

Many of the graphics images in this book and on the CD-ROM are animated. The figures in the book will give you a single snapshot of the graphics image, but you need to launch these images in a browser (or appletviewer) in order to capture the full quality of the visual effects.

WHAT HAS BEEN OMITTED FROM THIS BOOK?

This book provides as much real Java code as possible for creating graphics. This approach requires treading lightly in several areas, including object-oriented methodology. There are lots of great books available on these topics, and you can find one that best suits your needs. This book focuses on a neglected topic: the nuts-and-bolts details for interesting graphics. With that in mind, the Java code in this book minimizes its reliance on specific features of a language. In fact, most of the Java code could be implemented in other languages such as C or C++.

The graphics arena as a whole involves many difficult problems that require complex mathematics. This book does not contain such complicated problems. Instead, what you will find is how to render graphics images that seem complex but in reality are actually quite simple.

WHICH VERSION OF JAVA IS REQUIRED?

All the graphics images in this book can be rendered with version 1.02 or higher of the Java Development Kit (JDK).

HOW DIFFICULT IS THE CODE?

The answer depends primarily on your programming background. Programming knowledge is required because programming basics are not discussed in this book. Appendix B provides some Java essentials. You don't need knowledge of more advanced topics in Java such as RMI or EJB, nor do you need to understand numerical analysis.

ARE THERE ANY PREREQUISITES?

Prerequisites can be daunting at times, particularly in the field of graphics. This book relies on mathematical concepts from geometry and trigonometry. Appendix A covers most of the mathematics that you'll need in order to understand the underlying concepts of the Java code.

If you are unfamiliar or uncomfortable with basic trigonometry and geometry, don't panic! You will benefit by reading the sections that define a few trigonometric functions (i.e., sine, cosine, and tangent), as well as the notions of a parallelogram and a polygon. The section involving polar coordinates is optional, and unless you're specifically interested in graphs of polar coordinates, it can be omitted without any loss of continuity. You'll need very little knowledge of object-oriented analysis, design, and programming (OOA, OOD, and OOP, respectively) for this book.

IS THIS BOOK FOR ME?

By now you probably realize that the purpose of this book is to solve a great variety of useful and interesting graphics-related programming problems. This is a "how-to" book for people who want direct, simple, and clear solutions.

This is not a reference book for the syntax of the Java language, nor is it a book-length theoretical treatise on object-oriented programming or the design of the Java language. This book does not contain significant amounts of digressive exposition (as can be verified by quickly skimming

through the pages). Fortunately, you can learn a great deal from the examples, even if you do not have a strong programming background.

The "Supplemental" folder on the CD-ROM contains a variety of common-place objects that are based on various combinations of line segments, polygons, and ellipses. These images tend to be many pages of code that consists of drawing many "widgets" and components of "widgets." These examples will give you plenty of code that you can combine in order to produce your own graphics images of real-life objects.

WHERE TO GET IDEAS

The easy answer is that ideas for creating graphics images can be found everywhere. For people who need a starting point in order to develop the right mindset, try looking at art, architecture, and animation. These three areas are virtually boundless, hence they can stimulate an incredible variety of ideas. Once thoroughly grounded in the fundamental concepts, you'll find that writing code becomes much easier. If you persistently sharpen your coding skills, your speed and accuracy will improve dramatically.

CODE PORTABILITY

The Java programs in this book are generic, which means that they can be easily implemented in other languages that have low-level graphics primitives. For example, Motif has the same method names and parameters for drawing lines and rectangles.

Although Java-specific methods are avoided as much as possible, the sequence of execution of the code does rely on behavior that is specific to Java. For example, the methods *init()*, *start()*, *stop()*, *destroy()* are automatically executed in Java, whereas objects created in other languages must explicitly invoke these (or similar) methods.

Another point to keep in mind is that different object-oriented (OO) languages have different ways of instantiating objects. In Java, one constructor can invoke another constructor (with a different set of parameters, of course.) Such language constructs can be very convenient, but if the code is implemented in another language, these constructs cannot be used.

Remember this: given the ubiquitous nature of Java and its ideal suitability for graphics, it's not likely that you're going to port this Java code to another language. However, it is very likely that you will port non-Java code to this Java code.

What Graphics Capability Is Available in Java?

Appendix B contains a section labeled "Overview of AWT Drawing Methods" that provides background information regarding many of the graphics features that are part of the Java graphics package. Since these methods are used frequently in this book, it's probably worth your while to familiarize yourself with the contents of that section.

Graphics Versus Code

If the graphics images in a book look interesting, you'll be motivated to look at the code. This is particularly true for images that have some type of exotic or unusual visual component. In other cases, it's simply the fact that an obscure detail has been rendered in a particularly polished manner.

For anyone who has already written graphics code, consider the following approach: look at a graphics image and attempt to reproduce it with your own Java code. Then, compare your solution to the Java code in this book and judge them in terms of simplicity, clarity, and elegance. This approach will make you more actively involved in the process of writing graphics code, and will also underscore the fact that some images that look complex can actually be generated by means of simple code. The solution requires making key observations regarding the nature of these images.

The occurrence of jagged edges is a problem that arises in many images, particularly those that are non-linear in nature. This problem is most noticeable in the case of curves that are rendered by drawing a set of line segments in order to approximate the curve. You can see this effect when you render an ellipse. Regardless of its width or height, you will not be able to eliminate the jagged edges. If you attempt to "dither" this ellipse (see Appendix B for more information on dithering) with another ellipse with the same dimensions, you will simply shift the jagged edges from the original ellipse to the new ellipse.

You can smooth the jagged edges of the ellipse by rendering small circles inside the ellipse, which effectively "buff" the circumference. This approach minimizes the problem of jagged edges because the curvative of the ellipse is different from the curvative of the small circles. This solution has a trade-off: sometimes it requires substantially more code in order to achieve the desired effect. The examples of dithering in this book are confined to situations where the use of dithering involves very little extra code, thereby minimizing the additional complexity of the Java code.

WHY SO MUCH CODE?

The first reason is personal: writing Java code is a lot of fun. The graphics capability of Java makes programming a pleasure. Second, it's hard to find one place that contains detailed examples of visually appealing Java graphics. How many books have you seen that provide a really diverse assortment of good Java graphics? This book is meant to fill that void. Given that lofty purpose, it would be disingenuous to infer that understanding all the code in this book is a casual endeavor. *Caveat emptor:* patience and effort are required.

Unfortunately, in many cases the presentation of an idea can seem complicated, even if the idea itself is not difficult. Formality begets complexity. As a former Ph.D. student in mathematics, I was impressed to see that my advisor sailed through mathematical papers with minimal effort, after I had spent many hours struggling with all the details. Amazed, I asked him how he did it, to which he replied, "Always try to understand the key idea."

With that thought in mind, most of the Java code is preceded with a high-level algorithm that is a mixture of pseudo-code and Java statements; the source code contains the minutiae required to make the code work. Once you understand the key idea, the code becomes much easier to comprehend in its entirety. *Tempus fugit*, so let's move on to the Java code!

COLORS AND BASIC SHAPES

OVERVIEW

This chapter starts with an introduction to the Java coordinate system, after which you will be able to draw simple objects, such as lines, rectangles, and polygons. Different techniques are discussed for drawing these objects. If you are already familiar with the Java coordinate system, then you can quickly skim through the material.

The second part of this chapter contains an introduction to colors in Java graphics. The key point to remember is the representation of visible colors in terms of their RGB components. As you'll see, the set of possible colors exceeds sixteen million, which ought to satisfy most color requirements for images.

CONCEPT: THE JAVA COORDINATE SYSTEM

Perhaps you remember your introduction to the Cartesian coordinate system in high school. The horizontal axis is labeled the x-axis, and motion to the right is positive. The vertical axis is labeled the y-axis, and upward motion is positive. The origin is the intersection point of the x-axis and the y-axis.

The situation is almost the same in the Java coordinate system. The x-axis is horizontal and the positive direction is toward the right. The y-axis is vertical, but the positive direction is *downward* (i.e., south). As you can see, the positive y-axis points in the opposite direction of most graphs in a typical Mathematics textbook. When drawing these graphs, be sure to take this fact into account. This detail is easy to forget, and is often the underlying cause of incorrect graphs.

There are two more important details to remember about the Java coordinate system: the origin is in the upper left-hand corner of the screen,

and the unit of measurement is the pixel, so the largest visible display is usually 1024 x 728.

Consider the following depiction (Figure 1.1) of the Java coordinate system in which four points have been drawn.

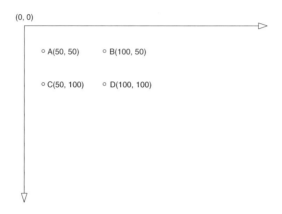

FIGURE 1.1 The Java coordinate system.

Based on the definition of the Java coordinate system, we now know that:

- Point A(50, 50) is 50 units to the right and 50 units downward.
- Point B(100, 50) is 100 units to the right and 50 units downward.
- Point C(50, 100) is 50 units to the right and 100 units downward.
- Point D(100, 100) is 100 units to the right and 100 units downward.

CONCEPT: DRAWING LINES TO RENDER RECTANGLES

Suppose you want to draw the rectangle in Figure 1.2 of which the vertices are the following four points: A(50, 50), B(100, 50), C(50, 100), and D(100, 100).

ON THE CD

The Java class *Rect1.java* (Listing 1.1) demonstrates how to draw such a rectangle by invoking the standard method *drawLine()* in the *paint()* method order to draw the four edges of the rectangle.

FIGURE 1.2 The outline of a rectangle.

LISTING 1.1 Rect1.java

```java
import java.awt.Graphics;
import java.io.Serializable;

public class Rect1 extends java.applet.Applet
      implements Serializable
{
    public Rect1()
    {
    }

    public void paint(Graphics gc)
    {
        gc.drawLine(50, 50, 100, 50);      // line AB
        gc.drawLine(50, 50, 50, 100);      // line AC
        gc.drawLine(100, 50, 100, 100);    // line BD
        gc.drawLine(50, 100, 100, 100);    // line CD

    } // paint

} // Rect1
```

ON THE CD

The HTML file *Rect1.html* (Listing 1.2) contains the code for launching *Rect1.class*.

LISTING 1.2 Rect1.html

```html
<HTML>
<HEAD></HEAD>
<BODY>
<APPLET CODE=Rect1.class WIDTH=800 HEIGHT=500></APPLET>
</BODY>
</HTML>
```

To display the applet, copy the files *Rect1.class* and *Rect1.html* into the appropriate directory in order to access the files using a browser, or launch the applet via the *appletviewer* utility by typing the following at the command line:

```
appletviewer Rect1.html
```

The displayed image will be similar to the image in Figure 1.2

REMARKS

In this book, rectangles are rarely drawn by four invocations of the method *drawLine()* because it's simpler to invoke the method *drawRect()* that is illustrated in *Rect2.java*. Nevertheless, the method *drawLine()* can be combined with gradient shading and other drawing techniques in order to render subtle color combinations. Such examples are demonstrated later in this book.

CONCEPT: USING *DRAWRECT()* TO RENDER RECTANGLES

You might already know that there is a simpler way to draw a rectangle; i.e., instead of drawing the four individual line segments, you can invoke the Java method drawRect(x, y, width, height). This method draws a rectangle of width width and height height of which the upper-left hand corner has coordinates (x, y).

ON THE CD

The Java class *Rect2.java* (Listing 1.3) uses the *drawRect()* method in order to accomplish the same thing as *Rect1.java*.

LISTING 1.3 Rect2.java

```java
import java.awt.Graphics;
import java.io.Serializable;

public class Rect2 extends java.applet.Applet
        implements Serializable
{
    public Rect2()
    {
    }

    public void paint(Graphics gc)
    {
        gc.drawRect(50, 50, 50, 50);  // rectangle ABDC

    } // paint

} // Rect2
```

The HTML file *Rect2.html* (Listing 1.4) contains the code for launching *Rect2.class*.

LISTING 1.4 Rect2.html

```
<HTML>
<HEAD></HEAD>
<BODY>
<APPLET CODE=Rect2.class WIDTH=800 HEIGHT=500></APPLET>
</BODY>
</HTML>
```

When the following is typed in the command line:

```
appletviewer Rect2.html
```

the result is the same output as *Rect1.java*.

REMARKS

It is easy to create variations of *Rect2.java*. For example, you can add a loop that increments the x-coordinate of the upper-left vertex in order to render a set of adjacent rectangles with different colors. The code fragment might look something like this:

```
for(int x=0; x<200; x++)
{
    if(x % 2 == 0) { gc.setColor(Color.white); }
    else           { gc.setColor(Color.red);   }

    gc.drawRect(x+50, 50, 50, 50);
}
```

Another possibility involves combining the method *drawRect()* with the method *fillRect()* that fills a rectangle while varying the width or the height of each rendered rectangle. This new code fragment also requires that you include the following line in your Java code:

```
import java.awt.Color;
```

Colors are an integral part of the Java code in this book, and they are the next topic of discussion.

CONCEPT: COLORS AND THEIR COMPONENTS

Color is the *sine qua non* ("without that which") of graphics. Imagine, if you can, what graphics or art would be like without any color. Apart from watching *film noir*, could anyone look forward to such an impoverished state of affairs?

In the Java world, a color can be defined by specifying an RGB triplet of integers, which specify values for its red component, green component, and blue component, respectively. The values for R, G, and B are independent of each other, and each one is a decimal integer between 0 and 255. Consequently, there are 255 x 255 x 255 = 16,777,216 possible colors combinations. The human eye cannot distinguish between every pair of possible colors; this allows for interesting shading effects. Note that the color white has all colors present, while the color black is actually the absence of all color.

EXAMPLES

```
White:  (R, G, B) = (255, 255, 255)
Black:  (R, G, B) = (0, 0, 0)
Red:    (R, G, B) = (255, 0, 0)
Green:  (R, G, B) = (0, 255, 0)
Blue:   (R, G, B) = (0, 0, 255)
```

As the values of RGB decrease from a maximum of 255 to a minimum of 0, the associated color will darken. This behavior is consistent with the fact that white is (255, 255, 255) and black is (0, 0, 0).

CONCEPT: STANDARD COLORS

Well-known colors can be defined in terms of their RGB components. A short list of the more common colors is provided below.

```
Blue      =    0,   0, 255
Green     =    0, 255,   0
Magenta   =  255,   0, 255
Orange    =  255, 200,   0
Pink      =  255, 175, 175
Red       =  255,   0,   0
Yellow    =  255, 255,   0
LightGray =  192, 192, 192
DarkGray  =   64,  64,  64
Gray      =  128, 128, 128
```

```
Black      =     0,    0,   0
White      =   255,  255, 255
```

CONCEPT: RECTANGLES AND GRADIENT SHADING

Creating interesting shading effects can be achieved by specifying color gradients in various ways. The simplest way to use color involves standard colors such as red, green, and blue. For the sake of illustration, let's say you define a Java class that draws four rectangles, all of which have the same dimensions (i.e., width and height). Assume that the rectangles occupy the four corners of the screen. Suppose a Java class starts with a simple rendering of the rectangles, and then explains how to draw increasingly sophisticated graphics by means of *iterations*.

The first iteration involves drawing all the rectangles with the color red. This is the simplest case and not particularly interesting.

The second iteration renders the rectangles and alternates between red and blue. This case is only a slight improvement over the first one.

The third iteration renders the rectangles with weighted colors. For example, rectangle #1 is red and blue, which means that its RGB triple will be (255, 0, 255). Rectangle #2 is red and green, so it has an RGB of (255, 255, 0). Rectangle #3 is blue and green, so it has an RGB of (0, 255, 255). Rectangle #4 has all three colors but only at "half strength," so it has an RGB of (128, 128, 128). This case has potential, but now it suffers from a significant drawback: the weights of these colors must be manually specified for every rectangle. This tedious effort eliminates most of the fun from the resulting image.

The fourth iteration departs from its predecessors by using a loop, and in this case, pseudo-code to draw rectangle number one, which is in the upper left-hand corner of the screen. For convenience, let's assume that this rectangle has a width of 256. We can draw it using a color gradient from black to red as follows:

```
rVal = 0;
gVal = 0;
bVal = 0;

for(rVal=0; rVal<256; rVal++)
{
    gc.setColor(new Color(rVal, bVal, gVal));
    draw vertical line segment;
    shift one pixel to the right;
}
```

The pseudo-code for drawing the actual line segment and then shifting to the right by one pixel is present in order to illustrate the shading aspect of this iteration.

The rendering of the rectangles has improved; rectangle number one has much better visual subtlety when compared to the other rectangles.

The fifth iteration involves moving one of the rectangles around the screen. Motion can be achieved by assigning a horizontal and vertical initial "velocity" to the selected rectangle. Next, define a loop that does the following:

- Increment the vertices by the "velocity" in the x and y direction.
- Reverse the x velocity when reaching the left or right screen border.
- Reverse the y velocity when reaching the top or bottom screen border.
- Draw the rectangle using the loop from the previous iteration.

Now things are definitely more interesting! The result is a rectangle drawn with a color gradient that appears to "bounce" around the screen.

The sixth iteration involves varying the width and height of the rectangle so that it will expand and contract as it bounces around the screen.

Each of these iterations can be modified in a manner that does not depend on any assumptions regarding the width or the height of the rectangle. In fact, there's no reason why we need to restrict ourselves to a rectangle. This methodology can be used for a variety of two-dimensional and three-dimensional objects, including: ellipses, cylinders, cones, and cubes.

The color gradient can be made much more sophisticated and more interesting. For instance, the preceding iterations used a linear, incremental gradient in which the weight of the color component increased from 0 to 255. Define other color gradients in which the color component increased in multiples of two or three, or some other integer, and then it "wraps" around from 255 to 0 via the modulus function. Use a different color gradient for the R, G, and B color components. Set the color white for every tenth iteration through the associated loop. Instead of using the number 10, use a "gap" variable that increases and decreases in value. Can you visualize what will happen in this situation? You'll see the answer in subsequent chapters!

Using iterations in order to create increasingly complex graphics is a good strategy because you'll make rapid progress and you'll gain a much better understanding of the effects of modifying the code. In some cases, changing the code slightly can produce unexpectedly vivid results. In fact,

"mistakes" can actually be more interesting than the intended result, which can lead to other previously unexplored avenues.

One final point is in order. If you've read the preceding section carefully, you understand the basis for most of the graphics code in this book. In theory, you already know what to do and how to write the code. This comment is not meant to trivialize the graphics code in this book. The fact is that theory and practice often diverge. Be that as it may, you'll see that the Java code in the following chapters is not difficult to grasp.

CONCEPT: RECTANGLES AS POLYGONS

Polygons are defined in terms of a set of vertices and the line segments that connect the given set of vertices. Defining two integer arrays that contain the coordinates of the vertices of the polygon can represent a polygon. For example, suppose you want to render the filled-in rectangle in Figure 1.3 by means of a polygon. First, define the integer arrays *xpts* and *ypts* for the x-coordinates and the y-coordinates, respectively, of the vertices of the rectangle. After assigning values to the elements of *xpts* and *ypts*, you can instantiate a polygon like this:

```
Polygon testPolygon = new Polygon(xpts,ypts,vertexCount);
```

Now set the color and render the polygon:

```
gc.setColor(Color.blue);
gc.drawPolygon(testPolygon);
```

If you want to render a "filled-in" blue rectangle, you can use something like this:

```
gc.setColor(Color.blue);
gc.fillPolygon(testPolygon);
```

ON THE CD

The Java class *Poly1.java* (Listing 1.5) demonstrates how to define a polygon for drawing a filled-in rectangle.

FIGURE 1.3 A filled-in rectangle.

LISTING 1.5 Poly1.java

```java
import java.awt.Color;
import java.awt.Graphics;
import java.awt.Polygon;
import java.io.Serializable;

public class Poly1 extends java.applet.Applet
        implements Serializable
{
    private int vertexCount = 4;
    private int[] xpts = new int[vertexCount];
    private int[] ypts = new int[vertexCount];

    private Polygon polygon = null;

    public Poly1()
    {
    }

    public void paint(Graphics gc)
    {
        // the xpts array holds the x-coordinates and
        // the ypts array holds the y-coordinates

        xpts[0] =  50;     ypts[0] = 100;
        xpts[1] = 100;     ypts[1] = 100;
        xpts[2] = 100;     ypts[2] =  50;
        xpts[3] =  50;     ypts[3] =  50;

        gc.setColor(Color.blue);

        polygon = new Polygon(xpts, ypts, vertexCount);

        gc.fillPolygon(polygon);

    } // paint

} // Poly1
```

ON THE CD

The HTML file *Poly1.html* (Listing 1.6) contains the code for launching *Poly1.class*.

LISTING 1.6 Poly1.html

```html
<HTML>
<HEAD></HEAD>
```

```
<BODY>
<APPLET CODE=Poly1.class WIDTH=800 HEIGHT=500></APPLET>
</BODY>
</HTML>
```

REMARKS

The preceding example is intended only for illustrative purposes. In subsequent examples, you'll see techniques for initializing the vertices of rectangles in one method and then drawing those rectangles in another method. This small change in style will make it easy to add code that creates animation effects.

CONCEPT: SHADED RECTANGLES

As a starting point, consider what might be required for rendering the image depicted in Figure 1.4.

Recall that the x-axis is the horizontal axis (positive toward the right) and that the y-axis is the vertical axis (positive downward). Hence, decrementing the x- and y-coordinates of the upper left-hand corner of the rectangle "pushes" the rectangle upward and toward the left. Figure 1.4 consists of a set of diagonally overlapping blue rectangles that are superimposed with a white rectangle.

ON THE CD

The Java class *Rect3.java* (Listing 1.7) contains a loop in its *paint()* method that invokes the standard method *fillRect()* in order to draw a set of "sliding rectangles" by decrementing the coordinates of the upper left-hand corner of the rectangle, thereby creating the impression of a three-dimensional rectangular object.

FIGURE 1.4 A shaded rectangle.

LISTING 1.7 Rect3.java

```java
import java.awt.Color;
import java.awt.Graphics;
import java.io.Serializable;

public class Rect3 extends java.applet.Applet
        implements Serializable
{
    private int basePointX = 50;
    private int basePointY = 50;

    private int thickness      = 20;

    private int rectangleWidth  = 200;
    private int rectangleHeight = 200;

    public Rect3()
    {
    }

    public void paint(Graphics gc)
    {
        for(int z=thickness; z>=0; z-)
        {
            if( z > 0 ) { gc.setColor(Color.blue); }
            else        { gc.setColor(Color.white); }

            gc.fillRect(basePointX+z,
                        basePointY+z,
                        rectangleWidth,
                        rectangleHeight);
        }

    } // paint

} // Rect3
```

ON THE CD

The HTML file *Rect3.html* (Listing 1.8) contains the code for launching *Rect3.class*.

LISTING 1.8 Rect3.html

```html
<HTML>
<HEAD></HEAD>
<BODY>
<APPLET CODE=Rect3.class WIDTH=800 HEIGHT=500></APPLET>
```

```
</BODY>
</HTML>
```

REMARKS

Notice how the preceding graphics images appears to be created by a light source that is above and to the left of the image. You can create images in which the light source is below or to the right of the image simply by changing the sign of the z variable in the following line:

```
gc.fillRect(basePointX+z, basePointY+z,
            rectangleWidth, rectangleHeight);
```

Three other possibilities are listed below:

```
gc.fillRect(basePointX+z, basePointY-z,
            rectangleWidth, rectangleHeight);

gc.fillRect(basePointX-z, basePointY+z,
            rectangleWidth, rectangleHeight);

gc.fillRect(basePointX-z, basePointY-z,
            rectangleWidth, rectangleHeight);
```

Can you guess what type of image will be produced by each of the preceding lines?

CONCEPT: PARALLELOGRAMS AS POLYGONS

Now let's take a look at parallelograms, which can be viewed as a generalization of rectangles. Unlike rectangles, which have four right angles, the internal angles of a parallelogram are not necessarily right angles. Consider the image in Figure 1.5.

Notice that the line segments with length slantHeight, x, and y, respectively, represent the three sides of a right-angled triangle. If you assign a value to slantHeight and a value to theta, you can calculate the values for x and y using the definitions of *sine* and *cosine* as follows:

```
sine theta   = y/slantHeight
cosine theta = x/slantHeight
```

Multiplying both sides of the first equation by slantHeight gives:

```
y = slantHeight*(sine theta)
```

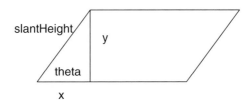

FIGURE 1.5 A parallelogram.

Multiplying both sides of the second equation by `slantHeight` gives:

```
x = slantHeight*(cosine theta)
```

Now we're ready to render any parallelogram with a horizontal set of parallel edges. Let's consider Figure 1.6 that has the following set of values. The starting point P0 and P1 have coordinates (50, 100) and (100, 100), respectively. The value of `theta` is 30 degrees and the value of `slantHeight` is 80. Notice how the vertices have been labeled: P0 is the lower left vertex and the others are labeled sequentially by rotating in a counter clockwise direction.

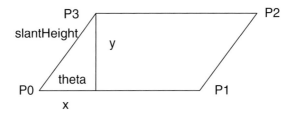

FIGURE 1.6 A labeled parallelogram.

Since x and y are the lengths of the line segments of the right-angled triangle whose hypotenuse has length `slantHeight`, the coordinates of point P2(x2, y2) are:

```
x2 = x1 + x
y2 = y1 - y
```

and the coordinates of point P3(x3, y3) are:

```
x3 = x0 + x
y3 = y0 - y
```

Since the positive x-axis points east, you must add the value x to x2 and x3 but since the positive y-axis points south, you must *subtract* the value y from y2 and y3.

NOTE

When the preceding parallelogram is rendered, it will look something like Figure 1.7.

FIGURE 1.7 A filled parallelogram.

ON THE CD

The Java class *Poly2.java* (Listing 1.9) demonstrates how to draw the parallelogram in Figure 1.7 by first defining a polygon that represents the parallelogram and then rendering the polygon.

LISTING 1.9 Poly2.java

```java
import java.awt.Color;
import java.awt.Graphics;
import java.awt.Polygon;
import java.io.Serializable;

public class Poly2 extends java.applet.Applet
        implements Serializable
{
    private int basePointX = 100;
    private int basePointY = 100;

    private int rectangleWidth  = 200;
    private int rectangleHeight = 100;

    private int vertexCount = 4;

    private int[] xpts = new int[vertexCount];
    private int[] ypts = new int[vertexCount];

    private double offsetX  = 0;
    private double offsetY  = 0;

    private double theta     = 30*Math.PI/180;

    private int slantHeight = 80;

    private Polygon polygon = null;

    public Poly2()
    {
    }
```

```
public void paint(Graphics gc)
{
    offsetX = slantHeight*Math.cos(theta);
    offsetY = slantHeight*Math.sin(theta);

    // counter clockwise from lower-left vertex...
    xpts[0] = basePointX;
    ypts[0] = basePointY;

    xpts[1] = basePointX+rectangleWidth;
    ypts[1] = basePointY;

    xpts[2] = basePointX+rectangleWidth+(int)offsetX;
    ypts[2] = basePointY-(int)offsetY;

    xpts[3] = basePointX+(int)offsetX;
    ypts[3] = basePointY-(int)offsetY;

    // draw filled polygon
    gc.setColor(Color.blue);
    gc.fillPolygon(polygon);

    // draw border of polygon
    gc.setColor(Color.red);
    gc.drawPolygon(polygon);

} // paint

} // Poly2
```

 The HTML file *Poly2.html* (Listing 1.10) contains the code for launching
Poly2.class.

ON THE CD

LISTING 1.10 Poly2.html

```
<HTML>
<HEAD></HEAD>
<BODY>
<APPLET CODE=Poly2.class WIDTH=800 HEIGHT=500></APPLET>
</BODY>
</HTML>
```

REMARKS

The example is slightly atypical in the sense that the *paint()* method is clut-
tered by code that initializes the values of offsetX, offsetY, the points of

the rectangle, and the instantiation of the polygon. All of this code can be moved into a method such as *initializeRectangle()* that is invoked from *init()*. When *paint()* is invoked, it will simply contain the *gc.fillPolygon()* method that displays the instantiated polygon.

CD LIBRARY

ON THE CD

The CD-ROM for this chapter contains "class" files and HTML files that are required for viewing the graphics images in the following Java files:

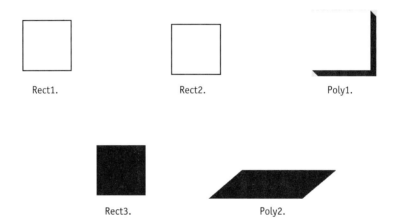

Rect1. Rect2. Poly1.

Rect3. Poly2.

SUMMARY

This chapter covered the following topics that form the cornerstone for many Java classes in subsequent chapters:

- The Java coordinate system
- Colors and color weights
- Basic AWT methods for drawing simple polygons
- The method *drawRect()* for drawing rectangles
- The method *fillPolygon()* for drawing parallelograms

BUILDING BLOCKS

Overview

The quintessential purpose of this book is to present Java code that is derived from "building blocks" which provide the means to deconstruct (in a manner of speaking) seemingly complex graphics images into surprisingly simple Java code. This chapter begins by describing some easy building blocks and provides simple yet illustrative examples. Since every graphics image in this book is defined in terms of its fundamental or "core" building blocks, the building blocks presented in this chapter form the starting point for creating graphics images from their simple subcomponents. As you can surmise, building blocks will be explored in greater detail in future chapters, and invariably the Java code will become more complex. If you always attempt to read the Java code in terms of the associated building blocks, you'll find that the code flows more naturally.

This chapter contains Java code that shows you techniques for drawing polyhedra in interesting ways. We'll start with polyhedra that can be decomposed into a set of parallelograms, each of which can be defined in terms of its four vertices. The coordinates of the vertices can be stored in two arrays (one for the x-coordinates and one for the y-coordinates), and then the parallelograms can be rendered by means of the standard AWT drawing method *fillPolygon()*. More complex polyhedra are represented by more polygons with more than four vertices, but the principle remains the same. All the examples use some type of color gradient or shading technique that creates a three-dimensional effect.

CONCEPT: BUILDING BLOCKS

In this book, the term *core building block* refers to an "object" that can be used to create a larger and more complex object. Core building blocks are building blocks that are "primitive," which means that they cannot be decomposed into smaller building blocks. Note that when you see the term "building block," you can assume that it actually means "core building block" unless otherwise specified.

Every Java class in this book draws a graphics object that is either a core building block or can be decomposed into a set of one or more core building blocks, along with one or more shading techniques. The explanation of the Java code is always preceded by a description of the core building blocks in a given Java class, as well as the methods that are used to render those building blocks.

Why are building blocks important? The use of building blocks (in lieu of pseudo-code) captures the essence of each graphics object in a concise manner. Think of the building blocks as the core components of a graphics image. When an image is visualized in terms of its building blocks, the Java code becomes much easier to grasp. As you become accustomed to the coding style in this book, you'll recognize a consistent pattern for each of the building blocks. Eventually you won't even need to read the code in detail because you'll know how to assemble the building blocks into the required graphics object! At the same time, though, it is important to thoroughly understand how to construct the fundamental building blocks. Read the code for the fundamental building blocks and then periodically review the code in order to reinforce the underlying concepts.

You might be surprised to discover that the vast majority of the Java code in this book relies on various combinations of three core building blocks: triangles, parallelograms, and ellipses.

CONCEPT: TRIANGLES AS BUILDING BLOCKS

A triangle is the polygon with the smallest number of sides, and it's as simple as it is useful. Together with the *sine* and *cosine* functions, triangles are used for calculating horizontal and vertical offsets for other polygons. Every polygon can be decomposed into a set of one or more triangles, which is technique known as *triangularization*. This is an extremely useful fact, because many animation scenes involve objects that are approximated by means of polygons. Each polygon is successively refined until the human eye cannot discern the set of polygons from the object. For in-

stance, you probably cannot discern the difference between a circle and a regular polygon with one thousand sides.

Consider Figure 2.1, which demonstrates how to render a set of nested triangles.

FIGURE 2.1 A nested set of triangles.

The *paint()* method in the Java class *HollowTriangle1.java* invokes the method *drawHollowTriangle()* that contains a loop for drawing a set of nested triangles that "shrink" inward as they are rendered. The three vertices of each triangle have an x-coordinate and a y-coordinate that are stored in the array xpts and ypts, respectively. Notice how the RGB components for the color of each triangle are defined in the loop.

ON THE CD

The Java class *HollowTriangle1.java* (Listing 2.1) demonstrates how to draw a nested set of triangles with gradient shading.

LISTING 2.1 HollowTriangle1.java

```java
import java.awt.Color;
import java.awt.Graphics;
import java.awt.Image;
import java.awt.Polygon;
import java.io.Serializable;

public class HollowTriangle1 extends java.applet.Applet
       implements Serializable
{
   private Graphics offScreenBuffer = null;
   private Image    offScreenImage  = null;

   private int width     = 800;
   private int height    = 500;

   private int basePointX    = 100;
   private int basePointY    = 100;
```

```
private int triangleWidth  = 400;
private int triangleHeight = 200;

private int thickness    = triangleHeight/8;
private int vertexCount   = 3;

private int[] xpts = new int[vertexCount];
private int[] ypts = new int[vertexCount];

private int rVal = 0;
private int gVal = 0;
private int bVal = 255;

private Polygon triangle = null;

public HollowTriangle1()
{
}

public void init()
{
   offScreenImage  = this.createImage(width, height);
   offScreenBuffer = offScreenImage.getGraphics();

} // init

public void paint(Graphics gc)
{
   offScreenBuffer.setColor(Color.lightGray);
   offScreenBuffer.fillRect(0, 0, width, height);

   drawHollowTriangle(offScreenBuffer);

   gc.drawImage(offScreenImage, 0, 0, this);

} // paint

public void drawHollowTriangle(Graphics gc)
{
   for(int z=0; z<thickness; z++)
   {
      // clockwise from the top vertex...
      xpts[0] = basePointX+triangleWidth/2;
      ypts[0] = basePointY+z;

      xpts[1] = basePointX+triangleWidth-2*z;
      ypts[1] = basePointY+triangleHeight-z;

      xpts[2] = basePointX+2*z;
      ypts[2] = basePointY+triangleHeight-z;
```

```
        triangle = new Polygon(xpts, ypts, vertexCount);

        rVal = z*255/thickness;
        gVal = z*255/thickness;

        gc.setColor(new Color(rVal, gVal, bVal));

        gc.drawPolygon(triangle);
      }

   } // drawHollowTriangle

} // HollowTriangle1
```

ON THE CD

The HTML file *HollowTriangle1.html* (Listing 2.2) contains the code for launching *HollowTriangle1.class*.

LISTING 2.2 HollowTriangle1.html

```
<HTML>
<HEAD></HEAD>
<BODY>
<APPLET CODE=HollowTriangle1.class WIDTH=800 HEIGHT=500></APPLET>
</BODY>
</HTML>
```

REMARKS

Since the RGB components of the triangles range from (0, 0, 255) to (255, 255, 255), the color gradient ranges from blue to white. On the other hand, a color range from (255, 255, 255) to (0, 0, 0) creates gradient shading from white to black. You can experiment with other combinations as well. For example, try a color range from (255, 0, 255) to (0, 255, 0). Can you guess what color effect will be produced? This gradient range can be achieved with the following code fragment:

```
for(int z=0; z<thickness; z++)
{
   rVal = 255-z*255/thickness;
   gVal = z*255/thickness;
   bVal = 255-z*255/thickness;
}
```

This example introduces several variables that will appear frequently in this book, so their purpose requires clarification. The variables `off-ScreenBuffer` and `offScreenImage` (and the strange looking code in the *init()* method) are used for *double buffering*, which is extremely important when creating animation effects. The key idea involves three steps: 1) create an "off-screen" buffer (hence the code in the *init()* method), 2) draw something in that off-screen buffer (e.g., the code in the method *drawHollowTriangle()*), and 3) invoke the method *drawImage()* to copy the off-screen buffer to the primary screen. Strictly speaking, this technique is not required unless your Java code involves some type of animation; nevertheless, the Java code in this book will always use double-buffering so that modifying the code in order to incorporate animation can be easily attained.

The variables `width` and `height` define the dimensions of the screen that will be rendered. Their values will change when you resize the screen, and there are methods available that enable you to determine the new values.

The variables `basePointX` and `basePointY` are the x-coordinate and y-coordinate, respectively, of a "base point." Think of this point as an "anchor" point because everything is drawn relative to this point. You can easily create simple animation effects by changing the value of these two variables. The recommended approach involves defining two other variables, `currentX` and `currentY` (the initial values of which are `base-PointX` and `basePointY`, respectively.) These points can be modified in some fashion, thereby maintaining `basePointX` and `basePointY` with fixed values. By using this approach in a consistent manner, you'll be able to delve into lengthier Java classes more quickly because you'll already know the purpose of many variables and the manner in which they are used.

The purpose of the other variables is straightforward. The variables `triangleWidth` and `triangleHeight` represent the initial width and height of a triangle. The variable `thickness` represents the number of nested triangles that will be drawn. The variable `vertexCount` represents the number of vertices of the polygon in the given Java code, and in this example its value is three. This variable is a convenient way to define the size of the arrays `xpts` and `ypts` as well as the maximum value in loops that compute new coordinate values for the associated polygon. The variables `rVal`, `gVal`, and `bVal` represent the values of the RGB components of a color. Finally, the variable `triangle` is an instance of a `Polygon` class.

Concept: Parallelograms as Building Blocks

The parallelogram is a useful building block that can be used for shading in order to create a three-dimensional effect. For example, you can draw a three-dimensional cube simply by drawing three parallelograms: the front face, the top face, and the right face. Each face is defined by its four vertices, and hence can be rendered quickly on the screen. The parallelogram is also the basis for a common shading technique called *polygon shading*. Now consider Figure 2.2 that looks like a three-dimensional cube-like object.

If you look at Figure 2.2, you can see that it consists of three building blocks (all parallelograms):

FIGURE 2.2 Image of a cube-like object.

- Parallelogram Pgram1 is the "front" rectangle.
- Parallelogram Pgram2 is on the right side of Pgram1.
- Parallelogram Pgram3 is directly above Pgram1.

Now look at Figure 2.3, which decomposes *SimpleCube1* into its three building blocks.

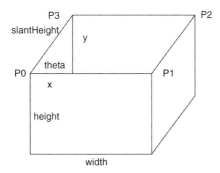

FIGURE 2.3 A diagram of the building blocks in SimpleCube1.

This diagram labels the `height` and `width` of parallelogram Pgram1, as well as the `slantHeight` and angle `theta` of parallelogram Pgram2. Drawing the three parallelograms requires knowing which quantities are assigned values and how to compute the unknown quantities. Let's assign numbers to some quantities:

```
width:                   200
height:                  100
slantHeight:              50
theta:                    30
```

Thus far, we have known values for four quantities and unknown values for two other quantities:

```
Known values:    width, height, slantHeight, theta
Unknown values:  x, y
```

Look closely at Figure 2.3, you'll notice that the three line segments with lengths `slantHeight`, `x`, and `y` form a right-angled triangle. Based on the definitions of the *sine* and *cosine* functions (you can review that section if you've forgotten the definitions of these functions), the values of *x* and *y* can be computed by means of two formulas:

```
x = slantHeight*(cosine theta)
y = slantHeight*(sine theta)
```

Now we're in a position to draw the three building blocks as follows:

1. Pgram1 is the same as the rectangle in *Poly1.java* (see Chapter 1).
2. Pgram2 can be derived from Pgram1 and the quantities *x* and *y*.
3. Pgram3 is the same as the parallelogram in *Poly2.java* (see Chapter 1).

The Java class *SimpleCube1.java* renders the preceding polyhedron primarily by means of three methods:

drawTop()

drawFront()

drawRight()

As you've no doubt surmised, the methods *drawTop()*, *drawFront()*, and *drawRight()* contain the code for drawing the top (Pgram3), front (Pgram1), and right parallelograms (Pgram2), respectively. Each method uses a pair of arrays in order to store the coordinates of the vertices of its respective parallelogram (recall that a rectangle is also a parallelogram). One array stores the x-coordinates of the vertices and the other array stores the y-coordinates of the vertices.

The code for the Java class *SimpleCube1.java* is given in Listing 2.3.

LISTING 2.3 SimpleCube1.java

```java
import java.awt.Color;
import java.awt.Graphics;
import java.awt.Polygon;
import java.io.Serializable;

public class SimpleCube1 extends java.applet.Applet
      implements Serializable
{
    private int basePointX = 100;
    private int basePointY = 200;

    private int vertexCount = 4;

    // dimensions of the parallelogram
    private int rectangleHeight = 100;
    private int rectangleWidth  = 200;

    private int slantHeight     = 50;

    // exterior angle between parallelogram and x-axis
    private double theta = 30*Math.PI/180;

    private double offsetX  = slantHeight*
                                   Math.cos(theta);
    private double offsetY  = slantHeight*
                                   Math.sin(theta);

    // arrays for the "base" rectangle
    private int[] baseXPts = new int[vertexCount];
    private int[] baseYPts = new int[vertexCount];

    // arrays for the top parallelogram
    private int[] topXPts = new int[vertexCount];
    private int[] topYPts = new int[vertexCount];

    // arrays for the right-side parallelogram
    private int[] rightXPts = new int[vertexCount];
    private int[] rightYPts = new int[vertexCount];

    private Polygon basePoly  = null;
    private Polygon topPoly   = null;
    private Polygon rightPoly = null;

    public SimpleCube1()
    {
```

```
}

public void init()
{
}

public void paint(Graphics gc)
{
    drawFront(gc);
    drawTop(gc);
    drawRight(gc);

} // paint

public void drawFront(Graphics gc)
{
    // specify coordinates of "basic" rectangle
    // counter clockwise from lower-left vertex
    baseXPts[0] = basePointX;
    baseYPts[0] = basePointY;

    baseXPts[1] = basePointX+rectangleWidth;
    baseYPts[1] = basePointY;

    baseXPts[2] = basePointX+rectangleWidth;
    baseYPts[2] = basePointY-rectangleHeight;

    baseXPts[3] = basePointX;
    baseYPts[3] = basePointY-rectangleHeight;

    basePoly = new Polygon(baseXPts, baseYPts,
                           vertexCount);

    // draw the "base" rectangle
    gc.setColor(Color.blue);
    gc.fillPolygon(basePoly);

} // drawFront

public void drawTop(Graphics gc)
{
    // specify coordinates of the "top" polygon
    topXPts[0] = baseXPts[3];
    topYPts[0] = baseYPts[3];

    topXPts[1] = baseXPts[2];
    topYPts[1] = baseYPts[2];

    topXPts[2] = topXPts[1]+(int)offsetX;
    topYPts[2] = topYPts[1]-(int)offsetY;
```

```
            topXPts[3] = topXPts[0]+(int)offsetX;
            topYPts[3] = topYPts[0]-(int)offsetY;

            basePoly = new Polygon(topXPts, topYPts,
                                   vertexCount);

            // draw the top polygon
            gc.setColor(Color.green);
            gc.fillPolygon(basePoly);

        } // drawTop

        public void drawRight(Graphics gc)
        {
            // specify coordinates of the "right" polygon
            rightXPts[0] = baseXPts[1];
            rightYPts[0] = baseYPts[1];

            rightXPts[1] = baseXPts[2];
            rightYPts[1] = baseYPts[2];

            rightXPts[2] = rightXPts[1]+(int)offsetX;
            rightYPts[2] = rightYPts[1]-(int)offsetY;

            rightXPts[3] = rightXPts[0]+(int)offsetX;
            rightYPts[3] = rightYPts[0]-(int)offsetY;

            rightPoly = new Polygon(rightXPts,rightYPts,
                                    vertexCount);

            // draw the right-side polygon
            gc.setColor(Color.red);
            gc.fillPolygon(rightPoly);

        } // drawRight

} // SimpleCube1
```

The HTML file *SimpleCube1.html* (Listing 2.4) contains the code for launching *SimpleCube1.class*.

LISTING 2.4 SimpleCube1.html

```
<HTML>
<HEAD></HEAD>
<BODY>
<APPLET CODE=SimpleCube1.class WIDTH=800 HEIGHT=500></APPLET>
</BODY>
</HTML>
```

REMARKS

The preceding example separates the drawing of the cube into three methods, each of which draws a single face of the cube. However, the code can be further modified in order to separate the initialization of polygons and the drawing of those polygons. For example, the initialization code in *drawFront(Graphics gc)* can be moved into a method called *initializeFront()*, which is invoked at the bottom of the *init()* method. Similar comments apply to the two methods *drawTop()* and *drawRight()*.

Notice that the initialization of the "base" rectangle starts from the lower left-hand vertex and then proceeds in a counter clockwise direction for the remaining vertices. Some of the vertices of the base rectangle are used in the definition of the coordinates of some of the vertices in the top and right-side parallelograms. For instance, the initialization of the top parallelogram also starts from the top-left vertex of the base rectangle and proceeds in a counter clockwise fashion for the remaining vertices. On the other hand, the initialization of the right parallelogram starts from the lower-left vertex and proceeds in a clockwise fashion for the remaining vertices.

Consider the definition of the variable *theta*, which represents the angle between the positive x-axis and the slant side of the top parallelogram:

```
private double theta = 30*Math.PI/180;
```

Since the angle that you supply to trigonometric functions such as *sine* and *cosine* is assumed to be in *radians* (recall that one radian is 180/PI degrees), we must multiply 30 by Math.PI/180 in order to compute the *sine* and *cosine* of 30 degrees.

CONCEPT: OSCILLATING POLYHEDRA

Now that you've seen how to create a cube-like object in *SimpleCube1.java*, we can easily vary the height of cube-like polyhedra, thereby creating an animation effect. In subsequent chapters you'll see how to enhance the technique in this example in order to create more sophisticated animation effects.

Consider Figure 2.4 and Figure 2.5, both of which resemble a three-dimensional cube.

Figure 2.4 and Figure 2.5 consist of the same three building blocks as *SimpleCube1.java:*

FIGURE 2.4 Snapshot of a shrinking cube-like object.

FIGURE 2.5 Subsequent snapshot of a shrinking cube-like object.

- Parallelogram Pgram1 is the "front" rectangle.
- Parallelogram Pgram2 is on the right side of Pgram1.
- Parallelogram Pgram3 is directly above Pgram1.

The Java class *ShrinkingCube1.java* contains the following important methods:

drawTop()

drawFront()

drawRight()

updateCoordinates()

paint()

As in the previous example, the methods *drawTop()*, *drawFront()*, and *drawRight()* contain the code for drawing the top, front, and right parallelograms, respectively. So far everything is the same as the Java class *SimpleCube1.java*.

The distinguishing feature of this example is the logic that is used for varying the height of the front rectangle between a minimum and a maximum value. This logic is contained in the method *updateCoordinates()*. In this method, the variable `rectangleHeight` is updated as follows:

```
rectangleHeight += yDirection*yDelta;
```

The variable `yDirection` can be either +1 or −1, and `yDelta` is a value that is fixed for the life of the applet and can be changed. The variable `yDelta` specifies the amount by which the height will be incremented. When the variable `rectangleHeight` exceeds a maximum height or becomes less than a minimum height, the value of `yDirection` is "toggled"; +1 is replaced by −1 and −1 is replaced by +1.

```
        drawRight(offScreenBuffer);

        gc.drawImage(offScreenImage, 0, 0, this);

        updateCoordinates();
    }

} // paint

public void updateCoordinates()
{
    rectangleHeight += yDirection*yDelta;

    if( rectangleHeight < minRectangleHeight )
    {
        rectangleHeight = minRectangleHeight;
        yDirection      *= -1;
    }

    if( rectangleHeight > maxRectangleHeight )
    {
        rectangleHeight = maxRectangleHeight;
        yDirection      *= -1;
    }

} // updateCoordinates

public void drawFront(Graphics gc)
{
    // specify coordinates of "basic" rectangle
    baseXPts[0] = basePointX;
    baseYPts[0] = basePointY;

    baseXPts[1] = basePointX+rectangleWidth;
    baseYPts[1] = basePointY;

    baseXPts[2] = basePointX+rectangleWidth;
    baseYPts[2] = basePointY-rectangleHeight;

    baseXPts[3] = basePointX;
    baseYPts[3] = basePointY-rectangleHeight;

    basePoly = new Polygon(baseXPts, baseYPts,
                             vertexCount);

    // draw the "base" rectangle
    gc.setColor(Color.blue);
    gc.fillPolygon(basePoly);

} // drawFront
```

```
public void drawTop(Graphics gc)
{
    // specify coordinates of the "top" polygon
    topXPts[0] = baseXPts[3];
    topYPts[0] = baseYPts[3];

    topXPts[1] = baseXPts[2];
    topYPts[1] = baseYPts[2];

    topXPts[2] = topXPts[1]+(int)offsetX;
    topYPts[2] = topYPts[1]-(int)offsetY;

    topXPts[3] = topXPts[0]+(int)offsetX;
    topYPts[3] = topYPts[0]-(int)offsetY;

    basePoly = new Polygon(topXPts,
                           topYPts,
                           vertexCount);

    // draw the top polygon
    gc.setColor(Color.green);
    gc.fillPolygon(basePoly);

} // drawTop

public void drawRight(Graphics gc)
{
    // specify coordinates of the "right" polygon
    rightXPts[0] = baseXPts[1];
    rightYPts[0] = baseYPts[1];

    rightXPts[1] = baseXPts[2];
    rightYPts[1] = baseYPts[2];

    rightXPts[2] = rightXPts[1]+(int)offsetX;
    rightYPts[2] = rightYPts[1]-(int)offsetY;

    rightXPts[3] = rightXPts[0]+(int)offsetX;
    rightYPts[3] = rightYPts[0]-(int)offsetY;

    rightPoly = new Polygon(rightXPts, rightYPts,
                            vertexCount);

    // draw the right-side polygon
    gc.setColor(Color.red);
    gc.fillPolygon(rightPoly);

} // drawRight

} // ShrinkingCube1
```

ON THE CD

The HTML file *ShrinkingCube1.html* (Listing 2.6) contains the code for launching *ShrinkingCube1.class*.

LISTING 2.6 ShrinkingCube1.html

```
<HTML>
<HEAD></HEAD>
<BODY>
<APPLET CODE=ShrinkingCube1.class WIDTH=800 HEIGHT=500></APPLET>
</BODY>
</HTML>
```

REMARKS

A three-dimensional cube has six faces, each of which is a square. In the preceding example, the width and height of each face is actually a rectangle rather than a square. The technical term for the resulting image is a *parallelopiped*. Sometimes you'll see the term "cube-like" object because it is readily understood by a greater number of people. Keep in mind, though, that whenever you see the term "cube-like" object in this book, it refers to a parallelopiped.

The preceding example introduces two simple yet useful techniques: the *for()* loop in *paint()* and the method *updateCoordinates()*. The purpose of the *for()* loop is to control the number of iterations of the code in the *paint()* method. The purpose of the *updateCoordinates()* method is to change the values of the vertices of the cube. You'll see this technique used in many Java classes, particularly those that involve animation or mouse events. The key idea involves varying the height of the base rectangle between a maximum and minimum value by means of a linear increment. You can also use non-linear increments for changing the height of the rectangle, but they tend not to enhance the visual effect in a meaningful fashion.

Notice how the height of the base rectangle is computed. The current height is defined by `rectangleHeight`, and the new height is computed by incrementing `rectangleHeight` by the product of two numbers: `yDelta` (which specifies the rate of change) and `yDirection` (which is either +1 or −1). When `yDirection` equals 1, the height will increase to its maximum allowable value; when `yDirection` equals −1, the height will decrease to its minimum allowable value. Toggling the value of `yDirection` causes the height to oscillate between its minimum and maximum allowable values, thereby creating an animation effect.

CONCEPT: ELLIPSES AS CORE BUILDING BLOCKS

In addition to polygonal approximation, many non-polygonal objects can be approximated by means of ellipses. Let's start with a very simple example that renders a set of ellipses that is illustrated in Figure 2.6.

FIGURE 2.6 A set of overlapping ellipses.

As you can see, code in *Ellipse1.java* is straightforward: the *paint()* method invokes the method *drawEllipses()*, which in turn contains a loop that draws a set of diagonally shifting ellipses.

The Java class *Ellipse1.java* (Listing 2.7) demonstrates how to draw a set of ellipses with gradient shading.

ON THE CD

LISTING 2.7 Ellipse1.java

```java
import java.awt.Color;
import java.awt.Graphics;
import java.awt.Image;

import java.io.Serializable;

public class Ellipse1 extends java.applet.Applet
        implements Serializable
{
    private Image offScreenImage    = null;
    private Graphics offScreenBuffer = null;

    private int width      = 800;
    private int height     = 500;

    private int basePointX = 100;
    private int basePointY = 100;

    private int eWidth     = 240;
    private int eHeight    = 150;
    private int thickness  = 20;
```

```
public Ellipse1()
{
}

public void init()
{
    offScreenImage  = this.createImage(width, height);
    offScreenBuffer = offScreenImage.getGraphics();
}

public void update(Graphics gc)
{
    paint(gc);

} // update

public void paint(Graphics gc)
{
    offScreenBuffer.setColor(Color.lightGray);
    offScreenBuffer.fillRect(0, 0, width, height);

    drawEllipses(offScreenBuffer);

    gc.drawImage(offScreenImage, 0, 0, this);

} // paint

public void drawEllipses(Graphics gc)
{
    for(int z=thickness; z>=0; z-)
    {
        if(z > 0) { gc.setColor(Color.black); }
        else      { gc.setColor(Color.red); }

        gc.fillOval(basePointX+z,
                    basePointY+z,
                    eWidth,
                    eHeight);
    }

} // drawEllipses

} // Ellipse1
```

ON THE CD

The HTML file *Ellipse1.html* (Listing 2.8) contains the code for launching *Ellipse1.class*.

LISTING 2.8 Ellipse1.html

```
<HTML>
<HEAD></HEAD>
<BODY>
<APPLET CODE=Ellipse1.class WIDTH=800 HEIGHT=500></APPLET>
</BODY>
</HTML>
```

REMARKS

You probably remember that circles are a special case of ellipses (i.e., the major axis and the minor axis are equal). Arcs and sectors can be thought of as "partial" ellipses, and they are used to render common objects. The animation in this book uses a combination of ellipses, arcs, sectors, and various other functions in order to render non-linear objects. There is a more detailed discussion of ellipses, along with more sophisticated examples, in Chapter 8 of this book.

CONCEPT: ELLIPSES AS BUILDING BLOCKS FOR CYLINDERS

Consider the example of drawing a vertical cylinder. From a graphical standpoint, this cylinder can be viewed as the juxtaposition of a rectangle and two ellipses. In fact, that's exactly how one Java class draws a cylinder. Another method for drawing a cylinder—which is demonstrated in the next example—involves displaying a set of adjacent horizontal ellipses. While both techniques can produce the same result, the second method is more sophisticated because it can be combined with gradient shading in order to achieve more subtle shading effects. Figure 2.7 illustrates this concept in an elegant fashion.

FIGURE 2.7 A set of candles.

The Java class *Candles1.java* contains the following methods:

initializeEllipses()

calculateColorWeights()

drawVerticalCylinder()

drawCandleWicks()

The method *initializeEllipses()* initializes the x-coordinate and y-coordinate of the upper-left corner of the bounding rectangle of each ellipse in a rectangular "grid" of ellipses. The method *calculateColorWeights()* assigns the array `colorWeights` with the RGB components of several standard colors. This assignment relies on the Java methods *getRed()*, *getGreen()*, and *getBlue()*. The method *drawVerticalCylinder()* draws a rectangular grid of vertical cylinders, each of which consists of a set of adjacent horizontal ellipses. The method *drawCandleWicks()* draws a vertical line segment on top of each cylinder in order to simulate a candle wick.

ON THE CD

The Java class *Candles1.java* (Listing 2.9) demonstrates how to draw a set of candle-like objects by means of multiple sets of ellipses via gradient shading.

LISTING 2.9 Candles1.java

```java
import java.awt.Color;
import java.awt.Graphics;
import java.awt.Image;

import java.io.Serializable;

public class Candles1 extends java.applet.Applet
       implements Serializable
{
   private Graphics offScreenBuffer = null;
   private Image    offScreenImage  = null;

   private int width   = 800;
   private int height  = 500;

   private int basePointX = 100;
   private int basePointY = 400;

   private int currentX   = basePointX;
   private int currentY   = basePointY;

   private int rowCount = 4;
```

```
private int colCount = 6;

private int eWidth   = 60;
private int eHeight  = 20;

private int wickHeight       = eWidth/4;
private int wickWidth        = 4;

private int interCellWidth   = 0;
private int interCellHeight   = 0;

private int[][] ellipseXCoord =
                       new int[rowCount][colCount];

private int[][] ellipseYCoord =
                       new int[rowCount][colCount];

private Color[] stackedColors = {
   Color.red, Color.green, Color.blue, Color.yellow,
   Color.pink, Color.magenta
};

private int[][] colorWeights =
                    new int[stackedColors.length][3];

private int bTheta       = 20;
private int candleHeight = 200;

private int rVal       = 0;
private int gVal       = 0;
private int bVal       = 0;

private int offsetX     = 0;
private int offsetY     = 0;
private int randomColor = 0;

public Candles1()
{
}

public void init()
{
   offScreenImage  = this.createImage(width, height);
   offScreenBuffer = offScreenImage.getGraphics();

   initializeEllipses();
   calculateColorWeights();

} // init
```

```java
public void initializeEllipses()
{
    offsetX = (int)(10*Math.cos(bTheta*Math.PI/180));
    offsetY = (int)(10*Math.sin(bTheta*Math.PI/180));

    for(int row=0; row<rowCount; row++)
    {
        for(int col=0; col<colCount; col++)
        {
            ellipseXCoord[row][col] = currentX+
                row*offsetX+col*(eWidth+interCellWidth);

            ellipseYCoord[row][col] = currentY-
                row*offsetY-row*(eHeight+interCellHeight);

        }
    }

} // initializeEllipses

public void calculateColorWeights()
{
    colorWeights = new int[stackedColors.length][3];

    colorWeights[0][0] = Color.red.getRed();
    colorWeights[0][1] = Color.red.getGreen();
    colorWeights[0][2] = Color.red.getBlue();

    colorWeights[1][0] = Color.green.getRed();
    colorWeights[1][1] = Color.green.getGreen();
    colorWeights[1][2] = Color.green.getBlue();

    colorWeights[2][0] = Color.blue.getRed();
    colorWeights[2][1] = Color.blue.getGreen();
    colorWeights[2][2] = Color.blue.getBlue();

    colorWeights[3][0] = Color.yellow.getRed();
    colorWeights[3][1] = Color.yellow.getGreen();
    colorWeights[3][2] = Color.yellow.getBlue();

    colorWeights[4][0] = Color.pink.getRed();
    colorWeights[4][1] = Color.pink.getGreen();
    colorWeights[4][2] = Color.pink.getBlue();

    colorWeights[5][0] = Color.magenta.getRed();
    colorWeights[5][1] = Color.magenta.getGreen();
    colorWeights[5][2] = Color.magenta.getBlue();

} // calculateColorWeights
```

```java
public void update(Graphics gc)
{
   paint(gc);

} // update

public void paint(Graphics gc)
{
   offScreenBuffer.setColor(Color.lightGray);
   offScreenBuffer.fillRect(0, 0, width, height);

   for(int row=rowCount-1; row>=0; -row)
   {
      for(int col=0; col<colCount; ++col)
      {
         drawVerticalCylinder(offScreenBuffer,
                              row,
                              col);
      }
   }

   drawCandleWicks(offScreenBuffer);

   gc.drawImage(offScreenImage, 0, 0, this);

} // paint

public void drawCandleWicks(Graphics gc)
{
   gc.setColor(Color.white);

   for(int row=0; row<rowCount; row++)
   {
      for(int col=0; col<colCount; col++)
      {
         gc.fill3DRect(
                 ellipseXCoord[row][col]+
                              eWidth/2-wickWidth/2,
                 ellipseYCoord[row][col]-candleHeight,
                 wickWidth,
                 wickHeight,
                 true);
      }
   }

} // drawCandleWicks

public void drawVerticalCylinder(Graphics gc,
                                 int row, int col)
{
```

```
randomColor = (int)(6*Math.random());

// draw current ellipse...
for(int k=0; k<candleHeight; k++)
{
    rVal = k*colorWeights[randomColor][0]/
                            candleHeight;
    gVal = k*colorWeights[randomColor][1]/
                            candleHeight;
    bVal = k*colorWeights[randomColor][2]/
                            candleHeight;

    gc.setColor(new Color(rVal, gVal, bVal));

    gc.fillOval(ellipseXCoord[row][col],
                ellipseYCoord[row][col]-k,
                eWidth,
                eHeight);
}

// draw top of current ellipse...
gc.setColor(Color.white);
gc.drawOval(ellipseXCoord[row][col],
            ellipseYCoord[row][col],
            eWidth,
            eHeight);

// draw bottom of current ellipse...
gc.drawOval(ellipseXCoord[row][col],
            ellipseYCoord[row][col]-candleHeight,
            eWidth,
            eHeight);

    } // drawVerticalCylinder

} // Candles1
```

ON THE CD

The HTML file *Candles1.html* (Listing 2.10) contains the code for launching *Candles1.class*.

LISTING 2.10 Candles1.html

```
<HTML>
<HEAD></HEAD>
<BODY>
<APPLET CODE=Candles1.class WIDTH=800 HEIGHT=500></APPLET>
</BODY>
</HTML>
```

REMARKS

The key idea in *Candles1.java* is actually quite simple: each "candle" consists of a set of vertically stacked ellipses, each of which is drawn with a vertical color gradient. A white rectangle is used for rendering the "wick" of each candle. By the way, the term "horizontal ellipse" is somewhat of a misnomer, but it's a convenient way to convey the notion of an ellipse whose major axis is the horizontal axis of the plane. Similarly, a "vertical ellipse" refers to an ellipse of which major axis is the vertical axis of the plane. The same comments apply for a "horizontal cylinder" and a "vertical cylinder."

CD LIBRARY

ON THE CD

The CD-ROM for this chapter contains "class" files and HTML files that are required for viewing the graphics images in the following Java files:

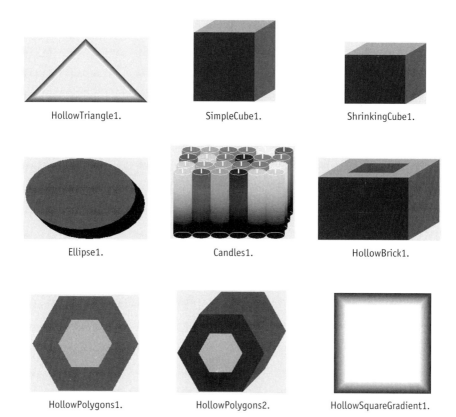

HollowTriangle1.

SimpleCube1.

ShrinkingCube1.

Ellipse1.

Candles1.

HollowBrick1.

HollowPolygons1.

HollowPolygons2.

HollowSquareGradient1.

HollowSquareGradient2. HollowTrapezoid1.

These Java files combine various shading techniques (such as gradient shading) in order to render squares, trapezoids, hexagons, and triangles. The Java files vary between one and three pages of code. Some of the images, such as the one rendered by the file *HollowPolygons2.java*, create a three-dimensional effect by drawing multiple overlapping polygons. Other images, such as the image rendered by the Java file *HollowSquareGradient2.java*, have a slightly "brushed" effect that is the result of gradient shading. Look at the graphics image rendered by the Java file *HollowTrapezoid1.java* and then read the code. You'll probably be surprised by what you can render with one page of Java code!

SUMMARY

This chapter presented Java code that introduced you to basic techniques for rendering the following objects by means of building blocks:

- Three-dimensional cube-like objects
- Three-dimensional oscillating cube-like objects
- Stacked ellipses
- A set of candle-like objects

The techniques in these examples are refined in subsequent chapters in order to draw more complex-looking graphics images. In many cases, the code in the associated Java classes is very reasonable in size (i.e., three or four pages), despite the richness of the graphics images.

LINE SEGMENTS AND TRIGONOMETRY (I)

Overview

This chapter contains Java code that demonstrates how to draw objects that combine polar equations with line segments. Different color gradients are used in order to enhance the visual effect. If you haven't already done so, this would be a good time to review the section on polar coordinates in Appendix A.

Polar equations in the plane usually have limited visual appeal. Granted, some equations have a few interesting twists or some type of unusual curvature, but the novelty quickly wears off. One technique for making these equations much more interesting is to combine them with another simple geometric object. In this chapter we'll combine polar equations with line segments. You're probably wondering why this would make any significant difference. The answer involves the notion of building blocks. We'll use the polar equations as the means by which we can trace a curve in the plane, and at each point on the curve we'll draw a line segment. This deceptively simple concept can be exploited in interesting ways. In fact, when you see the resultant graphics you'll find that they have a surprising richness, despite their mathematical simplicity.

Incidentally, the only thing in the plane that is simpler (i.e., has fewer dimensions) than a line segment is a point. You might think that we can't do anything with a single point and a curve, but it turns out that even a single point can be used to our advantage.

The Java classes in this chapter are based on the names of the associated polar equation. For example, *ConchoidLines1.java* is a Java class that is based on a polar equation that is known as a *Conchoid*. You can search the

Web for an extensive list of well-known polar equations, some of which are named after famous historical figures.

CONCEPT: DRAWING LINE SEGMENTS AND *CONCHOIDS*

The next object (Figure 3.1) consists of the following building blocks:

FIGURE 3.1 A set of *Conchoid*-based line segments.

- A set of line segments
- A *Conchoid*

The Java class *ConchoidLines1.java* contains the following methods:

drawSpiral()

drawLine()

The method *drawSpiral()* computes the (x, y) coordinates of the points on a *Conchoid* and invokes the method *drawLine()* in order to draw a line segment.

The method *drawLine()* draws a slanted line segment at the current point represented by the point with coordinates (x, y).

ON THE CD

The Java class *ConchoidLines1.java* (Listing 3.1) demonstrates how to draw line segments that follow the path of a *Conchoid*.

LISTING 3.1 ConchoidLines1.java

```
import java.awt.Color;
import java.awt.Graphics;
import java.awt.Image;
```

```java
import java.io.Serializable;

public class ConchoidLines1 extends java.applet.Applet
        implements Serializable
{
   private Graphics offScreenBuffer = null;
   private Image    offScreenImage  = null;

   private int width      = 800;
   private int height     = 500;

   private int basePointX = 300;
   private int basePointY = 150;

   private int currentX   = basePointX;
   private int currentY   = basePointY;

   private double offsetX = 0;
   private double offsetY = 0;

   private int constant1 = 120;
   private int constant2 = 40;
   private int branches  = 1;

   private double radius = 40;
   private double Radius = 60;

   private double frequency = 1.0;

   private int eHeight    = 20;
   private int eWidth     = 20;
   private int minEHeight = 20;
   private int maxEHeight = 80;

   private int startTheta = (int)(0/frequency);
   private int endTheta   = (int)(360/frequency);

   private int angleSpan = endTheta-startTheta;

   private double slantLength = 60;
   private double slantAngle  = 20;

   private double slantX = slantLength*Math.cos(
                                slantAngle*Math.PI/180);
   private double slantY = slantLength*Math.sin(
                                slantAngle*Math.PI/180);

   private int thickness = 20;

   private Color[] lineColors = {
```

```
    Color.red, Color.green, Color.blue, Color.yellow,
    Color.white, Color.magenta
};

private int colorCount = lineColors.length;

public ConchoidLines1()
{
}

public void init()
{
    offScreenImage  = this.createImage(width, height);
    offScreenBuffer = offScreenImage.getGraphics();

} // init

public void update(Graphics gc)
{
    paint(gc);

} // update

public void paint(Graphics gc)
{
    offScreenBuffer.setColor(Color.lightGray);
    offScreenBuffer.fillRect(0, 0, width, height);

    offScreenBuffer.setColor(Color.red);
    drawSpiral(offScreenBuffer);
    gc.drawImage(offScreenImage, 0, 0, this);

} // paint

public void drawSpiral(Graphics gc)
{
    for(int angle=startTheta; angle<endTheta; angle++)
    {
      radius = Math.cos(branches*angle*Math.PI/180);

      if( radius != 0 )
      {
         radius = constant1+constant2/radius;

         offsetX = radius*Math.cos(angle*Math.PI/180);
         offsetY = radius*Math.sin(angle*Math.PI/180);

         currentX = basePointX+(int)offsetX;
         currentY = basePointY+(int)offsetY;
```

```
            drawLine(gc, angle, currentX, currentY);
         }
      }

   } // drawSpiral

   public void drawLine(Graphics gc, int x,
                        int xCoord, int yCoord)
   {
      gc.setColor(lineColors[(x%2)*2]);

      for(int z=0; z<thickness; z++)
      {
         gc.drawLine(xCoord,
                     yCoord+z,
                     xCoord+(int)slantX,
                     yCoord+z-(int)slantY);
      }

   } // drawLine

} // ConchoidEllipses1
```

ON THE CD

The HTML file *ConchoidLines1.html* (Listing 3.2) contains the code for launching *ConchoidLines1.class*.

LISTING 3.2 ConchoidLines1.html

```
<HTML>
<HEAD></HEAD>
<BODY>
<APPLET CODE=ConchoidLines1.class WIDTH=800 HEIGHT=450></APPLET>
</BODY>
</HTML>
```

REMARKS

Notice how the method *drawLine()* draws a line segment. First, it computes the index into the array of colors lineColors with the following statement:

```
gc.setColor(lineColors[(x%2)*2]);
```

The value of x%2 is the remainder of x divided by 2, which means it's either 0 or 1. The value of (x%2)*2 is therefore either 2*0 or 2*1, which means either 0 or 2. This simple technique allows you to "toggle" between two non-adjacent colors in a color array.

Second, it draws a slanted line from the current point on the *Conchoid* to another point that has a pre-defined horizontal and vertical "offset." The offsets are specified by slantX and slantY, which are defined at the top of the Java code.

Let's take another look at the color-setting technique because this will give you some ideas for your own variations. You've probably noticed that you could shuffle the contents of the color array so that the desired colors are adjacent to each other, and then replace (x%2)*2 with the simple expression (x%2). While this is certainly true, you won't have as much flexibility if you use that approach. You could replace the expression (x%2)*2 with (x%2)*3, or some other factor that you can control by means of conditional logic.

CONCEPT: LINE SEGMENTS AND *NEPHROIDS*

The next object (Figure 3.2) consists of the following building blocks:

- A set of line segments
- A *Nephroid*

The Java class *NephroidLines1.java* contains the following methods:

drawSpiral()
drawLine()

The method *drawSpiral()* computes the (x, y) coordinates of the points on a *Nephroid* and invokes the method *drawLine()* in order to draw a line segment.

FIGURE 3.2 A set of *Nephroid*-based line segments.

The method *drawLine()* draws a slanted line segment at the current point represented by the pair (x, y).

ON THE CD

The Java class *NephroidLines1.java* (Listing 3.3) demonstrates how to draw line segments that follow the path of a *Nephroid*.

LISTING 3.3 NephroidLines1.java

```java
import java.awt.Color;
import java.awt.Graphics;
import java.awt.Image;

import java.io.Serializable;

public class NephroidLines1 extends java.applet.Applet
      implements Serializable
{
   private Graphics offScreenBuffer = null;
   private Image    offScreenImage  = null;

   private int width    = 800;
   private int height   = 500;

   private int basePointX = 300;
   private int basePointY = 250;

   private int currentX   = basePointX;
   private int currentY   = basePointY;

   private double offsetX = 0;
   private double offsetY = 0;

   private int C1 = 40;
   private int branches = 3;

   private double radius = 40;
   private double Radius = 60;

   private double frequency = 1.0;

   private int eHeight   = 20;
   private int eWidth    = 20;
   private int minEHeight = 20;
   private int maxEHeight = 80;

   private int startTheta = (int)(0/frequency);
   private int endTheta   = (int)(720/frequency);

   private int angleSpan = endTheta-startTheta;
```

```
private double slantLength = 60;
private double slantAngle  = 20;

private double slantX = slantLength*Math.cos(
                            slantAngle*Math.PI/180);
private double slantY = slantLength*Math.sin(
                            slantAngle*Math.PI/180);

private int thickness = 20;

private Color[] lineColors = {
   Color.red, Color.green, Color.blue, Color.yellow,
   Color.white, Color.magenta
};

private int colorCount = lineColors.length;

public NephroidLines1()
{
}

public void init()
{
   offScreenImage  = this.createImage(width, height);
   offScreenBuffer = offScreenImage.getGraphics();

} // init

public void update(Graphics gc)
{
   paint(gc);

} // update

public void paint(Graphics gc)
{
   offScreenBuffer.setColor(Color.lightGray);
   offScreenBuffer.fillRect(0, 0, width, height);

   offScreenBuffer.setColor(Color.red);
   drawSpiral(offScreenBuffer);
   gc.drawImage(offScreenImage, 0, 0, this);

} // paint

public void drawSpiral(Graphics gc)
{
   for(int angle=startTheta; angle<endTheta; angle++)
   {
      radius = C1*(1+branches*Math.sin(
```

```
                               (angle/branches)*Math.PI/180));

         offsetX = radius*Math.cos(angle*Math.PI/180);
         offsetY = radius*Math.sin(angle*Math.PI/180);

         currentX = basePointX+(int)offsetX;
         currentY = basePointY+(int)offsetY;

         drawLine(gc, angle, currentX, currentY);
      }

   } // drawSpiral

   public void drawLine(Graphics gc, int x,
                        int xCoord, int yCoord)
   {
      gc.setColor(lineColors[((x%2)*x)%colorCount]);

      for(int z=0; z<thickness; z++)
      {
         gc.drawLine(xCoord,
                     yCoord+z,
                     xCoord+(int)slantX,
                     yCoord+z-(int)slantY);
      }

   } // drawLine

} // NephroidEllipses1
```

The HTML file *NephroidLines1.html* (Listing 3.4) contains the code for launching *NephroidLines1.class*.

ON THE CD

LISTING 3.4 NephroidLines1.html

```
<HTML>
<HEAD></HEAD>
<BODY>
<APPLET CODE=NephroidLines1.class WIDTH=800 HEIGHT=450></APPLET>
</BODY>
</HTML>
```

REMARKS

Do not use the expression (x%2)*x, because it is wrong! This expression will quickly become larger than the number of elements in the color array,

at which point you'll get a run-time error. This quantity can be restricted to a valid size by computing its remainder modulo `colorCount`. Another way to compute the index into the color array is an expression of the form `(x+(x%2)*x)%colorCount`. Alternatively, you can experiment with other variations by adding some conditional logic such as the following:

```
if( x % 8 == 0)
{
    gc.setColor(Color.white);
}
else
{
    gc.setColor(lineColors[((x%2)*x)%colorCount]);
}
```

The use of conditional logic in order to determine the current color is a technique that is used for a certain type of visual effect. Can you guess what it might be?

CONCEPT: TILTING LINE SEGMENTS AND *LISSAJOUS* CURVES

The next object (Figure 3.3) consists of the following building blocks:

- A set of line segments
- A *Lissajous* curve

The Java class *LissajousTiltingLines1.java* contains the following methods:

drawSpiral()

drawLine()

updateCoordinates()

FIGURE 3.3 A set of *Lissajous*-based tilting line segments.

The method *drawSpiral()* computes the (x, y) coordinates of the points on a *Lissajous* curve and invokes the method *drawLine()* in order to draw a line segment.

The method *drawLine()* draws a slanted line segment at the current point represented by the pair (x, y).

The method *updateCoordinates()* updates the current "tilt" angle and ensures that its value lies between a minimum and maximum allowable value.

ON THE CD

The Java class *LissajousTiltingLines1.java* (Listing 3.5) demonstrates how to draw line segments that follow the path of a *Lissajous* curve.

LISTING 3.5 LissajousTiltingLines1.java

```java
import java.awt.Color;
import java.awt.Graphics;
import java.awt.Image;

import java.io.Serializable;

public class LissajousTiltingLines1 extends
        java.applet.Applet implements Serializable
{
    private Graphics offScreenBuffer = null;
    private Image    offScreenImage  = null;

    private int width  = 800;
    private int height = 500;

    private int basePointX = 300;
    private int basePointY = 250;

    private int currentX  = basePointX;
    private int currentY  = basePointY;

    private double offsetX = 0;
    private double offsetY = 0;

    private double sineAngle1 = 0;
    private double sineAngle2 = 0;

    private double C1 = 160;
    private double C2 = 200;

    private int branches1 = 5;

    private double frequency = 1.0;
```

```java
private int startTheta = (int)(0/frequency);
private int endTheta   = (int)(360/frequency);

private double slantLength = 60;
private double minSlantLength = 20;
private double maxSlantLength = 200;
private double slantLengthDelta = 4;
private double slantLengthDirection = 1;

private double slantAngle = 20;
private double minSlantAngle = 0;
private double maxSlantAngle = 40;
private double slantAngleDelta = 1;
private double slantAngleDirection = 1;

private double slantX = slantLength*Math.cos(
                            slantAngle*Math.PI/180);
private double slantY = slantLength*Math.sin(
                            slantAngle*Math.PI/180);

private int thickness = 20;

private Color[] lineColors = {
   Color.red, Color.green, Color.blue, Color.yellow,
   Color.white, Color.magenta
};

private int colorCount = lineColors.length;

private int rVal = 255;
private int gVal = 0;
private int bVal = 0;

public LissajousTiltingLines1()
{
}

public void init()
{
   offScreenImage  = this.createImage(width, height);
   offScreenBuffer = offScreenImage.getGraphics();

} // init

public void update(Graphics gc)
{
   paint(gc);

} // update
```

```
public void paint(Graphics gc)
{
   offScreenBuffer.setColor(Color.lightGray);
   offScreenBuffer.fillRect(0, 0, width, height);

   offScreenBuffer.setColor(Color.red);
   drawSpiral(offScreenBuffer, gc);

} // paint

public void updateCoordinates()
{
   slantLength += slantLengthDelta*
                  slantLengthDirection;

   if( slantLength > maxSlantLength )
   {
      slantLength = maxSlantLength;
      slantLengthDirection *= -1;
   }

   if( slantLength < minSlantLength )
   {
      slantLength = minSlantLength;
      slantLengthDirection *= -1;
   }

   slantAngle += slantAngleDelta*slantAngleDirection;

   if( slantAngle > maxSlantAngle )
   {
      slantAngle = maxSlantAngle;
      slantAngleDirection *= -1;
   }

   if( slantAngle < minSlantAngle )
   {
      slantAngle = minSlantAngle;
      slantAngleDirection *= -1;
   }

   slantX = slantLength*Math.cos(
               slantAngle*Math.PI/180);
   slantY = slantLength*Math.sin(
               slantAngle*Math.PI/180);

} // updateCoordinates

public void drawSpiral(Graphics gc, Graphics gcMain)
{
```

```
    for(int angle=startTheta; angle<endTheta; angle++)
    {
        sineAngle1 = Math.sin(angle*Math.PI/180);
        sineAngle2 = Math.sin((branches1*angle+C1)*
                                        Math.PI/180);

        offsetX = C1*sineAngle2;
        offsetY = C2*sineAngle1;

        currentX = basePointX+(int)offsetX;
        currentY = basePointY+(int)offsetY;

        drawLine(gc, angle, currentX, currentY);
        gcMain.drawImage(offScreenImage, 0, 0, this);
        updateCoordinates();
    }

} // drawSpiral

public void drawLine(Graphics gc, int x,
                        int xCoord, int yCoord)
{
    gc.setColor(lineColors[((x%2)*2)%colorCount]);

    for(int z=0; z<thickness; z++)
    {
        gc.drawLine(xCoord,
                        yCoord+z,
                        xCoord+(int)slantX,
                        yCoord+z-(int)slantY);
    }

} // drawline

} // LissajousTiltingLines1
```

ON THE CD

The HTML file *LissajousTiltingLines1.html* (Listing 3.6) contains the code for launching *LissajousTiltingLines1.class*.

LISTING 3.6 LissajousTiltingLines1.html

```
<HTML>
<HEAD></HEAD>
<BODY>
<APPLET CODE=LissajousTiltingLines1.class WIDTH=800
HEIGHT=450></APPLET>
</BODY>
</HTML>
```

REMARKS

The preceding example adds variability to the line segments by rotating them as they are drawn along the *Lissajous* curve. This back-and-forth rotation gives them a tilting effect. If you look closely, you'll notice that this is the same technique that was used in a previous chapter in order to create a "bouncing" effect.

CONCEPT: LINE SEGMENTS AND *HYPOCYCLOIDS*

The next object (Figure 3.4) consists of the following building blocks:

- A set of line segments
- A *Hypocycloid*

The Java class *HypocycloidLines1.java* contains the following methods:

drawSpiral()
drawLine()

The method *drawSpiral()* computes the (x, y) coordinates of the points on a *Hypocycloid* and invokes the method *drawLine()* in order to draw a line segment.

The method *drawLine()* draws a slanted line segment at the current point represented by the pair (x, y).

ON THE CD

The Java class *HypocycloidLines1.java* (Listing 3.7) demonstrates how to draw line segments that follow the path of a *Hypocycloid*.

FIGURE 3.4 A set of *Hypocycloid*-based line segments.

LISTING 3.7 HypocycloidLines1.java

```java
import java.awt.Color;
import java.awt.Graphics;
import java.awt.Image;

import java.io.Serializable;

public class HypocycloidLines1 extends java.applet.Applet
        implements Serializable
{
    private Graphics offScreenBuffer = null;
    private Image    offScreenImage  = null;

    private int width     = 800;
    private int height    = 500;

    private int basePointX = 300;
    private int basePointY = 250;

    private int currentX   = basePointX;
    private int currentY   = basePointY;

    private double offsetX = 0;
    private double offsetY = 0;

    private double sineAngle1   = 0;
    private double cosineAngle1 = 0;

    private double sineAngle2   = 0;
    private double cosineAngle2 = 0;

    private double numerator   = 0;
    private double denominator = 0;

    private double A = 110;
    private double B = 40;

    private int thickness = 20;

    private double slantLength = 100;
    private double slantAngle  = 20;

    private double slantX = slantLength*Math.cos(
                                slantAngle*Math.PI/180);
    private double slantY = slantLength*Math.sin(
                                slantAngle*Math.PI/180);

    private double frequency = 1.0;

    private int startTheta = (int)(0/frequency);
```

```java
private int endTheta   = (int)(1440/frequency);

private Color[] lineColors = {
   Color.red, Color.green, Color.blue, Color.yellow,
   Color.white, Color.magenta
};

private int colorCount = lineColors.length;

public HypocycloidLines1()
{
}

public void init()
{
   offScreenImage  = this.createImage(width, height);
   offScreenBuffer = offScreenImage.getGraphics();

} // init

public void update(Graphics gc)
{
   paint(gc);

} // update

public void paint(Graphics gc)
{
   offScreenBuffer.setColor(Color.lightGray);
   offScreenBuffer.fillRect(0, 0, width, height);

   offScreenBuffer.setColor(Color.red);
   drawSpiral(offScreenBuffer);
   gc.drawImage(offScreenImage, 0, 0, this);

} // paint

public void drawSpiral(Graphics gc)
{
   for(int angle=startTheta; angle<endTheta; angle++)
   {
      sineAngle1   = Math.sin(angle*Math.PI/180);
      cosineAngle1 = Math.cos(angle*Math.PI/180);

      sineAngle2   = Math.sin(((A/B)-1)*angle*
                                      Math.PI/180);
      cosineAngle2 = Math.cos(((A/B)-1)*angle*
                                      Math.PI/180);

      offsetX = (A-B)*cosineAngle1 + B*cosineAngle2;
```

```
        offsetY = (A-B)*sineAngle1   - B*sineAngle2;

        currentX = basePointX+(int)offsetX;
        currentY = basePointY+(int)offsetY;

        drawLine(gc, angle, currentX, currentY);
    }

} // drawSpiral

public void drawLine(Graphics gc, int x,
                     int xCoord, int yCoord)
{
    gc.setColor(lineColors[(x%2)*2]);

    for(int z=0; z<thickness; z++)
    {
        gc.drawLine(xCoord,
                    yCoord+z,
                    xCoord+(int)slantX,
                    yCoord+z-(int)slantY);
    }

} // drawLine

} // HypocycloidLines1
```

ON THE CD

The HTML file *HypocycloidLines1.html* (Listing 3.8) contains the code for launching *HypocycloidLines1.class*.

LISTING 3.8 HypocycloidLines1.html

```
<HTML>
<HEAD></HEAD>
<BODY>
<APPLET CODE=HypocycloidLines1.class WIDTH=800 HEIGHT=450></APPLET>
</BODY>
</HTML>
```

REMARKS

The preceding example shows you yet another twist for polar equations in terms of the manner in which the horizontal and vertical offsets are computed. You can experiment with different values for the constants A and B. Some suggestions include:

- Large positive values for A and B
- A small positive B with respect to positive A
- Large positive A and large negative B
- Large negative values for A and B

You can also modify the code so that A and B are defined as *double* rather than *int* variables and experiment with different ways of modifying their values.

CD LIBRARY

ON THE CD

The CD-ROM for this chapter contains "class" files and HTML files that are required for viewing the graphics images in the following Java files:

NOTE

Many of the graphics images in the CD Library are animated. The figures provide a single snapshot of the graphics image, but you need to launch these images in a browser (or appletviewer) in order to capture the full quality of the visual effects. This will be true for many images in the remaining chapters of this book.

ConchoidLines1.

NephroidLines1.

LissajousTiltingLines1.

HypocycloidLines1.

EpitrochoidLines1.

EpitrochoidOscillatingLines1.

HypocycloidOscillatingLines1. HypocycloidOscillatingLines2. HypocycloidOscillating
 TiltingLines1.

NephroidOscillatingLines1. NephroidOscillatingTiltingLines1.

These Java files combine various shading techniques (such as gradient shading) in order to render graphics images that are a combination of line segments and polar equations such as *Epitrochoids*, *Hypocycloids*, and *Nephroids*. Some examples are particularly rich in color combinations. The Java files vary between two and three pages of code. Some of the Java files contain commented out code to give you ideas for creating your own variations of these examples.

SUMMARY

This chapter presented Java code that introduced you to two-dimensional polar equations. The Java code also demonstrated several techniques for combining color gradients and line segments in order to draw graphics based on the following types of curves:

- *Conchoids*
- *Nephroids*
- *Lissajous* curves
- *Hypocycloids*

LINE SEGMENTS AND TRIGONOMETRY (II)

OVERVIEW

This chapter contains Java code for graphics that arise from combining polar equations with line segments. As demonstrated in a previous chapter, different techniques for color gradients are used in order to enhance the aesthetic appeal of the graphics.

In addition, this chapter will introduce a fundamental technique for creating attractive animation effects. This technique is demonstrated in the following example: suppose you're given an initial horizontal and vertical "velocity" and you want to move a given object inside an enclosing rectangle. Simply move the object along the points of a line segment (where the coordinates of the points are be calculated by means of the horizontal and vertical velocity). Eventually the object will encounter an edge of the enclosing rectangle, and then reverse either the horizontal or the vertical velocity. This reversal is accomplished by multiplying the velocity by negative one. Now put the resulting code inside a loop and *voila!* You now have a bouncing object.

You'll see examples that implement the preceding informal description later in this chapter, as well as variations of this technique that are used in subsequent chapters in order to draw more complex graphics.

CONCEPT: OSCILLATING LINE SEGMENTS AND *FOLIUM* CURVES

The next object (Figure 4.1) consists of the following building blocks:

- A set of line segments
- A *Folium* curve

FIGURE 4.2 A set of *Folium*-based oscillating variable-length line segments.

The Java class *FoliumOscillatingLines3.java* contains the following methods:

drawSpiral()

drawLine()

The method *drawSpiral()* computes the (x, y) coordinates of the points on a *Folium* curve and invokes the method *drawLine()* in order to draw a line segment.

The method *drawLine()* draws a slanted line segment at the current point represented by the pair (x, y).

ON THE CD

The Java class *FoliumOscillatingLines3.java* (Listing 4.3) demonstrates how to draw line segments that follow the path of a *Folium* curve.

LISTING 4.3 FoliumOscillatingLines3.java

```java
import java.awt.Color;
import java.awt.Graphics;
import java.awt.Image;

import java.io.Serializable;

public class FoliumOscillatingLines3 extends
        java.applet.Applet implements Serializable
{
    private Graphics offScreenBuffer = null;
    private Image    offScreenImage  = null;
```

```
private int width      = 800;
private int height     = 500;

private int basePointX = 300;
private int basePointY = 150;

private int currentX   = basePointX;
private int currentY   = basePointY;

private double offsetX = 0;
private double offsetY = 0;

private int C1 = 160;
private double ratio = 0;

private double minRatio = -1.0;
private double maxRatio = 1.0;

private double slantAngle  = 20;
private double slantLength = 60;
private double minSlantLength = 20;
private double maxSlantLength = 160;
private double slantLengthDelta = 4;
private double slantLengthDirection = 1;

private double slantX = slantLength*Math.cos(
                            slantAngle*Math.PI/180);

private double slantY = slantLength*Math.sin(
                            slantAngle*Math.PI/180);

private int thickness = 20;

private Color[] lineColors = {
   Color.red, Color.green, Color.blue, Color.yellow,
   Color.white, Color.magenta
};

private int colorCount = lineColors.length;

public FoliumOscillatingLines3()
{
}

public void init()
{
   offScreenImage  = this.createImage(width, height);
   offScreenBuffer = offScreenImage.getGraphics();
```

```
} // init

public void update(Graphics gc)
{
   paint(gc);

} // update

public void paint(Graphics gc)
{
   offScreenBuffer.setColor(Color.lightGray);
   offScreenBuffer.fillRect(0, 0, width, height);

   offScreenBuffer.setColor(Color.red);
   drawSpiral(offScreenBuffer, gc);

} // paint

public void updateCoordinates()
{
   slantLength += slantLengthDelta*
                  slantLengthDirection;

   if( slantLength > maxSlantLength )
   {
      slantLength = maxSlantLength;
      slantLengthDirection *= -1;
   }

   if( slantLength < minSlantLength )
   {
      slantLength = minSlantLength;
      slantLengthDirection *= -1;
   }

   slantX = slantLength*Math.cos(
               slantAngle*Math.PI/180);
   slantY = slantLength*Math.sin(
               slantAngle*Math.PI/180);

} // updateCoordinates

public void drawSpiral(Graphics gc, Graphics gcMain)
{
   for(ratio=minRatio; ratio<maxRatio; ratio += 0.005)
   {
      offsetX = C1*ratio/(1+ratio*ratio*ratio);
      offsetY = C1*ratio*ratio/(1+ratio*ratio*ratio);
```

```
            currentX = basePointX+(int)offsetX;
            currentY = basePointY-(int)offsetY;
            drawLine(gc, ratio, currentX, currentY);

            currentX = basePointX-(int)offsetX;
            currentY = basePointY+(int)offsetY;
            drawLine(gc, ratio, currentX, currentY);

            gcMain.drawImage(offScreenImage, 0, 0, this);
            updateCoordinates();
        }

    } // drawSpiral

    public void drawLine(Graphics gc, double ratio,
                         int xCoord, int yCoord)
    {
        int x = (int)(100*Math.abs(ratio));

        gc.setColor(lineColors[((x%2)*2)%colorCount]);

        for(int z=0; z<thickness; z++)
        {
            gc.drawLine(xCoord,
                        yCoord+z,
                        xCoord+(int)slantX,
                        yCoord+z-(int)slantY);
        }

    } // drawLine

} // FoliumOscillatingLines3
```

ON THE CD

The HTML file *FoliumOscillatingLines3.html* (Listing 4.4) contains the code for launching *FoliumOscillatingLines3.class*.

LISTING 4.4 FoliumOscillatingLines3.html

```
<HTML>
<HEAD></HEAD>
<BODY>
<APPLET CODE=FoliumOscillatingLines3.class WIDTH=800
HEIGHT=450></APPLET>
</BODY>
</HTML>
```

```
private double constant = 80;

private int colorOffset = 0;
private int partition = 60;

private double slantLength = 100;
private double slantAngle  = 20;

private double slantX = slantLength*Math.cos(
                            slantAngle*Math.PI/180);

private double slantY = slantLength*Math.sin(
                            slantAngle*Math.PI/180);

private Color[] lineColors = {
   Color.red, Color.green, Color.blue, Color.yellow,
   Color.white, Color.magenta
};

private int colorCount = lineColors.length;

public TschirnhausOscillatingLines1()
{
}

public void init()
{
   offScreenImage  = this.createImage(width, height);
   offScreenBuffer = offScreenImage.getGraphics();

} // init

public void update(Graphics gc)
{
   paint(gc);

} // update

public void paint(Graphics gc)
{
   offScreenBuffer.setColor(Color.lightGray);
   offScreenBuffer.fillRect(0, 0, width, height);

   offScreenBuffer.setColor(Color.red);
   drawSpiral(offScreenBuffer, gc);

} // paint

public void drawSpiral(Graphics gc, Graphics gcMain)
{
```

```
    int count = 0;

    for(int x=startX; x<endX; x++)
    {
        offsetX = x;
        offsetY = x*(x-constant)*(x-constant)/constant;

        if( offsetY >= 0 )
        {
            offsetY = Math.sqrt(offsetY);

            currentX = basePointX+(int)offsetX;
            currentY = basePointY+(int)offsetY;
            drawLine(gc, x, currentX, currentY);

            currentX = basePointX+(int)offsetX;
            currentY = basePointY-(int)offsetY;
            drawLine(gc, x, currentX, currentY);

            gcMain.drawImage(offScreenImage, 0, 0, this);

            if(++count % partition == 0) { ++colorOffset; }
        }
    }

} // drawSpiral

public void drawLine(Graphics gc, int x,
                     int xCoord, int yCoord)
{
    gc.setColor(lineColors[((x%2)*2+colorOffset)%
                                    colorCount]);

    for(int z=0; z<thickness; z++)
    {
        gc.drawLine(xCoord,
                    yCoord+z,
                    xCoord+(int)slantX,
                    yCoord+z-(int)slantY);
    }

} // drawLine

} // TschirnhausOscillatingLines1
```

ON THE CD

The HTML file *TschirnhausOscillatingLines1.html* (Listing 4.6) contains the code for launching *TschirnhausOscillatingLines1.class*.

LISTING 4.6 TschirnhausOscillatingLines1.html

```
<HTML>
<HEAD></HEAD>
<BODY>
<APPLET CODE=TschirnhausOscillatingLines1.class WIDTH=800
HEIGHT=450></APPLET>
</BODY>
</HTML>
```

REMARKS

Strictly speaking, the line segments in the preceding example do not follow the path of a polar equation, but it's included in this chapter because the graphics has a flavor that is similar to the other examples. The other reason is to show you that you don't always need exotic polar equations for implementing the techniques in this chapter. So are we finished with drawing line segments and polar equations? Not quite. The next example introduces another technique that creates a *striping effect*. This technique is so simple that you will be surprised by the visual effect!

CONCEPT: GRADIENT OSCILLATING LINE SEGMENTS AND *TSCHIRNHAUS* CURVES

The next object (Figure 4.4) consists of the following building blocks:

- A set of line segments
- A *Tschirnhaus* curve

FIGURE 4.4 An outline of *Tschirnhaus*-based oscillating line segments.

The Java class *TschirnhausOscillatingLinesOutline1.java* contains the following methods:

drawSpiral()

drawLine()

The method *drawSpiral()* computes the (x, y) coordinates of the points on a *Tschirnhaus* curve and invokes the method *drawLine()* in order to draw a line segment.

The method *drawLine()* draws a slanted line segment at the current point represented by the pair (x, y).

ON THE CD

The Java class *TschirnhausOscillatingLinesOutline1.java* (Listing 4.7) demonstrates how to draw line segments that follow the path of a *Tschirnhaus* curve.

LISTING 4.7 TschirnhausOscillatingLinesOutline1.java

```java
import java.awt.Color;
import java.awt.Graphics;
import java.awt.Image;

import java.io.Serializable;

public class TschirnhausOscillatingLinesOutline1 extends
        java.applet.Applet implements Serializable
{
   private Graphics offScreenBuffer = null;
   private Image    offScreenImage  = null;

   private int width       = 800;
   private int height      = 500;

   private int basePointX = 300;
   private int basePointY = 250;

   private int currentX   = basePointX;
   private int currentY   = basePointY;

   private double offsetX = 0;
   private double offsetY = 0;

   private double sineAngle = 0;
   private double cosineAngle = 0;

   private int thickness = 20;
   private int maxCount = 200;
```

```
private int hGap = 8;
private int minHGap = 8;
private int maxHGap = 20;
private int hGapDelta     = 1;
private int hGapDirection = 1;

private double frequency = 1.0;

private int startX = (int)(0/frequency);
private int endX   = (int)(360/frequency);
private int minEndX = startX;
private int maxEndX = (int)(360/frequency);
private int endXDelta = 8;
private int endXDirection = 1;

private double constant = 80;

private int colorOffset = 0;
private int partition = 60;

private double slantLength = 100;
private double slantAngle  = 20;

private double slantX = slantLength*Math.cos(
                          slantAngle*Math.PI/180);

private double slantY = slantLength*Math.sin(
                          slantAngle*Math.PI/180);

private int rVal = 0;
private int gVal = 0;
private int bVal = 0;

public TschirnhausOscillatingLinesOutline1()
{
}

public void init()
{
   offScreenImage  = this.createImage(width, height);
   offScreenBuffer = offScreenImage.getGraphics();

} // init

public void update(Graphics gc)
{
   paint(gc);

} // update
```

```
public void paint(Graphics gc)
{
   for(int tick=0; tick<maxCount; tick++)
   {
      offScreenBuffer.setColor(Color.lightGray);
      offScreenBuffer.fillRect(0, 0, width, height);

      drawSpiral(offScreenBuffer, gc);
      gc.drawImage(offScreenImage, 0, 0, this);
      updateCoordinates();
   }

} // paint

public void updateCoordinates()
{
   endX += endXDelta*endXDirection;

   if( endX > maxEndX )
   {
      endX = maxEndX;
      endXDirection *= -1;
   }

   if( endX < minEndX )
   {
      endX = minEndX;
      endXDirection *= -1;
   }

   hGap += hGapDirection*hGapDelta;

   if(hGap > maxHGap )
   {
      hGap = maxHGap;
      hGapDirection *= -1;
   }

   if(hGap < minHGap )
   {
      hGap = minHGap;
      hGapDirection *= -1;
   }

} // updateCoordinates()

public void drawSpiral(Graphics gc, Graphics gcMain)
{
   int count = 0;
```

```
      for(int x=startX; x<endX; x++)
      {
         offsetX = x;
         offsetY = x*(x-constant)*(x-constant)/constant;

         if( offsetY >= 0 )
         {
            offsetY = Math.sqrt(offsetY);

            currentX = basePointX+(int)offsetX;
            currentY = basePointY+(int)offsetY;
            drawLine(gc, x, currentX, currentY);

            currentX = basePointX+(int)offsetX;
            currentY = basePointY-(int)offsetY;
            drawLine(gc, x, currentX, currentY);

            if(++count%partition == 0) { ++colorOffset; }
         }
      }

   } // drawSpiral

   public void drawLine(Graphics gc, int x,
                        int xCoord, int yCoord)
   {
      if(x % hGap == 0 )
      {
         gc.setColor(Color.white);
      }
      else
      {
         rVal = (x-startX)*255/(endX-startX);
         gc.setColor(new Color(rVal, gVal, bVal));
      }

      for(int z=0; z<thickness; z++)
      {
         gc.drawLine(xCoord,
                     yCoord+z,
                     xCoord+(int)slantX,
                     yCoord+z-(int)slantY);
      }

   } // drawLine

} // TschirnhausOscillatingLinesOutline1
```

The HTML file *TschirnhausOscillatingLinesOutline1.html* (Listing 4.8) contains the code for launching *TschirnhausOscillatingLinesOutline1.class*.

LISTING 4.8 TschirnhausOscillatingLinesOutline1.html

```
<HTML>
<HEAD></HEAD>
<BODY>
<APPLET CODE=TschirnhausOscillatingLinesOutline1.class WIDTH=800
HEIGHT=450></APPLET>
</BODY>
</HTML>
```

REMARKS

The key idea in the preceding code is based on the following code fragment:

```
if(x % hGap == 0 )
{
   gc.setColor(Color.white);
}
```

For example, when hGap = 10, then every tenth line segment will be white. As you increase the value of hGap, so will the distance between white stripes. Conversely, as you decrease the value of hGap, the white stripes will be drawn closer to each other. The method *updateCoordinates()* varies the value of hGap, and the resulting image has an oscillating effect. The method *updateCoordinates()* also varies the width of the image that is drawn during each "pass" in order to create a nice animation effect. The next example will show you how to add vertical line segments to the preceding code in order to create a cage-like effect.

CONCEPT: STRIPED OSCILLATING LINE SEGMENTS AND *TSCHIRNHAUS* CURVES

The next object (Figure 4.5) consists of the following building blocks:

- A set of line segments
- A *Tschirnhaus* curve
- A set of vertical line segments

FIGURE 4.5 Striped *Tschirnhaus*-based oscillating line segments.

The Java class *TschirnhausOscillatingLinesVStripes1.java* contains the following methods:

drawSpiral()

drawLine()

updateCoordinates()

The method *drawSpiral()* computes the (x, y) coordinates of the points on a *Tschirnhaus* curve and invokes the method *drawLine()* in order to draw a line segment.

The method *drawLine()* draws a slanted line segment at the current point represented by the pair (x, y).

The method *updateCoordinates()* updates the "tilt" angle and ensures that its value lies between a minimum and maximum allowable value.

ON THE CD

The Java class *TschirnhausOscillatingLinesVStripes1.java* (Listing 4.9) demonstrates how to draw tilting line segments that follow the path of a *Tschirnhaus* curve.

LISTING 4.9 TschirnhausOscillatingLinesVStripes1.java

```
import java.awt.Color;
import java.awt.Graphics;
import java.awt.Image;

import java.io.Serializable;

public class TschirnhausOscillatingLinesVStripes1 extends
```

```java
          java.applet.Applet implements Serializable
{
   private Graphics offScreenBuffer = null;
   private Image    offScreenImage  = null;

   private int width     = 800;
   private int height     = 500;

   private int basePointX = 300;
   private int basePointY = 250;

   private int currentX   = basePointX;
   private int currentY   = basePointY;

   private double offsetX = 0;
   private double offsetY = 0;

   private double frequency = 1.0;

   private int verticalCount = 8;
   private double vOffsetX = 0;
   private double vOffsetY = 0;

   private int thickness = 20;
   private int maxCount = 200;
   private double constant = 80;

   private int hGap = 8;
   private int minHGap = 8;
   private int maxHGap = 16;
   private int hGapDelta = 2;
   private int hGapDirection = 1;

   private int startX = (int)(0/frequency);
   private int endX    = (int)(100/frequency);
   private int minEndX = startX;
   private int maxEndX = (int)(360/frequency);
   private int endXDelta = 8;
   private int endXDirection = 1;

   private double slantLength = 100;
   private double slantAngle  = 20;

   private double slantX = slantLength*Math.cos(
                           slantAngle*Math.PI/180);

   private double slantY = slantLength*Math.sin(
                           slantAngle*Math.PI/180);

   private Color[] lineColors = {
```

```
    Color.red, Color.green, Color.blue, Color.yellow,
    Color.white, Color.magenta
};

private int colorCount = lineColors.length;

public TschirnhausOscillatingLinesVStripes1()
{
}

public void init()
{
    offScreenImage  = this.createImage(width, height);
    offScreenBuffer = offScreenImage.getGraphics();

} // init

public void update(Graphics gc)
{
    paint(gc);

} // update

public void paint(Graphics gc)
{
    for(int tick=0; tick<maxCount; tick++)
    {
        offScreenBuffer.setColor(Color.lightGray);
        offScreenBuffer.fillRect(0, 0, width, height);

        drawSpiral(offScreenBuffer, gc);
        gc.drawImage(offScreenImage, 0, 0, this);
        updateCoordinates();
    }

} // paint

public void updateCoordinates()
{
    endX += endXDelta*endXDirection;

    if( endX > maxEndX )
    {
        endX = maxEndX;
        endXDirection *= -1;
    }

    if( endX < minEndX )
    {
        endX = minEndX;
```

```
         endXDirection *= -1;
      }

   hGap += hGapDirection*hGapDelta;

   if(hGap > maxHGap )
   {
      hGap = maxHGap;
      hGapDirection *= -1;
   }

   if(hGap < minHGap )
   {
      hGap = minHGap;
      hGapDirection *= -1;
   }

} // updateCoordinates()

public void drawVerticalLines(Graphics gc)
{
   for(int c=0; c<verticalCount; c++)
   {
      gc.setColor(lineColors[(c%2)+2]);

      vOffsetX = c*slantX/verticalCount;
      vOffsetY = c*slantY/verticalCount;

      gc.drawLine(basePointX+
                     (int)(offsetX+slantX-vOffsetX),
                  basePointY+
                     (int)(offsetY-slantY+vOffsetY),
                  basePointX+
                     (int)(offsetX+slantX-vOffsetX),
                  basePointY-
                     (int)(offsetY+slantY-vOffsetY));
   }

} // drawVerticalLines

public void drawSpiral(Graphics gc, Graphics gcMain)
{
   int count = 0;

   for(int x=startX; x<endX; x++)
   {
      offsetX = x;
      offsetY = x*(x-constant)*(x-constant)/constant;

      if( offsetY >= 0 )
```

```
        {
            offsetY = Math.sqrt(offsetY);

            if(x % hGap == 0 ) { drawVerticalLines(gc); }

            currentX = basePointX+(int)offsetX;
            currentY = basePointY+(int)offsetY;
            drawLine(gc, x, currentX, currentY);

            currentX = basePointX+(int)offsetX;
            currentY = basePointY-(int)offsetY;
            drawLine(gc, x, currentX, currentY);
        }
    }

} // drawSpiral

public void drawLine(Graphics gc, int x,
                     int xCoord, int yCoord)
{
    if(x % hGap == 0 )
    {
        gc.setColor(Color.white);
    }
    else
    {
        gc.setColor(lineColors[((x%2)*2)%
                               colorCount]);
    }

    for(int z=0; z<thickness; z++)
    {
        gc.drawLine(xCoord,
                    yCoord+z,
                    xCoord+(int)slantX,
                    yCoord+z-(int)slantY);
    }

} // drawLine

} // TschirnhausOscillatingLinesVStripes1
```

The HTML file *TschirnhausOscillatingLinesVStripes1.html* (Listing 4.10) contains the code for launching *TschirnhausOscillatingLinesVStripes1.class*.

LISTING 4.10 TschirnhausOscillatingLinesVStripes1.html

```
<HTML>
<HEAD></HEAD>
<BODY>
<APPLET CODE=TschirnhausOscillatingLinesVStripes1.class WIDTH=800
HEIGHT=450></APPLET>
</BODY>
</HTML>
```

REMARKS

The preceding code is the last in a series of examples of drawing line segments in conjunction with color gradients. This would be a good time for you to review the Java code in this chapter and the previous chapter. Considering the fact that we started without any complex mathematics, we've come a long way. Did you notice that all of these examples consist of less than three pages of code? The code samples on the accompanying CD-ROM contain a number of additional variations that you can enhance by means of your own ideas.

CD LIBRARY

ON THE CD

The CD-ROM for this chapter contains "class" files and HTML files that are needed for viewing the graphics images in the following Java files:

FoliumOscillatingLines1. FoliumOscillatingLines3. TschirnhausOscillatingLines1.

TschirnhausOscillating
LinesOutline1.

TschirnhausOscillating
LinesVStripes1.

FoliumOscillatingLines2.

FoliumOscillatingLines5.

PlateauCurvesOscillating
Lines.

StrophoidLines1.

StrophoidOscillatingLines1.

StrophoidOscillatingLines2.

StrophoidOscillating
TiltingLines1.

TschirnhausOscillating
LinesOutline2.

TschirnhausOscillating
LinesOutline3.

The preceding Java files combine various shading techniques (for example, gradient shading) in order to render graphics images that are a combination of line segments and Polar equations such as *Epitrochoids*, *Folium* curves, *Nephroids*, *Strophoids*, and *Tschirnhaus* curves. Some examples are particularly rich in color combinations. The Java files vary between two and three pages of code. Some of the Java files contain commented out code to give you ideas for creating your own variations of these examples.

SUMMARY

This chapter showed you several techniques for combining color gradients, striping effects, and two-dimensional polar equations. The Java code also demonstrated how to create animation effects for drawing graphics based on a combination of line segments and the following types of curves:

- *Folium* curves
- *Tschirnhaus* curves

RECTANGLES AND TRIGONOMETRY

OVERVIEW

Rectangles are simple objects that can be combined with two-dimensional polar equations in interesting ways. Recall that line segments have one dimension (i.e., length) whereas rectangles have two dimensions (i.e., width and height), which enables us to combine more complex building blocks in our graphics images. As you saw in previous chapters, we'll use an array of colors for color gradients in order to render graphics. Incidentally, using an array of colors is simply a convenient way to select from an assortment of pre-defined colors. A more fine-grained technique involves constructing the RGB components of a color. The key idea behind constructing such components involves the selection of a "suitable" function that computes the color weights in a manner that produces pleasing visual effects. Feel free to modify all the following examples so that they use this technique!

CONCEPT: RECTANGLES AND *DELTOIDS*

The next object (Figure 5.1) consists of the following building blocks:

- A set of rectangles
- A four-point *Deltoid*

The Java class *Deltoid4PointRectangles1.java* contains the following methods:

drawSpiral()

drawRectangle()

FIGURE 5.1 A set of *Deltoid*-based rectangles.

The method *drawSpiral()* contains a loop that computes the (x, y) coordinates of the points on a *Deltoid* and then invokes the method *drawRectangle()* in order to draw a rectangle.

The method *drawRectangle()* computes an index into an array of colors for computing the current color and then invokes the standard *fillRect()* method that's available in Java in order to draw a rectangle at a point represented by the pair (x, y).

ON THE CD

The Java class *Deltoid4PointRectangles1.java* (Listing 5.1) demonstrates how to draw rectangles that follow the path of a *Deltoid*.

LISTING 5.1 Deltoid4PointRectangles1.java

```java
import java.awt.Color;
import java.awt.Graphics;
import java.awt.Image;

import java.io.Serializable;

public class Deltoid4PointRectangles1 extends
        java.applet.Applet implements Serializable
{
    private Graphics offScreenBuffer = null;
    private Image    offScreenImage  = null;

    private int width        = 800;
    private int height       = 500;

    private int basePointX = 300;
    private int basePointY = 250;

    private int currentX   = basePointX;
    private int currentY   = basePointY;

    private double offsetX    = 0;
    private double offsetY    = 0;
```

```
private double sineAngle1 = 0;
private double sineAngle2 = 0;

private double cosineAngle1 = 0;
private double cosineAngle2 = 0;

private int anglePartition = 90;

private int branch = 0;
private int Radius = 40;
private int radius = 40;

private int eHeight    = 60;
private int eWidth     = 60;

private double frequency = 0.5;

private int startTheta = (int)(0/frequency);
private int endTheta   = (int)(360/frequency);

private int angleSpan = endTheta-startTheta;

private Color[] rectangleColors = {
   Color.red, Color.green, Color.blue, Color.yellow,
   Color.white
};

private int colorCount = rectangleColors.length;

public Deltoid4PointRectangles1()
{
}

public void init()
{
   offScreenImage  = this.createImage(width, height);
   offScreenBuffer = offScreenImage.getGraphics();

} // init

public void update(Graphics gc)
{
   paint(gc);

} // update

public void paint(Graphics gc)
{
   offScreenBuffer.setColor(Color.lightGray);
```

```
        offScreenBuffer.fillRect(0, 0, width, height);

        offScreenBuffer.setColor(Color.red);
        drawSpiral(offScreenBuffer);
        gc.drawImage(offScreenImage, 0, 0, this);

    } // paint

    public void drawSpiral(Graphics gc)
    {
        for(int angle=startTheta; angle<endTheta; angle++)
        {
            if( angle % anglePartition == 0 ) { ++branch; }

            sineAngle1 = Math.sin(angle*Math.PI/180);
            sineAngle2 = Math.sin(3*angle*Math.PI/180);

            cosineAngle1 = Math.cos(angle*Math.PI/180);
            cosineAngle2 = Math.cos(3*angle*Math.PI/180);

            offsetX = radius*(2*cosineAngle1+cosineAngle2);
            offsetY = radius*(2*sineAngle1-sineAngle2);

            currentX = basePointX+(int)offsetX;
            currentY = basePointY+(int)offsetY;

            drawRectangle(gc, angle, currentX, currentY);
        }

    } // drawSpiral

    public void drawRectangle(Graphics gc, int x,
                              int xCoord, int yCoord)
    {
        gc.setColor(
          rectangleColors[((x%2)*2+branch)%colorCount]);

        gc.fillRect(xCoord, yCoord, eWidth, eHeight);

    } // drawRectangle

} // Deltoid4PointRectangles1
```

The HTML file *Deltoid4PointRectangles1.html* (Listing 5.2) contains the code for launching *Deltoid4PointRectangles1.class*.

LISTING 5.2 Deltoid4PointRectangles1.html

```
<HTML>
<HEAD></HEAD>
<BODY>
<APPLET CODE=Deltoid4PointRectangles1.class WIDTH=800
HEIGHT=450></APPLET>
</BODY>
</HTML>
```

REMARKS

The previous example shows you how to produce complex-looking graphics image by means of very simple polar equations. The image contains four "branches," each of which creates a striped effect by alternating between different pairs of colors. The different striped effects is controlled by the value of *branch* in the following line:

```
gc.setColor(rectangleColors[((x%2)*2+branch)%colorCount]);
```

The term (x%2)*2, which is either 0 or 2, creates the alternating effect for each branch. Notice that by adding the value of the variable branch to this term, the set of possible values is branch or branch+2, thereby "shifting" the offset into the array of colors. This simple technique allows you to select different alternating pairs of colors for each branch. You can generalize this technique even further by specifying the term (x%2)*factor, where factor is any integer between 3 and colorCount−1.

CONCEPT: RECTANGLES AND *EPICYCLOIDS*

The next object (Figure 5.2) consists of the following building blocks:

- A set of rectangles
- An *Epicycloid* curve

The Java class *EpicycloidRectangles1.java* contains the following methods:

drawSpiral()

drawRectangle()

The method *drawSpiral()* contains a loop that computes the (x, y) coordinates of the points on an *Epicycloid* and then invokes the method *drawRectangle()* in order to draw a rectangle.

FIGURE 5.2 *Epicycloid*-based rectangles.

The method *drawRectangle()* computes an index into an array of colors for computing the current color and then invokes the standard *fillRect()* method that's available in Java in order to draw a rectangle at a point represented by the pair (x, y).

ON THE CD

The Java class *EpicycloidRectangles1.java* (Listing 5.3) demonstrates how to draw rectangles that follow the path of an *Epicycloid* curve.

LISTING 5.3 EpicycloidRectangles1.java

```java
import java.awt.Color;
import java.awt.Graphics;
import java.awt.Image;

import java.io.Serializable;

public class EpicycloidRectangles1 extends
       java.applet.Applet implements Serializable
{
   private Graphics offScreenBuffer = null;
   private Image    offScreenImage  = null;

   private int width     = 800;
   private int height    = 500;

   private int basePointX = 300;
   private int basePointY = 200;

   private int currentX   = basePointX;
   private int currentY   = basePointY;

   private double offsetX = 0;
```

```
private double offsetY = 0;

private double sineAngle1   = 0;
private double cosineAngle1 = 0;

private double sineAngle2   = 0;
private double cosineAngle2 = 0;

private double numerator   = 0;
private double denominator = 0;

private double A = 30;
private double B = 60;

private int branches  = 1;

private double frequency = 1.0;

private int eHeight = 60;
private int eWidth  = 60;

private int startTheta = (int)(0/frequency);
private int endTheta   = (int)(1440/frequency);

private int angleSpan = endTheta-startTheta;

private Color[] rectangleColors = {
   Color.red, Color.green, Color.blue, Color.yellow,
   Color.white, Color.magenta
};

private int colorCount = rectangleColors.length;

public EpicycloidRectangles1()
{
}

public void init()
{
   offScreenImage  = this.createImage(width, height);
   offScreenBuffer = offScreenImage.getGraphics();

} // init

public void update(Graphics gc)
{
   paint(gc);

} // update
```

```
public void paint(Graphics gc)
{
   offScreenBuffer.setColor(Color.lightGray);
   offScreenBuffer.fillRect(0, 0, width, height);

   offScreenBuffer.setColor(Color.red);
   drawSpiral(offScreenBuffer);
   gc.drawImage(offScreenImage, 0, 0, this);

} // paint

public void drawSpiral(Graphics gc)
{
   for(int angle=startTheta; angle<endTheta; angle++)
   {
      sineAngle1   = Math.sin(angle*Math.PI/180);
      cosineAngle1 = Math.cos(angle*Math.PI/180);

      sineAngle2   = Math.sin(((A/B)+1)*angle*
                                      Math.PI/180);

      cosineAngle2 = Math.cos(((A/B)+1)*angle*
                                      Math.PI/180);

      offsetX = (A+B)*cosineAngle1 - B*cosineAngle2;
      offsetY = (A+B)*sineAngle1   - B*sineAngle2;

      currentX = basePointX+(int)offsetX;
      currentY = basePointY+(int)offsetY;

      drawRectangle(gc, angle, currentX, currentY);
   }

} // drawSpiral

public void drawRectangle(Graphics gc, int x,
                          int xCoord, int yCoord)
{
   gc.setColor(rectangleColors[(x%2)*2]);
   gc.fillRect(xCoord, yCoord, eWidth, eHeight);

} // drawRectangle

} // EpicycloidRectangles1
```

ON THE CD

The HTML file *EpicycloidRectangles1.html* (Listing 5.4) contains the code for launching *EpicycloidRectangles1.class*.

LISTING 5.4 EpicycloidRectangles1.html

```
<HTML>
<HEAD></HEAD>
<BODY>
<APPLET CODE=EpicylcoidRectangles1.class WIDTH=800
HEIGHT=450></APPLET>
</BODY>
</HTML>
```

REMARKS

The preceding example draws a rectangle (of fixed width and height) whose upper left-hand vertex is a point on an *Epicycloid*. The calculation of the color gradient involves a standard technique for computing an index into an array of colors. The code in the method *drawSpiral()* calculates the coordinates of a point on a two-dimensional curve and then the method *drawRectangle()* invokes the standard *fillRect()* method that is available in Java.

You can create your own variations of this code by experimenting with the index into the color array. You can also add conditional logic in order to vary the width or height (or both) of the rectangle that is drawn in the method *drawRectangle()*.

CONCEPT: RECTANGLES AND OSCILLATING *EPICYCLOIDS*

The next pair of objects (Figure 5.3 and Figure 5.4) consists of the following building blocks:

- A set of rectangles
- An *Epicycloid* curve

The Java class *EpicycloidOscillatingRectangles1.java* contains the following methods:

drawSpiral()
drawRectangle()

The method *drawSpiral()* contains a loop that computes the (x, y) coordinates of the points on an *Epicycloid* and then invokes the method *drawRectangle()* in order to draw a rectangle.

FIGURE 5.3 Snapshot of *Epicycloid-*based oscillating rectangles.

FIGURE 5.4 Subsequent snapshot of *Epicycloid*-based oscillating rectangles.

The method *drawRectangle()* computes an index into an array of colors for computing the current color and then invokes the standard *fillRect()* method that's available in Java in order to draw a rectangle at a point represented by the pair (x, y).

ON THE CD

The Java class *EpicycloidOscillatingRectangles1.java* (Listing 5.5) demonstrates how to draw rectangles that follow the path of an *Epicycloid* curve.

LISTING 5.5 EpicycloidOscillatingRectangles1.java

```
import java.awt.Color;
import java.awt.Graphics;
import java.awt.Image;

import java.io.Serializable;

public class EpicycloidOscillatingRectangles1 extends
        java.applet.Applet implements Serializable
{
   private Graphics offScreenBuffer = null;
   private Image    offScreenImage  = null;

   private int width        = 800;
   private int height       = 500;

   private int basePointX = 300;
   private int basePointY = 200;

   private int currentX    = basePointX;
   private int currentY    = basePointY;

   private double offsetX = 0;
   private double offsetY = 0;
```

```java
private double sineAngle1   = 0;
private double cosineAngle1 = 0;

private double sineAngle2   = 0;
private double cosineAngle2 = 0;

private double numerator   = 0;
private double denominator = 0;

private double A = 110;
private double B = 20;

private int branches  = 1;
private int colorPartition = 45;
private int colorOffset = 0;

private double radius = 80;
private double Radius = 60;

private double frequency = 1.0;

private int eHeight    = 40;
private int eWidth     = 40;
private int minEHeight = 40;
private int maxEHeight = 160;

private int startTheta = (int)(0/frequency);
private int endTheta   = (int)(1440/frequency);

private int angleSpan = endTheta-startTheta;

private Color[] rectangleColors = {
   Color.red, Color.green, Color.blue, Color.yellow,
   Color.white, Color.magenta
};

private int colorCount = rectangleColors.length;

public EpicycloidOscillatingRectangles1()
{
}

public void init()
{
   offScreenImage  = this.createImage(width, height);
   offScreenBuffer = offScreenImage.getGraphics();

} // init

public void update(Graphics gc)
```

```
{
   paint(gc);

} // update

public void paint(Graphics gc)
{
   offScreenBuffer.setColor(Color.lightGray);
   offScreenBuffer.fillRect(0, 0, width, height);

   offScreenBuffer.setColor(Color.red);
   drawSpiral(offScreenBuffer, gc);
 //gc.drawImage(offScreenImage, 0, 0, this);

} // paint

public void drawSpiral(Graphics gc, Graphics gcMain)
{
   for(int angle=startTheta; angle<endTheta; angle++)
   {
      if(angle%colorPartition == 0) { ++colorOffset; }

      sineAngle1   =
            Math.sin(branches*angle*Math.PI/180);

      cosineAngle1 =
            Math.cos(branches*angle*Math.PI/180);

      sineAngle2   =Math.sin(((A/B)+1)*branches*
                          angle*Math.PI/180);

      cosineAngle2 = Math.cos(((A/B)+1)*branches*
                          angle*Math.PI/180);

      offsetX = (A+B)*cosineAngle1 - B*cosineAngle2;
      offsetY = (A+B)*sineAngle1   - B*sineAngle2;

      currentX = basePointX+(int)offsetX;
      currentY = basePointY+(int)offsetY;

      drawRectangle(gc, angle, currentX, currentY);
      gcMain.drawImage(offScreenImage, 0, 0, this);
   }

} // drawSpiral

public void drawRectangle(Graphics gc, int x,
                        int xCoord, int yCoord)
{
   gc.setColor(rectangleColors[((x%2)*2+colorOffset)%
```

```
                                          colorCount]);

      gc.fillRect(xCoord, yCoord, eWidth, eHeight);

   } // drawRectangle

} // EpicycloidOscillatingRectangles1
```

ON THE CD

The HTML file *EpicycloidOscillatingRectangles1.html* (Listing 5.6) contains the code for launching *EpicycloidOscillatingRectangles1.class*.

LISTING 5.6 EpicycloidOscillatingRectangles1.html

```
<HTML>
<HEAD></HEAD>
<BODY>
<APPLET CODE=EpicycloidOscillatingRectangles1.class WIDTH=800
HEIGHT=450></APPLET>
</BODY>
</HTML>
```

REMARKS

The preceding example draws a rectangle (of fixed width and height), the upper left-hand vertex of which is a point on an *Epicycloid*. The calculation of the color gradient involves a variation on previous techniques for computing an index into an array of colors. This variation uses conditional logic in order to increment a variable offset that essentially shifts the index into the color array when drawing each rectangle.

The code in the method *drawSpiral()* calculates the coordinates of a point on a two-dimensional curve and then the method *drawRectangle()* invokes the standard *fillRect()* method that is available in Java.

You can create your own variations of this code by experimenting with the index into the color array. You can also add conditional logic in order to vary the width or height (or both) of the rectangle that is drawn in the method *drawRectangle()*.

CONCEPT: RECTANGLES AND *HYPOCYCLOIDS*

The next object (Figure 5.5) consists of the following building blocks:

- A set of rectangles
- A *Hypocloid* curve

FIGURE 5.5 *Hypocycloid*-based rectangles.

The Java class *HypocycloidRectangles1.java* contains the following methods:

drawSpiral()

drawRectangle()

The method *drawSpiral()* contains a loop that computes the (x, y) coordinates of the points on a *Deltoid* and then invokes the method *drawRectangle()* in order to draw a rectangle.

The method *drawRectangle()* computes an index into an array of colors for computing the current color and then invokes the standard *fillRect()* method that's available in Java in order to draw a rectangle at a point represented by the pair (x, y).

ON THE CD

The Java class *HypocycloidRectangles1.java* (Listing 5.7) demonstrates how to draw rectangles that follow the path of a *Hypocycloid*.

LISTING 5.7 HypocycloidRectangles1.java

```
import java.awt.Color;
import java.awt.Graphics;
import java.awt.Image;

import java.io.Serializable;

public class HypocycloidRectangles1 extends
       java.applet.Applet implements Serializable
{
   private Graphics offScreenBuffer = null;
   private Image    offScreenImage  = null;
```

```
private int width      = 800;
private int height     = 500;

private int basePointX = 300;
private int basePointY = 200;

private int currentX   = basePointX;
private int currentY   = basePointY;

private double offsetX = 0;
private double offsetY = 0;

private double sineAngle1   = 0;
private double cosineAngle1 = 0;

private double sineAngle2   = 0;
private double cosineAngle2 = 0;

private double numerator   = 0;
private double denominator = 0;

private double A = 110;
private double B = 20;

private int hGap       = 16;
private int branches   = 1;

private double radius = 80;
private double Radius = 60;

private double frequency = 1.0;

private int eHeight    = 40;
private int eWidth     = 40;
private int minEHeight = 40;
private int maxEHeight = 160;

private int startTheta = (int)(0/frequency);
private int endTheta   = (int)(1440/frequency);

private int angleSpan = endTheta-startTheta;

private Color[] rectangleColors = {
   Color.red, Color.green, Color.blue, Color.yellow,
   Color.white, Color.magenta
};

private int colorCount = rectangleColors.length;

public HypocycloidRectangles1()
```

```
{
}

public void init()
{
   offScreenImage  = this.createImage(width, height);
   offScreenBuffer = offScreenImage.getGraphics();

} // init

public void update(Graphics gc)
{
   paint(gc);

} // update

public void paint(Graphics gc)
{
   offScreenBuffer.setColor(Color.lightGray);
   offScreenBuffer.fillRect(0, 0, width, height);

   offScreenBuffer.setColor(Color.red);
   drawSpiral(offScreenBuffer);
   gc.drawImage(offScreenImage, 0, 0, this);

} // paint

public void drawSpiral(Graphics gc)
{
   for(int angle=startTheta; angle<endTheta; angle++)
   {
      sineAngle1   = Math.sin(angle*Math.PI/180);
      cosineAngle1 = Math.cos(angle*Math.PI/180);

      sineAngle2   = Math.sin(((A/B)-1)*
                              angle*Math.PI/180);

      cosineAngle2 = Math.cos(((A/B)-1)*
                              angle*Math.PI/180);

      offsetX = (A-B)*cosineAngle1 + B*cosineAngle2;
      offsetY = (A-B)*sineAngle1   - B*sineAngle2;

      currentX = basePointX+(int)offsetX;
      currentY = basePointY+(int)offsetY;

      drawRectangle(gc, angle, currentX, currentY);
   }

} // drawSpiral
```

```
public void drawRectangle(Graphics gc, int x,
                          int xCoord, int yCoord)
{
   if( x % hGap == 0 )
   {
      gc.setColor(rectangleColors[x%colorCount]);
      gc.fillRect(xCoord, yCoord, eWidth, eHeight+2);
   }
   else
   {
      gc.setColor(rectangleColors[(x%2)*2]);
      gc.fillRect(xCoord, yCoord, eWidth, eHeight);
   }

} // drawRectangle

} // HypocycloidRectangles1
```

ON THE CD

The HTML file *HypocycloidRectangles1.html* (Listing 5.8) contains the code for launching *HypocycloidRectangles1.class*.

LISTING 5.8 HypocycloidRectangles1.html

```
<HTML>
<HEAD></HEAD>
<BODY>
<APPLET CODE=HypocycloidRectangles1.class WIDTH=800
HEIGHT=450></APPLET>
</BODY>
</HTML>
```

REMARKS

The preceding example draws a rectangle (of fixed width and height) whose upper left-hand vertex is a point on a *Hypocycloid*. The calculation of the color gradient is a standard technique for computing an index into an array of colors.

As in previous examples, the code in the method *drawSpiral()* calculates the coordinates of a point on a two-dimensional curve and then the method *drawRectangle()* invokes the standard *fillRect()* method that is available in Java.

You can create your own variations of this code by experimenting with the index into the color array. You can also add conditional logic in order to vary the width or height (or both) of the rectangle that is drawn in the method *drawRectangle()*.

CONCEPT: RECTANGLES AND OSCILLATING HYPOCYCLOIDS

The next pair of objects (Figure 5.6 and Figure 5.7) consists of the following building blocks:

- A set of rectangles
- A *Hypocycloid* curve

FIGURE 5.6 Snapshot of *Hypocycloid*-based oscillating rectangles.

FIGURE 5.7 Subsequent snapshot of *Hypocycloid*-based oscillating rectangles.

The Java class *HypocycloidOscillatingRectangles1.java* contains the following methods:

drawSpiral()

drawRectangle()

The method *drawSpiral()* contains a loop that computes the (x, y) coordinates of the points on a *Hypocycloid* and then invokes the method *drawRectangle()* in order to draw a rectangle.

The method *drawRectangle()* computes an index into an array of colors for computing the current color and then invokes the standard *fillRect()* method that's available in Java in order to draw a rectangle at a point represented by the pair (x, y).

ON THE CD

The Java class *HypocycloidOscillatingRectangles1.java* (Listing 5.9) demonstrates how to draw rectangles that follow the path of a *Hypocycloid*.

LISTING 5.9 HypocycloidOscillatingRectangles1.java

```java
import java.awt.Color;
import java.awt.Graphics;
```

```
import java.awt.Image;

import java.io.Serializable;

public class HypocycloidOscillatingRectangles1 extends
      java.applet.Applet implements Serializable
{
   private Graphics offScreenBuffer = null;
   private Image    offScreenImage  = null;

   private int width       = 800;
   private int height      = 500;

   private int basePointX = 300;
   private int basePointY = 200;

   private int currentX   = basePointX;
   private int currentY   = basePointY;

   private double offsetX = 0;
   private double offsetY = 0;

   private double sineAngle1   = 0;
   private double cosineAngle1 = 0;

   private double sineAngle2   = 0;
   private double cosineAngle2 = 0;

   private double numerator   = 0;
   private double denominator = 0;

   private double A = 110;
   private double B = 20;

   private int branches  = 1;
   private int colorPartition = 45;
   private int colorOffset = 0;

   private double radius = 80;
   private double Radius = 60;

   private double frequency = 1.0;

   private int eHeight    = 40;
   private int eWidth     = 40;
   private int minEHeight = 40;
   private int maxEHeight = 160;

   private int startTheta = (int)(0/frequency);
   private int endTheta   = (int)(1440/frequency);
```

```
private int angleSpan = endTheta-startTheta;

private Color[] rectangleColors = {
   Color.red, Color.green, Color.blue, Color.yellow,
   Color.white, Color.magenta
};

private int colorCount = rectangleColors.length;

public HypocycloidOscillatingRectangles1()
{
}

public void init()
{
   offScreenImage  = this.createImage(width, height);
   offScreenBuffer = offScreenImage.getGraphics();

} // init

public void update(Graphics gc)
{
   paint(gc);

} // update

public void paint(Graphics gc)
{
   offScreenBuffer.setColor(Color.lightGray);
   offScreenBuffer.fillRect(0, 0, width, height);

   offScreenBuffer.setColor(Color.red);
   drawSpiral(offScreenBuffer, gc);

} // paint

public void drawSpiral(Graphics gc, Graphics gcMain)
{
   for(int angle=startTheta; angle<endTheta; angle++)
   {
      if(angle%colorPartition == 0) { ++colorOffset; }

      sineAngle1   =
               Math.sin(branches*angle*Math.PI/180);

      cosineAngle1 =
               Math.cos(branches*angle*Math.PI/180);

      sineAngle2   = Math.sin(
               ((A/B)-1)*angle*Math.PI/180);
```

```
      cosineAngle2 = Math.cos(
                  ((A/B)-1)*angle*Math.PI/180);

      offsetX = (A-B)*cosineAngle1 + B*cosineAngle2;
      offsetY = (A-B)*sineAngle1   - B*sineAngle2;

      currentX = basePointX+(int)offsetX;
      currentY = basePointY+(int)offsetY;

      drawRectangle(gc, angle, currentX, currentY);
      gcMain.drawImage(offScreenImage, 0, 0, this);
   }

 } // drawSpiral

 public void drawRectangle(Graphics gc, int x,
                           int xCoord, int yCoord)
 {
  //eHeight = x*maxEHeight/angleSpan+minEHeight;

   gc.setColor(rectangleColors[((x%2)*2+colorOffset)%
                                   colorCount]);

   gc.fillRect(xCoord, yCoord, eWidth, eHeight);

 } // drawRectangle

} // HypocycloidOscillatingRectangles1
```

ON THE CD

The HTML file *HypocycloidOscillatingRectangles1.html* (Listing 5.10) contains the code for launching *HypocycloidOscillatingRectangles1.class*.

LISTING 5.10 HypocycloidOscillatingRectangles1.html

```
<HTML>
<HEAD></HEAD>
<BODY>
<APPLET CODE=HypocycloidOscillatingRectangles1.class WIDTH=800
HEIGHT=450></APPLET>
</BODY>
</HTML>
```

REMARKS

The preceding example draws a rectangle (of fixed width and height), the upper left-hand vertex of which is a point on a *Hypocycloid*. The calculation

of the color gradient involves a variation on previous techniques for computing an index into an array of colors. The code in the method *drawSpiral()* calculates the coordinates of a point on a two-dimensional curve and then the method *drawRectangle()* invokes the standard *fillRect()* method that is available in Java.

Notice how this example consists of a set of "sub-bands," each of which contains an alternating pair of colors. This effect is achieved by virtue of the computation of the index into the color array.

CONCEPT: RECTANGLES AND MULTI POLAR LOOPS

The next object (Figure 5.8) consists of the following building blocks:

- A set of rectangles
- Multiple polar loops

The Java class *MultiPolarLoopsRectangles1.java* contains the following methods:

drawSpiral()

drawRectangle()

The method *drawSpiral()* contains a loop that computes the (x, y) coordinates of the points on a *Deltoid* and then invokes the method *drawRectangle()* in order to draw a rectangle.

The method *drawRectangle()* computes an index into an array of colors for computing the current color and then invokes the standard *fillRect()* method that's available in Java in order to draw a rectangle at a point represented by the pair (x, y).

FIGURE 5.8 MultiPolarLoopsRectangles1.

The Java class *MultiPolarLoopsRectangles1.java* (Listing 5.11) demonstrates how to draw rectangles that follow the path of a set of polar loops.

LISTING 5.11 MultiPolarLoopsRectangles1.java

```
import java.awt.Color;
import java.awt.Graphics;
import java.awt.Image;

import java.io.Serializable;

public class MultiPolarLoopsRectangles1 extends
       java.applet.Applet implements Serializable
{
   private Graphics offScreenBuffer = null;
   private Image    offScreenImage  = null;

   private int width        = 800;
   private int height       = 500;

   private int basePointX = 300;
   private int basePointY = 250;

   private int currentX   = basePointX;
   private int currentY   = basePointY;

   private double offsetX = 0;
   private double offsetY = 0;

   private int eHeight      = 60;
   private int eWidth       = 60;

   private double A = 160;
   private double B = 110;

   private double sineAngle1   = 0;
   private double cosineAngle1 = 0;

   private double sineAngle2   = 0;
   private double cosineAngle2 = 0;

   private double Radius = 60;
   private double radius = 60;

   private double frequency = 1.0;

   private int startTheta = (int)(0/frequency);
   private int endTheta   = (int)(1440/frequency);

   private Color[] rectangleColors = {
```

```
      Color.red, Color.green, Color.blue, Color.yellow,
      Color.white, Color.magenta
   };

   private int colorCount = rectangleColors.length;

   public MultiPolarLoopsRectangles1()
   {
   }

   public void init()
   {
      offScreenImage  = this.createImage(width, height);
      offScreenBuffer = offScreenImage.getGraphics();

   } // init

   public void update(Graphics gc)
   {
      paint(gc);

   } // update

   public void paint(Graphics gc)
   {
      offScreenBuffer.setColor(Color.lightGray);
      offScreenBuffer.fillRect(0, 0, width, height);

      offScreenBuffer.setColor(Color.red);
      drawSpiral(offScreenBuffer);
      gc.drawImage(offScreenImage, 0, 0, this);

   } // paint

   public void drawSpiral(Graphics gc)
   {
      for(int angle=startTheta; angle<endTheta; angle++)
      {
         sineAngle1   = Math.sin(angle*Math.PI/180);
         cosineAngle1 = Math.cos(angle*Math.PI/180);

         sineAngle2   = Math.sin(((A-B)/B)*
                                 angle*Math.PI/180);

         cosineAngle2 = Math.cos(((A-B)/B)*
                                 angle*Math.PI/180);

         offsetX = (A-B)*cosineAngle1+B*cosineAngle2;
         offsetY = (A-B)*sineAngle1+B*sineAngle2;
```

```
            currentX = basePointX+(int)offsetX;
            currentY = basePointY+(int)offsetY;

            drawRectangle(gc, angle, currentX, currentY, 2);
            gc.fillOval(currentX,currentY,eWidth,eHeight);
      }

   } // drawSpiral

   public void drawRectangle(Graphics gc, int x,
                  int xCoord, int yCoord, int offset)
   {
      gc.setColor(rectangleColors[(x%2)*2+offset]);
      gc.fillRect(xCoord, yCoord, eWidth, eHeight);

   } // drawRectangle

} // MultiPolarLoopsRectangles1
```

ON THE CD

The HTML file *MultiPolarLoopsRectangles1.html* (Listing 5.12) contains the code for launching *MultiPolarLoopsRectangles1.class*.

LISTING 5.12 MultiPolarLoopsRectangles1.html

```
<HTML>
<HEAD></HEAD>
<BODY>
<APPLET CODE=MultiPolarLoopsRectangles1.class WIDTH=800
HEIGHT=450></APPLET>
</BODY>
</HTML>
```

REMARKS

The preceding example draws a rectangle (of fixed width and height), the upper left-hand vertex of which is a point on a polar loop. The calculation of the color gradient involves a variation on previous techniques for computing an index into an array of colors. The code in the method *drawSpiral()* calculates the coordinates of a point on a two-dimensional curve and then the method *drawRectangle()* invokes the standard *fillRect()* method that is available in Java.

You can create your own variations of this code by experimenting with the index into the color array. You can also add conditional logic in order

to vary the width or height (or both) of the rectangle that is drawn in the method *drawRectangle()*.

CD LIBRARY

ON THE CD

The CD-ROM for this chapter contains "class" files and HTML files that are needed for viewing the graphics images in the following Java files:

Deltoid4PointRectangles1.

EpicycloidRectangles.

EpicycloidOscillating
Rectangles1.

HypocycloidRectangles1.

HypocycloidOscillating
Rectangles1.

MultiPolarLoopsRectangles1.

Deltoid4PointOscillating
Rectangles1.

Deltoid6PointOscillating
Rectangles1.

Deltoid6PointRectangles1.

Epicycloid1.

Epicycloid2.

SUMMARY

This chapter presented Java code that demonstrated how to combine color gradients, color arrays, and rectangles with two-dimensional polar equations in order to draw graphics based on the following types of curves:

- Four-point *Deltoids*
- *Epicycloids*
- Polar loops

POLYNOMIALS AND LINE SEGMENTS

OVERVIEW

You probably remember polynomials from high school mathematics as squiggly lines that you drew on a piece of graph paper. Since polynomials are not especially interesting, why bother doing anything with them? There are two answers to this question: values for polynomials are easy to calculate (i.e., multiplication of numbers) and polynomials can be combined with line segments and color gradients to produce interesting visual effects.

Just to refresh your memory, a polynomial is the sum of powers of a variable, such as x, and the value of the highest power of x is the *degree* of the polynomial. In general, a polynomial equation is designated as having "degree n," but there are some other terms as well. For example, a *cubic* equation is a polynomial of degree three; a *quartic* equation is a polynomial of degree four; a *quintic* is a polynomial of degree five.

In this chapter, a polynomial will be expressed in terms of its *roots*, which is another word for the values of x where a polynomial crosses the x-axis. There is also the notion of a *scale factor*, which is simply a number that is used when computing a point on a polynomial. Usually the scale factor is between 40 and 100, but it can be anything you want.

CONCEPT: COMPUTING POLYNOMIAL VALUES

Instead of using the general form of a polynomial, we'll use a variation that expresses the polynomial as a product of its roots. For example, consider the following cubic equation:

```
y = (x-50)*(x-100)*(x-200);
```

This cubic equation has three roots: x = 50, x = 100, and x = 200. Another way of expressing this fact is by saying that the cubic equation crosses the x-axis for these three values of x. This cubic equation has a scale factor of 1, and its graph won't fit on the screen. After experimenting with different values, you'll find that a scale factor of 40 produces a graph that fits on the screen. The new equation looks like this:

```
y = (x-50)/scaleFactor*(x-100)/scaleFactor*
    (x-200)/scaleFactor;
```

You can draw the graph of this cubic equation by using a loop in which x varies from 0 to 500. The values for y will be within range of your screen, and you'll see a reasonable rendition of a cubic equation.

The preceding technique is also used in order to define quartic and quintic equations. The scale factor needs to be adjusted slightly for higher-degree polynomials, and you can find a suitable range of values by experimentation.

CONCEPT: POLYNOMIALS AND LINE SEGMENTS

The next object (Figure 6.1) consists of the following building blocks:

- A set of line segments
- A set of polynomials

The Java class *PolynomialLines1.java* contains the following methods:

FIGURE 6.1 Polynomial-based line segments.

initializePolynomials()

drawPolynomialCone()

drawLine()

updateCoordinates()

The method *drawPolynomialCone()* contains a loop that invokes the method *drawLine()* in order to draw a set of line segments.

The method *drawLine()* draws a line segment between a pair of points that lie on different polynomials.

The method *updateCoordinates()* updates variables and ensures that their values lie between a maximum and minimum allowable value.

ON THE CD

The Java class *PolynomialLines1.java* (Listing 6.1) demonstrates how to draw line segments that follow the path of a polynomial curve.

LISTING 6.1 PolynomialLines1.java

```java
import java.awt.Color;
import java.awt.Graphics;
import java.awt.Image;

import java.io.Serializable;

public class PolynomialLines1 extends java.applet.Applet
      implements Serializable
{
   private Graphics offScreenBuffer = null;
   private Image    offScreenImage  = null;

   private int width    = 800;
   private int height   = 500;

   private int basePointX = 100;
   private int basePointY = 250;

   private int currentX   = basePointX;
   private int currentY   = basePointY;

   private int lineGap = 2;
   private int maxCount = 300;

   private double deltaY = 0;
   private double[] scaleFactors = {40, 40, 80};

   private int[] polynomialDegrees  = {3, 4, 5};
   private int polynomialCount=polynomialDegrees.length;
```

```
private int[] polynomialXOffsets =
                              new int[polynomialCount];

private int[][] polynomialRoots =
                        { {100, 150, 300, 300, 300},
                          {50, 200, 400, 450, 550},
                          {100, 150, 350, 500, 600},
                        };

private int coneWidth    = polynomialRoots[1][1];
private int minConeWidth = polynomialRoots[1][0];
private int maxConeWidth = polynomialRoots[1][3];

private int coneDelta     = 4;
private int coneDirection = 1;

private int maxXPoints = polynomialRoots[2][4];

private double[][] polynomialYPoints =
              new double[polynomialCount][maxXPoints];

private int[] colorWeights = new int[3];

public PolynomialLines1()
{
}

public void init()
{
   offScreenImage  = this.createImage(width, height);
   offScreenBuffer = offScreenImage.getGraphics();

   initializePolynomials();

} // init

public void initializePolynomials()
{
  for(int x=0; x<maxXPoints; x++)
  {
     for(int poly=0; poly<polynomialCount; poly++)
     {
         deltaY = 1.0;
         for(int z=0; z<polynomialDegrees[poly]; z++)
         {
            deltaY *= (x-polynomialRoots[poly][z])/
                       scaleFactors[poly];
         }
     }
```

```
            polynomialYPoints[poly][x] = deltaY;
        }
    }

    for(int poly=0; poly<polynomialCount; poly++)
    {
        polynomialXOffsets[poly] = 50;
    }

} // initializePolynomials

public void update(Graphics gc)
{
    paint(gc);

} // update

public void paint(Graphics gc)
{
    for(int tick=0; tick<maxCount; ++tick)
    {
        offScreenBuffer.setColor(Color.lightGray);
        offScreenBuffer.fillRect(0, 0, width, height);

        drawPolynomialCone(offScreenBuffer, gc);

        gc.drawImage(offScreenImage, 0, 0, this);
        updateCoordinates();
    }

} // paint

public void updateCoordinates()
{
    coneWidth += coneDelta*coneDirection;

    if( coneWidth > maxConeWidth )
    {
        coneWidth = maxConeWidth;
        coneDirection *= -1;
    }

    if( coneWidth < minConeWidth )
    {
        coneWidth = minConeWidth;
        coneDirection *= -1;
    }

} // updateCoordinates
```

```
public void drawPolynomialCone(Graphics gc,
                                 Graphics gcMain)
{
   for(int xValue=0; xValue<coneWidth; xValue++)
   {
      if( xValue % lineGap == 0 )
      {
         drawLine(gc, xValue);
      }
   }

} // drawPolynomialCone

public void drawLine(Graphics gc, int x)
{
   colorWeights[0] = x*255/coneWidth;
   colorWeights[1] = x*255/coneWidth;

   gc.setColor(new Color(colorWeights[0],
                         colorWeights[1],
                         colorWeights[2]));

   gc.drawLine(
         basePointX+x,
         basePointY-(int)polynomialYPoints[0][x],
         basePointX+x+polynomialXOffsets[1],
         basePointY-(int)polynomialYPoints[1][x]);

} // drawLine

} // PolynomialLines1
```

ON THE CD

The HTML file *PolynomialLines1.html* (Listing 6.2) contains the code for launching *PolynomialLines1.class*.

LISTING 6.2 PolynomialLines1.html

```
<HTML>
<HEAD></HEAD>
<BODY>
<APPLET CODE=PolynomialLines1.class WIDTH=800 HEIGHT=450></APPLET>
</BODY>
</HTML>
```

REMARKS

The preceding example contains an array that represents the roots of three polynomials—a cubic, a quartic, and a quintic equation. For simplicity, the rows in the array are "padded" so that they contain the same number of elements. Since the scale factors for the polynomials are also in an array, it's very easy to add more polynomials that can be processed by means of simple loops.

Instead of computing indexes into an array of colors, the color gradients are based on RGB values. Since the calculations for the color weights depend on the current `coneWidth`, which is updated in the method *updateCoordinates()*, the color gradients will be updated many times.

Incidentally, you'll find the variable `coneWidth` in many examples in this book, which somehow implies that the associated image is a cone. This naming convention requires some clarification (mainly for the purists.) According to the usual definition of a cone, many of the images are not cones; consequently, the interpretation (not the definition) of a cone in this book has been generalized in order to include images that are (in some sense) a generalization of a traditional view of a cone.

CONCEPT: POLYNOMIALS AND STRIPED LINE SEGMENTS

The next object (Figure 6.2) consists of the following building blocks:

- A set of line segments
- A set of polynomials

The Java class *PolynomialLinesOutline1.java* contains the following methods:

FIGURE 6.2 An outline of polynomial-based line segments.

initializePolynomials()

drawPolynomialCone()

drawLine()

updateCoordinates()

The method *drawPolynomialCone()* contains a loop that invokes the method *drawLine()* in order to draw a set of line segments.

The method *drawLine()* draws a line segment between a pair of points that lie on different polynomials.

The method *updateCoordinates()* updates variables and ensures that their values lie between a maximum and minimum allowable value.

ON THE CD

The Java class *PolynomialLinesOutline1.java* (Listing 6.3) demonstrates how to draw line segments that follow the path of a polynomial curve.

LISTING 6.3 PolynomialLinesOutline1.java

```java
import java.awt.Color;
import java.awt.Graphics;
import java.awt.Image;

import java.io.Serializable;

public class PolynomialLinesOutline1 extends
        java.applet.Applet implements Serializable
{
   private Graphics offScreenBuffer = null;
   private Image    offScreenImage  = null;

   private int width     = 800;
   private int height    = 500;

   private int basePointX = 100;
   private int basePointY = 250;

   private int currentX    = basePointX;
   private int currentY    = basePointY;

   private int hGap = 2;
   private int minHGap = 2;
   private int maxHGap = 12;
   private int hGapDelta = 1;
   private int hGapDirection = 1;

   private int lineGap = 2;
   private int maxCount = 300;
```

```
private double deltaY = 0;
private double[] scaleFactors = {40, 40, 80};

private int[] polynomialDegrees  = {3, 4, 5};
private int polynomialCount=polynomialDegrees.length;
private int[] polynomialXOffsets =
                          new int[polynomialCount];

private int[][] polynomialRoots =
                      { {100, 150, 300, 300, 300},
                        {50,  200, 400, 450, 550},
                        {100, 150, 350, 500, 600},
                      };

private int coneWidth    = polynomialRoots[1][1];
private int minConeWidth = polynomialRoots[1][0];
private int maxConeWidth = polynomialRoots[1][3];

private int coneDelta    = 4;
private int coneDirection = 1;

private int maxXPoints = polynomialRoots[2][4];
private double[][] polynomialYPoints =
               new double[polynomialCount][maxXPoints];

private int[] colorWeights = new int[3];

public PolynomialLinesOutline1()
{
}

public void init()
{
   offScreenImage  = this.createImage(width, height);
   offScreenBuffer = offScreenImage.getGraphics();

   initializePolynomials();

} // init

public void initializePolynomials()
{
  for(int x=0; x<maxXPoints; x++)
  {
     for(int poly=0; poly<polynomialCount; poly++)
     {
        deltaY = 1.0;
        for(int z=0; z<polynomialDegrees[poly]; z++)
        {
           deltaY *= (x-polynomialRoots[poly][z])/
```

```
                    scaleFactors[poly];
        }

        polynomialYPoints[poly][x] = deltaY;
      }
    }

    for(int poly=0; poly<polynomialCount; poly++)
    {
      polynomialXOffsets[poly] = 50;
    }

  } // initializePolynomials

  public void update(Graphics gc)
  {
    paint(gc);

  } // update

  public void paint(Graphics gc)
  {
    for(int tick=0; tick<maxCount; ++tick)
    {
      offScreenBuffer.setColor(Color.lightGray);
      offScreenBuffer.fillRect(0, 0, width, height);

      drawPolynomialCone(offScreenBuffer, gc);

      gc.drawImage(offScreenImage, 0, 0, this);
      updateCoordinates();
    }

  } // paint

  public void updateCoordinates()
  {
    coneWidth += coneDelta*coneDirection;

    if( coneWidth > maxConeWidth )
    {
      coneWidth = maxConeWidth;
      coneDirection *= -1;
    }

    if( coneWidth < minConeWidth )
    {
      coneWidth = minConeWidth;
      coneDirection *= -1;
    }
```

```
    hGap += hGapDelta*hGapDirection;

    if( hGap > maxHGap )
    {
       hGap = maxHGap;
       hGapDirection *= -1;
    }

    if( hGap < minHGap )
    {
       hGap = minHGap;
       hGapDirection *= -1;
    }

} // updateCoordinates

public void drawPolynomialCone(Graphics gc,
                              Graphics gcMain)
{
   for(int xValue=0; xValue<coneWidth; xValue++)
   {
      if( xValue % lineGap == 0 )
      {
         drawLine(gc, xValue, 0);
      }

      if( xValue % hGap == 0 )
      {
         drawLine(gc, xValue, 1);
         drawLine(gc, xValue, 1);
         drawLine(gc, xValue, 1);
      }
   }

} // drawPolynomialCone

public void drawLine(Graphics gc, int x,
                     int colorSwitch)
{
   if( colorSwitch == 0 )
   {
      colorWeights[0] = x*255/coneWidth;
      colorWeights[1] = x*255/coneWidth;

      gc.setColor(new Color(colorWeights[0],
                            colorWeights[1],
                            colorWeights[2]));
   }
   else
   {
```

```
        gc.setColor(Color.white);
    }

    gc.drawLine(
            basePointX+x,
            basePointY-(int)polynomialYPoints[0][x],
            basePointX+x+polynomialXOffsets[1],
            basePointY-(int)polynomialYPoints[1][x]);

  } // drawLine

} // PolynomialLinesOutline1
```

ON THE CD

The HTML file *PolynomialLinesOutline1.html* (Listing 6.4) contains the code for launching *PolynomialLinesOutline1.class*.

LISTING 6.4 PolynomialLinesOutline1.html

```
<HTML>
<HEAD></HEAD>
<BODY>
<APPLET CODE=PolynomialLinesOutline1.class WIDTH=800
HEIGHT=450></APPLET>
</BODY>
</HTML>
```

REMARKS

The preceding example demonstrates how to create a striped effect by means of the variable hGap that is updated in the method *updateCoordinates()*. The current width of the drawn image is determined by the variable coneWidth, which is also updated in the method *updateCoordinates()* in order to create an oscillating effect.

As in the prior example, the Java code contains an array that represents the roots of three polynomials—a cubic, a quartic, and a quintic equation. For simplicity, the rows in the array are "padded" so that they contain the same number of elements. Since the scale factors for the polynomials are also in an array, it's very easy to add more polynomials that can be processed by means of simple loops.

CONCEPT: MULTIPLE POLYNOMIALS AND LINE SEGMENTS

The next object (Figure 6.3) consists of the following building blocks:

- A set of line segments
- A set of polynomials

FIGURE 6.3 Multiple polynomial-based line segments.

The Java class *MultiPolynomialLines1.java* contains the following methods:

initializePolynomials()
drawPolynomialCone()
drawLine()
updateCoordinates()

The method *drawPolynomialCone()* contains a loop that invokes the method *drawLine()* in order to draw a set of line segments.

The method *drawLine()* draws a line segment between a pair of points that lie on different polynomials.

The method *updateCoordinates()* updates variables and ensures that their values lie between a maximum and minimum allowable value.

ON THE CD

The Java class *MultiPolynomialLines1.java* (Listing 6.5) demonstrates how to draw line segments that follow the path of a set of polynomial curves.

LISTING 6.5 MultiPolynomialLines1.java

```
import java.awt.Color;
import java.awt.Graphics;
```

```
import java.awt.Image;

import java.io.Serializable;

public class MultiPolynomialLines1 extends
      java.applet.Applet implements Serializable
{
   private Graphics offScreenBuffer = null;
   private Image    offScreenImage  = null;

   private int width      = 800;
   private int height     = 500;

   private int basePointX = 100;
   private int basePointY = 250;

   private int currentX   = basePointX;
   private int currentY   = basePointY;

   private int lineGap = 1;
   private int maxCount = 300;

   private double deltaY = 0;
   private double[] scaleFactors = {40, 40, 80};

   private int[] polynomialDegrees  = {3, 4, 5};
   private int polynomialCount=polynomialDegrees.length;
   private int[] polynomialXOffsets =
                           new int[polynomialCount];

   private int[][] polynomialRoots =
                        { {100, 150, 300, 300, 300},
                          {50,  200, 400, 450, 550},
                          {100, 150, 350, 500, 600},
                        };

   private int coneWidth    = polynomialRoots[1][1];
   private int minConeWidth = polynomialRoots[1][0];
   private int maxConeWidth = polynomialRoots[1][3];

   private int coneDelta     = 4;
   private int coneDirection = 1;

   private int maxXPoints = polynomialRoots[2][4];
   private double[][] polynomialYPoints =
             new double[polynomialCount][maxXPoints];

   private Color[] lineColors = {
      Color.red, Color.green, Color.blue, Color.yellow,
      Color.white, Color.magenta
```

```
};

private int colorCount = lineColors.length;

public MultiPolynomialLines1()
{
}

public void init()
{
   offScreenImage  = this.createImage(width, height);
   offScreenBuffer = offScreenImage.getGraphics();

   initializePolynomials();

} // init

public void initializePolynomials()
{
  for(int x=0; x<maxXPoints; x++)
  {
    for(int poly=0; poly<polynomialCount; poly++)
    {
       deltaY = 1.0;
       for(int z=0; z<polynomialDegrees[poly]; z++)
       {
          deltaY *= (x-polynomialRoots[poly][z])/
                    scaleFactors[poly];
       }

       polynomialYPoints[poly][x] = deltaY;
    }
  }

  for(int poly=0; poly<polynomialCount; poly++)
  {
     polynomialXOffsets[poly] = 50;
  }

} // initializePolynomials

public void update(Graphics gc)
{
   paint(gc);

} // update

public void paint(Graphics gc)
{
   for(int tick=0; tick<maxCount; ++tick)
```

```
      {
        offScreenBuffer.setColor(Color.lightGray);
        offScreenBuffer.fillRect(0, 0, width, height);

        drawPolynomialCone(offScreenBuffer, gc);

        gc.drawImage(offScreenImage, 0, 0, this);
        updateCoordinates();
      }

  } // paint

  public void updateCoordinates()
  {
     coneWidth += coneDelta*coneDirection;

     if( coneWidth > maxConeWidth )
     {
        coneWidth = maxConeWidth;
        coneDirection *= -1;
     }

     if( coneWidth < minConeWidth )
     {
        coneWidth = minConeWidth;
        coneDirection *= -1;
     }

  } // updateCoordinates

  public void drawPolynomialCone(Graphics gc,
                                 Graphics gcMain)
  {
     for(int xValue=0; xValue<coneWidth; xValue++)
     {
        if( xValue % lineGap == 0 )
        {
           for(int poly=0; poly<polynomialCount; poly++)
           {
              drawLine(gc, xValue, poly);
           }
        }
     }

  } // drawPolynomialCone

  public void drawLine(Graphics gc, int x, int poly)
  {
     gc.setColor(lineColors[poly%colorCount]);
```

```
gc.drawLine(
      basePointX+x,
      basePointY-(int)polynomialYPoints[poly][x],
      basePointX+x+polynomialXOffsets[poly],
      basePointY-(int)polynomialYPoints[
                   (poly+1)%polynomialCount][x]);

} // drawEllipse

} // MultiPolynomialLines1
```

ON THE CD

The HTML file *MultiPolynomialLines1.html* (Listing 6.6) contains the code for launching *MultiPolynomialLines1.class*.

LISTING 6.6 MultiPolynomialLines1.html

```
<HTML>
<HEAD></HEAD>
<BODY>
<APPLET CODE=MultiPolynomialLines1.class WIDTH=800
HEIGHT=450></APPLET>
</BODY>
</HTML>
```

REMARKS

The preceding example computes an index into an array of colors in order to set the color gradient. The current width of the drawn image is determined by the variable `coneWidth`, which is also updated in the method *updateCoordinates()* in order to create an oscillating effect.

The Java code contains an array that represents the roots of three polynomials. For simplicity, the rows in the array are "padded" so that they contain the same number of elements. Since the scale factors for the polynomials are also in an array, it's very easy to add more polynomials that can be processed by means of simple loops.

CONCEPT: MULTIPLE POLYNOMIALS AND STRIPED LINE SEGMENTS

The next object (Figure 6.4) consists of the following building blocks:

- A set of line segments
- A set of polynomials

FIGURE 6.4 Multiple polynomial-based line segments.

The Java class *MultiPolynomialLinesOutline1.java* contains the following methods:

initializePolynomials()

drawPolynomialCone()

drawLine()

updateCoordinates()

The method *drawPolynomialCone()* contains a loop that invokes the method *drawLine()* in order to draw a set of line segments.

The method *drawLine()* draws a line segment between a pair of points that lie on different polynomials.

The method *updateCoordinates()* updates variables and ensures that their values lie between a maximum and minimum allowable value.

ON THE CD

The Java class *MultiPolynomialLinesOutline1.java* (Listing 6.7) demonstrates how to draw line segments that follow the path of a set of polynomial curves.

LISTING 6.7 MultiPolynomialLinesOutline1.java

```
import java.awt.Color;
import java.awt.Graphics;
import java.awt.Image;
```

```java
import java.io.Serializable;

public class MultiPolynomialLinesOutline1 extends
      java.applet.Applet implements Serializable
{
   private Graphics offScreenBuffer = null;
   private Image   offScreenImage  = null;

   private int width      = 800;
   private int height     = 500;

   private int basePointX = 100;
   private int basePointY = 250;

   private int currentX   = basePointX;
   private int currentY   = basePointY;

   private int hGap = 4;
   private int minHGap = 4;
   private int maxHGap = 12;
   private int hGapDelta = 1;
   private int hGapDirection = 1;

   private int lineGap = 1;
   private int maxCount = 300;

   private double deltaY = 0;
   private double[] scaleFactors = {40, 40, 80};

   private int[] polynomialDegrees  = {3, 4, 5};
   private int polynomialCount=polynomialDegrees.length;
   private int[] polynomialXOffsets =
                          new int[polynomialCount];

   private int[][] polynomialRoots =
                          { {100, 150, 300, 300, 300},
                            {50,  200, 400, 450, 550},
                            {100, 150, 350, 500, 600},
                          };

   private int coneWidth    = polynomialRoots[1][1];
   private int minConeWidth = polynomialRoots[1][0];
   private int maxConeWidth = polynomialRoots[1][3];

   private int coneDelta    = 4;
   private int coneDirection = 1;

   private int maxXPoints = polynomialRoots[2][4];
   private double[][] polynomialYPoints =
               new double[polynomialCount][maxXPoints];
```

```
private int[] colorWeights = new int[3];

public MultiPolynomialLinesOutline1()
{
}

public void init()
{
   offScreenImage  = this.createImage(width, height);
   offScreenBuffer = offScreenImage.getGraphics();

   initializePolynomials();

} // init

public void initializePolynomials()
{
  for(int x=0; x<maxXPoints; x++)
  {
    for(int poly=0; poly<polynomialCount; poly++)
    {
        deltaY = 1.0;
        for(int z=0; z<polynomialDegrees[poly]; z++)
        {
           deltaY *= (x-polynomialRoots[poly][z])/
                    scaleFactors[poly];
        }

        polynomialYPoints[poly][x] = deltaY;
      }
    }

    for(int poly=0; poly<polynomialCount; poly++)
    {
        polynomialXOffsets[poly] = 50;
    }

} // initializePolynomials

public void update(Graphics gc)
{
   paint(gc);

} // update

public void paint(Graphics gc)
{
   for(int tick=0; tick<maxCount; ++tick)
   {
      offScreenBuffer.setColor(Color.lightGray);
```

```
            offScreenBuffer.fillRect(0, 0, width, height);

            drawPolynomialCone(offScreenBuffer, gc);

            gc.drawImage(offScreenImage, 0, 0, this);
            updateCoordinates();
        }

} // paint

public void updateCoordinates()
{
    coneWidth += coneDelta*coneDirection;

    if( coneWidth > maxConeWidth )
    {
        coneWidth = maxConeWidth;
        coneDirection *= -1;
    }

    if( coneWidth < minConeWidth )
    {
        coneWidth = minConeWidth;
        coneDirection *= -1;
    }

    hGap += hGapDelta*hGapDirection;

    if( hGap > maxHGap )
    {
        hGap = maxHGap;
        hGapDirection *= -1;
    }

    if( hGap < minHGap )
    {
        hGap = minHGap;
        hGapDirection *= -1;
    }

} // updateCoordinates

public void drawPolynomialCone(Graphics gc,
                               Graphics gcMain)
{
    for(int xValue=0; xValue<coneWidth; xValue++)
    {
        if( xValue % lineGap == 0 )
        {
            drawLine(gc, xValue, 0, 0);
```

MultiPolynomialLines
Outline1.

MultiPolynomialLines2.

PolynomialLines2.

SUMMARY

This chapter demonstrated the advantage of defining polynomials in terms of their roots. The roots of multiple polynomials can be conveniently defined in an array so that the values of the dependent variable of polynomials (which essentially represents the height at a given point) can be efficiently calculated. When you combine polynomials, line segments, and a variety of techniques for computing color gradients, you can produce vivid and striking images.

POLYGONS AND 3D POLAR COORDINATES

OVERVIEW

This chapter presents Java code that uses a combination of polygons and three-dimensional polar equations. If you've read the previous chapters, you'll notice that this chapter is both a continuation as well as an extension of previous concepts. By drawing polygons that follow the path of a three-dimensional polar equation, the resulting graphics images sometimes have an almost palpable texture as part of their visual richness. Such textural effects are achieved by employing certain types of color gradients that skirt certain boundaries of our visual acuity.

Some clarification is required regarding the use of certain terms that refer to well-known geometric objects. In this chapter, the term "cylinder" actually refers to "pseudo cylinders" rather than a mathematical cylinder. Think of the graphics images as being "generalizations" of a true cylinder. In some cases, the graphics images do not have much resemblance to cylinders, but they are included under the heading of cylinder-like objects because the equations that generate them are variations of equations that generate pseudo-cylinders. Similar comments apply to other geometric objects (e.g., cones) that are presented in other chapters in this book.

CONCEPT: MAPPING 3D POINTS TO A 2D COORDINATE SYSTEM

Since everything that you draw on the screen is a two-dimensional point, you need to know how to convert a point represented by three coordinates into a "drawable" two-dimensional point. Suppose you have a

point P(x, y, z) in three dimensions and you want to draw that point in a two-dimensional plane. This can be done by computing the coordinates of the two-dimensional point P'(x', y') as follows:

```
1) x' = x + z*cos(theta);
2) y' = y + z*sin(theta);
```

The angle theta is the "visual angle" that is formed by the axis that comes out of the plane toward you and the negative vertical axis. Note that the true angle between these two axes is 90 degrees; the "visual angle" refers to the angle between these two axes as they are drawn on a sheet of paper.

CONCEPT: POLYGONS AND 3D POLAR COORDINATES

The next object (Figure 7.1) consists of the following building blocks:

- A set of rectangles
- A 3D polar equation

FIGURE 7.1 Three-dimensional partial polar cylinder.

The Java class *PolarCylinder3D1.java* contains the methods:

drawRectangle()

drawSpiral()

The method *drawRectangle()* calculates an index into an array of colors and then draws a rectangle at the current (x, y) location determined by two parameters that are passed in to the method.

The method *drawSpiral()* computes the current radial value and then invokes the method *drawRectangle()* in order to draw a rectangle.

ON THE CD

The Java class *PolarCylinder3D1.java* (Listing 7.1) demonstrates how to draw a set of rectangles that follow the path of a cylinder.

LISTING 7.1 PolarCylinder3D1.java

```java
import java.awt.Color;
import java.awt.Graphics;
import java.awt.Image;

import java.io.Serializable;

public class PolarCylinder3D1 extends java.applet.Applet
      implements Serializable
{
   private Graphics offScreenBuffer = null;
   private Image    offScreenImage  = null;

   private int width     = 800;
   private int height    = 500;

   private int basePointX = 400;
   private int basePointY = 250;

   private int currentX   = basePointX;
   private int currentY   = basePointY;

   private double offsetX = 0;
   private double offsetY = 0;

   private int sideLength = 4;
   private double radius = 80;

   private int maxU = 180;
   private int maxV = 180;

   private double sineU = 0;
   private double sineV = 0;

   private double cosineU = 0;
   private double cosineV = 0;

   private int baseAngle = 40;

   private double frequency = 1.0;

   private int startTheta = (int)(0/frequency);
   private int endTheta   = (int)(360/frequency);

   private Color[] rectangleColors = {
```

```
         Color.red, Color.green, Color.blue, Color.yellow,
         Color.white, Color.magenta
      };

      private int colorCount = rectangleColors.length;

      public PolarCylinder3D1()
      {
      }

      public void init()
      {
         offScreenImage  = this.createImage(width, height);
         offScreenBuffer = offScreenImage.getGraphics();

      } // init

      public void update(Graphics gc)
      {
         paint(gc);

      } // update

      public void paint(Graphics gc)
      {
         offScreenBuffer.setColor(Color.lightGray);
         offScreenBuffer.fillRect(0, 0, width, height);

         drawSpiral(offScreenBuffer);
         gc.drawImage(offScreenImage, 0, 0, this);

      } // paint

      public void drawSpiral(Graphics gc)
      {
         double x=0.0, y=0.0, z=0.0;

///////////////////////////////////
// 3D -> 2D mapping:
// offsetX = x + z*cos(theta);
// offsetY = y + z*sin(theta);
///////////////////////////////////

         for(int u=0; u<maxU; u++)
         {
            for(int v=0; v<maxV; v++)
            {
               sineU  = Math.sin(u*Math.PI/180);
               sineV  = Math.sin(v*Math.PI/180);
```

```
             cosineU = Math.cos(u*Math.PI/180);
             cosineV = Math.cos(v*Math.PI/180);

             x = radius*sineU;
             y = radius*cosineU;
             z = radius*cosineV;

             offsetX = x+z*Math.cos(
                            baseAngle*Math.PI/180);
             offsetY = y+z*Math.sin(baseAngle*
                            Math.PI/180);

             currentX = basePointX+(int)offsetX;
             currentY = basePointY+(int)offsetY;
             drawRectangle(gc, u+v, currentX, currentY);
          }
       }

    } // drawSpiral

    public void drawRectangle(Graphics gc, int x,
                               int xCoord, int yCoord)
    {
       gc.setColor(rectangleColors[((x%2)*2)%colorCount]);

       gc.draw3DRect(xCoord, yCoord,
                     sideLength, sideLength, true);

    } // drawRectangle

} // PolarCylinder3D1
```

ON THE CD

The HTML file *PolarCylinder3D1.html* (Listing 7.2) contains the code for launching *PolarCylinder3D1.class*.

LISTING 7.2 PolarCylinder3D1.html

```
<HTML>
<HEAD></HEAD>
<BODY>
<APPLET CODE=PolarCylinder3D1.class WIDTH=800 HEIGHT=450></APPLET>
</BODY>
</HTML>
```

REMARKS

As is the case with cones, the interpretation of a cylinder in this book has been generalized in order to include an additional set of images. For instance, the graphics image in the preceding example is actually a partial cylinder. In other code examples you'll see additional variations of the commonly held notion of a cylinder.

The visual effect in this example is achieved by the method *drawRectangle()*, which calculates an index into a color array before it draws a small, raised rectangle at a point that is specified by two parameters that are passed into the method.

Notice the unusual visual patterns that resemble either globule-like "islands" or star-like clusters of color. This interesting effect will be reproduced in other examples in this chapter.

CONCEPT: POLYGONS AND CYLINDERS

The next object (Figure 7.2) consists of the following building blocks:

- A set of rectangles
- A 3D polar equation

FIGURE 7.2 Three-dimensional polar cylinder.

The Java class *PolarCylinder3D2.java* contains the methods:

drawRectangle()
drawSpiral()

The method *drawRectangle()* calculates an index into an array of colors and then draws a rectangle at the current (x, y) location determined by two parameters that are passed in to the method.

The method *drawSpiral()* computes the current radial value and then invokes the method *drawRectangle()* in order to draw a rectangle.

The Java class *PolarCylinder3D2.java* (Listing 7.3) demonstrates how to draw a set of rectangles that follow the path of a cylinder.

LISTING 7.3 PolarCylinder3D2.java

```java
import java.awt.Color;
import java.awt.Graphics;
import java.awt.Image;

import java.io.Serializable;

public class PolarCylinder3D2 extends
        java.applet.Applet implements Serializable
{
   private Graphics offScreenBuffer = null;
   private Image    offScreenImage  = null;

   private int width    = 800;
   private int height   = 500;

   private int basePointX = 400;
   private int basePointY = 250;

   private int currentX   = basePointX;
   private int currentY   = basePointY;

   private double offsetX = 0;
   private double offsetY = 0;

   private int sideLength = 4;
   private double radius = 80;

   private int maxU = 360;
   private int maxV = 180;

   private double sineU = 0;
   private double sineV = 0;

   private double cosineU = 0;
   private double cosineV = 0;

   private int baseAngle = 40;
```

```
    private double frequency = 1.0;

    private int startTheta = (int)(0/frequency);
    private int endTheta   = (int)(360/frequency);

    private Color[] rectangleColors = {
       Color.red, Color.green, Color.blue, Color.yellow,
       Color.white, Color.magenta
    };

    private int colorCount = rectangleColors.length;

    public PolarCylinder3D2()
    {
    }

    public void init()
    {
       offScreenImage  = this.createImage(width, height);
       offScreenBuffer = offScreenImage.getGraphics();

    } // init

    public void update(Graphics gc)
    {
       paint(gc);

    } // update

    public void paint(Graphics gc)
    {
       offScreenBuffer.setColor(Color.lightGray);
       offScreenBuffer.fillRect(0, 0, width, height);

       drawSpiral(offScreenBuffer, gc);

    } // paint

    public void drawSpiral(Graphics gc, Graphics gcMain)
    {
       double x=0.0, y=0.0, z=0.0;

////////////////////////////////////
// 3D -> 2D mapping:
// offsetX = x + z*cos(theta);
// offsetY = y + z*sin(theta);
////////////////////////////////////

       for(int u=0; u<maxU; u++)
       {
```

```
        for(int v=0; v<maxV; v++)
        {
            sineU   = Math.sin(u*Math.PI/180);
            sineV   = Math.sin(v*Math.PI/180);

            cosineU = Math.cos(u*Math.PI/180);
            cosineV = Math.cos(v*Math.PI/180);

            x = radius*sineU;
            y = radius*cosineU;
            z = radius*cosineV;

            offsetX = x+z*Math.cos(
                            baseAngle*Math.PI/180);
            offsetY = y+z*Math.sin(
                            baseAngle*Math.PI/180);

            currentX = basePointX+(int)offsetX;
            currentY = basePointY+(int)offsetY;
            drawRectangle(gc, u+v, currentX, currentY);
        }
        gcMain.drawImage(offScreenImage, 0, 0, this);

    }

} // drawSpiral

public void drawRectangle(Graphics gc, int x,
                          int xCoord, int yCoord)
{
    gc.setColor(rectangleColors[((x%2)*2)%colorCount]);

  //gc.drawOval(xCoord, yCoord, eRadius, eRadius);
    gc.draw3DRect(xCoord, yCoord,
                  sideLength, sideLength, true);

} // drawRectangle

} // PolarCylinder3D2
```

ON THE CD
The HTML file *PolarCylinder3D2.html* (Listing 7.4) contains the code for launching *PolarCylinder3D2.class*.

LISTING 7.4 PolarCylinder3D2.html

```
<HTML>
<HEAD></HEAD>
<BODY>
```

```
<APPLET CODE=PolarCylinder3D2.class WIDTH=800 HEIGHT=450></APPLET>
</BODY>
</HTML>
```

REMARKS

The preceding example adds more functionality by drawing a full cylinder via a simple animation technique. As you've seen before, the visual effect in this example is achieved by the method *drawRectangle()*, which calculates an index into a color array before it draws a small, raised rectangle at a point that is specified by two parameters that are passed into the method. While watching the cylinder being rendered, you probably did not anticipate the final image. Instead of seeing a "normal" cylinder, you see something that might remind you of a Moebius-like twist performed on the cylinder.

In case you're wondering, here's how you can make a Moebius strip: find a long narrow strip of paper, with one end in each hand, and then twist one end by 180 degrees before you glue the two ends together. The resulting object has only one side, and you can prove this to yourself by tracing a finger along this object until you return to your original starting point. See how you're on the "other side"? Here's another interesting twist (so to speak): cut the Moebius strip along its middle. You might be surprised by the result. Check out the Web for other fun stuff you can do with Moebius strips. Incidentally, Moebius strips are useful in machinery because they wear out evenly instead of fraying one side.

CONCEPT: GRADIENT POLYGONS AND PARTIAL CYLINDERS

The next object (Figure 7.3) consists of the following building blocks:

- A set of rectangles
- A 3D polar equation

The Java class *PolarCylinderGradient3D1.java* contains the methods:

drawRectangle()

drawSpiral()

The method *drawRectangle()* uses color weighting for RGB and then draws a rectangle at the current (x, y) location determined by two parameters that are passed into the method.

FIGURE 7.3 Three-dimensional polar cylinder gradient.

The method *drawSpiral()* computes the current radial value and then invokes the method *drawRectangle()* in order to draw a rectangle.

ON THE CD

The Java class *PolarCylinderGradient3D1.java* (Listing 7.5) demonstrates how to draw a set of rectangles that follow the path of a cylinder.

LISTING 7.5 PolarCylinderGradient3D1.java

```java
import java.awt.Color;
import java.awt.Graphics;
import java.awt.Image;

import java.io.Serializable;

public class PolarCylinderGradient3D1 extends
       java.applet.Applet implements Serializable
{
   private Graphics offScreenBuffer = null;
   private Image    offScreenImage  = null;

   private int width    = 800;
   private int height   = 500;

   private int basePointX = 400;
   private int basePointY = 250;

   private int currentX   = basePointX;
   private int currentY   = basePointY;

   private double offsetX = 0;
   private double offsetY = 0;
```

```java
private int sideLength = 4;
private double radius = 80;

private int maxU = 180;
private int maxV = 180;

private double sineU = 0;
private double sineV = 0;

private double cosineU = 0;
private double cosineV = 0;

private int baseAngle = 40;

private double frequency = 1.0;

private int startTheta = (int)(0/frequency);
private int endTheta   = (int)(360/frequency);

private int[] colorWeights = new int[3];

public PolarCylinderGradient3D1()
{
}

public void init()
{
   offScreenImage  = this.createImage(width, height);
   offScreenBuffer = offScreenImage.getGraphics();

} // init

public void update(Graphics gc)
{
   paint(gc);

} // update

public void paint(Graphics gc)
{
   offScreenBuffer.setColor(Color.lightGray);
   offScreenBuffer.fillRect(0, 0, width, height);

   drawSpiral(offScreenBuffer);
   gc.drawImage(offScreenImage, 0, 0, this);

} // paint

public void drawSpiral(Graphics gc)
{
```

```
      double x=0.0, y=0.0, z=0.0;

//////////////////////////////////
// 3D -> 2D mapping:
// offsetX = x + z*cos(theta);
// offsetY = y + z*sin(theta);
//////////////////////////////////

      for(int u=0; u<maxU; u++)
      {
         for(int v=0; v<maxV; v++)
         {
            sineU   = Math.sin(u*Math.PI/180);
            sineV   = Math.sin(v*Math.PI/180);

            cosineU = Math.cos(u*Math.PI/180);
            cosineV = Math.cos(v*Math.PI/180);

            x = radius*sineU;
            y = radius*cosineU;
            z = radius*cosineV;

            offsetX = x+z*Math.cos(baseAngle*Math.PI/180);
            offsetY = y+z*Math.sin(baseAngle*Math.PI/180);

            currentX = basePointX+(int)offsetX;
            currentY = basePointY+(int)offsetY;
            drawRectangle(gc, u, v, currentX, currentY);
         }
      }

   } // drawSpiral

   public void drawRectangle(Graphics gc, int u, int v,
                             int xCoord, int yCoord)
   {
      colorWeights[0] = u%255;
      colorWeights[1] = v%255;
      colorWeights[2] = (u+v)%255;

      gc.setColor(new Color(colorWeights[0],
                            colorWeights[1],
                            colorWeights[2]));

      gc.draw3DRect(xCoord, yCoord,
                    sideLength, sideLength, true);

   } // drawRectangle

} // PolarCylinderGradient3D1
```

The HTML file *PolarCylinderGradient3D1.html* (Listing 7.6) contains the code for launching *PolarCylinderGradient3D1.class*.

LISTING 7.6 PolarCylinderGradient3D1.html

```
<HTML>
<HEAD></HEAD>
<BODY>
<APPLET CODE=PolarCylinderGradient3D1.class WIDTH=800
HEIGHT=450></APPLET>
</BODY>
</HTML>
```

REMARKS

The preceding graphics image is dramatically different from the image in *PolarCylinder3D1.java*, even though the code is similar. The key difference is the technique for determining the color of each rectangle: *PolarCylinder3D1.java* uses an index into an array of colors, whereas the preceding class uses color weighting in the method *drawRectangle()*:

```
colorWeights[0] = u%255;
colorWeights[1] = v%255;
colorWeights[2] = (u+v)%255;
```

The variables u and v, which are passed as parameters to the method *drawRectangle()*, are the variables in a nested loop. As you can see, the RGB components are calculated in a very straightforward manner. You can experiment with other techniques for calculating the RGB values.

CONCEPT: GRADIENT POLYGONS AND CYLINDERS

The next object (Figure 7.4) consists of the following building blocks:

- A set of rectangles
- A 3D polar equation

The Java class *PolarCylinderGradient3D2.java* contains the methods:

drawRectangle()

drawSpiral()

FIGURE 7.4 Three-dimensional gradient polar cylinder.

The method *drawRectangle()* uses color weighting for RGB and then draws a rectangle at the current (x, y) location determined by two parameters that are passed in to the method.

The method *drawSpiral()* computes the current radial value and then invokes the method *drawRectangle()* in order to draw a rectangle.

ON THE CD

The Java class *PolarCylinderGradient3D2.java* (Listing 7.7) demonstrates how to draw a set of rectangles that follow the path of a cylinder.

LISTING 7.7 PolarCylinderGradient3D2.java

```java
import java.awt.Color;
import java.awt.Graphics;
import java.awt.Image;

import java.io.Serializable;

public class PolarCylinderGradient3D2 extends
        java.applet.Applet implements Serializable
{
    private Graphics offScreenBuffer = null;
    private Image    offScreenImage  = null;

    private int width     = 800;
    private int height    = 500;

    private int basePointX = 400;
    private int basePointY = 250;

    private int currentX   = basePointX;
    private int currentY   = basePointY;

    private double offsetX = 0;
    private double offsetY = 0;
```

```java
private int sideLength = 4;
private double radius = 80;

private int maxU = 360;
private int maxV = 180;

private double sineU = 0;
private double sineV = 0;

private double cosineU = 0;
private double cosineV = 0;

private int baseAngle = 40;

private double frequency = 1.0;

private int startTheta = (int)(0/frequency);
private int endTheta   = (int)(360/frequency);

private int[] colorWeights = new int[3];

public PolarCylinderGradient3D2()
{
}

public void init()
{
    offScreenImage  = this.createImage(width, height);
    offScreenBuffer = offScreenImage.getGraphics();

} // init

public void update(Graphics gc)
{
    paint(gc);

} // update

public void paint(Graphics gc)
{
    offScreenBuffer.setColor(Color.lightGray);
    offScreenBuffer.fillRect(0, 0, width, height);

    drawSpiral(offScreenBuffer, gc);

} // paint

public void drawSpiral(Graphics gc, Graphics gcMain)
{
    double x=0.0, y=0.0, z=0.0;
```

```
/////////////////////////////////
// 3D -> 2D mapping:
// offsetX = x + z*cos(theta);
// offsetY = y + z*sin(theta);
/////////////////////////////////

      for(int u=0; u<maxU; u++)
      {
         for(int v=0; v<maxV; v++)
         {
            sineU   = Math.sin(u*Math.PI/180);
            sineV   = Math.sin(v*Math.PI/180);

            cosineU = Math.cos(u*Math.PI/180);
            cosineV = Math.cos(v*Math.PI/180);

            x = radius*sineU;
            y = radius*cosineU;
            z = radius*cosineV;

            offsetX = x+z*Math.cos(
                           baseAngle*Math.PI/180);
            offsetY = y+z*Math.sin(
                           baseAngle*Math.PI/180);

            currentX = basePointX+(int)offsetX;
            currentY = basePointY+(int)offsetY;
            drawRectangle(gc, u, v, currentX, currentY);
         }
         gcMain.drawImage(offScreenImage, 0, 0, this);

      }

   } // drawSpiral

   public void drawRectangle(Graphics gc, int u, int v,
                             int xCoord, int yCoord)
   {
      colorWeights[0] = u%255;
      colorWeights[1] = v%255;
      colorWeights[2] = (u+v)%255;

      gc.setColor(new Color(colorWeights[0],
                            colorWeights[1],
                            colorWeights[2]));

      gc.draw3DRect(xCoord, yCoord,
                    sideLength, sideLength, true);
```

```
    } // drawRectangle

} // PolarCylinderGradient3D2
```

ON THE CD

The HTML file *PolarCylinderGradient3D2.html* (Listing 7.8) contains the code for launching *PolarCylinderGradient3D2.class*.

LISTING 7.8 PolarCylinderGradient3D2.html

```
<HTML>
<HEAD></HEAD>
<BODY>
<APPLET CODE=PolarCylinderGradient3D2.class WIDTH=800
HEIGHT=450></APPLET>
</BODY>
</HTML>
```

REMARKS

The preceding graphics image is dramatically different from the image in *PolarCylinder3D2.java*, even though the code is similar. The key difference is the technique for determining the color of each rectangle: *PolarCylinder3D2.java* uses an index into an array of colors, whereas the preceding class uses color weighting in the method *drawRectangle()*:

```
colorWeights[0] = u%255;
colorWeights[1] = v%255;
colorWeights[2] = (u+v)%255;
```

The variables u and v, which are passed as parameters to the method *drawRectangle()*, are the variables in a nested loop. As you can see, the RGB components are calculated in a very straightforward manner. You can experiment with other techniques for calculating the RGB values.

CONCEPT: POLYGONS AND DISTENDED CYLINDERS

The next object (Figure 7.5) consists of the following building blocks:

- A set of rectangles
- A 3D polar equation

FIGURE 7.5 Three-dimensional multiple partial polar cylinders.

The Java class *PolarMultiCylinder3D1.java* contains the methods:

drawRectangle()

drawSpiral()

The method *drawRectangle()* calculates an index into an array of colors and then draws a rectangle at the current (x, y) location determined by two parameters that are passed into the method.

The method *drawSpiral()* computes the current radial value and then invokes the method *drawRectangle()* in order to draw a rectangle.

ON THE CD

The Java class *PolarMultiCylinder3D1.java* (Listing 7.9) demonstrates how to draw a set of rectangles that follow the path of a cylinder.

LISTING 7.9 PolarMultiCylinder3D1.java

```java
import java.awt.Color;
import java.awt.Graphics;
import java.awt.Image;

import java.io.Serializable;

public class PolarMultiCylinder3D1 extends
        java.applet.Applet implements Serializable
{
    private Graphics offScreenBuffer = null;
    private Image    offScreenImage  = null;

    private int width     = 800;
    private int height    = 500;

    private int basePointX = 400;
    private int basePointY = 250;
```

```java
private int currentX    = basePointX;
private int currentY    = basePointY;

private double offsetX = 0;
private double offsetY = 0;

private int sideLength = 4;
private double radius = 80;

private int maxU = 180;
private int maxV = 180;

private double sineU = 0;
private double sineV = 0;

private double cosineU = 0;
private double cosineV = 0;

private int baseAngle = 40;

private double frequency = 1.0;

private int startTheta = (int)(0/frequency);
private int endTheta   = (int)(360/frequency);

private Color[] rectangleColors = {
   Color.red, Color.green, Color.blue, Color.yellow,
   Color.white, Color.magenta
};

private int colorCount = rectangleColors.length;

public PolarMultiCylinder3D1()
{
}

public void init()
{
   offScreenImage  = this.createImage(width, height);
   offScreenBuffer = offScreenImage.getGraphics();

} // init

public void update(Graphics gc)
{
   paint(gc);

} // update

public void paint(Graphics gc)
```

```
    {
        offScreenBuffer.setColor(Color.lightGray);
        offScreenBuffer.fillRect(0, 0, width, height);

        drawSpiral(offScreenBuffer);
        gc.drawImage(offScreenImage, 0, 0, this);

    } // paint

    public void drawSpiral(Graphics gc)
    {
        double x=0.0, y=0.0, z=0.0;

///////////////////////////////////
// 3D -> 2D mapping:
// offsetX = x + z*cos(theta);
// offsetY = y + z*sin(theta);
///////////////////////////////////

        for(int u=0; u<maxU; u++)
        {
            for(int v=0; v<maxV; v++)
            {
                sineU   = Math.sin(u*Math.PI/180);
                sineV   = Math.sin(v*Math.PI/180);

                cosineU = Math.cos(u*Math.PI/180);
                cosineV = Math.cos(v*Math.PI/180);

                x = radius*sineU;
                y = radius*cosineU;
                z = radius*cosineV;

                offsetX = x+z*Math.cos(
                            baseAngle*Math.PI/180);
                offsetY = y+z*Math.sin(
                            baseAngle*Math.PI/180);

                currentX = basePointX+(int)offsetX;
                currentY = basePointY+(int)offsetY;
                drawRectangle(gc, u+v, currentX, currentY);

                currentX = basePointX-(int)offsetX;
                currentY = basePointY-(int)offsetY;
                drawRectangle(gc, u+v, currentX, currentY);

                currentX = basePointX+(int)offsetX;
                currentY = basePointY-(int)offsetY;
                drawRectangle(gc, u+v, currentX, currentY);
```

```
            currentX = basePointX-(int)offsetX;
            currentY = basePointY+(int)offsetY;
            drawRectangle(gc, u+v, currentX, currentY);
        }
    }

} // drawSpiral

public void drawRectangle(Graphics gc, int x,
                              int xCoord, int yCoord)
{
    gc.setColor(rectangleColors[((x%2)*2)%colorCount]);

    gc.draw3DRect(xCoord, yCoord,
                    sideLength, sideLength, true);

} // drawRectangle

} // PolarMultiCylinder3D1
```

The HTML file *PolarMultiCylinder3D1.html* (Listing 7.10) contains the code for launching *PolarMultiCylinder3D1.class*.

ON THE CD

LISTING 7.10 PolarMultiCylinder3D1.html

```
<HTML>
<HEAD></HEAD>
<BODY>
<APPLET CODE=PolarMultiCylinder3D1.class WIDTH=800
HEIGHT=450></APPLET>
</BODY>
</HTML>
```

REMARKS

The preceding graphics image is surprisingly rich in texture, much more than what you might have expected from reading the code! The basic structure involves variations of the following three lines in the method *drawSpiral()*:

```
currentX = basePointX+(int)offsetX;
currentY = basePointY+(int)offsetY;
drawRectangle(gc, u+v, currentX, currentY);
```

By toggling the "+" sign to a "−" sign in front of *offsetX* and *offsetY*, you can get three additional points in the plane that can be passed to the

method *drawRectangle()*. These variations, plus the original one, produce the four "leaves" of the preceding graphics image.

CONCEPT: POLYGONS AND MULTI-COLORED DISTENDED CYLINDERS

The next object (Figure 7.6) consists of the following building blocks:

- A set of rectangles
- A 3D polar equation

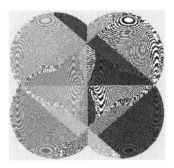

FIGURE 7.6 Three-dimensional multi-colored multiple polar cylinders.

The Java class *PolarMultiCylinder3D2.java* contains the methods:

drawRectangle()

drawSpiral()

The method *drawRectangle()* uses color weighting for RGB and then draws a rectangle at the current (x, y) location determined by two parameters that are passed into the method.

The method *drawSpiral()* computes the current radial value and then invokes the method *drawRectangle()* in order to draw a rectangle.

ON THE CD

The Java class *PolarMultiCylinder3D2.java* (Listing 7.11) demonstrates how to draw a set of rectangles that follow the path of a cylinder.

LISTING 7.11 PolarMultiCylinder3D2.java

```
import java.awt.Color;
import java.awt.Graphics;
```

```java
import java.awt.Image;

import java.io.Serializable;

public class PolarMultiCylinder3D2 extends
        java.applet.Applet implements Serializable
{
   private Graphics offScreenBuffer = null;
   private Image    offScreenImage  = null;

   private int width       = 800;
   private int height      = 500;

   private int basePointX = 400;
   private int basePointY = 250;

   private int currentX    = basePointX;
   private int currentY    = basePointY;

   private double offsetX = 0;
   private double offsetY = 0;

   private int sideLength = 4;
   private double radius = 80;

   private int maxU = 180;
   private int maxV = 180;

   private double sineU = 0;
   private double sineV = 0;

   private double cosineU = 0;
   private double cosineV = 0;

   private int baseAngle = 40;

   private double frequency = 1.0;

   private int startTheta = (int)(0/frequency);
   private int endTheta   = (int)(360/frequency);

   private Color[] rectangleColors = {
      Color.red, Color.green, Color.blue, Color.yellow,
      Color.white, Color.magenta
   };

   private int colorCount = rectangleColors.length;

   public PolarMultiCylinder3D2()
   {
```

```
   }

   public void init()
   {
      offScreenImage  = this.createImage(width, height);
      offScreenBuffer = offScreenImage.getGraphics();

   } // init

   public void update(Graphics gc)
   {
      paint(gc);

   } // update

   public void paint(Graphics gc)
   {
      offScreenBuffer.setColor(Color.lightGray);
      offScreenBuffer.fillRect(0, 0, width, height);

      drawSpiral(offScreenBuffer);
      gc.drawImage(offScreenImage, 0, 0, this);

   } // paint

   public void drawSpiral(Graphics gc)
   {
      double x=0.0, y=0.0, z=0.0;

////////////////////////////////////
// 3D -> 2D mapping:
// offsetX = x + z*cos(theta);
// offsetY = y + z*sin(theta);
////////////////////////////////////

      for(int u=0; u<maxU; u++)
      {
         for(int v=0; v<maxV; v++)
         {
            sineU   = Math.sin(u*Math.PI/180);
            sineV   = Math.sin(v*Math.PI/180);

            cosineU = Math.cos(u*Math.PI/180);
            cosineV = Math.cos(v*Math.PI/180);

            x = radius*sineU;
            y = radius*cosineU;
            z = radius*cosineV;

            offsetX = x+z*Math.cos(
```

```
                                baseAngle*Math.PI/180);
                offsetY = y+z*Math.sin(
                                baseAngle*Math.PI/180);

                currentX = basePointX+(int)offsetX;
                currentY = basePointY+(int)offsetY;
                drawRectangle(gc,u+v,currentX,currentY,0);

                currentX = basePointX-(int)offsetX;
                currentY = basePointY-(int)offsetY;
                drawRectangle(gc,u+v,currentX,currentY,1);

                currentX = basePointX+(int)offsetX;
                currentY = basePointY-(int)offsetY;
                drawRectangle(gc,u+v,currentX,currentY,2);

                currentX = basePointX-(int)offsetX;
                currentY = basePointY+(int)offsetY;
                drawRectangle(gc,u+v,currentX,currentY,3);
            }
        }

    } // drawSpiral

    public void drawRectangle(Graphics gc, int x,
                              int xCoord, int yCoord, int c)
    {
        gc.setColor(
            rectangleColors[((x%2)*2+c)%colorCount]);

        gc.draw3DRect(xCoord, yCoord,
                      sideLength, sideLength, true);

    } // drawRectangle

} // PolarMultiCylinder3D2
```

ON THE CD

The HTML file *PolarMultiCylinder3D2.html* (Listing 7.12) contains the code for launching *PolarMultiCylinder3D2.class*.

LISTING 7.12 PolarMultiCylinder3D2.html

```
<HTML>
<HEAD></HEAD>
<BODY>
<APPLET CODE=PolarMultiCylinder3D2.class WIDTH=800
HEIGHT=450></APPLET>
</BODY>
</HTML>
```

REMARKS

The preceding graphics image contains four overlapping "leaves," each of which has a distinctive color that is rendered by the following line:

```
gc.setColor(rectangleColors[((x%2)*2+c)%colorCount]);
```

The value of the variable c, which is passed as a parameter to *draw-Rectangle()*, varies between 0 and 3. Each value of *c* determines the color combination for each leaf. One thing is certain, this technique is delightfully simple!

CD LIBRARY

ON THE CD

The CD-ROM for this chapter contains "class" files and HTML files that are needed for viewing the graphics images in the following Java files:

PolarCylinder3D1. PolarCylinder3D2. PolarCylinderGradient3D1.

PolarCylinderGradient3D2. PolarMultiCylinder3D1. PolarMultiCylinder3D2.

PolarCylinderGradient3D3.

PolarCylinderSectors3D1.

PolarCylinderSectors3D2.

PolarTwistedCylinder3D1.

PolarTwistedCylinder3D2.

PolarTwistedCylinder3D3.

PolarTwistedStriped
Cylinder3D1.

SUMMARY

This chapter demonstrated how to draw combined polygons, three-dimensional polar equations, and gradient shading in order to draw striking graphics images. Although some of the techniques in this chapter are an extension of those used in previous chapters, many of the graphics images have a vivid texture, which is achieved by drawing many small rectangles in close proximity to each other. You can replace the rectangles in the examples in this chapter with other polygons, such as hexagons or octagons, in order to create your own interesting variations.

ELLIPSE-BASED OBJECTS

OVERVIEW

This chapter contains Java code that renders ellipses. The first example shows you how to draw a basic ellipse. Next, you'll see how to draw an ellipse with gradient shading in order to create a graduated shading effect. Other shading techniques are used in order to draw hollow ellipses, ellipses with horizontal or vertical stripes, and rotated ellipses.

The ellipse is a fundamental building block in the sense that it is used in many other Java classes (often in conjunction with other building blocks) in order to draw some sophisticated objects. Although the techniques presented in this chapter are fairly straightforward, they are important because they form the foundation for subsequent chapters. In particular, the code for calculating the points on an ellipse is important—you'll see it used in the Java code for spinning cones and cylinders—so it's worthwhile investing the effort to understand how it works. Better yet, see if you can improve the code!

CONCEPT: DRAWING AN ELLIPSE

The following diagram (Figure 8.1) displays an ellipse whose major axis is horizontal and whose minor axis is vertical.

CONCEPT: DRAWING ELLIPSES WITH SHADING

The following figure (Figure 8.2) consists of a set of black ellipses.

The Java class *Ellipse1.java* contains the method *drawEllipses()* which draws a set of ellipses by shifting them diagonally as they are drawn in order to provide the illusion of depth. The top-most ellipse is drawn in red, thereby creating a three-dimensional effect.

FIGURE 8.1 The outline of an ellipse. **FIGURE 8.2** A set of layered ellipses.

ON THE CD

The Java class *Ellipse1.java* (Listing 8.1) demonstrates how to draw a filled-in ellipse with simple shading

LISTING 8.1 Ellipse1.java

```java
import java.awt.Color;
import java.awt.Graphics;
import java.awt.Image;

import java.io.Serializable;

public class Ellipse1 extends java.applet.Applet
        implements Serializable
{
   private Image offScreenImage     = null;
   private Graphics offScreenBuffer = null;

   private int width      = 800;
   private int height     = 500;

   private int basePointX = 100;
   private int basePointY = 100;

   private int eWidth     = 240;
   private int eHeight    = 150;
   private int thickness  = 20;

   public Ellipse1()
   {
   }

   public void init()
   {
      offScreenImage  = this.createImage(width, height);
      offScreenBuffer = offScreenImage.getGraphics();
   }
```

```
public void update(Graphics gc)
{
   paint(gc);

} // update

public void paint(Graphics gc)
{
   offScreenBuffer.setColor(Color.lightGray);
   offScreenBuffer.fillRect(0, 0, width, height);

   drawEllipses(offScreenBuffer);

   gc.drawImage(offScreenImage, 0, 0, this);

} // paint

public void drawEllipses(Graphics gc)
{
   for(int z=thickness; z>=0; z—)
   {
      if(z > 0) { gc.setColor(Color.black); }
      else      { gc.setColor(Color.red); }

      gc.fillOval(basePointX+z,
                  basePointY+z,
                  eWidth,
                  eHeight);
   }

} // drawEllipses

} // Ellipse1
```

ON THE CD

The HTML file *Ellipse1.html* (Listing 8.2) contains the code for launching *Ellipse1.class*.

LISTING 8.2 Ellipse1.html

```
<HTML>
<HEAD></HEAD>
<BODY>
<APPLET CODE=Ellipse1.class WIDTH=800 HEIGHT=500></APPLET>
</BODY>
</HTML>
```

REMARKS

The preceding example demonstrates how to draw an ellipse with gradient shading. The key idea is simple: the method *drawEllipses()* contains a loop that determines the current color and draws an ellipse at the current location. Based on this example, you can create your own variations. For example, instead of using one color for shading, you can calculate an index into an array of colors in order to render a wider range of colors.

CONCEPT: DRAWING ELLIPSES USING LINE SEGMENTS

The following diagram (Figure 8.3) illustrates an ellipse with vertical lines that will be drawn with a color gradient.

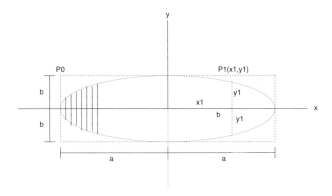

FIGURE 8.3 An ellipse as a set of vertical line segments.

REMARKS

Figure 8.3 depicts an ellipse as a set of adjacent line segments. Only a subset of the line segments are actually rendered, so you need to visualize the line segments that have not been drawn. Given the x-coordinate of a point P1 on an ellipse, you can use its equation in order to determine the y-coordinate of P1. The corresponding point on the other side of the ellipse (let's call it point P2) has the same x-coordinate as point P1. The y-coordinates of P1 and P2 are the same distance away from the horizontal axis of symmetry. Hence, the line segment from P1 to P2 can be rendered after specifying the RGB components of that line segment.

CONCEPT: ELLIPSES WITH GRADIENT AND DIAGONAL SHADING

The following figure (Figure 8.4) consists of a set of vertical adjacent line segments that are drawn by means of gradient shading.

FIGURE 8.4 An ellipse with gradient shading.

In Figure 8.4, the "background" ellipses are shifted one unit up and one unit to the left, which gives the ellipses an illusion of depth. The top-most ellipse is drawn by means of a set of vertical lines whose color changes from blue to black.

The Java class *Ellipse2.java* (Listing 8.3) demonstrates how to draw a set of stacked ellipses using diagonal shading and gradient shading.

LISTING 8.3 Ellipse2.java

```java
import java.awt.Color;
import java.awt.Font;
import java.awt.Graphics;
import java.awt.Image;

import java.io.Serializable;

public class Ellipse2 extends java.applet.Applet
       implements Serializable
{
    private Image offScreenImage    = null;
    private Graphics offScreenBuffer = null;

    private int width    = 800;
    private int height   = 500;

    private int basePointX = 200;
    private int basePointY = 200;

    private int eWidth  = 256;
    private int eHeight = 100;
```

draw the "lower" ellipses by means of one color weighting algorithm, then use a different algorithm for rendering the top-most ellipse.

CONCEPT: DRAWING SHRINKING ELLIPSES

The next object (Figure 8.5 and Figure 8.6) consists of the following building blocks:

- A set of ellipses drawn with gradient shading

FIGURE 8.5 Snapshot of a shrinking ellipse.

FIGURE 8.6 Subsequent snapshot of a shrinking ellipse.

The Java class *ShrinkingEllipse1.java* contains the following methods:

drawEllipse()

updateCoordinates()

drawEllipseGradient()

The method *drawEllipse()* uses diagonal shading in order to draw a set of ellipses that create a three-dimensional effect.

The method *drawEllipseGradient()* uses gradient shading in order to draw the "front" ellipse so that it ranges from black to red.

The method *updateCoordinates()* resizes the height of the ellipse and ensures that it remains between the minimum and maximum allowable values.

ON THE CD

The Java class *ShrinkingEllipse1.java* (Listing 8.5) demonstrates how to draw an ellipse that expands and contracts and creates a three-dimensional effect by means of diagonal shading.

LISTING 8.5 ShrinkingEllipse1.java

```
import java.awt.Color;
import java.awt.Font;
```

```java
import java.awt.Graphics;
import java.awt.Image;

import java.io.Serializable;

public class ShrinkingEllipse1 extends java.applet.Applet
      implements Serializable
{
   private Image offScreenImage      = null;
   private Graphics offScreenBuffer = null;

   private int width       = 800;
   private int height      = 500;

   private int maxCount    = 400;

   private int basePointX = 100;
   private int basePointY = 100;

   private int eWidth   = 512;
   private int eHeight = 200;

   private int minEHeight = 100;
   private int maxEHeight = 300;

   private int yDirection = 1;
   private int yDelta      = 1;

   private int thickness   = 20;

   private double offsetY1 = 0;
   private double offsetY2 = 0;
   private int    offsetY3 = 0;

   private int rVal = 0;
   private int gVal = 0;
   private int bVal = 0;

   public ShrinkingEllipse1()
   {
   }

   public void init()
   {
      offScreenImage  = this.createImage(width, height);
      offScreenBuffer = offScreenImage.getGraphics();
   }

   public void paint(Graphics gc)
   {
```

```
   for(int tick=0; tick<maxCount; ++tick)
   {
      offScreenBuffer.setColor(Color.lightGray);
      offScreenBuffer.fillRect(0, 0, width, height);

      drawEllipse(offScreenBuffer);
      drawEllipseGradient(offScreenBuffer);

      gc.drawImage(offScreenImage, 0, 0, this);
      updateCoordinates();
   }

} // paint

public void updateCoordinates()
{
   eHeight += yDirection*yDelta;

   if( eHeight < minEHeight )
   {
      eHeight = minEHeight;
      yDirection     *= -1;
   }

   if( eHeight > maxEHeight )
   {
      eHeight = maxEHeight;
      yDirection     *= -1;
   }

} // updateCoordinates

public void drawEllipse(Graphics gc)
{
   for(int z=thickness; z>0; z--)
   {
      gc.setColor(Color.darkGray);
      gc.fillOval(basePointX+z,
                  basePointY+z,
                  eWidth,
                  eHeight);
   }

} // drawEllipse

public void drawEllipseGradient(Graphics gc)
{
   rVal = 0;
   gVal = 0;
   bVal = 0;
```

```
    for(int x=-eWidth/2; x<=eWidth/2; x++)
    {
        rVal = (x+eWidth/2)*255/eWidth;

        offsetY1 = (eHeight/2)*(eHeight/2)*
                        ((eWidth/2)*(eWidth/2)-x*x);

        offsetY2 = offsetY1/((eWidth/2)*(eWidth/2));

        offsetY3 = (int) Math.sqrt(offsetY2);

        gc.setColor(new Color(rVal, gVal, bVal));

        gc.drawLine(basePointX+eWidth/2+x,
                        basePointY+eHeight/2-offsetY3,
                        basePointX+eWidth/2+x,
                        basePointY+eHeight/2+offsetY3);
    }

  } // drawEllipseGradient

} // ShrinkingEllipse1
```

ON THE CD

The HTML file *ShrinkingEllipse1.html* (Listing 8.6) contains the code for launching *ShrinkingEllipse1.class*.

LISTING 8.6 ShrinkingEllipse1.html

```
<HTML>
<HEAD></HEAD>
<BODY>
<APPLET CODE=ShrinkingEllipse1.class WIDTH=800 HEIGHT=500></APPLET>
</BODY>
</HTML>
```

REMARKS

The preceding example uses vertical gradient shading for the topmost ellipse and simple diagonal shading for the lower ellipses in order to create a three-dimensional effect. The rendering of this graphics image is slower than other examples because of the following factors: the calculation of all the points on each ellipse, the instantiation of a new color object, and the rendering of a set of vertical line segments that represent the topmost ellipse. The combination of these factors causes a visible time delay when creating an animation effect for the expanding and contracting ellipse.

CONCEPT: DRAWING ORGAN PIPES

The next figure (Figure 8.7) consists of the following building blocks:

- A set of cylindrical ellipses

FIGURE 8.7 Organ-like set of ellipses.

The Java class *OrganEllipses1.java* contains the following methods:

initializeEllipses()

drawEllipses()

The method *initializeEllipses()* initializes the heights of a set of ellipses and stores the heights in an array.

The method *drawEllipses()* uses horizontal shading while drawing a set of vertically "stacked" ellipses in order to create a cylindrical effect.

ON THE CD

The Java class *OrganEllipses1.java* (Listing 8.7) demonstrates how to draw a set of elliptic cylinders that resemble the pipes of an organ.

LISTING 8.7 OrganEllipses1.java

```
import java.awt.Color;
import java.awt.Font;
import java.awt.Graphics;
import java.awt.Image;

import java.io.Serializable;

public class OrganEllipses1 extends java.applet.Applet
       implements Serializable
{
```

```java
private Graphics offScreenBuffer = null;
private Image   offScreenImage  = null;

private int width     = 800;
private int height    = 500;

private int basePointX = 200;
private int basePointY = 100;

private int currentX  = 200;
private int currentY  = 160;

private int eHeight      = 300;
private int ellipseCount = 8;

private int[] radii    = new int[ellipseCount];
private int[] eHeights = new int[ellipseCount];

private int innerRadius = 20;

private Color[] ellipseColors = {
    Color.red, Color.blue, Color.green,
    Color.white, Color.yellow
};

public OrganEllipses1()
{
}

public void init()
{
   offScreenImage  = this.createImage(width, height);
   offScreenBuffer = offScreenImage.getGraphics();

   initializeEllipses();

} // init

public void initializeEllipses()
{
   for(int k=0; k<ellipseCount; k++)
   {
      radii[k] = innerRadius;

      if( (k>ellipseCount/4)&&(k<3*ellipseCount/4) )
      {
         eHeights[k] = eHeight;
      }
      else
      {
```

```
                  eHeights[k] = 3*eHeight/4;
            }
      }

} // initializeEllipses

public void update(Graphics gc)
{
    paint(gc);

} // update

public void paint(Graphics gc)
{
    offScreenBuffer.setColor(Color.lightGray);
    offScreenBuffer.fillRect(0, 0, width, height);

    drawEllipses(offScreenBuffer);

    gc.drawImage(offScreenImage, 0, 0, this);

} // paint

public void drawEllipses(Graphics gc)
{
    for(int e=0; e<ellipseCount; e++)
    {
        gc.setColor(ellipseColors[e%2]);

        // draw full height of current ellipse...
        for(int y=0; y<eHeights[e]; y++)
        {
            gc.fillOval(basePointX+2*e*radii[e],
                        basePointY+eHeight-eHeights[e]+y,
                        2*radii[e],
                        radii[e]);
        }

        // draw top-most ellipse...
        gc.setColor(Color.white);
        gc.drawOval(basePointX+2*e*radii[e],
                    basePointY+eHeight-eHeights[e],
                    2*radii[e],
                    radii[e]);
    }

} // drawEllipses

} // OrganEllipses1
```

ON THE CD

The HTML file *OrganEllipses1.html* (Listing 8.8) contains the code for launching *OrganEllipses1.class*.

LISTING 8.8 OrganEllipses1.html

```
<HTML>
<HEAD></HEAD>
<BODY>
<APPLET CODE=OrganEllipses1.class WIDTH=800 HEIGHT=500></APPLET>
</BODY>
</HTML>
```

REMARKS

The previous example shows how easy it is to draw a set of cylinders. The method *drawEllipses()* calculates an index into an array of colors in order to draw a set of adjacent cylinders with alternating colors. Each cylinder consists of a stack of adjacent horizontal ellipses, all of which are drawn with the same color. You can easily modify the color so that it uses color weighting for RGB in order to create richer graphics images.

CONCEPT: DRAWING A ROTATED ELLIPSE

The next figure (Figure 8.8) consists of the following building blocks:

- An ellipse
- A set of colored line segments

The Java class *RotatedEllipse1.java* contains the method *drawEllipseGradient()* that computes the coordinates of a rotated ellipse. If you want to see the derivation of the equations that are used for rotating an ellipse, you can review the appropriate section in Appendix A. Gradient shading is used for drawing a set of line segments to create a filled-in effect.

ON THE CD

The Java class *RotatedEllipse1.java* (Listing 8.9) demonstrates how to draw a rotated ellipse. The line segments that are used for drawing the rotated ellipse are at an angle, which results in visible gaps in the color of the ellipse.

FIGURE 8.8 A rotated ellipse.

LISTING 8.9 RotatedEllipse1.java

```java
import java.awt.Color;
import java.awt.Graphics;
import java.awt.Image;

import java.io.Serializable;

public class RotatedEllipse1 extends java.applet.Applet
        implements Serializable
{
    private Image offScreenImage    = null;
    private Graphics offScreenBuffer = null;

    private int width       = 800;
    private int height      = 500;

    private int basePointX = 100;
    private int basePointY = 200;

    private double xPrime1 = 0;
    private double xPrime2 = 0;

    private double yPrime1 = 0;
    private double yPrime2 = 0;

    private double theta  = 30*(Math.PI)/180;

    private double offsetY1 = 0;
    private double offsetY2 = 0;
    private int    offsetY3 = 0;

    private int thickness =  20;
    private int eWidth    = 256;
    private int eHeight   =  80;

    private int rVal       =   0;
    private int gVal       =   0;
    private int bVal       = 255;
```

```java
public RotatedEllipse1()
{
}

public void init()
{
   offScreenImage  = this.createImage(width, height);
   offScreenBuffer = offScreenImage.getGraphics();
}

public void update(Graphics gc)
{
   paint(gc);

} // update

public void paint(Graphics gc)
{
   offScreenBuffer.setColor(Color.lightGray);
   offScreenBuffer.fillRect(0, 0, width, height);

   drawEllipseGradient(offScreenBuffer);

   gc.drawImage(offScreenImage, 0, 0, this);

} // paint

public void drawEllipseGradient(Graphics gc)
{
   gc.setColor(Color.blue);

   for(int x=-eWidth/2; x<=eWidth/2; x++)
   {
      // experiment with different color weights...
      rVal = (x+eWidth/2)*255/eWidth;
      gVal = (x+eWidth/2)*255/eWidth;
      bVal = (x+eWidth/2)*128/eWidth;

      gc.setColor(new Color(rVal, gVal, bVal));

      // rotation equations:
      //(x') = (cos theta -sin theta)(x)
      //(y') = (sin theta  cos theta)(y)

      offsetY1 = (eHeight/2)*(eHeight/2)*
                  ((eWidth/2)*(eWidth/2)-x*x);

      offsetY2 = offsetY1/((eWidth/2)*(eWidth/2));
```

```
        offsetY3 = (int) Math.sqrt(offsetY2);

        // rotate counter-clockwise theta degrees...
        xPrime1 = (x*Math.cos(-theta)-
                        offsetY3*Math.sin(-theta));

        yPrime1 = (x*Math.sin(-theta)+
                        offsetY3*Math.cos(-theta));

        xPrime2 = (x*Math.cos(-theta)-
                        (-offsetY3)*Math.sin(-theta));

        yPrime2 = (x*Math.sin(-theta)+
                        (-offsetY3)*Math.cos(-theta));

        gc.drawLine(basePointX+eWidth/2+(int)xPrime1,
                basePointY+eHeight/2+(int)yPrime1,
                basePointX+eWidth/2+(int)xPrime2,
                basePointY+eHeight/2+(int)yPrime2);

        // dithering creates sharper image...
        gc.drawLine(basePointX+eWidth/2+(int)xPrime1,
                basePointY+1+eHeight/2+(int)yPrime1,
                basePointX+eWidth/2+(int)xPrime2,
                basePointY+1+eHeight/2+
                        (int)yPrime2);
    }

  } // drawEllipseGradient

} // RotatedEllipse1
```

ON THE CD

The HTML file RotatedEllipse1.html (Listing 8.10) contains the code for launching RotatedEllipse1.class.

LISTING 8.10 RotatedEllipse1.html

```
<HTML>
<HEAD></HEAD>
<BODY>
<APPLET CODE=RotatedEllipse1.class WIDTH=512 HEIGHT=400></APPLET>
</BODY>
</HTML>
```

REMARKS

The preceding example renders a rotated ellipse, and can be extended in a variety of ways. For example, you can create simple animation by combining horizontal and vertical motion, varying the width or height of the ellipse, and a variety of color gradient techniques. Another possibility involves changing the angle of rotation of the ellipse each time that it is rendered in order to create a spinning effect.

CD LIBRARY

ON THE CD

The CD-ROM for this chapter contains "class" files and HTML files that are needed for viewing the graphics images in the following Java files:

Ellipse1.

Ellipse2.

ShrinkingEllipse1.

OrganEllipses1.

RotatedEllipse1.

RotatedEllipseOutline1.

RotatedEllipseOutline2.

SUMMARY

This chapter presented Java code in order to draw the following objects:

- Simple ellipses
- Shaded ellipses
- Shrinking ellipses
- Organ pipes
- Rotated ellipses

This chapter introduced you to the ellipse as a fundamental building block, and showed you how to combine ellipses with shading tables. Ellipses are also very useful for rendering real-life objects and are the cornerstone of another common object: the cylinder.

ELLIPSES AND SIMPLE SHADING

OVERVIEW

This chapter presents additional shading techniques for drawing ellipses, some of which can be applied to other geometric objects. The first example shows you how to draw a horizontal subset of an ellipse that resembles the image you see when looking at an ellipse through a set of window shades. In this chapter, you'll find some Java classes that refer to ellipses, even though the graphics image actually contains a set of circles. This terminology is permissible because (as you probably remember) a circle is actually a special case of an ellipse.

CONCEPT: DRAWING ELLIPSES WITH HORIZONTAL STRIPES

The next object (Figure 9.1) consists of the following building blocks:

- An ellipse
- A set of horizontal rectangles

The Java class *EllipseHBands1.java* contains the method *drawEllipseHBands()* that draws an ellipse and then a horizontal set of rectangles that create a striped effect.

The Java class *EllipseHBands1.java* (Listing 9.1) demonstrates how to draw an ellipse with horizontal stripes.

ON THE CD

FIGURE 9.1 An ellipse with horizontal strips.

LISTING 9.1 EllipseHBands1.java

```
import java.awt.Color;
import java.awt.Graphics;
import java.awt.Image;
import java.awt.Polygon;

public class EllipseHBands1 extends java.applet.Applet
{
   public Graphics offScreenBuffer = null;
   public Image    offScreenImage  = null;

   private int width      = 800;
   private int height     = 500;

   private int basePointX = 100;
   private int basePointY = 100;

   private int baseRed    = 255;
   private int baseGreen  = 0;
   private int baseBlue   = 0;

   private int eWidth     = 400;
   private int eHeight    = 200;

   private int stripHCount  = 32;
   private int stripHWidth  = eWidth;
   private int stripHHeight = eHeight/stripHCount;

   private Color[] stripColors = {
       Color.red, Color.blue, Color.green,
       Color.white, Color.yellow
   };

   public EllipseHBands1()
   {
   }

   public void init()
```

```
   {
      offScreenImage  = this.createImage(width, height);
      offScreenBuffer = offScreenImage.getGraphics();

   } // init

   public void update(Graphics gc)
   {
      paint(gc);

   } // update

   public void paint(Graphics gc)
   {
      offScreenBuffer.setColor(Color.lightGray);
      offScreenBuffer.fillRect(0, 0, width, height);

      drawEllipseHBands(offScreenBuffer);

      gc.drawImage(offScreenImage, 0, 0, this);

   } // paint

   public void drawEllipseHBands(Graphics gc)
   {
      gc.setColor(stripColors[0]);

      gc.fillOval(basePointX,
                  basePointY,
                  eWidth,
                  eHeight);

      gc.setColor(Color.lightGray);

      for(int strip=0; strip<stripHCount/2; strip++)
      {
         gc.fillRect(basePointX,
                     basePointY+2*strip*stripHHeight,
                     stripHWidth,
                     stripHHeight);
      }

   } // drawEllipseHBands

} // EllipseHBands1
```

The HTML file *EllipseHBands1.html* (Listing 9.2) contains the code for launching *EllipseHBands1.class*.

LISTING 9.2 EllipseHBands1.html

```
<HTML>
<HEAD></HEAD>
<BODY>
<APPLET CODE=EllipseHBands1.class WIDTH=800 HEIGHT=500></APPLET>
</BODY>
</HTML>
```

REMARKS

The preceding example shows you a straightforward technique for creating a horizontally striped ellipse. Instead of calculating each stripe in the ellipse, you can draw an evenly spaced set of horizontal rectangles on top of the ellipse in order to achieve the same effect. The only requirement is that the color of the rectangles needs to be the same as the background color. This technique can be used in other situations that require creating a striped effect with ellipses.

CONCEPT: DRAWING NESTED ELLIPSES WITH A COMMON END POINT

The next object (Figure 9.2) consists of the following building blocks:

- A set of nested ellipses

FIGURE 9.2 A set of nested ellipses.

The Java class *NestedEllipses2.java* contains the following methods:

initializeRadii()

drawEllipses()

The method *initializeRadii()* initializes the radii of the set of nested ellipses and the method *drawEllipses()* draws the ellipses so that they have the same left end-point. The resulting image looks as if you had stretched the set of ellipses in *NestedEllipses1.java* toward the right.

ON THE CD

The Java class *NestedEllipses2.java* (Listing 9.3) demonstrates how to draw a set of ellipses whose left-most end points are aligned on the same vertical line.

LISTING 9.3 NestedEllipses2.java

```java
import java.awt.Color;
import java.awt.Font;
import java.awt.Graphics;
import java.awt.Image;

import java.io.Serializable;

public class NestedEllipses2 extends java.applet.Applet
        implements Serializable
{
    private Graphics offScreenBuffer = null;
    private Image    offScreenImage  = null;

    private int width     = 800;
    private int height     = 500;

    private int basePointX = 50;
    private int basePointY = 100;

    private int ellipseCount = 24;

    private int[] radii      = new int[ellipseCount];
    private int innerRadius = 4;
    private int radiusDelta = 10;

    private Color[] ellipseColors = {
        Color.red, Color.blue, Color.green,
        Color.white, Color.yellow
    };

    public NestedEllipses2()
    {
    }

    public void init()
    {
        offScreenImage  = this.createImage(width, height);
```

```
    offScreenBuffer = offScreenImage.getGraphics();

    initializeRadii();

} // init

public void initializeRadii()
{
    for(int k=0; k<ellipseCount; k++)
    {
        radii[k] = innerRadius+k*radiusDelta;
    }

} // initializeRadii

public void update(Graphics gc)
{
    paint(gc);

} // update

public void paint(Graphics gc)
{
    offScreenBuffer.setColor(Color.lightGray);
    offScreenBuffer.fillRect(0, 0, width, height);

    drawNestedEllipses(offScreenBuffer);
    gc.drawImage(offScreenImage, 0, 0, this);

} // paint

public void drawNestedEllipses(Graphics gc)
{
    for(int k=ellipseCount-1; k>=0; k--)
    {
        gc.setColor(ellipseColors[k%2]);

        gc.fillOval(basePointX,
                    basePointY,
                    3*radii[k],
                    radii[k]);
    }

} // drawNestedEllipses

} // NestedEllipses2
```

The HTML file *NestedEllipses2.html* (Listing 9.4) contains the code for launching *NestedEllipses2.class*.

LISTING 9.4 NestedEllipses2.html

```
<HTML>
<HEAD></HEAD>
<BODY>
<APPLET CODE=NestedEllipses2.class WIDTH=800 HEIGHT=500></APPLET>
</BODY>
</HTML>
```

REMARKS

The key idea for the preceding example is contained in the method *drawNestedEllipses()*. This method contains a loop that calculates an index into a color array and then draws an ellipse with a calculated width and height. All the ellipses share a common point for the upper left-hand corner of the outermost bounding rectangle. The ellipses are drawn from largest to smallest, simply by decreasing their width, in order to create the visual effect.

CONCEPT: DRAWING NESTED ELLIPSES IN RECTANGLES

The next object (Figure 9.3) consists of the following building blocks:

- A grid of rectangles
- A grid of ellipses

FIGURE 9.3 Superimposing ellipses on rectangles.

The Java class *EllipseRect2.java* contains the method *drawRectangle-Ellipses()* that draws a rectangular grid of ellipses in the following manner:

1. Draw a rectangle for each "cell" in the grid.
2. Superimpose each rectangle with an ellipse.
3. Use diagonal shading for a three-dimensional effect.

ON THE CD

The Java class *EllipseRect2.java* (Listing 9.5) demonstrates how to draw an array of ellipses that are nested inside rectangles. The ellipses and rectangles are drawn with depth to create a three-dimensional effect.

LISTING 9.5 EllipseRect2.java

```java
import java.awt.Color;
import java.awt.Graphics;
import java.awt.Image;

import java.io.Serializable;

public class EllipseRect2 extends java.applet.Applet
      implements Serializable
{
   private Graphics offScreenBuffer = null;
   private Image    offScreenImage = null;
   private int      width          = 600;
   private int      height         = 400;

   private int pWidth     = 80;
   private int pHeight    = 40;

   private int basePointX = 100;
   private int basePointY = 200;

   private int rowCount   = 4;
   private int colCount   = 4;

   private int bTheta      = 20;
   private int slantLength = 100;
   private int offsetX     = 0;
   private int offsetY     = 0;

   private Color[] ellipseColors = {
      Color.red, Color.green, Color.blue, Color.yellow,
      Color.pink, Color.magenta
   };

   private int rVal=255, gVal=100, bVal=100;
```

```
public EllipseRect2()
{
}

public void init()
{
   offScreenImage  = this.createImage(width, height);
   offScreenBuffer = offScreenImage.getGraphics();

} // init

public void paint(Graphics gc)
{
   offScreenBuffer.setColor(Color.lightGray);
   offScreenBuffer.fillRect(0, 0, width, height);

   drawRectangleEllipse(offScreenBuffer);
   gc.drawImage(offScreenImage, 0, 0, this);

} // paint

public void drawRectangleEllipse(Graphics gc)
{
   for(int k=slantLength; k>=0; −k)
   {
      offsetX = (int)(k*Math.cos(bTheta*Math.PI/180));
      offsetY = (int)(k*Math.sin(bTheta*Math.PI/180));

      for(int i=0; i<rowCount; i++)
      {
         for(int j=0; j<colCount; j++)
         {
            // draw the rectangle...
            gc.setColor(ellipseColors[(i+j)%6]);
            gc.fill3DRect(basePointX+j*pWidth+offsetX,
                          basePointY+i*pHeight-
                                        offsetY,
                          pWidth,
                          pHeight/2,
                          true);

            // draw the ellipse...
            gc.setColor(Color.lightGray);
            gc.fillOval(basePointX+j*pWidth+offsetX,
                        basePointY+i*pHeight-offsetY,
                        pWidth,
                        pHeight);
         }
      }
   }
```

```
    } // drawRectangleEllipse

} // EllipseRect2
```

ON THE CD

The HTML file *EllipseRect2.html* (Listing 9.6) contains the code for launching *EllipseRect2.class*.

LISTING 9.6 EllipseRect2.html

```
<HTML>
<HEAD></HEAD>
<BODY>
<APPLET CODE=EllipseRect2.class WIDTH=800 HEIGHT=500></APPLET>
</BODY>
</HTML>
```

REMARKS

The preceding example relies on a "canceling effect" in order to produce its graphics image. This technique involves drawing a grid of ellipses super-imposed on a corresponding set of rectangles. Since the ellipses have the same color as the background, drawing them creates a canceling effect on the graphics image. This technique can be immediately implemented with other combinations of geometric objects. Moreover, you can extend this technique in order to create basic animation effects.

CONCEPT: DRAWING GRADIENT ELLIPSES

The next object (Figure 9.4) consists of the following building blocks:

- A set of ellipses

The Java class *GradientEllipse1.java* contains the method *drawGradient-Ellipse()*, which contains a loop that uses gradient diagonal shading in order to draw a set of ellipses.

ON THE CD

The Java class *GradientEllipse1.java* (Listing 9.7) demonstrates how to draw a set of ellipses with diagonal shading and gradient shading.

FIGURE 9.4 An ellipse with gradient shading.

LISTING 9.7 GradientEllipse1.java

```java
import java.awt.Color;
import java.awt.Graphics;
import java.awt.Image;

import java.io.Serializable;

public class GradientEllipse1 extends java.applet.Applet
        implements Serializable
{
    private Image offScreenImage     = null;
    private Graphics offScreenBuffer = null;

    private int width      = 800;
    private int height     = 500;

    private int basePointX = 200;
    private int basePointY = 100;

    private int eWidth     = 300;
    private int eHeight     = 120;
    private int frameCount =  60;

    private int rVal       = 0;
    private int gVal       = 0;
    private int bVal       = 255;

    public GradientEllipse1()
    {
    }

    public void init()
    {
        offScreenImage  = this.createImage(width, height);
        offScreenBuffer = offScreenImage.getGraphics();
    }

    public void update(Graphics gc)
```

```
   {
      paint(gc);

   } // update

   public void paint(Graphics gc)
   {
      offScreenBuffer.setColor(Color.lightGray);
      offScreenBuffer.fillRect(0, 0, width, height);

      drawGradientEllipse(offScreenBuffer);
      gc.drawImage(offScreenImage, 0, 0, this);

   } // paint

   public void drawGradientEllipse(Graphics gc)
   {
      gc.setColor(Color.blue);

      for(int x=0; x<frameCount; x++)
      {
         rVal = x*255/frameCount;
         gVal = x*255/frameCount;

         gc.setColor(new Color(rVal, gVal, bVal));

         gc.fillOval(basePointX-x,
                     basePointY+x,
                     eWidth,
                     eHeight);
      }

   } // drawGradientEllipse

} // GradientEllipse1
```

The HTML file *GradientEllipse1.html* (Listing 9.8) contains the code for launching *GradientEllipse1.class*.

LISTING 9.8 GradientEllipse1.html

```
<HTML>
<HEAD></HEAD>
<BODY>
<APPLET CODE=GradientEllipse1.class WIDTH=800 HEIGHT=500></APPLET>
</BODY>
</HTML>
```

REMARKS

The method *drawGradientEllipse()* uses color weighting for RGB in order to render a set of adjacent ellipses in order to render an image that resembles a strangely colored marshmallow. You can create variations of the code by varying the width or the height of the ellipses. You can also create basic animation by adding horizontal and vertical motion to the ellipses.

CONCEPT: DRAWING HOLLOW ELLIPSES

The next object (Figure 9.5) consists of the following building blocks:

- An outer ellipse
- An inner "hollow" ellipse

FIGURE 9.5 A hollow ellipse.

The Java class *HollowEllipse1.java* contains the following methods:

drawRearEllipseGradient()
drawFrontEllipseGradient()

The method *drawRearEllipseGradient()* uses gradient shading in order to color the "rear" set of elliptic arcs.

The method *drawFrontEllipseGradient()* uses gradient shading in order to color the "front" set of elliptic arcs. Notice that both sets of ellipses are drawn by means of curvilinear shading; i.e., they are drawn by following the path of a point on an invisible and stationary ellipse. This technique draws a hollow-looking ellipse with a three-dimensional effect.

ON THE CD

The Java class *HollowEllipse1.java* (Listing 9.9) demonstrates how to use curvilinear shading in order to draw a set of ellipses that follow the outline of a fixed ellipse.

LISTING 9.9 HollowEllipse1.java

```java
import java.awt.Color;
import java.awt.Graphics;
import java.awt.Image;

import java.io.Serializable;

public class HollowEllipse1 extends java.applet.Applet
        implements Serializable
{
   private Image offScreenImage    = null;
   private Graphics offScreenBuffer = null;

   private int width      = 800;
   private int height     = 500;

   private double offsetY1 = 0;
   private double offsetY2 = 0;
   private int    offsetY3 = 0;

   private int outerEWidth  = 512;
   private int outerEHeight = 200;

   private int innerEWidth  = outerEWidth/8;
   private int innerEHeight = outerEHeight;

   private int basePointX = 300;
   private int basePointY = 200;

   private int startX     = -4*outerEWidth/9;
   private int endX       = 0;

   private int rVal       = 0;
   private int gVal       = 0;
   private int bVal       = 0;

   public HollowEllipse1()
   {
   }

   public void init()
   {
      offScreenImage  = this.createImage(width, height);
      offScreenBuffer = offScreenImage.getGraphics();
   }

   public void update(Graphics gc)
   {
      paint(gc);
```

```
} // update

public void paint(Graphics gc)
{
   offScreenBuffer.setColor(Color.lightGray);
   offScreenBuffer.fillRect(0, 0, width, height);

   drawRearEllipseGradient(offScreenBuffer);
   drawFrontEllipseGradient(offScreenBuffer);

   gc.drawImage(offScreenImage, 0, 0, this);

} // paint

public void drawRearEllipseGradient(Graphics gc)
{
 //for(int x=-outerEWidth/2; x<=0; x++)
   for(int x=startX; x<=endX; x++)
   {
      rVal = 255-(x+outerEWidth/2)*255/outerEWidth;
      gVal = 255-(x+outerEWidth/2)*255/outerEWidth;
      bVal = 255-(x+outerEWidth/2)*255/outerEWidth;

      offsetY1 = (outerEHeight/2)*(outerEHeight/2)*
                 ((outerEWidth/2)*(outerEWidth/2)-x*x);

      offsetY2 = offsetY1/((outerEWidth/2)*
                           (outerEWidth/2));

      offsetY3 = (int) Math.sqrt(offsetY2);

      gc.setColor(new Color(rVal, gVal, bVal));

      gc.drawArc(basePointX+x,
                 basePointY-offsetY3,
                 innerEWidth,
                 2*offsetY3,
                 -90,
                 180);
   }

} // drawRearEllipseGradient

public void drawFrontEllipseGradient(Graphics gc)
{
 //for(int x=-outerEWidth/2; x<=0; x++)
   for(int x=startX; x<=endX; x++)
   {
      rVal = 0;
      gVal = 0;
```

```
        bVal = 255-(x+outerEWidth/2)*255/outerEWidth;

        offsetY1 = (outerEHeight/2)*(outerEHeight/2)*
                    ((outerEWidth/2)*(outerEWidth/2)-x*x);

        offsetY2 = offsetY1/((outerEWidth/2)*
                            (outerEWidth/2));

        offsetY3 = (int) Math.sqrt(offsetY2);

        gc.setColor(new Color(rVal, gVal, bVal));

        gc.drawArc(basePointX+x,
                    basePointY-offsetY3,
                    innerEWidth,
                    2*offsetY3,
                    90,
                    180);
    }

  } // drawFrontEllipseGradient

} // HollowEllipse1
```

ON THE CD

The HTML file *HollowEllipse1.html* (Listing 9.10) contains the code for launching *HollowEllipse1.class*.

LISTING 9.10 HollowEllipse1.html

```
<HTML>
<HEAD></HEAD>
<BODY>
<APPLET CODE=HollowEllipse1.class WIDTH=800 HEIGHT=500></APPLET>
</BODY>
</HTML>
```

REMARKS

The preceding example introduces a technique that is used often in later chapters, particularly those that involve objects that appear to be embedded in other objects. This technique is based on drawing the "back" of an object before drawing the "front" of that object. (Simple, *n'est-ce pas?*) The back of the ellipse is a set of adjacent semi-ellipses that are drawn by the standard *drawArc()* method in combination with gradient shading.

CD LIBRARY

ON THE CD The CD-ROM for this chapter contains "class" files and HTML files that are needed for viewing the graphics images in the following Java files:

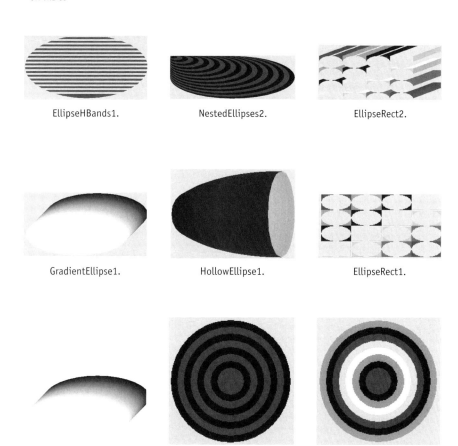

EllipseHBands1. NestedEllipses2. EllipseRect2.

GradientEllipse1. HollowEllipse1. EllipseRect1.

GradientEllipse4. NestedEllipses1. NestedEllipses3.

SUMMARY

This chapter presented Java code in order to draw the following objects:

- Ellipses with horizontal stripes
- Nested ellipses

- Concentric half-ellipses
- Nested half-ellipses
- Gradient ellipses
- Hollow ellipses

Whenever you view circles from an angle, those circles will appear to be ellipses. Consequently, the ellipse is a very useful building block when you want to create animation effects involving real-life objects that are comprised of sets of circles or building blocks that can be approximated by a set of ellipses. Subsequent chapters will show you how to combine ellipses with other shading techniques that produce vivid graphics images.

ELLIPSES, SHADING, AND SIMPLE MOTION

OVERVIEW

This chapter contains Java code that focuses on combining ellipses and gradient shading with simple motion. In this book, the term *Venetian shading* (distantly related to Venetian blinds) involves a variation of gradient shading that produces a set of striped "bands." The simplest type of Venetian shading involves alternating between two colors while rendering adjacent "regions" of a graphics image. Regions are often rectangles or parallelograms, but they can also be other polygons or more complex convex shapes. A more sophisticated type of Venetian shading involves color weighting of RGB components, which can produce subtly rich textural effects.

CONCEPT: DRAWING ELLIPTIC PILLARS WITH VENETIAN SHADING

The next figure (Figure 10.1) consists of the following building blocks:

- Two sets of adjacent ellipses

The Java class *EllipticVenetianPillars1.java* contains the method *drawEllipticPillars()* that draws two "pillars" of ellipses with Venetian shading.

The Java class *EllipticVenetianPillars1.java* (Listing 10.1) demonstrates how to draw a pair of elliptic pillars.

ON THE CD

FIGURE 10.1 A pair of Venetian pillars.

LISTING 10.1 EllipticVenetianPillars1.java

```java
import java.awt.Color;
import java.awt.Graphics;
import java.awt.Image;

import java.io.Serializable;

public class EllipticVenetianPillars1 extends
        java.applet.Applet implements Serializable
{
   private Graphics offScreenBuffer = null;
   private Image    offScreenImage  = null;

   private int width       = 800;
   private int height      = 500;

   private int basePointX = 300;
   private int basePointY = 100;

   private int currentX    = basePointX;
   private int currentY    = basePointY;

   private int eWidth      = 160;
   private int eHeight     = 40;

   private int currentEWidth = eWidth/2;
   private int minimumEWidth = 0;
   private int maximumEWidth = eWidth;

   private int eWidthDelta     = 2;
   private int eWidthDirection = 1;

   private int rectangleWidth  = eWidth/2;
   private int rectangleHeight = eHeight;

   private int amplitude = 40;
   private int frequency = 1;
```

```java
private int maxCount   = 200;
private int coneHeight = 240;

private int stripCount = 8;
private int stripHeight= coneHeight/stripCount;

private int yOffset = 0;

private int fixedAngle = 30;
private int startAngle = 30;

private int angleDelta = 8;

private int rVal = 0;
private int gVal = 0;
private int bVal = 0;

public EllipticVenetianPillars1()
{
}

public void init()
{
   offScreenImage  = this.createImage(width, height);
   offScreenBuffer = offScreenImage.getGraphics();

} // init

public void update(Graphics gc)
{
   paint(gc);

} // update

public void paint(Graphics gc)
{
   for(int tick=0; tick<maxCount; tick++)
   {
      offScreenBuffer.setColor(Color.lightGray);
      offScreenBuffer.fillRect(0, 0, width, height);

      drawEllipticPillars(offScreenBuffer, gc);
      gc.drawImage(offScreenImage, 0, 0, this);
      updateCoordinates();
   }

} // paint

public void updateCoordinates()
{
```

```
    currentEWidth += eWidthDelta*eWidthDirection;

    if( currentEWidth > maximumEWidth )
    {
       currentEWidth = maximumEWidth;
       eWidthDirection *= -1;
    }

    if( currentEWidth < minimumEWidth )
    {
       currentEWidth = minimumEWidth;
       eWidthDirection *= -1;
    }

} // updateCoordinates

public void drawEllipticPillars(Graphics gc,
                                Graphics gcMain)
{
    for(int strip=0; strip<stripCount; strip++)
    {
       for(int h=0; h<stripHeight; h++)
       {
          yOffset = strip*stripHeight+h;

          rVal = h*255/stripHeight;
          gc.setColor(new Color(rVal, gVal, bVal));

          gc.fillOval(basePointX-currentEWidth-
                                      yOffset/2,
                      basePointY+yOffset,
                      rectangleWidth,
                      rectangleHeight);

          gc.fillOval(basePointX+currentEWidth+
                                      yOffset/2,
                      basePointY+yOffset,
                      rectangleWidth,
                      rectangleHeight);
       }
    }

} // drawEllipticPillars

} // EllipticVenetianPillars1
```

The HTML file *EllipticVenetianPillars1.html* (Listing 10.2) contains the code for launching *EllipticVenetianPillars1.class*.

LISTING 10.2 EllipticVenetianPillars1.html

```
<HTML>
<HEAD></HEAD>
<BODY>
<APPLET CODE=EllipticVenetianPillars1.class WIDTH=800
HEIGHT=500></APPLET>
</BODY>
</HTML>
```

REMARKS

The preceding example invokes the method *drawEllipticPillars()* in order to draw two slanted elliptic pillars that alternately move apart and then toward each other. This method subdivides each pillar into a set of horizontal strips and uses color weighting for RGB as gradient shading for each horizontal strip. Since the G and B values are always 0 and R varies from 0 to 255 within a horizontal strip, the result is a color band that varies from black to red. You can easily make your own modifications to the code in order to cause some horizontal strips will vary from black to green and others to vary from black to blue, or some other color of your choice.

CONCEPT: DRAWING OVERLAPPING ELLIPTIC PILLARS WITH VENETIAN SHADING

The next figure (Figure 10.2) consists of the following building blocks:

- Two sets of ellipses

The Java class *EllipticVenetianPillars2.java* contains the method *drawEllipticPillars()* that draws two "pillars" of ellipses with Venetian shading.

FIGURE 10.2 An overlapping pair of Venetian pillars.

```
        if( currentEWidth < minimumEWidth )
        {
            currentEWidth = minimumEWidth;
            eWidthDirection *= -1;
        }

    } // updateCoordinates

    public void drawEllipticPillars(Graphics gc,
                                    Graphics gcMain)
    {
        for(int strip=0; strip<stripCount; strip++)
        {
            for(int h=0; h<stripHeight; h++)
            {
                yOffset = strip*stripHeight+h;

                rVal = h*255/stripHeight;
                gc.setColor(new Color(rVal, gVal, bVal));

                gc.fillOval(basePointX-currentEWidth-
                                            yOffset/2,
                            basePointY+yOffset,
                            rectangleWidth+yOffset,
                            rectangleHeight+h);

                gc.fillOval(basePointX+currentEWidth+
                                            yOffset/2,
                            basePointY+yOffset,
                            rectangleWidth+yOffset,
                            rectangleHeight+h);
            }
        }

    } // drawEllipticPillars

} // EllipticVenetianPillars2
```

ON THE CD

The HTML file *EllipticVenetianPillars2.html* (Listing 10.4) contains the code for launching *EllipticVenetianPillars2.class*.

LISTING 10.4 EllipticVenetianPillars2.html

```
<HTML>
<HEAD></HEAD>
<BODY>
<APPLET CODE=EllipticVenetianPillars2.class WIDTH=800
HEIGHT=500></APPLET>
```

```
</BODY>
</HTML>
```

REMARKS

The preceding example invokes the method *drawEllipticPillars()* in order to draw two slanted elliptic pillars that appear to merge together and then move apart from each other. This method subdivides each pillar into a set of horizontal strips and uses color weighting for RGB as gradient shading for each horizontal strip. Since the G and B values are always 0 and R varies from 0 to 255 within a horizontal strip, the result is a color band that varies from black to red. The method *drawEllipticPillars()* uses a simple technique in order to create the merging and splitting apart effect: it uses another variable in order to vary the width and the height of the ellipses that are drawn. As in the case of *EllipticVenetianPillars1.java*, you can easily make your own modifications to the code in order to cause some horizontal strips to vary from black to green and others to vary from black to blue, or some other color of your choice.

CONCEPT: DRAWING SHIFTING ELLIPSES AND WIRE FRAMES

The next figure (Figure 10.3) consists of the following building blocks:

- A set of ellipses
- A set of elliptic wedges

FIGURE 10.3 Cone-shaped set of ellipses.

The Java class *ShiftingEllipsesWireFrame1.java* contains the following methods:

drawEllipse()

drawEllipses()

The method *drawEllipse()* draws an 180-degree elliptic arc at the current location.

The method *drawEllipses()* draws a set of shifting ellipses that create a three-dimensional effect.

The Java class *ShiftingEllipsesWireFrame1.java* (Listing 10.5) demonstrates how to draw a wire frame outline of ellipses.

LISTING 10.5 ShiftingEllipsesWireFrame1.java

```
import java.awt.Color;
import java.awt.Graphics;
import java.awt.Image;

import java.io.Serializable;

public class ShiftingEllipsesWireFrame1 extends
        java.applet.Applet implements Serializable
{
    private Image offScreenImage    = null;
    private Graphics offScreenBuffer = null;

    private int width     = 800;
    private int height    = 500;

    private int basePointX = 200;
    private int basePointY = 100;

    private int eWidth    = 200;
    private int eHeight    = 160;

    private int rVal = 255;
    private int gVal = 0;
    private int bVal = 0;

    private int hGap = 3;

    public ShiftingEllipsesWireFrame1()
    {
    }
```

```
public void init()
{
   offScreenImage  = this.createImage(width, height);
   offScreenBuffer = offScreenImage.getGraphics();
}

public void update(Graphics gc)
{
   paint(gc);

} // update

public void paint(Graphics gc)
{
   offScreenBuffer.setColor(Color.lightGray);
   offScreenBuffer.fillRect(0, 0, width, height);

   drawEllipses(offScreenBuffer, 0);
   drawEllipses(offScreenBuffer, 1);

   gc.drawImage(offScreenImage, 0, 0, this);

} // paint

public void drawEllipses(Graphics gc, int outline)
{
   for(int x=-eWidth/2; x<=eWidth/2; x++)
   {
      if( outline == 1 )
      {
         if( x % hGap == 0 )
         {
            gc.setColor(Color.white);

            drawEllipse(gc,
                        basePointX+eWidth/2+2*x,
                        basePointY,
                        eWidth-x,
                        eHeight+x);
         }
      }
      else
      {
         gc.setColor(Color.blue);

         drawEllipse(gc,
                     basePointX+eWidth/2+2*x,
                     basePointY,
                     eWidth-x,
                     eHeight+x);
```

```
      }
    }

} // drawEllipses

public void drawEllipse(Graphics gc,
                        int currentX, int currentY,
                        int width, int height)
{
    gc.drawOval(currentX, currentY, width, height);

} // drawEllipse

} // ShiftingEllipsesWireFrame1
```

ON THE CD

The HTML file *ShiftingEllipsesWireFrame1.html* (Listing 10.6) contains the code for launching *ShiftingEllipsesWireFrame1.class*.

LISTING 10.6 ShiftingEllipsesWireFrame1.html

```
<HTML>
<HEAD></HEAD>
<BODY>
<APPLET CODE=ShiftingEllipsesWireFrame1.class WIDTH=512
HEIGHT=400></APPLET>
</BODY>
</HTML>
```

REMARKS

The preceding example invokes the method *drawEllipses()* in order to draw a set of ellipses with varying heights and widths. This method also creates a striped effect based on the value of the variable hGap. Notice that the horizontal shift of the x-coordinate of the upper left-hand corner of the enclosing rectangle increases at a different rate from the rate of increase in the width of each ellipse. Specifically, the method *drawEllipses()* contains a loop variable x that is used (among other things) for incrementing the width of each ellipse, whereas the x-coordinate of the corner vertex shifts to the right by the value of 2*x. This key point forms the basis for creating a wire frame effect.

CONCEPT: DRAWING OSCILLATING SHIFTING ELLIPSES AND WIRE FRAMES

The next pair of figures (Figure 10.4 and Figure 10.5) consist of the following building blocks:

- A set of ellipses
- A set of elliptic wedges

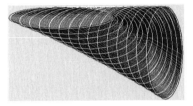

FIGURE 10.4 Snapshot of a shifting set of ellipses.

FIGURE 10.5 Subsequent snapshot of a shifting set of ellipses.

The Java class *ShiftingEllipseOscillatingWireFrame1.java* contains the following methods:

drawEllipse()

drawEllipses()

updateCoordinates()

The method *drawEllipse()* draws an 180-degree elliptic arc at the current location that is based on the value of two input parameters for this method.

The method *drawEllipses()* draws a set of shifting ellipses that create a three-dimensional effect.

The method *updateCoordinates()* updates the variable hGap that is used for creating an animation effect and ensures that its value lies between a minimum and maximum allowable value.

ON THE CD

The Java class *ShiftingEllipsesOscillatingWireFrame1.java* (Listing 10.7) demonstrates how to draw a wire frame outline of ellipses.

LISTING 10.7 ShiftingEllipsesOscillatingWireFrame1.java

```java
import java.awt.Color;
import java.awt.Graphics;
```

```java
import java.awt.Image;

import java.io.Serializable;

public class ShiftingEllipsesOscillatingWireFrame1
       extends java.applet.Applet implements Serializable
{
   private Image offScreenImage    = null;
   private Graphics offScreenBuffer = null;

   private int width     = 800;
   private int height    = 500;

   private int basePointX = 200;
   private int basePointY = 100;

   private int eWidth     = 200;
   private int eHeight    = 160;

   private int hGap = 3;
   private int maxCount = 300;

   private int minHGap = 2;
   private int maxHGap = 24;
   private int hGapDirection = 1;
   private int hGapDelta     = 2;

   private int rVal = 255;
   private int gVal = 0;
   private int bVal = 0;

   public ShiftingEllipsesOscillatingWireFrame1()
   {
   }

   public void init()
   {
      offScreenImage  = this.createImage(width, height);
      offScreenBuffer = offScreenImage.getGraphics();
   }

   public void update(Graphics gc)
   {
      paint(gc);

   } // update

   public void paint(Graphics gc)
   {
      for(int tick=0; tick<maxCount; tick++)
```

```
   {
      offScreenBuffer.setColor(Color.lightGray);
      offScreenBuffer.fillRect(0, 0, width, height);

      drawEllipses(offScreenBuffer, 0);
      drawEllipses(offScreenBuffer, 1);

      gc.drawImage(offScreenImage, 0, 0, this);
      updateCoordinates();
   }

} // paint

public void updateCoordinates()
{
   hGap += hGapDirection*hGapDelta;

   if( hGap > maxHGap )
   {
      hGap = maxHGap;
      hGapDirection *= -1;
   }

   if( hGap < minHGap )
   {
      hGap = minHGap;
      hGapDirection *= -1;
   }

} // updateCoordinates

public void drawEllipses(Graphics gc, int outline)
{
   for(int x=-eWidth/2; x<=eWidth/2; x++)
   {
      if( outline == 1 )
      {
         if( x % hGap == 0 )
         {
            gc.setColor(Color.white);

            drawEllipse(gc,
                        basePointX+eWidth/2+2*x,
                        basePointY,
                        eWidth-x,
                        eHeight+x);
         }
      }
      else
      {
```

```
        gc.setColor(Color.blue);

        drawEllipse(gc,
                        basePointX+eWidth/2+2*x,
                        basePointY,
                        eWidth-x,
                        eHeight+x);
      }
    }

  } // drawEllipses

  public void drawEllipse(Graphics gc,
                        int currentX, int currentY,
                        int width, int height)
  {
      gc.drawOval(currentX, currentY, width, height);

  } // drawEllipse

} // ShiftingEllipsesOscillatingWireFrame1
```

ON THE CD

The HTML file *ShiftingEllipsesOscillatingWireFrame1.html* (Listing 10.8) contains the code for launching *ShiftingEllipsesOscillatingWireFrame1.class*.

LISTING 10.8 ShiftingEllipsesOscillatingWireFrame1.html

```
<HTML>
<HEAD></HEAD>
<BODY>
<APPLET CODE=ShiftingEllipsesOscillatingWireFrame1.class WIDTH=512
HEIGHT=400></APPLET>
</BODY>
</HTML>
```

REMARKS

The preceding example invokes the method *drawEllipses()* in order to draw a set of ellipses with varying heights and widths. This method also creates a striped effect based on the value of the variable hGap. Notice that the horizontal shift of the x-coordinate of the upper left-hand corner of the enclosing rectangle increases at a different rate from the rate of increase in the width of each ellipse. Specifically, the method *drawEllipses()* contains a

loop variable x that is used (among other things) for incrementing the width of each ellipse, whereas the x-coordinate of the corner vertex shifts to the right by the value of $2*x$. This key point forms the basis for creating a wire frame effect.

You can produce simple motion by changing the value of the variable hGap. This variable controls the relative distance between two adjacent white ellipses. As hGap increases, so does the relative distance; as hGap decreases, the relative distance decreases as well. This behavior produces an oscillating effect in the graphics image.

CD LIBRARY

ON THE CD

The CD-ROM for this chapter contains "class" files and HTML files that are needed for viewing the graphics images in the following Java files:

EllipticVenetianPillars1.

EllipticVenetianPillars2.

ShiftingEllipsesWireFrame1.

ShiftingEllipsesOscillating
WireFrame1.

ShiftingEllipseGradient1.

ShiftingEllipseGradient2.

ShiftingEllipseGradient
Outline1.

ShiftingEllipseGradient
Outline2.

ShiftingEllipses1.

ShiftingEllipsesGradient1.

SUMMARY

This chapter presented Java code that used so-called "Venetian shading" for drawing pillar-like objects consisting of ellipses as well as ellipse-based wire frame cones. You can create a wire frame effect by drawing a subset of adjacent ellipses. Simple motion can be achieved by updating variables that control the rate at which objects appear to move apart or toward each other. You can also create more sophisticated motion effects by adding another variable that controls the rate at which the objects move in the vertical direction.

ELLIPSES AND BASIC ANIMATION

OVERVIEW

This chapter contains Java code that uses ellipses in order to create basic animation effects. You'll see a common theme in the Java code that is embellished in a variety of ways in order to create interesting graphics images.

Although we have not discussed threads, we can use the static method *sleep()* that belongs to the *Thread* class that is a standard part of Java. The *sleep()* method does what its name suggests: it sleeps for a period of time that is measured in milliseconds. In this book, the *sleep()* method is "wrapped" inside the method *shortPause()*. Whenever you want to pause for a short period of time, invoke *shortPause()*. The Java code in this book uses the integer variable `pause` in order to specify the number of milliseconds for which to sleep, but you can devise your own methodology. You can change the value of this variable in order to speed up or slow down your animation effects, and a pause rate that is somewhere between 40 and 100 milliseconds will produce the best animation effects. If you need to use a value for `pause` that is less than twenty milliseconds, then you probably don't need this method at all! In particular, avoid using values less than 5 milliseconds because the results can sometimes be unpredictable.

CONCEPT: DRAWING WIND CHIMES WITH ELLIPSES

The next object (Figure 11.1) consists of the following building blocks:

- A set of ellipses
- A set of line segments

- A horizontal rectangle

FIGURE 11.1 A set of ellipse-based wind chimes.

The Java class *WindChimes1.java* contains the following methods:

initializeChimes()

drawBar()

drawChimes()

updateChimeCoordinates()

shortPause()

The method *initializeChimes()* initializes the coordinates of the ellipses.
The method *drawBar()* draws the stationary horizontal "bar" (which is a rectangle) to which the ellipses are connected via line segments.

The method *drawChimes()* draws a set of ellipses and a set of line segments that attach the ellipses to the stationary bar.

The method *updateChimeCoordinates()* updates the coordinates of the ellipses to create the effect that they are bouncing up and down.

The method *shortPause()* sleeps for a specified number of milliseconds.

ON THE CD

The Java class *WindChimes1.java* (Listing 11.1) demonstrates how to draw a set of rotating ellipses, each of which is attached to a variable-length string. The color of each ellipse changes whenever it changes its direction of rotation.

LISTING 11.1 WindChimes1.java

```java
import java.awt.Color;
import java.awt.Graphics;
import java.awt.Image;
import java.io.Serializable;
```

```
public class WindChimes1 extends java.applet.Applet
      implements Serializable
{
   private Graphics offScreenBuffer = null;
   private Image    offScreenImage  = null;

   private int width    = 800;
   private int height   = 500;

   private int basePointX    = 50;
   private int basePointY    = 50;

   private int minBasePointX = 50;
   private int minBasePointY = 50;

   private int maxBasePointX = 50;
   private int maxBasePointY = 300;

   private int pause     = 50;              // milliseconds
   private int maxCount = 20*1000/pause;    // 10 seconds

   private int chimeBarWidth  = 400;
   private int chimeBarHeight =  20;
   private int chimeCount     =   8;

   private int[] chimeLengths   = new int[chimeCount];
   private int[] chimeRadii      = new int[chimeCount];

   private int[] chimeXCoords    = new int[chimeCount];
   private int[] chimeYCoords    = new int[chimeCount];

   private int[] chimeLDirection = new int[chimeCount];
   private int[] chimeRDirection = new int[chimeCount];
   private int[] chimeXDirection = new int[chimeCount];
   private int[] chimeYDirection = new int[chimeCount];
   private int[] rotationCount   = new int[chimeCount];

   private int[] chimeLDelta     = new int[chimeCount];
   private int[] chimeRDelta     = new int[chimeCount];
   private int[] chimeXDelta     = new int[chimeCount];
   private int[] chimeYDelta     = new int[chimeCount];

   private int minChimeLength    =  20;
   private int maxChimeLength    = 200;

   private int maxRadius     = 25;
   private int minRadius     =  5;
   private int currentRadius = 10;
   private int rotation      = 0;
   private int e             = 2;
```

```
private Color[] rotationColors = {
  Color.red, Color.blue, Color.green, Color.yellow,
  Color.pink, Color.white
};

public WindChimes1()
{
}

public void init()
{
    offScreenImage  = this.createImage(width, height);
    offScreenBuffer = offScreenImage.getGraphics();

    currentRadius = minRadius;

    initializeChimes();

} // init

public void initializeChimes()
{
    int neg1 = -1;

    for(int i=0; i<chimeCount; i++)
    {
        neg1 *= -1;
        chimeRadii[i]       = maxRadius;

        chimeLDirection[i] = neg1;
        chimeRDirection[i] = 1;
        chimeXDirection[i] = 0;
        chimeYDirection[i] = 1;

        chimeLDelta[i]      = 4;
        chimeRDelta[i]      = 1;
        chimeXDelta[i]      = 1;
        chimeYDelta[i]      = 1;

        chimeXCoords[i]     = basePointX+
                    (i*chimeBarWidth)/(chimeCount-1);

        chimeYCoords[i]     = basePointY+chimeBarHeight;

        chimeLengths[i]     = (int)(maxChimeLength*
                                Math.random()/2);
    }

} // initializeChimes
```

```java
public void update(Graphics gc)
{
   paint(gc);

} // update

public void paint(Graphics gc)
{
   for(int tick=0; tick<maxCount; tick++)
   {
      offScreenBuffer.setColor(Color.lightGray);
      offScreenBuffer.fillRect(0, 0, width, height);

      drawBar(offScreenBuffer);
      drawChimes(offScreenBuffer);
      updateChimeCoordinates();

      gc.drawImage(offScreenImage, 0, 0, this);
      shortPause();
   }

} // paint

public void drawBar(Graphics gc)
{
   gc.setColor(Color.blue);

   gc.fill3DRect(basePointX,
                 basePointY,
                 chimeBarWidth,
                 chimeBarHeight,
                 true);

} // drawBar

public void drawChimes(Graphics gc)
{
   for(int i=0; i<chimeCount; i++)
   {
      // draw vertical anchor line...
      gc.setColor(Color.white);
      gc.drawLine(chimeXCoords[i],
               basePointY+chimeBarHeight,
               chimeXCoords[i],
               chimeYCoords[i]+chimeLengths[i]);

      if(rotationCount[i]==0)
      {
         gc.setColor(rotationColors[i%6]);
      }
```

```
      else
      {
         gc.setColor(rotationColors[(i+1)%6]);
      }

      // fill the current oval...
      gc.fillOval(chimeXCoords[i]-chimeRadii[i]/2,
                  chimeYCoords[i]+
                     chimeLengths[i]-chimeRadii[i]/2,
                  chimeRadii[i],
                  2*maxRadius);
   }

} // drawChimes

public void updateChimeCoordinates()
{
   for(int i=0; i<chimeCount; i++)
   {
      chimeLengths[i] += chimeLDirection[i]*
                          chimeLDelta[i];
      chimeRadii[i]   += chimeRDirection[i]*
                          chimeRDelta[i];

      if(chimeRadii[i]>maxRadius)
      {
         chimeRDirection[i] *= -1;
         rotationCount[i]   = 1-rotationCount[i];
      }

      if(chimeRadii[i]<minRadius)
      {
         chimeRDirection[i] *= -1;
         rotationCount[i]   = 1-rotationCount[i];
      }

      if( chimeLengths[i]<minChimeLength)
      {
         chimeLengths[i]    = minChimeLength;
         chimeLDirection[i] *= -1;
      }

      if( chimeLengths[i]>maxChimeLength)
      {
         chimeLengths[i]    = maxChimeLength;
         chimeLDirection[i] *= -1;
      }
   }

} // updateChimeCoordinates
```

```
public void shortPause()
{
   try {
      Thread.sleep(pause);
   }
   catch(Exception e){};

} // shortPause

} // WindChimes1
```

ON THE CD

The HTML file *WindChimes1.html* (Listing 11.2) contains the code for launching *WindChimes1.class*.

LISTING 11.2 WindChimes1.html

```
<HTML>
<HEAD></HEAD>
<BODY>
<APPLET CODE=WindChimes1.class WIDTH=800 HEIGHT=500></APPLET>
</BODY>
</HTML>
```

REMARKS

The preceding example demonstrates how to create the illusion of rotating ellipses. The width of each ellipse, which is stored in an array, is incremented by a fixed amount in the method *updateChimeCoordinates()*. This method ensures that the width of each ellipse varies between a minimum and maximum allowable value. Since the ellipses are drawn with a varying width, they appear to rotate while they are bouncing up and down.

You've probably noticed that the code uses a structured programming style; this is because widgets are represented by information that is stored in a collection of arrays. If you are familiar with object-oriented programming, you might try converting the code from a collection of arrays to a collection of objects that represent the bouncing ellipses. The object-oriented approach has well-known advantages over the structured programming style. However, don't worry if you do not have an object-oriented background. The primary purpose of this code is to generate graphics images!

CONCEPT: DRAWING CHAINS WITH ELLIPSES

The next object (Figure 11.2) consists of the following building blocks:

- A set of chain links
- A set of ellipses for each chain link
- A set of line segments
- A horizontal rectangle

FIGURE 11.2 A set of ellipse-based chains.

The Java class *Chains1.java* contains the following methods:

initializeChains()

drawBar()

drawChains()

updateChainCoordinates()

shortPause()

 The method *initializeChains()* initializes the coordinates of the ellipses.
 The method *drawBar()* draws the stationary horizontal "bar" (which is a rectangle) to which the ellipses are connected via line segments.
 The method *drawChains()* draws a set of ellipses and a set of line segments that attach the ellipses to the stationary bar.
 The method *updateChainCoordinates()* updates the coordinates of the ellipses to create the impression that they are bouncing up and down.
 The method *shortPause()* sleeps for a specified number of milliseconds.

ON THE CD

The Java class *Chains1.java* (Listing 11.3) demonstrates how to draw a rotating set of chain links that oscillate vertically.

LISTING 11.3 Chains1.java

```java
import java.awt.Color;
import java.awt.Graphics;
import java.awt.Image;
import java.io.Serializable;

public class Chains1 extends java.applet.Applet
      implements Serializable
{
   private Graphics offScreenBuffer = null;
   private Image    offScreenImage  = null;

   private int width         = 800;
   private int height        = 500;

   private int basePointX    = 50;
   private int basePointY    = 50;

   private int minBasePointX = 50;
   private int minBasePointY = 50;

   private int maxBasePointX = 50;
   private int maxBasePointY = 300;

   private int chainBarWidth  = 400;
   private int chainBarHeight = 20;
   private int chainCount     = 8;

   private int pause         = 50;              // msec
   private int maxCount      = 20*1000/pause; // sec

   private int thickness     = 8;
   private int linkCount      = 4;

   private int[] chainLengths    = new int[chainCount];
   private int[] chainRadii      = new int[chainCount];

   private int[] chainXCoords    = new int[chainCount];
   private int[] chainYCoords    = new int[chainCount];

   private int[] chainLDirection = new int[chainCount];
   private int[] chainRDirection = new int[chainCount];
   private int[] chainXDirection = new int[chainCount];
   private int[] chainYDirection = new int[chainCount];
```

```
private int[] chainLDelta      = new int[chainCount];
private int[] chainRDelta      = new int[chainCount];
private int[] chainXDelta      = new int[chainCount];
private int[] chainYDelta      = new int[chainCount];
private int[] rotationCount     = new int[chainCount];

private int minchainLength     =  20;
private int maxchainLength     = 200;

private int maxRadius     = 25;
private int minRadius     =  5;
private int currentRadius = 10;
private int rotation      = 0;
private int e             = 2;

private Color[] rotationColors = {
  Color.red, Color.blue, Color.green, Color.yellow,
  Color.pink, Color.white
};

public Chains1()
{
}

public void init()
{
    offScreenImage  = this.createImage(width, height);
    offScreenBuffer = offScreenImage.getGraphics();

    currentRadius = minRadius;

    initializeChains();

} // init

public void initializeChains()
{
    int neg1 = -1;

    for(int i=0; i<chainCount; i++)
    {
        neg1 *= -1;
        chainRadii[i]       = maxRadius;

        chainLDirection[i] = neg1;
        chainRDirection[i] = 1;
        chainXDirection[i] = 0;
        chainYDirection[i] = 1;

        chainLDelta[i]     = 4;
```

```
         chainRDelta[i]    = 1;
         chainXDelta[i]    = 1;
         chainYDelta[i]    = 1;

         chainXCoords[i]   = basePointX+
                     (i*chainBarWidth)/(chainCount-1);

         chainYCoords[i]   = basePointY+chainBarHeight;

         chainLengths[i]   = (int)(maxchainLength*
                               Math.random()/2);
      }

   } // initializeChains

   public void update(Graphics gc)
   {
      paint(gc);

   } // update

   public void paint(Graphics gc)
   {
      for(int tick=0; tick<maxCount; tick++)
      {
         offScreenBuffer.setColor(Color.lightGray);
         offScreenBuffer.fillRect(0, 0, width, height);

         shortPause();
         drawBar(offScreenBuffer);
         drawChains(offScreenBuffer);
         updateChainCoordinates();

         gc.drawImage(offScreenImage, 0, 0, this);
      }

   } // paint

   public void drawBar(Graphics gc)
   {
      gc.setColor(Color.blue);

      gc.fill3DRect(basePointX,
                    basePointY,
                    chainBarWidth,
                    chainBarHeight,
                    true);

   } // drawBar
```

```
public void drawChains(Graphics gc)
{
   for(int i=0;  i<chainCount;  i++)
   {
      // draw vertical anchor line...
      gc.setColor(Color.white);
      gc.drawLine(chainXCoords[i],
                  basePointY+chainBarHeight,
                  chainXCoords[i],
                  chainYCoords[i]+chainLengths[i]);

      if(rotationCount[i]==0)
      {
         gc.setColor(rotationColors[i%6]);
      }
      else
      {
         gc.setColor(rotationColors[(i+1)%6]);
      }

      // draw the current oval...
      for(int k=0;  k<thickness;  k++)
      {
         for(int m=0;  m<linkCount;  ++m)
         {
            gc.drawOval(
                chainXCoords[i]-
                chainRadii[i]/2+k,
                chainYCoords[i]+chainLengths[i]-
                chainRadii[i]/2+m*7*maxRadius/4,
              //chainRadii[i]/2+m*7*chainRadii[i]/4,
                chainRadii[i],
              //2*chainRadii[i]);
                2*maxRadius);
         }
      }
   }

} // drawChains

public void updateChainCoordinates()
{
   for(int i=0;  i<chainCount;  i++)
   {
      chainLengths[i]  +=  chainLDirection[i]*
                          chainLDelta[i];
      chainRadii[i]    +=  chainRDirection[i]*
                          chainRDelta[i];

      if(chainRadii[i]>maxRadius)
```

```
         {
            chainRDirection[i] *= -1;
            rotationCount[i]    = 1-rotationCount[i];
         }

         if(chainRadii[i]<minRadius)
         {
            chainRDirection[i] *= -1;
            rotationCount[i]    = 1-rotationCount[i];
         }

         if( chainLengths[i]<minchainLength)
         {
            chainLengths[i]    = minchainLength;
            chainLDirection[i] *= -1;
         }

         if( chainLengths[i]>maxchainLength)
         {
            chainLengths[i]    = maxchainLength;
            chainLDirection[i] *= -1;
         }
      }

   } // updateChainCoordinates

   public void shortPause()
   {
      try {
         Thread.sleep(pause);
      }
      catch(Exception e){};

   } // shortPause

} // Chains1
```

ON THE CD

The HTML file *Chains1.html* (Listing 11.4) contains the code for launching *Chains1.class*.

LISTING 11.4 Chains1.html

```
<HTML>
<HEAD></HEAD>
<BODY>
<APPLET CODE=Chains1.class WIDTH=800 HEIGHT=500></APPLET>
</BODY>
</HTML>
```

REMARKS

The preceding example demonstrates how to create the appearance of chains that are oscillating up and down. Each chain consists of a set of "links," each of which can be rendered by drawing a set of ellipses. As in the case of *updateChainCoordinates()* in *Chimes1.java*, the method *updateChainCoordinates()* updates the width of each ellipse (stored in an array) that is part of each chain and then ensures that the width of each ellipse varies between a minimum and maximum allowable value. Since the ellipses are drawn with a varying width, they appear to rotate while they are bouncing up and down. This example also lends itself to conversion from a collection of arrays to a collection of objects that represent the bouncing chains.

CONCEPT: DRAWING PULLEYS WITH ELLIPSES

The next object (Figure 11.3) consists of the following building blocks:

- A set of chain links
- A set of ellipses for each chain link
- A set of vertical line segments
- Two sets of slanted line segments
- A horizontal rectangle for the bar

The Java class *Pulleys1.java* contains the following methods:

initializeChains()
drawBar()
drawChains()
drawPyramid()
drawCrossHairs()
updateChainCoordinates()
shortPause()

The method *initializeChains()* initializes the coordinates of the ellipses.
The method *drawBar()* draws the shifting horizontal "bar" (which is a rectangle) to which the ellipses are connected via line segments.
The method *drawChains()* draws a set of ellipses and a set of line segments that attach the ellipses to the shifting horizontal bar.

FIGURE 11.3 A set of ellipse-based pulleys.

The method *drawPyramid()* draws a pyramid-like base that is attached to the bottom-most ellipse of each chain.

The method *drawCrossHairs()* draws a set of line segments at the top of each ellipse in order to create a spiked effect.

The method *updateChainCoordinates()* updates the coordinates of the ellipses to create the impression that they are bouncing up and down.

The method *shortPause()* sleeps for a specified number of milliseconds.

ON THE CD

The Java class *Pulleys1.java* (Listing 11.5) demonstrates how to draw a set of chains which have a payload attached to them. The pulleys oscillate vertically as well as horizontally as the supporting beam oscillates horizontally.

LISTING 11.5 Pulleys1.java

```
import java.awt.Color;
import java.awt.Graphics;
import java.awt.Image;
import java.awt.Polygon;

import java.io.Serializable;

public class Pulleys1 extends java.applet.Applet
        implements Serializable
{
    private Graphics offScreenBuffer = null;
    private Image    offScreenImage = null;

    private int width       = 800;
    private int height      = 500;

    private int basePointX  = 50;
```

```
         chainXDirection[i] = 0;
         chainYDirection[i] = 1;

         chainLDelta[i]    = 4;
         chainRDelta[i]    = 1;
         chainXDelta[i]    = 1;
         chainYDelta[i]    = 1;

      //chainXCoords[i]    = basePointX+
      //chainYCoords[i]    = basePointY+chainBarHeight;

         chainXCoords[i]    = currentBarX+
                                (i*chainBarWidth)/
                                (chainCount-1);

         chainYCoords[i]    = currentBarY+
                                chainBarHeight;

         chainLengths[i]    = (int)(maxchainLength*
                                Math.random()/2);
      }

   } // initializeChains

   public void update(Graphics gc)
   {
      paint(gc);

   } // update

   public void paint(Graphics gc)
   {
      for(int tick=0; tick<maxCount; tick++)
      {
         offScreenBuffer.setColor(Color.lightGray);
         offScreenBuffer.fillRect(0, 0, width, height);

         shortPause();
         drawBar(offScreenBuffer);
         drawChains(offScreenBuffer);
         updateChainCoordinates();

         gc.drawImage(offScreenImage, 0, 0, this);
      }

   } // paint

   public void drawBar(Graphics gc)
   {
      gc.setColor(Color.blue);
```

```
   gc.fill3DRect(currentBarX,
                 currentBarY,
                 chainBarWidth,
                 chainBarHeight,
                 true);

} // drawBar

public void drawChains(Graphics gc)
{
   for(int i=0; i<chainCount; i++)
   {
      // draw vertical anchor line...
      gc.setColor(Color.white);

    //gc.drawLine(chainXCoords[i],
                //basePointY+chainBarHeight,

      gc.drawLine(chainXCoords[i],
                  currentBarY+chainBarHeight,
                  chainXCoords[i],
                  chainYCoords[i]+chainLengths[i]);

      if(rotationCount[i]==0)
      {
         gc.setColor(rotationColors[i%6]);
      }
      else
      {
         gc.setColor(rotationColors[(i+1)%6]);
      }

      // draw the current oval...
      for(int k=0; k<thickness; k++)
      {
         for(int m=0; m<linkCount; ++m)
         {
            gc.drawOval(
                    chainXCoords[i]-
                    chainRadii[i]/2+k,
                    chainYCoords[i]+chainLengths[i]-
                    chainRadii[i]/2+m*7*maxRadius/4,
                    chainRadii[i],
                    2*maxRadius);
         }

         drawCrossHairs(gc,
                    chainXCoords[i]-
                        chainRadii[i]/2+thickness,
                    chainYCoords[i]+chainLengths[i]-
```

```
                              chainRadii[i]/2-7*maxRadius/4,
                         2*maxRadius,
                         7*maxRadius/4);

         drawPyramid(gc,
                        chainXCoords[i]-
                            chainRadii[i]/2+thickness+
                            chainRadii[i]/4,
                        chainYCoords[i]+chainLengths[i]-
                            chainRadii[i]/2+
                            linkCount*7*maxRadius/4+
                            2*maxRadius,
                        7*maxRadius/4);
      }
   }

} // drawChains

public void drawPyramid(Graphics gc, int currX,
                  int currY, int vShift)
{
   int offsetX = (int)(pyrHeight*
                       Math.cos(bTheta*Math.PI/180));
   int offsetY = (int)(pyrHeight*
                       Math.sin(bTheta*Math.PI/180));

   // counterclockwise from lower-left vertex...
   xpts[0] = currX-pyrWidth;
   ypts[0] = currY+pyrHeight/2;

   xpts[1] = currX+pyrWidth/2;
   ypts[1] = currY+pyrHeight/2;

   xpts[2] = currX+pyrWidth/2+offsetX;
   ypts[2] = currY-offsetY;

   xpts[3] = currX-pyrWidth+offsetX;
   ypts[3] = currY-offsetY;

   polygon = new Polygon(xpts, ypts, vertexCount);

   gc.fillPolygon(polygon);

   // draw connecting lines...
   for(int i=0; i<vertexCount; i++)
   {
      gc.drawLine(currX, currY-vShift,
                  xpts[i], ypts[i]);
   }
```

```
} // drawPyramid

public void drawCrossHairs(Graphics gc, int currX,
                    int currY, int vStart, int vShift)
{
    int offsetX = (int)(pyrHeight*
                        Math.cos(bTheta*Math.PI/180));
    int offsetY = (int)(pyrHeight*
                        Math.sin(bTheta*Math.PI/180));

    for(int i=0; i<linkCount; i++)
    {
        // counterclockwise from lower-left vertex...
        xpts[0] = currX-pyrWidth/2;
        ypts[0] = currY+pyrHeight/2+vStart+i*vShift;

        xpts[1] = currX+pyrWidth/2;
        ypts[1] = currY+pyrHeight/2+vStart+i*vShift;

        xpts[2] = currX+pyrWidth/2+offsetX;
        ypts[2] = currY-offsetY+vStart+i*vShift;

        xpts[3] = currX-pyrWidth/2+offsetX;
        ypts[3] = currY-offsetY+vStart+i*vShift;

        // draw connecting lines...
        for(int j=0; j<vertexCount; j++)
        {
            gc.drawLine(currX,    currY+vStart+i*vShift,
                        xpts[j], ypts[j]);
        }
    }

} // drawCrossHairs

public void updateChainCoordinates()
{
    currentBarX += barXDirection*barXDelta;
    currentBarY += barYDirection*barYDelta;

    if(currentBarX < minBarX) { barXDirection *= -1; }
    if(currentBarX > maxBarX) { barXDirection *= -1; }

    if(currentBarY < minBarY) { barYDirection *= -1; }
    if(currentBarY > maxBarY) { barYDirection *= -1; }

    for(int i=0; i<chainCount; i++)
    {
        chainXCoords[i] = currentBarX+
                    (i*chainBarWidth)/(chainCount-1);
```

```
            chainYCoords[i] = currentBarY+chainBarHeight;

            chainLengths[i] += chainLDirection[i]*
                                    chainLDelta[i];
            chainRadii[i]   += chainRDirection[i]*
                                    chainRDelta[i];

            if(chainRadii[i]>maxRadius)
            {
               chainRDirection[i] *= -1;
               rotationCount[i]    = 1-rotationCount[i];
            }

            if(chainRadii[i]<minRadius)
            {
               chainRDirection[i] *= -1;
               rotationCount[i]    = 1-rotationCount[i];
            }

            if( chainLengths[i]<minchainLength)
            {
               chainLengths[i]    = minchainLength;
               chainLDirection[i] *= -1;
            }

            if( chainLengths[i]>maxchainLength)
            {
               chainLengths[i]    = maxchainLength;
               chainLDirection[i] *= -1;
            }
        }

    } // updateChainCoordinates

    public void shortPause()
    {
        try {
           Thread.sleep(pause);
        }
        catch(Exception e){};

    } // shortPause

} // Pulleys1
```

ON THE CD

The HTML file *Pulleys1.html* (Listing 11.6) contains the code for launching *Pulleys1.class*.

LISTING 11.6 Pulleys1.html

```
<HTML>
<HEAD></HEAD>
<BODY>
<APPLET CODE=Pulleys1.class WIDTH=800 HEIGHT=500></APPLET>
</BODY>
</HTML>
```

REMARKS

The preceding example demonstrates how to create the appearance of "pulleys" that are oscillating up and down. Each pulley consists of a chain to which a horizontal platform is attached. Each platform is represented by a parallelogram. As in the case of *Chimes1.java*, the method *updateChainCoordinates()* updates the width of each ellipse (stored in an array) and then ensures that the width of each ellipse varies between a minimum and maximum allowable value. Since the ellipses are drawn with a varying width, they appear to rotate while they are bouncing up and down. This example also lends itself to conversion from a collection of arrays to a collection of objects that represent the bouncing chains.

Notice how the method *drawCrossHairs()* adds a prickly effect to the graphics image by drawing a set of intersecting lines near the top of each "link" in every chain.

CONCEPT: DRAWING CURLING SHEETS OF PAPER

The next object (Figure 11.4 and Figure 11.5) consists of the following building blocks:

- A parallelogram
- Two sets of line segments

The Java class *CurlingPage2.java* contains the following methods:

updateCoordinates()

fillBasePolygon()

drawLeftCurl()

drawRightCurl()

updateLeftTriangleCoordinates()

FIGURE 11.4 A snapshot of a curling
sheet of paper.

FIGURE 11.5 A subsequent snapshot of
a curling sheet of paper.

updateLeftTriangleTopVertex()

updateRightTriangleCoordinates()

updateRightTriangleTopVertex()

shortPause()

The method *updateCoordinates()* initializes the coordinates of the parallelogram.

The method *fillBasePolygon()* draws the base parallelogram.

The methods *drawLeftCurl()* and *drawRightCurl()* draw the lower left and right curled edges of the sheet of paper.

The method *updateLeftTriangleCoordinates()* updates the coordinates of the lower left curling edge, whereas the method *updateRightTriangle-Coordinates()* updates the coordinates of the lower right curling edge.

The method *updateLeftTriangleTopVertex()* is responsible for keeping track of the coordinates of the region on the left side of the base that is "exposed" as the sheet of paper curls toward the center. This region is initially a triangle and eventually becomes a quadrilateral. You can confirm this detail by observing the graphics image.

The method *updateRightTriangleTopVertex()* performs an analogous task for the exposed region on the right side of the base.

The method *shortPause()* sleeps for a specified number of milliseconds.

ON THE CD

The Java class *CurlingPage2.java* (Listing 11.7) demonstrates how to "peel back" the lower corners of a sheet of paper.

LISTING 11.7 CurlingPage2.java

```java
import java.awt.Color;
import java.awt.Graphics;
import java.awt.Image;
```

```java
import java.awt.Polygon;

import java.io.Serializable;

public class CurlingPage2 extends java.applet.Applet
      implements Serializable
{
   private Image offScreenImage    = null;
   private Graphics offScreenBuffer = null;

   private int width       = 800;
   private int height      = 500;

   private int pause       =  80;
   private int maxCount     = 200;

   private Polygon polygon     = null;
   private Polygon tempPolygon = null;

   private int leftTHShift  =   0;
   private int rightTHShift =   0;

   private int basePointX   = 100;
   private int basePointY   = 100;

   private int thickness    =  10;

   private int pWidth       = 200;
   private int pHeight      = 250;
   private int bTheta       =  80;

   private int startLTheta  = 270;
   private int endLTheta    =  45;
   private int cLTheta      = startLTheta;

   private int startRTheta  = -90;
   private int endRTheta    = 135;
   private int cRTheta      = startRTheta;

   private int cRadius      =  10;
   private int rval         =   0;
   private int gval         =   0;
   private int bval         =   0;

   private double[] sideRatio = null;

   private int vertexCount = 5;

   private int[] outerXPts  = new int[vertexCount];
   private int[] outerYPts  = new int[vertexCount];
```

```java
private int[] leftTXPts  = new int[vertexCount];
private int[] leftTYPts  = new int[vertexCount];

private int[] rightTXPts = new int[vertexCount];
private int[] rightTYPts = new int[vertexCount];

public CurlingPage2()
{
}

public void init()
{
   offScreenImage  = this.createImage(width, height);
   offScreenBuffer = offScreenImage.getGraphics();

   sideRatio = new double[2];
   sideRatio[0] = 0.67;
   sideRatio[1] = 0.67;

   updateCoordinates();

} // init

public void updateCoordinates()
{
   int offsetX = (int)(pHeight*Math.cos(bTheta*
                                   Math.PI/180));

   int offsetY = (int)(pHeight*Math.sin(bTheta*
                                   Math.PI/180));

   // counterclockwise from lower-left vertex...
   outerXPts[0] = basePointX;
   outerYPts[0] = basePointY+offsetY;

   outerXPts[1] = basePointX+pWidth;
   outerYPts[1] = basePointY+offsetY;

   outerXPts[2] = basePointX+pWidth+offsetX;
   outerYPts[2] = basePointY;

   outerXPts[3] = basePointX+offsetX;
   outerYPts[3] = basePointY;

   outerXPts[4] = basePointX;
   outerYPts[4] = basePointY+offsetY;

   // counterclockwise from lower-left vertex...
   leftTXPts[0] = outerXPts[0];
   leftTYPts[0] = outerYPts[0];
```

```
         leftTXPts[1] = outerXPts[0]+cRadius;
         leftTYPts[1] = outerYPts[0];

         leftTXPts[2] = outerXPts[0]-2*(outerXPts[0]-
                                       outerXPts[3])/3;
         leftTYPts[2] = outerYPts[0]-2*(outerYPts[0]-
                                       outerYPts[3])/3;

         leftTXPts[3] = outerXPts[0]-2*(outerXPts[0]-
                                       outerXPts[3])/3;
         leftTYPts[3] = outerYPts[0]-2*(outerYPts[0]-
                                       outerYPts[3])/3;

         leftTXPts[4] = outerXPts[3];
         leftTYPts[4] = outerYPts[3];

         // counterclockwise from lower-right vertex...
         rightTXPts[0] = outerXPts[1];
         rightTYPts[0] = outerYPts[1];

         rightTXPts[1] = outerXPts[1]-2*(outerXPts[1]-
                                         outerXPts[2])/3;
         rightTYPts[1] = outerYPts[1]-2*(outerYPts[1]-
                                         outerYPts[2])/3;

         rightTXPts[2] = outerXPts[1]-2*(outerXPts[1]-
                                         outerXPts[2])/3;
         rightTYPts[2] = outerYPts[1]-2*(outerYPts[1]-
                                         outerYPts[2])/3;

         rightTXPts[3] = outerXPts[1]-cRadius;
         rightTYPts[3] = outerYPts[1];

         rightTXPts[4] = outerXPts[1];
         rightTYPts[4] = outerYPts[1];

   } // updateCoordinates

   public void update(Graphics gc)
   {
      paint(gc);

   } // update

   public void paint(Graphics gc)
   {
      offScreenBuffer.setColor(Color.lightGray);
      offScreenBuffer.fillRect(0, 0, width, height);

      for(int tick=0; tick<maxCount; tick++)
```

```
   {
      fillBasePolygon(offScreenBuffer);
      drawLeftCurl(offScreenBuffer);
      drawRightCurl(offScreenBuffer);

      gc.drawImage(offScreenImage, 0, 0, this);

      updateLeftTriangleCoordinates();
      updateRightTriangleCoordinates();
      shortPause();
   }

} // paint

public void updateLeftTriangleCoordinates()
{
   if( leftTXPts[1] < rightTXPts[3])
   {
      ++leftTHShift;
      ++leftTXPts[1];

      if( leftTHShift % 4 == 0 )
      {
         ++cRadius;
      }
   }
   else
   {
      updateLeftTriangleTopVertex();
   }

} // updateLeftTriangleCoordinates

public void updateLeftTriangleTopVertex()
{
   if( leftTXPts[2] < outerXPts[3] )
   {
      if( sideRatio[0] < 1.00 )
      {
         sideRatio[0] += 0.01;

         leftTXPts[2] = outerXPts[0]-(int)
                     ((outerXPts[0]-outerXPts[3])*
                        sideRatio[0]);

         leftTYPts[2] = outerYPts[0]-(int)
                     ((outerYPts[0]-outerYPts[3])*
                        sideRatio[0]);
      }
   }
```

```
   else
   {
      if(leftTXPts[2] < (outerXPts[2]+outerXPts[3])/2)
      {
         ++leftTXPts[2];

         leftTXPts[3] = outerXPts[3];
         leftTYPts[3] = outerYPts[3];
      }
   }

} // updateLeftTriangleTopVertex

public void fillBasePolygon(Graphics gc)
{
   int[] tempOuterXPts = new int[5];
   int[] tempOuterYPts = new int[5];

   gc.setColor(Color.black);

   for(int i=0; i<thickness; i++)
   {
      for(int j=0; j<5; j++)
      {
         tempOuterXPts[j] = outerXPts[j];
         tempOuterYPts[j] = outerYPts[j]+i;
      }

      tempPolygon = new Polygon(tempOuterXPts,
                                tempOuterYPts,
                                5);

      gc.fillPolygon(tempPolygon);
   }

   polygon = new Polygon(outerXPts, outerYPts, 5);
   gc.setColor(Color.blue);
   gc.fillPolygon(polygon);

   gc.setColor(Color.white);
   gc.drawPolygon(polygon);

} // fillBasePolygon

public void drawLeftCurl(Graphics gc)
{
   int currX=0,currY=0;

   polygon = new Polygon(leftTXPts, leftTYPts, 5);
   gc.setColor(Color.black);
```

```
    gc.fillPolygon(polygon);
    gc.setColor(Color.red);

    // arc from 270 degrees to 45 degrees...
    for(cLTheta = startLTheta;
        cLTheta >= endLTheta; --cLTheta)
    {
        currX = (int)(cRadius*
                    Math.cos(cLTheta*Math.PI/180));
        currY = (int)(cRadius*
                    Math.sin(cLTheta*Math.PI/180));

        rval = 128+(int)(cLTheta*255/
                        (2*Math.abs(startLTheta)));

        gc.setColor(new Color(rval, gval, bval));

        gc.drawLine(leftTXPts[2],
                    leftTYPts[2],
                    leftTXPts[1]+currX,
                    leftTYPts[1]-cRadius-currY);
    }

} // drawLeftCurl

public void drawRightCurl(Graphics gc)
{
    int currX=0,currY=0;

    polygon = new Polygon(rightTXPts, rightTYPts, 5);
    gc.setColor(Color.black);
    gc.fillPolygon(polygon);
    gc.setColor(Color.red);

    // arc from 270 degrees to 45 degrees...
    for(cRTheta = startRTheta;
        cRTheta <= endRTheta; ++cRTheta)
    {
        currX = (int)(cRadius*
                    Math.cos(cRTheta*Math.PI/180));
        currY = (int)(cRadius*
                    Math.sin(cRTheta*Math.PI/180));

        rval = 128+(int)(cRTheta*255/
                        (2*Math.abs(endRTheta)));

        gc.setColor(new Color(rval, gval, bval));

        gc.drawLine(rightTXPts[2],
                    rightTYPts[2],
```

```
                           rightTXPts[3]+currX,
                           rightTYPts[3]-cRadius-currY);
      }

   } // drawRightCurl

   public void updateRightTriangleCoordinates()
   {
      if( rightTXPts[3] > leftTXPts[1])
      {
         —rightTXPts[3];
      }
      else
      {
         updateRightTriangleTopVertex();
      }

   } // updateRightTriangleCoordinates

   public void updateRightTriangleTopVertex()
   {
      if( rightTYPts[1] > outerYPts[2] )
      {
         if( sideRatio[1] < 1.00 )
         {
            sideRatio[1] += 0.01;

            rightTXPts[1] = outerXPts[1]-(int)
                          ((outerXPts[1]-outerXPts[2])*
                            sideRatio[1]);

            rightTYPts[1] = outerYPts[1]-(int)
                          ((outerYPts[1]-outerYPts[2])*
                            sideRatio[1]);

            rightTXPts[2] = rightTXPts[1];
            rightTYPts[2] = rightTYPts[1];
         }
      }
      else
      {
         if(rightTXPts[2]>(outerXPts[2]+outerXPts[3])/2)
         {
            —rightTXPts[2];
         }
      }

   } // updateRightTriangleTopVertex

   public void shortPause()
```

```
    {
        try {
            Thread.sleep(pause);
        }
        catch(Exception e){};

    } // shortPause

} // CurlingPage2
```

The HTML file *CurlingPage2.html* (Listing 11.8) contains the code for launching *CurlingPage2.class*.

ON THE CD

LISTING 11.8 CurlingPage2.html

```
<HTML>
<HEAD></HEAD>
<BODY>
<APPLET CODE=CurlingPage2.class WIDTH=800 HEIGHT=500></APPLET>
</BODY>
</HTML>
```

REMARKS

The preceding example is longer than the other Java code in this chapter because it must calculate the coordinates of several polygonal objects in order to create the illusion of a curling sheet of paper. First, the sheet of paper requires six vertices in order to keep track of the portion of the paper that appears to be affixed to the stationary parallelogram. Second, the curling portions of the sheet of paper involve drawing a set of line segments in the shape of a half-ellipse. The method *shortPause()* is invoked to control the rate at which the sheet of paper curls inward. Notice that all the rendered components are either polygons or line segments, which means that redrawing is fast. You can add other variations to this code. For example, you might consider changing the color of the curled portion of the page by means of a color gradient.

CD LIBRARY

ON THE CD

The CD-ROM for this chapter contains "class" files and HTML files that are needed for viewing the graphics images in the following Java files:

WindChimes1. Chains1. Pulleys1.

CurlingPage2. CurlingPage1.

SUMMARY

This chapter presented Java code that used an ellipse as a fundamental building block for drawing the following objects:

- Ellipses with shifting horizontal stripes
- Wind chimes
- Chains
- Pulleys
- Curling sheets of paper

The Java code in this chapter started with a simple example and then re-fined the code in order to produce more sophisticated images. This chapter also demonstrated how to control the speed of animation effects by means of the static *sleep()* method in the *Thread* class in Java. You are now in a position to add your own constraints on the rate of motion of objects in graphics images that contain animation effects. For simplicity, all the Java examples in this chapter use constant clock "ticks." Feel free to devise your own techniques for specifying variable-length time intervals, for they can add style to your animation.

SPINNING OBJECTS WITH LINES AND ELLIPTIC ARCS

OVERVIEW

This chapter contains Java code that uses line segments and elliptic arcs in order to create animation effects. The first example shows you how to rotate a set of line segments and a set of elliptic-shaped wedges, in conjunction with gradient shading, in order to render a spinning cylinder. Previous chapters cover polar equations and sets of adjacent parallel line segments or adjacent rectangles in order to create animation. This chapter introduces animation effects based on ellipses and elliptic arcs.

CONCEPT: DRAWING SPINNING CONES WITH ELLIPTIC WEDGES

The next object (Figure 12.1 and Figure 12.2) consists of the following building blocks:

- Two sets of parallel adjacent line segments
- An ellipse consisting of a set of elliptic wedges

The Java class *SpinningCylinder1.java* contains the following methods:

initializeWedges()
drawWedges()
colorOne()
colorTwo()

FIGURE 12.1 A snapshot of a spinning cylinder.

FIGURE 12.2 A subsequent snapshot of
a spinning cylinder.

calculateEllipseXValue()

drawEllipseGradient()

The method *initializeWedges()* initializes the angles for each wedge in the set of elliptic wedges, and the method *drawWedges()* draws the set of elliptic wedges.

The methods *colorOne()* and *colorTwo()* draw the front and rear, respectively, of the cylinder by using a color gradient in order to draw a set of horizontal lines.

The method *calculateEllipseXValue()* calculates the x value of a point on the ellipse with a given y value.

The method *drawEllipseGradient()* is invoked by a loop in the *paint()* method to repeatedly draw a cylinder in order to create a spinning effect.

The Java class *SpinningCylinder1.java* (Listing 12.1) demonstrates how to draw a spinning horizontal cylinder with elliptic wedges.

ON THE CD

LISTING 12.1 SpinningCylinder1.java

```
import java.awt.Color;
import java.awt.Graphics;
import java.awt.Image;

import java.io.Serializable;

public class SpinningCylinder1 extends
        java.applet.Applet implements Serializable
{
    private Graphics offScreenBuffer = null;
    private Image    offScreenImage  = null;

    private int width       = 800;
    private int height      = 500;
```

```java
private int basePointX = 200;
private int basePointY = 200;

private int maxCount = 200;

private int rectangleWidth  = 400;
private int rectangleHeight = 255;

private int eHeight = rectangleHeight;
private int eWidth  = rectangleHeight/4;

private int rVal = 0;
private int gVal = 0;
private int bVal = 0;

private int iTheta      = 0;
private int wedgeCount = 8;

private int[] wedgeAngle = new int[wedgeCount];

private Color[] wedgeColors = {
   Color.red, Color.green, Color.blue, Color.yellow,
   Color.magenta, Color.white, Color.darkGray
};

public SpinningCylinder1()
{
}

public void init()
{
   offScreenImage  = this.createImage(width, height);
   offScreenBuffer = offScreenImage.getGraphics();

   initializeWedges();

} // init

public void initializeWedges()
{
   for(int w=0; w<wedgeCount; w++)
   {
      wedgeAngle[w] = w*360/wedgeCount;
   }

} // initializeWedges()

public void update(Graphics gc)
{
   paint(gc);
```

```
} // update

public void paint(Graphics gc)
{
   offScreenBuffer.setColor(Color.lightGray);
   offScreenBuffer.fillRect(0, 0, width, height);

   for(int tick=0; tick<maxCount; tick++)
   {
      drawEllipseGradient(offScreenBuffer, gc, tick);
   }

   gc.drawImage(offScreenImage, 0, 0, this);

} // paint

public void drawEllipseGradient(Graphics gc,
                                Graphics gcMain,
                                int count)
{
   for(int currY=-rectangleHeight/2;
          currY<=rectangleHeight/2; currY++)
   {
      gc.setColor(Color.lightGray);
      gc.fillRect(0, 0, width, height);

      colorOne(gc, currY, rectangleHeight/2,  count);
      colorTwo(gc, -rectangleHeight/2, currY, count);

      drawWedges(gc);

      gcMain.drawImage(offScreenImage, 0, 0, this);
   }

} // drawEllipseGradient

public void drawWedges(Graphics gc)
{
   if( ++iTheta > 360 ) { iTheta = 0; }

   for(int w=0; w<wedgeCount; w++)
   {
      gc.setColor(wedgeColors[w%6]);

      gc.fillArc(basePointX+rectangleWidth-eWidth/2,
                 basePointY-rectangleHeight/2,
                 5*eWidth/4,
                 eHeight,
                 wedgeAngle[w]+iTheta,
                 360/wedgeCount);
```

```
      }

} // drawWedges

public void colorOne(Graphics gc, int startY,
                     int endY, int count)
{
   rVal = 0; gVal = 0; bVal = 0;

   double currX = 0;

   for(int currY=startY; currY<endY; currY++)
   {
      if(count%2 == 0)
      {
         rVal = (currY+rectangleHeight/2)*255/
               rectangleHeight;
      }
      else
      {
         gVal = (currY+rectangleHeight/2)*255/
               rectangleHeight;
      }

      currX = calculateEllipseXValue(currY);

      gc.setColor(new Color(rVal, gVal, bVal));

      gc.drawLine(
            basePointX-(int)currX,
            basePointY+currY,
            basePointX+rectangleWidth+(int)currX,
            basePointY+currY);
   }

} // colorOne

public double calculateEllipseXValue(int y)
{
   double result   = 0;
   double offsetX1 = 0;
   double offsetX2 = 0;

   offsetX1 = (eHeight/2)*(eHeight/2)-y*y;
   offsetX2 = offsetX1*eWidth/(2*eHeight);
   result   = Math.sqrt(offsetX2);

   return( result );
} // calculateEllipseXValue
```

```
public void colorTwo(Graphics gc, int startY,
                     int endY, int count)
{
   double currX = 0;

   rVal = 0; gVal = 0; bVal = 0;

   for(int currY=startY; currY<endY; currY++)
   {
      if(count%2 == 0)
      {
         gVal = (currY+rectangleHeight/2)*255/
               rectangleHeight;
      }
      else
      {
         rVal = (currY+rectangleHeight/2)*255/
               rectangleHeight;
      }

      currX = calculateEllipseXValue(currY);

      gc.setColor(new Color(rVal, gVal, bVal));
      gc.drawLine(
            basePointX-(int)currX,
            basePointY+currY,
            basePointX+rectangleWidth+(int)currX,
            basePointY+currY);
   }

   } // colorTwo

} // SpinningCylinder1
```

ON THE CD

The HTML file *SpinningCylinder1.html* (Listing 12.2) contains the code for launching *SpinningCylinder1.class*.

LISTING 12.2 SpinningCylinder1.html

```
<HTML>
<HEAD></HEAD>
<BODY>
<APPLET CODE=SpinningCylinder1.class WIDTH=800 HEIGHT=500></APPLET>
</BODY>
</HTML>
```

PLATE 1 A multi-colored brick wall.

PLATE 2 An ellipse-based set of candles.

PLATE 3 A checkerboard pattern
of hexagons and squares.

PLATE 4 A checkerboard
pattern of floor tiles.

PLATE 5 A set of
parallelograms with Venetian
gradient shading.

PLATE 6 A cross-hatched
pattern in a square.

PLATE 7 A crane with a
wrecking ball.

PLATE 8 A digital date comprised of GIF files.

PLATE 9 A set of swirling elliptic arcs with Venetian shading.

PLATE 10 A lava-like pattern based on a set of ellipses.

PLATE 11 A figure 8 pattern with a fixed point.

PLATE 12 A figure 8 pattern with gradient shading.

PLATE 13 A figure 8 with a mesh pattern.

PLATE 14 A set of multi-colored rectangles based on a *Hypocycloid*.

PLATE 15 A set of multi-colored line segments based on a *Nephroid*.

PLATE 16 Overlapping pseudo-cylinders based on a polar equation.

PLATE 17 A set of recursively generated line segments.

PLATE 18 A tree-like pattern based on recursion.

PLATE 19 A set of circles generated via recursion.

PLATE 20 An abstract set of ellipses generated via recursion.

PLATE 21 An ellipse-based outline of a pseudo-cone.

PLATE 22 A simple house.

PLATE 23 A spinning slanted cylinder.

PLATE 24 A spinning cylinder embedded in a polyhedron.

PLATE 25 An axle-like spinning cylinder.

PLATE 26 A spinning cylinder with a detachable cone.

PLATE 27 A pattern generated via a *Triaxial Tritorus*.

PLATE 28 A set of line segments based on a *Tschirnhaus* curve.

PLATE 29 A set of ellipses based on a cubic function.

PLATE 30 A nested set of diamonds with Venetian shading.

PLATE 31 A pseudo-sphere.

PLATE 32 A striped pattern based on a super *Toroid*.

REMARKS

The preceding example consists of two independent components. One component is a rotating set of elliptic wedges. An "offset angle" `iTheta` specifies the starting angle for drawing the set of wedges. A spinning effect is created by incrementing the value of `iTheta` each time the set of wedges is drawn. The second component involves the rendering of the cylindrical portion of the cylinder, which is done by drawing two sets of parallel adjacent line segments. Each set of line segments is rendered with its own weighted shading in order to create a spinning effect. This example is very efficient because the shapes require almost no computations, so the rendering time is very fast.

CONCEPT: DRAWING SPINNING CONE-LIKE OBJECTS WITH ELLIPTIC ARCS

The next object (Figure 12.3 and Figure 12.4) consists of the following building blocks:

- An elliptic cone consisting of a set of elliptic arcs
- An ellipse consisting of a set of elliptic wedges

FIGURE 12.3 A snapshot of a rotating cone-like object.

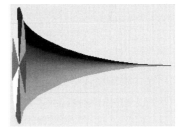

FIGURE 12.4 A subsequent snapshot of a rotating cone-like object.

The Java class *LeftVBaseECone1.java* contains the following methods:

initializeWedges()
drawWedges()
colorOne()
colorTwo()

drawEllipseGradient()

calculateEllipseXValue()

The method *initializeWedges()* initializes the angles for each wedge in the set of elliptic wedges, and the method *drawWedges()* draws the set of elliptic wedges.

The methods *colorOne()* and *colorTwo()* draw the front and rear, respectively, of the cone by using a color gradient in order to draw a set of elliptic arcs.

The method *calculateEllipseXValue()* calculates the x coordinate of a point on an ellipse based on the y coordinate of the point in question.

The method *drawEllipseGradient()* is invoked by a loop in the *paint()* method to repeatedly draw a cone in order to create a spinning effect.

ON THE CD

The Java class *LeftVBaseECone1.java* (Listing 12.3) demonstrates how to draw a horizontal cone with elliptic arcs.

LISTING 12.3 LeftVBaseECone1.java

```java
import java.awt.Color;
import java.awt.Graphics;
import java.awt.Image;

import java.io.Serializable;

public class LeftVBaseECone1 extends
        java.applet.Applet implements Serializable
{
    private Graphics offScreenBuffer = null;
    private Image    offScreenImage  = null;

    private int width       = 800;
    private int height      = 500;

    private int basePointX = 200;
    private int basePointY = 200;

    private int rectangleWidth  = 512;
    private int rectangleHeight = 384;

    private int eHeight = rectangleHeight/2;
    private int eWidth  = eHeight/8;

    private int maxCount = 200;

    private int rVal = 0;
```

```
private int gVal = 0;
private int bVal = 0;

private double currX = 0;

private int iTheta    = 0;
private int wedgeCount = 8;

private int[] wedgeAngle - new int[wedgeCount];

private Color[] wedgeColors = {
   Color.red, Color.green, Color.blue, Color.yellow,
   Color.magenta, Color.white, Color.darkGray
};

public LeftVBaseECone1()
{
}

public void init()
{
   offScreenImage  = this.createImage(width, height);
   offScreenBuffer = offScreenImage.getGraphics();

   initializeWedges();

} // init

public void initializeWedges()
{
   for(int w=0; w<wedgeCount; w++)
   {
      wedgeAngle[w] = w*360/wedgeCount;
   }

} // initializeWedges()

public void update(Graphics gc)
{
   paint(gc);

} // update

public void paint(Graphics gc)
{
   offScreenBuffer.setColor(Color.lightGray);
   offScreenBuffer.fillRect(0, 0, width, height);

   for(int tick=0; tick<maxCount; tick++)
   {
```

```java
            drawEllipseGradient(offScreenBuffer, gc, tick);
    }

} // paint

public void drawEllipseGradient(Graphics gc,
                        Graphics gcMain, int count)
{
    for(int currY=-rectangleHeight/2;
            currY<=rectangleHeight/2; currY++)
    {
        gc.setColor(Color.lightGray);
        gc.fillRect(0, 0, width, height);

        colorOne(gc, currY, rectangleHeight/2,  count);
        colorTwo(gc, -rectangleHeight/2, currY, count);

        drawWedges(gc);

        gcMain.drawImage(offScreenImage, 0, 0, this);
    }

} // drawEllipseGradient

public void drawWedges(Graphics gc)
{
    if( -iTheta < -360 ) { iTheta = 0; }

    for(int w=0; w<wedgeCount; w++)
    {
        gc.setColor(wedgeColors[w%6]);

        gc.fillArc(basePointX-eWidth/2,
                    basePointY-eHeight/2,
                    eWidth,
                    eHeight,
                    wedgeAngle[w]+iTheta,
                    360/wedgeCount);
    }

} // drawWedges

public void colorOne(Graphics gc, int startY,
                    int endY, int count)
{
    rVal = 0; gVal = 0; bVal = 0;

    for(int currY=startY; currY<endY; currY++)
    {
        if(count%2 == 0)
```

```
      {
         rVal = (currY+rectangleHeight/2)*255/
                  rectangleHeight;
      }
      else
      {
         gVal = (currY+rectangleHeight/2)*255/
                  rectangleHeight;
      }

      currX = calculateEllipseXValue(currY);

      gc.setColor(new Color(rVal, gVal, bVal));

      if(currY < 0 )     // draw lower arc...
      {
         gc.drawArc(basePointX,
                    basePointY+currY,
                    rectangleWidth,
                    -currY,
                    180,
                    90);
      }
      else               // draw upper arc...
      {
         gc.drawArc(basePointX,
                    basePointY,
                    rectangleWidth,
                    currY,
                    90,
                    90);
      }
   }

} // colorOne

public double calculateEllipseXValue(int y)
{
   double result   = 0;
   double offsetX1 = 0;
   double offsetX2 = 0;

   offsetX1 = (eHeight/2)*(eHeight/2)-y*y;
   offsetX2 = offsetX1*eWidth/(2*eHeight);
   result   = Math.sqrt(offsetX2);

   return( result );

} // calculateEllipseXValue
```

```
   public void colorTwo(Graphics gc,int startY,int endY,
                        int count)
{
   rVal = 0; gVal = 0; bVal = 0;

   for(int currY=startY; currY<endY; currY++)
   {
      if(count%2 == 0)
      {
         gVal = (currY+rectangleHeight/2)*255/
                rectangleHeight;
      }
      else
      {
         rVal = (currY+rectangleHeight/2)*255/
                rectangleHeight;
      }

      currX = calculateEllipseXValue(currY);

      gc.setColor(new Color(rVal, gVal, bVal));

      if(currY < 0 )     // draw upper arc...
      {
         gc.drawArc(basePointX,
                    basePointY+currY,
                    rectangleWidth,
                    -currY,
                    180,
                    90);
      }
      else               // draw lower arc...
      {
         gc.drawArc(basePointX,
                    basePointY,
                    rectangleWidth,
                    currY,
                    90,
                    90);
      }
   }

} // colorTwo

} // LeftVBaseECone1
```

The HTML file *LeftVBaseECone1.html* (Listing 12.4) contains the code for launching *LeftVBaseECone1.class*.

LISTING 12.4 LeftVBaseECone1.html

```
<HTML>
<HEAD></HEAD>
<BODY>
<APPLET CODE=LeftVBaseECone1.class WIDTH=800 HEIGHT=500></APPLET>
</BODY>
</HTML>
```

REMARKS

The preceding example consists of two independent building blocks. One building block is a rotating set of elliptic wedges. An "offset angle" iTheta specifies the starting angle for drawing the set of wedges. Since the value of iTheta is incremented each time that the set of wedges is drawn, a spinning effect is created. The second component involves the rendering of the curved portion of the cone. By drawing a set of elliptic arcs in conjunction with color weighting, a spinning effect is created for this component.

In *SpinningCylinder1.java*, the methods *colorOne()* and *colorTwo()* render a set of adjacent parallel line segments in conjunction with gradient shading in order to create the appearance of a spinning cylinder. In the preceding example, these two methods render a set of elliptic arcs by means of gradient shading in order to create the appearance of a spinning cone-like object.

CONCEPT: DRAWING SPINNING HORIZONTAL CONES

The next object (Figure 12.5 and Figure 12.6) consists of the following building blocks:

- A set of adjacent ellipses of decreasing height

The Java class *RightVBaseSpinningConeSectorsOutline1.java* contains the following methods:

initializeWedges()

drawWedges()

drawSpinningConeSectors()

drawRightEllipse()

FIGURE 12.5 A snapshot of a spinning horizontal cone.

FIGURE 12.6 A subsequent snapshot of a spinning horizontal cone.

updateCoordinates()

shortPause()

The method *initializeWedges()* initializes the coordinates of the set of wedges of an ellipse, and the method *drawWedges()* draws the set of wedges of an ellipse.

The method *drawSpinningConeSectors()* draws the outline of a set of ellipses from left to right on the screen.

The method *drawRightEllipse()* draws the right-most vertical ellipse.

The method *updateCoordinates()* updates the gap between consecutive ellipses and ensures that the value lies between a minimum and maximum allowable value.

The method *shortPause()* sleeps for a specified number of milliseconds.

ON THE CD

The Java class *RightVBaseSpinningConeOscillatingSectorsOutline1.java* (Listing 12.5) demonstrates how to draw a spinning horizontal cone outline with a variable wire frame pattern.

LISTING 12.5 RightVBaseSpinningConeOscillatingSectorsOutline1.java

```java
import java.awt.Color;
import java.awt.Graphics;
import java.awt.Image;

import java.io.Serializable;

public class
RightVBaseSpinningConeOscillatingSectorsOutline1

    extends java.applet.Applet implements Serializable
{
    private Graphics offScreenBuffer = null;
    private Image    offScreenImage  = null;
```

```
private int width     = 800;
private int height    = 500;

private int basePointX = 200;
private int basePointY = 300;

private int currentX   = basePointX;
private int currentY   = basePointY;

private int startAngle = 0;
private int endAngle   = 210;
private int deltaAngle = (int)(endAngle-startAngle);

private int maxCount = 200;
private int pause    = 100;

private int lineHGap = 4;
private int minLineHGap = 1;
private int maxLineHGap = 16;

private int lineHGapDirection = 1;
private int lineHGapDelta     = 1;

private int vDelta = 0;

private int offsetX = 0;
private int offsetY = 0;

private int eWidth  = 40;
private int eHeight = 240;

private int wedgeCount = 8;
private int iTheta     = 0;

private int[] wedgeAngle = new int[wedgeCount];

private Color[] wedgeColors = {
   Color.red, Color.green, Color.blue, Color.yellow,
   Color.magenta, Color.white, Color.darkGray
};

public
   RightVBaseSpinningConeOscillatingSectorsOutline1()
{
}

public void init()
{
   offScreenImage  = this.createImage(width, height);
   offScreenBuffer = offScreenImage.getGraphics();
```

```
      initializeWedges();

} // init

public void initializeWedges()
{
   for(int w=0; w<wedgeCount; w++)
   {
      wedgeAngle[w] = w*360/wedgeCount;
   }

} // initializeWedges()

public void update(Graphics gc)
{
   paint(gc);

} // update

public void paint(Graphics gc)
{
   offScreenBuffer.setColor(Color.lightGray);
   offScreenBuffer.fillRect(0, 0, width, height);

   for(int tick=0; tick<maxCount; ++tick)
   {
      drawSpinningConeSectors(offScreenBuffer);
      drawRightEllipse(offScreenBuffer);

      gc.drawImage(offScreenImage, 0, 0, this);
      shortPause();
      updateCoordinates();
   }

} // paint

public void updateCoordinates()
{
   lineHGap += lineHGapDirection*lineHGapDelta;

   if( lineHGap > maxLineHGap )
   {
      lineHGap = maxLineHGap;
      lineHGapDirection *= -1;
   }

   if( lineHGap < minLineHGap )
   {
      lineHGap = minLineHGap;
      lineHGapDirection *= -1;
```

```
   }

   if(lineHGap == minLineHGap) { pause = 2000; }
   else                        { pause = 100; }

} // updateCoordinates

public void drawWedges(Graphics gc, int xCoord)
{
   if( ++iTheta > 360 ) { iTheta = 0; }

   for(int w=0; w<wedgeCount; w++)
   {
      gc.setColor(wedgeColors[w%6]);

      gc.drawArc(xCoord,
                 basePointY-eHeight/2-vDelta,
                 eWidth,
                 2*vDelta,
                 wedgeAngle[w]+iTheta,
                 360/wedgeCount);
   }

} // drawWedges

public void drawSpinningConeSectors(Graphics gc)
{
   for(int angle=startAngle; angle<endAngle; angle++)
   {
      vDelta = (angle-startAngle)*eHeight/
                          (deltaAngle*2);

      currentX = basePointX+angle;

      if( angle % lineHGap == 0 )
      {
         drawWedges(gc, currentX+angle-startAngle);
      }
   }

} // drawSpinningConeSectors

public void drawRightEllipse(Graphics gc)
{
   for(int count=0; count<wedgeCount; count++)
   {
      offsetX = count*eWidth/wedgeCount;
      offsetY = count*eHeight/wedgeCount;

      for(int w=0; w<wedgeCount; w++)
```

```
        {
            gc.setColor(wedgeColors[w%6]);

            gc.drawArc(currentX+endAngle+offsetX,
                        basePointY-eHeight+offsetY,
                        eWidth-offsetX,
                        eHeight-2*offsetY,
                        wedgeAngle[w]+iTheta,
                        360/wedgeCount);
        }
    }

} // drawRightEllipse

public void shortPause()
{
    try {
        Thread.sleep(pause);
    }
    catch(Exception e) {};

} // shortPause

} // RightVBaseSpinningConeOscillatingSectorsOutline1
```

ON THE CD

The HTML file *RightVBaseSpinningConeOscillatingSectorsOutline1.html* (Listing 12.6) contains the code for launching *RightVBaseSpinning ConeOscillatingSectorsOutline1.class*.

LISTING 12.6 RightVBaseSpinningConeOscillatingSectorsOutline1.html

```
<HTML>
<HEAD></HEAD>
<BODY>
<APPLET CODE=RightVBaseSpinningConeOscillatingSectorsOutline1.class
WIDTH=800 HEIGHT=500></APPLET>
</BODY>
</HTML>
```

REMARKS

The preceding example consists of a set of ellipses, each of which consists of a set of elliptic wedges. Each time an ellipse is rendered by means of its associated set of elliptic wedges, an offset angle iTheta is incremented.

Since this value is used as the starting angle from which each set of wedges is rendered, a spinning effect is created.

The variable `lineHGap` determines the distance between consecutive renderings of elliptic wedges. The spinning cone is rendered in a more "dense" or "sparse" fashion by decreasing or increasing the value of this variable.

CONCEPT: DRAWING ROTATING ELLIPTIC BOWLS WITH ELLIPTIC WEDGES

The next object (Figure 12.7 and Figure 12.8) consists of the following building blocks:

- An ellipse
- Two sets of elliptic arcs

FIGURE 12.7 A snapshot of a bowl-like set of ellipses.

FIGURE 12.8 A subsequent snapshot of a bowl-like set of ellipses.

The Java class *OscillatingPartialEllipse2.java* contains the following methods:

drawFrontEllipseGradient()

drawRearEllipseGradient()

drawEllipseGradient()

updateCoordinates()

The method *drawRearEllipseGradient()* draws a set of elliptic arcs in order to render the rear portion of the elliptic bowl.

The method *drawFrontEllipseGradient()* draws a set of elliptic arcs in order to render the front portion of the elliptic bowl.

The method *drawEllipseGradient()* is invoked by a loop in the *paint()* method and it invokes the preceding two methods in order to draw a partial ellipse with gradient shading.

The method *updateCoordinates()* updates the width of the open end of the elliptic bowl and ensures that its value lies between a minimum and maximum allowable value.

ON THE CD

The Java class *OscillatingPartialEllipse2.java* (Listing 12.7) demonstrates how to draw an elliptic bowl that partially rotates horizontally.

LISTING 12.7 OscillatingPartialEllipse2.java

```java
import java.awt.Color;
import java.awt.Graphics;
import java.awt.Image;

import java.io.Serializable;

public class OscillatingPartialEllipse2
        extends java.applet.Applet implements Serializable
{
    private Graphics offScreenBuffer = null;
    private Image    offScreenImage  = null;

    private int width  = 800;
    private int height = 500;

    private int basePointX = 200;
    private int basePointY = 200;

    private int eHeight = 128;
    private int eWidth  = 50;

    private int maxCount = 400;

    private int rVal = 0;
    private int gVal = 0;
    private int bVal = 0;

    // variables for ellipse...
    private double offsetY1 = 0;
    private double offsetY2 = 0;
    private int    offsetY3 = 0;

    private int outerEWidth  = 512;
    private int outerEHeight = 200;

    private int startX = -4*outerEWidth/9;
    private int endX   = 0;

    private int ellipseBasePointX = basePointX+100;
```

```java
private int ellipseBasePointY = basePointY;

private int minInnerEWidth = basePointX/4;
private int maxInnerEWidth = basePointX+200;

private int innerEWidth  = minInnerEWidth;
private int innerEHeight = outerEHeight;

private int xDelta      = 4;
private int xDirection = 1;

public OscillatingPartialEllipse2()
{
}

public void init()
{
   offScreenImage  = this.createImage(width, height);
   offScreenBuffer = offScreenImage.getGraphics();

} // init

public void update(Graphics gc)
{
   paint(gc);

} // update

public void paint(Graphics gc)
{
   for(int tick=0; tick<maxCount; tick++)
   {
      offScreenBuffer.setColor(Color.lightGray);
      offScreenBuffer.fillRect(0, 0, width, height);

      drawEllipseGradient(offScreenBuffer, gc);
   }

} // paint

public void drawEllipseGradient(Graphics gc,
                                Graphics gcMain)
{
   drawRearEllipseGradient(gc);
   drawFrontEllipseGradient(gc);

   gcMain.drawImage(offScreenImage, 0, 0, this);
   updateCoordinates();

} // drawEllipseGradient
```

```
public void drawRearEllipseGradient(Graphics gc)
{
   for(int x=startX; x<=endX; x++)
   {
      rVal = 255-(x+outerEWidth/2)*255/outerEWidth;
      gVal = 255-(x+outerEWidth/2)*255/outerEWidth;
      bVal = 255-(x+outerEWidth/2)*255/outerEWidth;

      offsetY1 = (outerEHeight/2)*(outerEHeight/2)*
                 ((outerEWidth/2)*(outerEWidth/2)-x*x);

      offsetY2 = offsetY1/((outerEWidth/2)*
                           (outerEWidth/2));

      offsetY3 = (int) Math.sqrt(offsetY2);

      gc.setColor(new Color(rVal, gVal, bVal));

      gc.drawArc(ellipseBasePointX+x,
                 ellipseBasePointY-offsetY3,
                 innerEWidth,
                 2*offsetY3,
                 -90,
                 180);
   }

} // drawRearEllipseGradient

public void updateCoordinates()
{
   innerEWidth += xDelta*xDirection;

   if( innerEWidth < minInnerEWidth )
   {
      innerEWidth = minInnerEWidth;
      xDirection *= -1;
   }

   if( innerEWidth > maxInnerEWidth )
   {
      innerEWidth = maxInnerEWidth;
      xDirection *= -1;
   }

} // updateCoordinates

public void drawFrontEllipseGradient(Graphics gc)
{
   for(int x=startX; x<=endX; x++)
   {
```

```
            rVal = 0;
            gVal = 0;
            bVal = 255-(x+outerEWidth/2)*255/outerEWidth;

            offsetY1 = (outerEHeight/2)*(outerEHeight/2)*
                        ((outerEWidth/2)*(outerEWidth/2)-x*x);

            offsetY2 = offsetY1/((outerEWidth/2)*
                                  (outerEWidth/2));

            offsetY3 = (int) Math.sqrt(offsetY2);

            gc.setColor(new Color(rVal, gVal, bVal));

            gc.drawArc(ellipseBasePointX+x,
                        ellipseBasePointY-offsetY3,
                        innerEWidth,
                        2*offsetY3,
                        90,
                        180);
        }

    } // drawFrontEllipseGradient

} // OscillatingPartialEllipse2
```

ON THE CD

The HTML file *OscillatingPartialEllipse2.html* (Listing 12.8) contains the code for launching *OscillatingPartialEllipse2.class*.

LISTING 12.8 OscillatingPartialEllipse2.html

```
<HTML>
<HEAD></HEAD>
<BODY>
<APPLET CODE=OscillatingPartialEllipse2.class WIDTH=800
HEIGHT=500></APPLET>
</BODY>
</HTML>
```

REMARKS

The preceding example draws an elliptic-shaped cone by splitting a set of ellipses vertically and then rendering the "rear" and the "front" portions by means of a set of elliptic arcs. The front elliptic arcs are blue, while the rear

elliptic arcs are rendered by means of a color gradient that uses different shades of gray, thereby creating the illusion that a light source is shining through the elliptic-shaped cone. The width, height, and location of each elliptic arc vary with each rendering of the graphics image in order to create an animation effect.

CONCEPT: DRAWING ROTATING ELLIPTIC BOWLS WITH ELLIPTIC ARCS

The next object (Figure 12.9 and Figure 12.10) consists of the following building blocks:

- An ellipse
- A spinning cylinder
- Two sets of elliptic arcs

FIGURE 12.9 A snapshot of a cylinder inside an elliptic bowl.

FIGURE 12.10 A subsequent snapshot of a cylinder inside an elliptic bowl.

The Java class *SpinningCylinderInOscillatingEllipse1.java* contains the following methods:

initializeWedges()

drawWedges()

colorOne()

colorTwo()

calculateEllipseXValue()

drawFrontEllipseGradient()

drawRearEllipseGradient()

drawEllipseGradient()

updateCoordinates()

The method *initializeWedges()* initializes the angles for the set of elliptic wedges, and the method *drawWedges()* draws the set of elliptic wedges.

The methods *colorOne()* and *colorTwo()* draw the front and rear, respectively, of the cylinder by using a color gradient in order to draw a set of horizontal lines.

The method *calculateEllipseXValue()* calculates the x-coordinate of a point on the ellipse for a given y value.

The method *drawRearEllipseGradient()* draws a set of elliptic arcs in order to render the rear portion of the elliptic bowl.

The method *drawFrontEllipseGradient()* draws a set of elliptic arcs in order to render the front portion of the elliptic bowl.

The method *drawEllipseGradient()* is invoked by a loop in the *paint()* method and it invokes the preceding two methods in order to draw a partial ellipse with gradient shading.

The method *updateCoordinates()* updates the width of the open end of the elliptic bowl and ensures that its value lies between a minimum and maximum allowable value.

ON THE CD

The Java class *SpinningCylinderInOscillatingEllipse1.java* (Listing 12.9) demonstrates how to draw an elliptic bowl, with an embedded spinning horizontal cylinder, that partially rotates horizontally.

LISTING 12.9 SpinningCylinderInOscillatingEllipse1.java

```java
import java.awt.Color;
import java.awt.Graphics;
import java.awt.Image;

import java.io.Serializable;

public class SpinningCylinderInOscillatingEllipse1
        extends java.applet.Applet implements Serializable
{
    private Graphics offScreenBuffer = null;
    private Image    offScreenImage  = null;

    private int width     = 800;
    private int height    = 500;

    private int basePointX = 200;
    private int basePointY = 200;

    private int rectangleWidth  = 200;
    private int rectangleHeight = 128;
```

```java
private int eHeight = rectangleHeight;
private int eWidth  = rectangleHeight/4;

private int maxCount = 200;

private int iTheta     = 0;
private int wedgeCount = 8;

private int[] wedgeAngle = new int[wedgeCount];

private Color[] wedgeColors = {
   Color.red, Color.green, Color.blue, Color.yellow,
   Color.magenta, Color.white, Color.darkGray
};

private int rVal = 0;
private int gVal = 0;
private int bVal = 0;

// variables for ellipse...
private double offsetY1 = 0;
private double offsetY2 = 0;
private int    offsetY3 = 0;

private int outerEWidth  = 512;
private int outerEHeight = 200;

private int innerEWidth  = outerEWidth/8;
private int innerEHeight = outerEHeight;

private int startX = -4*outerEWidth/9;
private int endX   = 0;

private int ellipseBasePointX = basePointX+100;
private int ellipseBasePointY = basePointY;

private int minEllipseBasePointX = 0;
private int maxEllipseBasePointX = 200;

private int xDelta     = 4;
private int xDirection = 1;

public SpinningCylinderInOscillatingEllipse1()
{
}

public void init()
{
   offScreenImage  = this.createImage(width, height);
```

```java
    offScreenBuffer = offScreenImage.getGraphics();

    initializeWedges();

} // init

public void initializeWedges()
{
    for(int w=0; w<wedgeCount; w++)
    {
        wedgeAngle[w] = w*360/wedgeCount;
    }

} // initializeWedges()

public void update(Graphics gc)
{
    paint(gc);

} // update

public void paint(Graphics gc)
{
    offScreenBuffer.setColor(Color.lightGray);
    offScreenBuffer.fillRect(0, 0, width, height);

    for(int tick=0; tick<maxCount; tick++)
    {
        drawEllipseGradient(offScreenBuffer, gc, tick);
    }

} // paint

public void drawEllipseGradient(Graphics gc,
                                Graphics gcMain,
                                int count)
{
    for(int currY=-rectangleHeight/2;
            currY<=rectangleHeight/2; currY++)
    {
        gc.setColor(Color.lightGray);
        gc.fillRect(0, 0, width, height);

        drawRearEllipseGradient(gc);

        colorOne(gc, currY, rectangleHeight/2, count);
        colorTwo(gc, -rectangleHeight/2, currY, count);

        drawFrontEllipseGradient(gc);
```

```
                        basePointY+currY);
    }

} // colorTwo

public void drawRearEllipseGradient(Graphics gc)
{
    for(int x=startX; x<=endX; x++)
    {
        rVal = 255-(x+outerEWidth/2)*255/outerEWidth;
        gVal = 255-(x+outerEWidth/2)*255/outerEWidth;
        bVal = 255-(x+outerEWidth/2)*255/outerEWidth;

        offsetY1 = (outerEHeight/2)*(outerEHeight/2)*
                    ((outerEWidth/2)*(outerEWidth/2)-x*x);

        offsetY2 = offsetY1/((outerEWidth/2)*
                            (outerEWidth/2));

        offsetY3 = (int) Math.sqrt(offsetY2);

        gc.setColor(new Color(rVal, gVal, bVal));

        gc.drawArc(ellipseBasePointX+x,
                    ellipseBasePointY-offsetY3,
                    innerEWidth,
                    2*offsetY3,
                    -90,
                    180);
    }

} // drawRearEllipseGradient

public void updateCoordinates()
{
    innerEWidth += xDelta*xDirection;

    if( innerEWidth < minEllipseBasePointX )
    {
        innerEWidth = minEllipseBasePointX;
        xDirection *= -1;
    }

    if( innerEWidth > maxEllipseBasePointX )
    {
        innerEWidth = maxEllipseBasePointX;
        xDirection *= -1;
    }

} // updateCoordinates
```

```
public void drawFrontEllipseGradient(Graphics gc)
{
    for(int x=startX; x<=endX; x++)
    {
        rVal = 0;
        gVal = 0;
        bVal = 255-(x+outerEWidth/2)*255/outerEWidth;

        offsetY1 = (outerEHeight/2)*(outerEHeight/2)*
                   ((outerEWidth/2)*(outerEWidth/2)-x*x);

        offsetY2 = offsetY1/((outerEWidth/2)*
                             (outerEWidth/2));

        offsetY3 = (int) Math.sqrt(offsetY2);

        gc.setColor(new Color(rVal, gVal, bVal));

        gc.drawArc(ellipseBasePointX+x,
                   ellipseBasePointY-offsetY3,
                   innerEWidth,
                   2*offsetY3,
                   90,
                   180);
    }

} // drawFrontEllipseGradient

} // SpinningCylinderInOscillatingEllipse1
```

The HTML file *SpinningCylinderInOscillatingEllipse1.html* (Listing 12.10) contains the code for launching *SpinningCylinderInOscillatingEllipse1.class*.

LISTING 12.10 SpinningCylinderInOscillatingEllipse1.html

```
<HTML>
<HEAD></HEAD>
<BODY>
<APPLET CODE=SpinningCylinderInOscillatingEllipse1.class WIDTH=800
HEIGHT=500></APPLET>
</BODY>
</HTML>
```

REMARKS

The preceding graphics image consists of three building blocks that are drawn in the following order: first the "rear" set of elliptic arcs, then a rotating cylinder, and finally the "front" set of elliptic arcs. Both sets of elliptic arcs are drawn in the same manner as the class *OscillatingPartialEllipse2.java*. The spinning cylinder consists of three parts: the "lid," the front portion, and the rear portion. The lid consists of a set of rotating elliptic arcs, and you've seen this code in previous examples. The front portion and the rear portion of the cylinder consist of a set of adjacent parallel line segments. By using color weighting while rendering the line segments, the cylinder appears to rotate at the same rate as its lid.

CD Library

ON THE CD

The CD-ROM for this chapter contains "class" files and HTML files that are needed for viewing the graphics images in the following Java files:

SpinningCylinder1.

LeftVBaseEConeLines1.

LeftVBaseECone1.

OscillatingPartialEllipse2.

SpinningCylinderIn
OscillatingEllipse1.

OscillatingPartialEllipse1.

RightVBaseSpinningCone
OscillatingSectorsOutline1.

SpinningCylinder2.

SpinningCylinder2Cone1.

SpinningCylinderColorized
Sectors1.

SpinningCylinderCone1.

SpinningCylinderInEllipse1.

SpinningCylinderEmbedded
InCube1.

SpinningCylinderInTwo
SidedSineEllipse1.

SpinningCylinder
MovingCone1.

SpinningCylinderOscillating
Outline1.

SpinningCylinderOutline1.

SpinningCylinderOval1.

SpinningCylinderRandom
Sectors1.

SpinningCylinderSectors1.

SpinningCylinderSectors2.

SpinningCylinderWith
Window1.

SUMMARY

This chapter presented techniques for combining ellipses and color gradients with animation. In previous chapters you've seen how to create graphics images by drawing a set of adjacent line segments. In this chapter, you saw how to apply that technique to sets of adjacent elliptic arcs. This chapter also introduced you to a more sophisticated animation technique that involves drawing nested objects. In particular, you can embed rotating cylinders in objects because cylinders are sets of adjacent parallel line segments, which means they can be drawn very fast.

ELLIPSES AND CUBIC FUNCTIONS

Overview

This chapter contains Java code that combines ellipses with cubic functions. Animation effects are efficient because ellipses are easy to draw and points on a cubic function can be computed quickly. Perhaps you're wondering why we're skipping quadratic equations and starting with cubic equations. The reason is aesthetic. While it's true that parabolas (also known as quadratic equations) are used to represent the motion of projectiles and falling objects, they do not produce interesting graphics images. On the other hand, cubic equations and higher degree polynomials can be drawn in many interesting ways.

Concept: Drawing Horizontal Elliptic Sectors with Cubic Functions

The next object (Figure 13.1) consists of the following building blocks:

- A cubic function for curvilinear shading
- A set of elliptic wedges

The Java class *VBaseCubicSectors1.java* contains the following methods:

drawCubicSectors()

drawWedges()

FIGURE 13.1 A cubic-based set of ellipses.

The method *drawCubicSectors()* contains a loop that calculates a point on a cubic function and then invokes the method *drawWedges()* in order to draw a set of elliptic wedges at the current point on the cubic function.

ON THE CD
The Java class *VBaseCubicSectors1.java* (Listing 13.1) demonstrates how to draw a set of ellipses with gradient shading that follow the path of a cubic function.

LISTING 13.1 VBaseCubicSectors1.java

```java
import java.awt.Color;
import java.awt.Graphics;
import java.awt.Image;

import java.io.Serializable;

public class VBaseCubicSectors1 extends
        java.applet.Applet implements Serializable
{
   private Graphics offScreenBuffer = null;
   private Image    offScreenImage  = null;

   private int width     = 800;
   private int height    = 500;

   private int basePointX = 100;
   private int basePointY = 400;

   private int currentX   = basePointX;
   private int currentY   = basePointY;

   private int startX     = 000;
   private int endX       = 400;
```

```java
private int deltaX     = (int)(endX-startX);

private double scaleFactor = 30;
private double vDelta = 0;

private int rectangleHeight = 240;

private int eWidth     = 40;
private int eHeight     = rectangleHeight;
private int eThickness = 10;

private int wedgeCount = 8;
private int iTheta     = 0;

private int[] wedgeAngle = new int[wedgeCount];

private Color[] wedgeColors = {
   Color.red, Color.green, Color.blue, Color.yellow,
   Color.magenta, Color.white, Color.darkGray
};

private int polynomialDegree  = 3;
private double[] polynomialRoots = {100, 200, 300};

public VBaseCubicSectors1()
{
}

public void init()
{
   offScreenImage  = this.createImage(width, height);
   offScreenBuffer = offScreenImage.getGraphics();

   initializeWedges();

} // init

public void initializeWedges()
{
   for(int w=0; w<wedgeCount; w++)
   {
      wedgeAngle[w] = w*360/wedgeCount;
   }

} // initializeWedges()

public void update(Graphics gc)
{
   paint(gc);
```

```
} // update

public void paint(Graphics gc)
{
   offScreenBuffer.setColor(Color.lightGray);
   offScreenBuffer.fillRect(0, 0, width, height);

   drawCubicSectors(offScreenBuffer);

   gc.drawImage(offScreenImage, 0, 0, this);

} // paint

public void drawWedges(Graphics gc, int xCoord)
{
   for(int w=0; w<wedgeCount; w++)
   {
      gc.setColor(wedgeColors[w%6]);

      gc.fillArc(xCoord,
                 basePointY-
                    rectangleHeight/2-(int)vDelta,
                 eWidth,
                 (int)(2*vDelta),
                 wedgeAngle[w]+iTheta,
                 360/wedgeCount);
   }

} // drawWedges

public void drawCubicSectors(Graphics gc)
{
   for(int x=startX; x<endX; x++)
   {
      vDelta = 1.0;
      for(int z=0; z<polynomialDegree; z++)
      {
         vDelta *= (x-polynomialRoots[z])/scaleFactor;
      }
      vDelta = Math.abs(vDelta);

      drawWedges(gc, currentX+x-startX);
   }

} // drawCubicSectors

} // VBaseCubicSectors1
```

The HTML file *VBaseCubicSectors1.html* (Listing 13.2) contains the code for launching *VBaseCubicSectors1.class*.

LISTING 13.2 VBaseCubicSectors1.html

```
<HTML>
<HEAD></HEAD>
<BODY>
<APPLET CODE=VBaseCubicSectors1.class WIDTH=800
HEIGHT=500></APPLET>
</BODY>
</HTML>
```

REMARKS

The preceding example contains straightforward code that shows you how to combine elliptic wedges with a cubic equation. This example can be used as a basis for creating your own variations. For instance, instead of calculating an index into a color array, you can use color weighting in order to create a subtler coloring effect.

Another point to keep in mind is that the method *drawCubicSectors()* computes the points on a cubic equation, which is acceptable in this particular case because there is no animation. In general, though, you can define another method (invoked inside the *init()* method) in which the points on the cubic equation are initialized. The recommended approach involves an array of pre-defined values for code for animation that involves multiple building blocks (e.g., polynomials, sine-based patterns, polar equations, etc.) because it will improve performance. As an added benefit, you can draw more objects or use more compute-intensive shading techniques that produce more sophisticated shading effects if your performance is good!

CONCEPT: DRAWING SPINNING HORIZONTAL ELLIPTIC SECTORS WITH CUBIC FUNCTIONS

The next object (Figure 13.2 and Figure 13.3) consists of the following building blocks:

- A cubic function for curvilinear shading
- A set of elliptic wedges

FIGURE 13.2 A snapshot of a spinning cubic-based set of ellipses.

FIGURE 13.3 A subsequent snapshot of a spinning cubic-based set of ellipses.

The Java class *VBaseSpinningCubicSectors2.java* contains the following methods:

initializeWedges()

drawSpinningCubicSectors()

drawWedges()

updateCoordinates()

The *paint()* method contains a loop that invokes two methods. The first method is *drawSpinningCubicSectors()*, which invokes *drawWedges()* in order to render a cone-like object of a given width. The second method is *updateCoordinates()*, which updates the variable scaleFactor. This variable varies between a minimum and maximum value and is used for calculating the coordinates of a set of ellipses with variable height. As this variable changes values, the graphics image appears to oscillate in height.

The variable iTheta determines the starting point for the set of elliptic wedges that are rendered. Since this variable incremented each time the method *drawWedges()* is invoked, a spinning effect is created.

ON THE CD

The Java class *VBaseSpinningCubicSectors2.java* (Listing 13.3) demonstrates how to draw a set of spinning elliptic sectors that follow the path of a cubic function.

LISTING 13.3 VBaseSpinningCubicSectors2.java

```
import java.awt.Color;
import java.awt.Graphics;
import java.awt.Image;

import java.io.Serializable;

public class VBaseSpinningCubicSectors2 extends
```

```java
      java.applet.Applet implements  Serializable
{
   private Graphics offScreenBuffer = null;
   private Image    offScreenImage  = null;

   private int width     = 800;
   private int height    = 500;

   private int basePointX = 100;
   private int basePointY = 400;

   private int currentX   = basePointX;
   private int currentY   = basePointY;

   private int maxCount   = 200;

   private int startX     = 0;
   private int endX       = 400;
   private int deltaX     = (int)(endX-startX);

   private double xScaleFactor = 40;
   private int xScaleFactorDirection = 1;
   private int xScaleFactorDelta     = 2;
   private int maxXScaleFactor       = 100;
   private int minXScaleFactor       = 20;

   private double vDelta = 0;

   private int rectangleHeight = 240;

   private int eWidth     = 40;
   private int eHeight     = rectangleHeight;
   private int eThickness = 10;

   private int wedgeCount = 8;
   private int iTheta     = 0;

   private int[] wedgeAngle = new int[wedgeCount];

   private Color[] wedgeColors = {
      Color.red, Color.green, Color.blue, Color.yellow,
      Color.magenta, Color.white, Color.darkGray
   };

   private int polynomialDegree  = 3;
   private double[] polynomialRoots = {100, 200, 300};

   public VBaseSpinningCubicSectors2()
   {
   }
```

```
public void init()
{
   offScreenImage  = this.createImage(width, height);
   offScreenBuffer = offScreenImage.getGraphics();

   initializeWedges();

} // init

public void initializeWedges()
{
   for(int w=0; w<wedgeCount; w++)
   {
      wedgeAngle[w] = w*360/wedgeCount;
   }

} // initializeWedges()

public void update(Graphics gc)
{
   paint(gc);

} // update

public void paint(Graphics gc)
{
   offScreenBuffer.setColor(Color.lightGray);
   offScreenBuffer.fillRect(0, 0, width, height);

   for(int tick=0; tick<maxCount; tick++)
   {
      offScreenBuffer.setColor(Color.lightGray);
      offScreenBuffer.fillRect(0, 0, width, height);

      drawSpinningCubicSectors(offScreenBuffer);
      gc.drawImage(offScreenImage, 0, 0, this);
      updateCoordinates();
   }

} // paint

public void updateCoordinates()
{
   xScaleFactor += xScaleFactorDirection*
                   xScaleFactorDelta;

   if( xScaleFactor > maxXScaleFactor )
   {
      xScaleFactor = maxXScaleFactor;
      xScaleFactorDirection *= -1;
```

```
      }

      if( xScaleFactor < minXScaleFactor )
      {
         xScaleFactor = minXScaleFactor;
         xScaleFactorDirection *= -1;
      }

   } // updateCoordinates

   public void drawWedges(Graphics gc, int xCoord)
   {
      if( ++iTheta > 360 ) { iTheta = 0; }

      for(int w=0; w<wedgeCount; w++)
      {
         gc.setColor(wedgeColors[w%6]);

         gc.fillArc(xCoord,
                    basePointY-
                        rectangleHeight/2-(int)vDelta,
                    eWidth,
                    (int)(2*vDelta),
                    wedgeAngle[w]+iTheta,
                    360/wedgeCount);
      }

   } // drawWedges

   public void drawSpinningCubicSectors(Graphics gc)
   {
      for(int x=startX; x<endX; x++)
      {
         vDelta = 1.0;
         for(int z=0; z<polynomialDegree; z++)
         {
            vDelta *= (x-polynomialRoots[z])/
                                xScaleFactor;
         }
         vDelta = Math.abs(vDelta);

         drawWedges(gc, currentX+x-startX);
      }

   } // drawSpinningCubicSectors

} // VBaseSpinningCubicSectors2
```

ON THE CD

The HTML file *VBaseSpinningCubicSectors2.html* (Listing 13.4) contains the code for launching *VBaseSpinningCubicSectors2.class*.

LISTING 13.4 VBaseSpinningCubicSectors2.html

```
<HTML>
<HEAD></HEAD>
<BODY>
<APPLET CODE=VBaseSpinningCubicSectors2.class WIDTH=800
HEIGHT=500></APPLET>
</BODY>
</HTML>
```

REMARKS

The preceding example combines elliptic wedges with a cubic equation and creates the illusion of motion simply by changing the value of the variable `scaleFactor`. You can control the speed of the animation effect by changing the minimum or maximum allowable values for `scaleFactor`. Another way to control the speed is to change the value of the variable `xScaleFactorDelta`, which affects the rate of increase (or decrease) of `scaleFactor`.

CONCEPT: DRAWING CONTRA-SPINNING HORIZONTAL ELLIPTIC SECTORS WITH CUBIC FUNCTIONS

The next object (Figure 13.4) consists of the following building blocks:

- A cubic function for curvilinear shading
- A set of elliptic wedges

The Java class *VBaseContraSpinningCubicSectors1.java* contains the following methods:

initializeThetaValues()

initializeWedges()

findInterval()

drawSpinningCubicSectors()

drawWedges()

updateCurrentThetaValue()

FIGURE 13.4 A contra-spinning cubic-based set of ellipses.

The method *initializeThetaValues()* initializes the values that are used in order to compute the direction of rotation for each "bulb."

The method *initializeWedges()* initializes the coordinates of the elliptic wedges.

The method *findInterval()* determines the current "bulb" for a given value of x.

The method *drawSpinningCubicSectors()* calculates a point on a cubic function and then invokes the method *drawWedges()* in order to draw a set of elliptic wedges at that point.

The method *updateCurrentThetaValue()* updates the coordinates of startTheta and endTheta for each elliptic wedge and then draws the elliptic wedge.

ON THE CD

The Java class *VBaseContraSpinningCubicSectors1.java* (Listing 13.5) demonstrates how to draw a set of contra-spinning ellipses with gradient shading that follow the path of a cubic function.

LISTING 13.5 VBaseContraSpinningCubicSectors1.java

```java
import java.awt.Color;
import java.awt.Graphics;
import java.awt.Image;

import java.io.Serializable;

public class VBaseContraSpinningCubicSectors1 extends
        java.applet.Applet implements Serializable
{
    private Graphics offScreenBuffer = null;
    private Image    offScreenImage  = null;
```

```
private int width       = 800;
private int height      = 500;

private int basePointX = 100;
private int basePointY = 250;

private int currentX    = basePointX;
private int currentY    = basePointY;

private int maxCount    = 200;

private int startX      = 0;
private int endX        = 400;
private int deltaX      = (int)(endX-startX);

private double scaleFactor = 30;
private double vDelta = 0;

private int rectangleHeight = 240;

private int eWidth      = 40;
private int eHeight     = rectangleHeight;
private int eThickness  = 10;

private int wedgeCount  = 8;
private int iTheta      = 0;
private int minTheta    = 10;
private int multiplier  = 10;

private int[] wedgeAngle = new int[wedgeCount];

private Color[] wedgeColors = {
   Color.red, Color.green, Color.blue, Color.yellow,
   Color.magenta, Color.white, Color.darkGray
};

private int polynomialDegree  = 3;
private double[] polynomialRoots = {100, 200, 300};

private int[] thetaValues =
                     new int[polynomialDegree+1];

private int[] thetaDeltas =
                     new int[polynomialDegree+1];

private int currentInterval  = 0;

public VBaseContraSpinningCubicSectors1()
{
}
```

```
public void init()
{
   offScreenImage  = this.createImage(width, height);
   offScreenBuffer = offScreenImage.getGraphics();

   initializeWedges();
   initializeThetaValues();

} // init

public void initializeThetaValues()
{
   int sign = 1;

   for(int p=0; p<polynomialDegree+1; p++)
   {
    //thetaDeltas[p] = ((int)
    //    (Math.random()*multiplier)+minTheta)*sign;

      thetaDeltas[p] = minTheta*sign;
      thetaValues[p] = thetaDeltas[p];
      sign *= -1;
   }

} // initializeThetaValues

public void initializeWedges()
{
   for(int w=0; w<wedgeCount; w++)
   {
      wedgeAngle[w] = w*360/wedgeCount;
   }

} // initializeWedges()

public void update(Graphics gc)
{
   paint(gc);

} // update

public void paint(Graphics gc)
{
   offScreenBuffer.setColor(Color.lightGray);
   offScreenBuffer.fillRect(0, 0, width, height);

   for(int tick=0; tick<maxCount; tick++)
   {
      drawSpinningCubicSectors(offScreenBuffer);
      gc.drawImage(offScreenImage, 0, 0, this);
```

```
      }

   } // paint

   public void updateCurrentThetaValue()
   {
      if( ++iTheta > 360 ) { iTheta = 0; }

      thetaValues[currentInterval] +=
                        thetaDeltas[currentInterval];

      if( thetaValues[currentInterval] > 360 )
      {
         thetaValues[currentInterval] = 0;
      }

      if( thetaValues[currentInterval] < -360 )
      {
         thetaValues[currentInterval] = 0;
      }

   } // updateCurrentThetaValue

   public void drawWedges(Graphics gc, int xCoord)
   {
      int startTheta = 0;
      int endTheta   = 360/wedgeCount;

      updateCurrentThetaValue();

      for(int w=0; w<wedgeCount; w++)
      {
         gc.setColor(wedgeColors[w%6]);

         if( thetaValues[currentInterval] > 0 )
         {
            startTheta = wedgeAngle[w]+
                           thetaValues[currentInterval];
            endTheta   = 360/wedgeCount;
         }
         else
         {
            startTheta = -(wedgeAngle[w]-
                           thetaValues[currentInterval]);
            endTheta = -360/wedgeCount;
         }

         gc.fillArc(xCoord,
                    basePointY-(int)vDelta,
                    eWidth,
```

```
                    (int)(2*vDelta),
                    startTheta,
                    endTheta);
    }

 } // drawWedges

 public void drawSpinningCubicSectors(Graphics gc)
 {
    for(int x=startX; x<endX; x++)
    {
       vDelta = 1.0;
       for(int z=0; z<polynomialDegree; z++)
       {
          vDelta *= (x-polynomialRoots[z])/scaleFactor;
       }
       vDelta = Math.abs(vDelta);

       drawWedges(gc, currentX+x-startX);
    }

 } // drawSpinningCubicSectors

} // VBaseContraSpinningCubicSectors1
```

ON THE CD

The HTML file *VBaseContraSpinningCubicSectors1.html* (Listing 13.6)
contains the code for launching *VBaseContraSpinningCubicSectors1.class*.

LISTING 13.6 VBaseContraSpinningCubicSectors1.html

```
<HTML>
<HEAD></HEAD>
<BODY>
<APPLET CODE=VBaseContraSpinningCubicSectors1.class WIDTH=800
HEIGHT=500></APPLET>
</BODY>
</HTML>
```

REMARKS

The preceding example combines elliptic wedges with a cubic equation
and creates a "twisting" effect by rotating adjacent portions of the cubic re-
gion in opposite directions. Notice how the method *initializeThetaValues()*
initializes the array thetaValues with an alternating set of positive and

negative numbers. These numbers are used in order to determine whether a given portion of the cubic shape rotates clockwise or counterclockwise.

CONCEPT: DRAWING OSCILLATING HORIZONTAL ELLIPTIC SECTOR WIRE FRAMES WITH CUBIC FUNCTIONS

The next object (Figure 13.5) consists of the following building blocks:

- A cubic function for curvilinear shading
- A set of elliptic wedges

FIGURE 13.5 An outline of a cubic-based set of ellipses.

The Java class *VBaseCubicOscillatingWireFrameSectors1.java* contains the following methods:

initializeWedges()
drawWedges()
drawCubicSectors()
drawCubicEllipse()
updateCoordinates()

The methods *initializeWedges()* and *drawWedges()* initialize and draw a set of elliptic wedges, respectively.

The method *drawCubicSectors()* calculates a point on a cubic function and then invokes the method *drawCubicEllipse()* in order to draw a set of elliptic wedges at that point.

The method *updateCoordinates()* updates the variable that specifies the horizontal gap between consecutive ellipses and ensures that its value lies between a minimum and maximum allowable value.

ON THE CD The Java class *VBaseCubicOscillatingWireFrameSectors1.java* (Listing 13.7) demonstrates how to draw a set of ellipses with gradient shading that follow the path of a cubic function.

LISTING 13.7 VBaseCubicOscillatingWireFrameSectors1.java

```java
import java.awt.Color;
import java.awt.Graphics;
import java.awt.Image;

import java.io.Serializable;

public class VBaseCubicOscillatingWireFrameSectors1
        extends java.applet.Applet implements Serializable
{
   private Graphics offScreenBuffer = null;
   private Image    offScreenImage  = null;

   private int width      = 800;
   private int height     = 500;

   private int basePointX = 100;
   private int basePointY = 400;

   private int currentX   = basePointX;
   private int currentY   = basePointY;

   private int startX      = 000;
   private int endX        = 400;
   private int deltaX      = (int)(endX-startX);

   private double scaleFactor = 30;
   private double vDelta = 0;

   private int eWidth      = 40;
   private int eHeight     = 240;
   private int eThickness  = 10;

   private int hGap = 8;
   private int minHGap = 2;
   private int maxHGap = 16;
   private int hGapDirection = 1;
   private int hGapDelta      = 2;
```

```java
private int polynomialDegree  = 3;
private double[] polynomialRoots = {100, 200, 300};

private int maxCount = 300;

private int iTheta      = 0;
private int wedgeCount = 8;

private int[] wedgeAngle = new int[wedgeCount];

private Color[] wedgeColors = {
   Color.red, Color.green, Color.blue, Color.yellow,
   Color.magenta, Color.white, Color.darkGray
};

private int rVal = 0;
private int gVal = 0;
private int bVal = 255;

public VBaseCubicOscillatingWireFrameSectors1()
{
}

public void init()
{
   offScreenImage  = this.createImage(width, height);
   offScreenBuffer = offScreenImage.getGraphics();

   initializeWedges();

} // init

public void initializeWedges()
{
   for(int w=0; w<wedgeCount; w++)
   {
      wedgeAngle[w] = w*360/wedgeCount;
   }

} // initializeWedges()

public void update(Graphics gc)
{
   paint(gc);

} // update

public void paint(Graphics gc)
{
   for(int tick=0; tick<maxCount; tick++)
```

```
      {
         offScreenBuffer.setColor(Color.lightGray);
         offScreenBuffer.fillRect(0, 0, width, height);

         drawCubicSectors(offScreenBuffer, 0);
         drawCubicSectors(offScreenBuffer, 1);

         gc.drawImage(offScreenImage, 0, 0, this);
         updateCoordinates();
      }

} // paint

public void updateCoordinates()
{
   hGap += hGapDirection*hGapDelta;

   if( hGap > maxHGap )
   {
      hGap = maxHGap;
      hGapDirection *= -1;
   }

   if( hGap < minHGap )
   {
      hGap = minHGap;
      hGapDirection *= -1;
   }

} // updateCoordinates

public void drawWedges(Graphics gc, int xCoord)
{
   for(int w=0; w<wedgeCount; w++)
   {
      gc.setColor(wedgeColors[w%6]);

      gc.fillArc(xCoord,
                 basePointY-eHeight/2-(int)vDelta,
                 eWidth,
                 (int)(2*vDelta),
                 wedgeAngle[w]+iTheta,
                 360/wedgeCount);
   }

} // drawWedges

public void drawCubicSectors(Graphics gc, int outline)
{
   for(int x=startX; x<endX; x++)
```

```
{
    vDelta = 1.0;
    for(int z=0; z<polynomialDegree; z++)
    {
        vDelta *= (x-polynomialRoots[z])/scaleFactor;
    }
    vDelta = Math.abs(vDelta);

    if( outline == 1 )
    {
        if( x % hGap == 0 )
        {
            drawEllipse(gc, x,
                        currentX+x-startX,
                        basePointY-eHeight/2-
                                (int)vDelta);
        }
    }
    else
    {
        drawWedges(gc, currentX+x-startX);
    }
}

} // drawCubicSectors

public void drawEllipse(Graphics gc, int x,
                        int xCoord, int yCoord)
{
    bVal = x*255/endX;
    gc.setColor(new Color(rVal, gVal, bVal));

    gc.drawArc(xCoord, yCoord,
               eWidth, (int)(2*vDelta),
               90, 180);

} // drawEllipse

} // VBaseCubicOscillatingWireFrameSectors1
```

ON THE CD

The HTML file *VBaseCubicOscillatingWireFrameSectors1.html* (Listing
13.8) contains the code for launching *VBaseCubicOscillatingWireFrame-
Sectors1.class*.

LISTING 13.8 VBaseCubicOscillatingWireFrameSectors1.html

```
<HTML>
<HEAD></HEAD>
```

```
<BODY>
<APPLET CODE=VBaseCubicOscillatingWireFrameSectors1.class WIDTH=800
HEIGHT=500></APPLET>
</BODY>
</HTML>
```

REMARKS

The preceding example combines elliptic wedges with a cubic equation and creates the appearance of an oscillating wire frame effect by changing the value of the variable hGap. You can control the speed of the animation effect by changing the minimum or maximum allowable values for hGap or by changing the value of the variable hGapDelta, which affects the rate of increase (or decrease) of hGap.

CONCEPT: DRAWING BANDS OF HORIZONTAL OSCILLATING ELLIPTIC SECTOR WIRE FRAMES WITH CUBIC FUNCTIONS

The next object (Figure 13.6 and Figure 13.7) consists of the following building blocks:

- A cubic function for curvilinear shading
- A set of elliptic wedges

The Java class *VBaseCubicOscillatingWireFrameBandSectors1.java* contains the following methods:

initializeWedges()

drawWedges()

FIGURE 13.6 A snapshot of an oscillating cubic-based set of ellipses.

FIGURE 13.7 A subsequent snapshot of an oscillating cubic-based set of ellipses.

drawCubicSectors()

drawEllipse()

updateCoordinates()

The methods *initializeWedges()* and *drawWedges()* initialize and draw a set of elliptic wedges, respectively.

The method *drawCubicSectors()* calculates a point on a cubic function and then invokes the method *drawEllipse()* in order to draw a set of elliptic wedges at that point.

The method *updateCoordinates()* updates the variable that specifies the horizontal gap between consecutive ellipses and ensures that its value lies between a minimum and maximum allowable value.

ON THE CD

The Java class *VBaseCubicOscillatingWireFrameBandSectors1.java* (Listing 13.9) demonstrates how to draw a set of ellipses with gradient shading that follow the path of a cubic function.

LISTING 13.9 VBaseCubicOscillatingWireFrameBandSectors1.java

```java
import java.awt.Color;
import java.awt.Graphics;
import java.awt.Image;

import java.io.Serializable;

public class VBaseCubicOscillatingWireFrameBandSectors1
        extends java.applet.Applet implements Serializable
{
    private Graphics offScreenBuffer = null;
    private Image    offScreenImage  = null;

    private int width        = 800;
    private int height       = 500;

    private int basePointX = 100;
    private int basePointY = 400;

    private int currentX   = basePointX;
    private int currentY   = basePointY;

    private int startX     = 0;
    private int endX       = 400;
    private int deltaX     = (int)(endX-startX);

    private double scaleFactor = 30;
    private double vDelta = 0;
```

```
private int hGap = 8;
private int minHGap = 2;
private int maxHGap = 16;
private int hGapDirection = 1;
private int hGapDelta    = 2;

private int eWidth    = 40;
private int eHeight   = 240;
private int eThickness = minHGap;

private int polynomialDegree  = 3;
private double[] polynomialRoots = {100, 200, 300};

private int maxCount = 300;

private int iTheta     = 0;
private int wedgeCount = 8;

private int[] wedgeAngle = new int[wedgeCount];

private Color[] wedgeColors = {
   Color.red, Color.green, Color.blue, Color.yellow,
   Color.magenta, Color.white, Color.darkGray
};

private int rVal = 0;
private int gVal = 0;
private int bVal = 255;

public VBaseCubicOscillatingWireFrameBandSectors1()
{
}

public void init()
{
   offScreenImage  = this.createImage(width, height);
   offScreenBuffer = offScreenImage.getGraphics();

   initializeWedges();

} // init

public void initializeWedges()
{
   for(int w=0; w<wedgeCount; w++)
   {
      wedgeAngle[w] = w*360/wedgeCount;
   }

} // initializeWedges()
```

```
public void update(Graphics gc)
{
   paint(gc);

} // update

public void paint(Graphics gc)
{
   for(int tick=0; tick<maxCount; tick++)
   {
      offScreenBuffer.setColor(Color.lightGray);
      offScreenBuffer.fillRect(0, 0, width, height);

      drawCubicSectors(offScreenBuffer, 0);
      drawCubicSectors(offScreenBuffer, 1);

      gc.drawImage(offScreenImage, 0, 0, this);
      updateCoordinates();
   }

} // paint

public void updateCoordinates()
{
   hGap += hGapDirection*hGapDelta;

   if( hGap > maxHGap )
   {
      hGap = maxHGap;
      hGapDirection *= -1;
   }

   if( hGap < minHGap )
   {
      hGap = minHGap;
      hGapDirection *= -1;
   }

} // updateCoordinates

public void drawWedges(Graphics gc, int xCoord)
{
   for(int w=0; w<wedgeCount; w++)
   {
      gc.setColor(wedgeColors[w%6]);

      gc.fillArc(xCoord,
                 basePointY-eHeight/2-(int)vDelta,
                 eWidth,
                 (int)(2*vDelta),
```

```
                        wedgeAngle[w]+iTheta,
                        360/wedgeCount);
      }

   } // drawWedges

   public void drawCubicSectors(Graphics gc, int outline)
   {
      for(int x=startX; x<endX; x++)
      {
         vDelta = 1.0;
         for(int z=0; z<polynomialDegree; z++)
         {
            vDelta *= (x-polynomialRoots[z])/scaleFactor;
         }
         vDelta = Math.abs(vDelta);

         if( outline == 1 )
         {
            if( x % hGap == 0 )
            {
               drawEllipse(gc, x,
                           currentX+x-startX,
                           basePointY-eHeight/2-
                                   (int)vDelta);
            }
         }
         else
         {
            drawWedges(gc, currentX+x-startX);
         }
      }

   } // drawCubicSectors

   public void drawEllipse(Graphics gc, int x,
                           int xCoord, int yCoord)
   {
      gc.setColor(wedgeColors[x%6]);

      for(int z=0; z<eThickness; z++)
      {
         gc.drawArc(xCoord+z, yCoord,
                    eWidth, (int)(2*vDelta),
                    90, 180);
      }

   } // drawEllipse

} // VBaseCubicOscillatingWireFrameBandSectors1
```

The HTML file *VBaseCubicOscillatingWireFrameBandSectors1.html* (Listing 13.10) contains the code for launching *VBaseCubicOscillatingWireFrameBandSectors1.class*.

LISTING 13.10 VBaseCubicOscillatingWireFrameBandSectors1.html

```
<HTML>
<HEAD></HEAD>
<BODY>
<APPLET CODE=VBaseCubicOscillatingWireFrameBandSectors1.class
WIDTH=800 HEIGHT=500></APPLET>
</BODY>
</HTML>
```

REMARKS

The preceding example combines elliptic wedges with a cubic equation and creates the appearance of an oscillating wire frame "band" effect by changing the value of the variable hGap. This effect involves drawing a set of adjacent elliptic arcs that creates a more vivid textural effect than a wire frame effect. You can control the speed of the animation effect by changing the minimum or maximum allowable values for hGap or by changing the value of the variable hGapDelta, which affects the rate of increase (or decrease) of hGap.

CD LIBRARY

The CD-ROM for this chapter contains "class" files and HTML files that are needed for viewing the graphics images in the following Java files:

VBaseCubicSectors1. VBaseSpinningCubicSectors2. VBaseContraSpinningCubic
 Sectors1.

VBaseCubicOscillatingWire
FrameSectors1.

VBaseCubicOscillating
WireFrameBandSectors1.

VBaseContraSpinning
CubicSectors2.

VBaseCubicGradient1.

VBaseCubicOscillating
SectorsOutline1.

VBaseCubicSectorsOutline1.

VBaseCubicWireFrame
Sectors1.

VBaseSpinningCubicSectors1.

SUMMARY

This chapter contains Java code for drawing the following objects:

- Horizontal ellipse-shaped gradients via cubic functions
- Horizontal ellipse-shaped sectors via cubic functions
- Horizontal spiral sectors via cubic functions

- Horizontal spinning sectors via cubic functions
- Horizontal contra-spinning sectors via cubic functions
- Horizontal variable-width contra-spinning sectors via cubic functions

This chapter introduced techniques for rendering graphics images that are based on a combination of cubic functions and ellipses. You can create rather nice animation effects simply by varying a scale factor associated with a cubic function. Spinning effects involving elliptic sectors are very easy to create; i.e., increment a variable that determines the "start" angle of a set of colored elliptic sectors or wedges.

ELLIPSES AND LAVA-LIKE PATTERNS

OVERVIEW

This chapter contains Java code that combines ellipses with color gradients that produce some interesting and unusual effects. Some of the graphics images in this chapter might remind you of the lava lamps that were popular a few years ago (hence the title of this chapter). You might be surprised to know that some clever people figured out a way to generate random numbers by means of lava lamps. If that intrigues you, surf the Web for more details.

The key idea for the Java code in this chapter revolves around drawing multiple adjacent ellipses in conjunction with color weighting. You can create oscillating wire frame effects using techniques that you've seen in previous chapters.

CONCEPT: DRAWING OSCILLATING ELLIPTIC PATTERNS

The next object (Figure 14.1 and Figure 14.2) consists of the following building blocks:

- An ellipse for curvilinear shading
- A set of ellipses

The Java class *OscillatingEllipse1.java* contains the following methods:

drawEllipseGradient()
drawEllipses()
updateCoordinates()

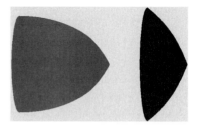

FIGURE 14.1 A snapshot of an oscillating ellipse.

FIGURE 14.2 A subsequent snapshot of an oscillating ellipse.

The method *drawEllipseGradient()* draws a set of ellipses by means of a loop that invokes *drawEllipses()* which then calculates the y-coordinate of each point on a fixed ellipse.

The method *updateCoordinates()* updates the length of the horizontal axis of the fixed ellipse and ensures that its value lies between a minimum and maximum allowable value.

ON THE CD

The Java class *OscillatingEllipse1.java* (Listing 14.1) demonstrates how to draw a set of ellipses that create a lava-like pattern.

LISTING 14.1 OscillatingEllipse1.java

```java
import java.awt.Color;
import java.awt.Graphics;
import java.awt.Image;

import java.io.Serializable;

public class OscillatingEllipse1 extends
      java.applet.Applet implements Serializable
{
   private Graphics offScreenBuffer = null;
   private Image    offScreenImage  = null;

   private int width  = 800;
   private int height = 500;

   private int basePointX = 100;
   private int basePointY = 200;

   private int eHeight = 128;
   private int eWidth  = 50;

   private int maxCount = 600;
```

```java
private int rVal = 0;
private int gVal = 0;
private int bVal = 0;

// variables for ellipse...
private double offsetY1 = 0;
private double offsetY2 = 0;
private int    offsetY3 = 0;

private int outerEWidth  = 512;
private int outerEHeight = 300;

private int innerEWidth  = outerEWidth/8;
private int innerEHeight = outerEHeight;

private int majorAxis = 0;

private int ellipseBasePointX = basePointX+100;
private int ellipseBasePointY = basePointY;

private int minInnerEWidth = 0;
private int maxInnerEWidth = 600;

private int xDelta     = 2;
private int xDirection = 1;

public OscillatingEllipse1()
{
}

public void init()
{
   offScreenImage  = this.createImage(width, height);
   offScreenBuffer = offScreenImage.getGraphics();

} // init

public void update(Graphics gc)
{
   paint(gc);

} // update

public void paint(Graphics gc)
{
   for(int tick=0; tick<maxCount; tick++)
   {
      offScreenBuffer.setColor(Color.lightGray);
      offScreenBuffer.fillRect(0, 0, width, height);
```

```
            drawEllipseGradient(offScreenBuffer, gc);
    }

} // paint

public void drawEllipseGradient(Graphics gc,
                                Graphics gcMain)
{
    drawEllipses(gc);
    gcMain.drawImage(offScreenImage, 0, 0, this);
    updateCoordinates();

} // drawEllipseGradient

public void drawEllipses(Graphics gc)
{
    for(int x=0; x<majorAxis; x++)
    {
        offsetY1 = (outerEHeight/2)*(outerEHeight/2)*
                      ((majorAxis/2)*(majorAxis/2)-x*x);

        offsetY2 = offsetY1/
                      ((majorAxis/2)*(majorAxis/2));

        offsetY3 = (int) Math.sqrt(offsetY2);

        bVal = 0;
        gVal = 0;
        rVal = 255-x*255/majorAxis;

        gc.setColor(new Color(rVal, gVal, bVal));

        gc.fillOval(basePointX+x,
                    basePointY-offsetY3,
                    eWidth,
                    2*offsetY3);
    }

} // drawEllipses

public void updateCoordinates()
{
    majorAxis += xDelta*xDirection;
    if( majorAxis < minInnerEWidth )
    {
        majorAxis = minInnerEWidth;
        xDirection *= -1;
    }

    if( majorAxis > maxInnerEWidth )
```

```
   {
      majorAxis = maxInnerEWidth;
      xDirection *= -1;
   }

   innerEWidth += xDelta*xDirection;

   if( innerEWidth < minInnerEWidth )
   {
      innerEWidth = minInnerEWidth;
      xDirection *= -1;
   }

   if( innerEWidth > maxInnerEWidth )
   {
      innerEWidth = maxInnerEWidth;
      xDirection *= -1;
   }

  } // updateCoordinates

} // OscillatingEllipse1
```

ON THE CD

The HTML file *OscillatingEllipse1.html* (Listing 14.2) contains the code for launching *OscillatingEllipse1.class*.

LISTING 14.2 OscillatingEllipse1.html

```
<HTML>
<HEAD></HEAD>
<BODY>
<APPLET CODE=OscillatingEllipse1.class WIDTH=800
HEIGHT=500></APPLET>
</BODY>
</HTML>
```

REMARKS

The preceding example forms the basis for the lava-like patterns in this chapter. Notice how the method *drawEllipses()* draws multiple adjacent ellipses based on the value of the variable `majorAxis` during a given iteration. This method contains a loop that modifies the "base point" and the height of each ellipse. The loop is controlled by the value of the variable

`majorAxis`, which oscillates between a minimum and maximum allowable value in order to create the illusion of motion. Moreover, the color weighting in each invocation of *drawEllipses()* iteration is based on the value of `majorAxis`, which creates a slightly rippling or ribbed effect as each set of ellipses is rendered on the screen.

The Java code for the preceding example produces an unexpected effect; i.e., the image on the right. Can you figure out why there are two images instead of one?

CONCEPT: DRAWING ELLIPTIC LAVA

The next object (Figure 14.3) consists of the following building blocks:

- An ellipse for curvilinear shading
- A set of ellipses

FIGURE 14.3 An ellipse-based "lava" pattern.

The Java class *EllipticLava1.java* contains the following methods:

drawEllipseGradient()
drawEllipses()
updateCoordinates()

The method *drawEllipseGradient()* draws a set of ellipses by means of a loop that invokes *drawEllipses()* which then calculates the y-coordinate of each point on a fixed ellipse.

The method *updateCoordinates()* updates the length of the horizontal axis of the fixed ellipse and ensures that its value lies between a minimum and maximum allowable value.

The Java class *EllipticLava1.java* (Listing 14.3) demonstrates how to draw a lava-like pattern based on a set of ellipses.

LISTING 14.3 EllipticLava1.java

```java
import java.awt.Color;
import java.awt.Graphics;
import java.awt.Image;

import java.io.Serializable;

public class EllipticLava1 extends java.applet.Applet
      implements Serializable
{
   private Graphics offScreenBuffer = null;
   private Image    offScreenImage  = null;

   private int width  = 800;
   private int height = 500;

   private int basePointX = 100;
   private int basePointY = 200;

   private int eHeight = 128;
   private int eWidth  = 100;

   private int maxCount = 1000;

   private int rVal = 0;
   private int gVal = 0;
   private int bVal = 0;

   // variables for ellipse...
   private double offsetY1 = 0;
   private double offsetY2 = 0;
   private int    offsetY3 = 0;

   private int outerEWidth  = 512;
   private int outerEHeight = 300;

   private int innerEWidth  = outerEWidth/8;
   private int innerEHeight = outerEHeight;

   private int majorAxis = 0;

   private int minInnerEWidth = 0;
   private int maxInnerEWidth = 600;

   private int xDelta     = 2;
```

```
private int xDirection = 1;

public EllipticLava1()
{
}

public void init()
{
   offScreenImage  = this.createImage(width, height);
   offScreenBuffer = offScreenImage.getGraphics();

} // init

public void update(Graphics gc)
{
   paint(gc);

} // update

public void paint(Graphics gc)
{
   for(int tick=0; tick<maxCount; tick++)
   {
      offScreenBuffer.setColor(Color.lightGray);
      offScreenBuffer.fillRect(0, 0, width, height);

      drawEllipseGradient(offScreenBuffer, gc);
   }

} // paint

public void drawEllipseGradient(Graphics gc,
                                Graphics gcMain)
{
   drawEllipses(gc);
   gcMain.drawImage(offScreenImage, 0, 0, this);
   updateCoordinates();

} // drawEllipseGradient

public void drawEllipses(Graphics gc)
{
   for(int x=0; x<majorAxis; x++)
   {
      offsetY1 = (outerEHeight/2)*(outerEHeight/2)*
                 ((majorAxis/2)*(majorAxis/2)-x*x);

      offsetY2 = offsetY1/
                     ((majorAxis/2)*(majorAxis/2));
```

```
        offsetY3 = (int) Math.sqrt(offsetY2);

        bVal = 0;
        gVal = 0;
        rVal = 255-x*255/majorAxis;

        gc.setColor(new Color(rVal, gVal, bVal));

        gc.fillOval(basePointX+x,
                    basePointY-offsetY3,
                    2*offsetY3,
                    eWidth);
    }

} // drawEllipses

public void updateCoordinates()
{
    majorAxis += xDelta*xDirection;
    if( majorAxis < minInnerEWidth )
    {
        majorAxis = minInnerEWidth;
        xDirection *= -1;
    }

    if( majorAxis > maxInnerEWidth )
    {
        majorAxis = maxInnerEWidth;
        xDirection *= -1;
    }

    innerEWidth += xDelta*xDirection;

    if( innerEWidth < minInnerEWidth )
    {
        innerEWidth = minInnerEWidth;
        xDirection *= -1;
    }

    if( innerEWidth > maxInnerEWidth )
    {
        innerEWidth = maxInnerEWidth;
        xDirection *= -1;
    }

} // updateCoordinates

} // EllipticLava1
```

The HTML file *EllipticLava1.html* (Listing 14.4) contains the code for launching *EllipticLava1.class*.

LISTING 14.4 EllipticLava1.html
```
<HTML>
<HEAD></HEAD>
<BODY>
<APPLET CODE=EllipticLava1.class WIDTH=800 HEIGHT=500></APPLET>
</BODY>
</HTML>
```

REMARKS

The preceding graphics image has more of a lava-like appearance. The key method is *drawEllipses()*, which draws multiple adjacent ellipses based on the value of the variable `majorAxis` during a given iteration. This method contains a loop that modifies the "base point" and the width of each ellipse. The loop is controlled by the value of the variable `majorAxis`, which oscillates between a minimum and maximum allowable value in order to create the illusion of motion. Moreover, the color weighting in each invocation of *drawEllipses()* iteration is based on the value of `majorAxis`, which creates a slightly rippling or ribbed effect as each set of ellipses is rendered on the screen.

Contrast the code in the method *drawEllipses()* with the code in *drawEllipses()* in *OscillatingEllipse1.java*. Both methods change the "base point" of each ellipse; however, one also changes the height of the ellipse whereas the other changes the width of the ellipse. Despite the similarity of the code, this small change is sufficient to produce a markedly different effect. Experiment with your own techniques for changing the width and the height based on conditional logic.

CONCEPT: ELLIPTIC LAVA AND COLORS

The next object (Figure 14.4) consists of the following building blocks:

- An ellipse for curvilinear shading
- A set of ellipses

The Java class *EllipticLava2.java* contains the following methods:

FIGURE 14.4 A multi-colored ellipse-based "lava" pattern.

drawEllipseGradient()

drawEllipses()

updateCoordinates()

The method *drawEllipseGradient()* draws a set of ellipses by means of a loop that invokes *drawEllipses()* which then calculates the y-coordinate of each point on a fixed ellipse.

The method *updateCoordinates()* updates the length of the horizontal axis of the fixed ellipse and ensures that its value lies between a minimum and maximum allowable value.

The Java class *EllipticLava2.java* (Listing 14.5) demonstrates how to draw a colored lava-like pattern based on a set of ellipses.

ON THE CD

LISTING 14.5 EllipticLava2.java

```java
import java.awt.Color;
import java.awt.Graphics;
import java.awt.Image;

import java.io.Serializable;

public class EllipticLava2 extends java.applet.Applet
      implements Serializable
{
   private Graphics offScreenBuffer = null;
   private Image    offScreenImage  = null;

   private int width  = 800;
   private int height = 500;

   private int basePointX = 100;
   private int basePointY = 200;
```

```
private int eHeight = 128;
private int eWidth  = 100;

private int minEWidth  = 10;
private int maxEWidth  = 100;

private int maxCount = 1000;

private int hBandCount = 8;

private Color[] ellipseColors = {
   Color.red, Color.green, Color.blue,
   Color.yellow, Color.white
};

private int rVal = 0;
private int gVal = 0;
private int bVal = 0;

// variables for ellipse...
private double offsetY1 = 0;
private double offsetY2 = 0;
private int    offsetY3 = 0;

private int outerEWidth  = 512;
private int outerEHeight = 300;

private int innerEWidth  = outerEWidth/8;
private int innerEHeight = outerEHeight;

private int majorAxis = 0;

private int minInnerEWidth = 0;
private int maxInnerEWidth = 600;

private int xDelta     = 2;
private int xDirection = 1;

public EllipticLava2()
{
}

public void init()
{
   offScreenImage  = this.createImage(width, height);
   offScreenBuffer = offScreenImage.getGraphics();

} // init

public void update(Graphics gc)
```

```
{
   paint(gc);

} // update

public void paint(Graphics gc)
{
   offScreenBuffer.setColor(Color.lightGray);
   offScreenBuffer.fillRect(0, 0, width, height);

   for(int tick=0; tick<maxCount; tick++)
   {
      offScreenBuffer.setColor(Color.lightGray);
      offScreenBuffer.fillRect(0, 0, width, height);

      drawEllipseGradient(offScreenBuffer, gc);
   }

} // paint

public void drawEllipseGradient(Graphics gc,
                                Graphics gcMain)
{
   drawEllipses(gc);
   gcMain.drawImage(offScreenImage, 0, 0, this);
   updateCoordinates();

} // drawEllipseGradient

public void drawEllipses(Graphics gc)
{
   for(int x=0; x<majorAxis; x++)
   {
      offsetY1 = (outerEHeight/2)*(outerEHeight/2)*
                   ((majorAxis/2)*(majorAxis/2)-x*x);

      offsetY2 = offsetY1/
                   ((majorAxis/2)*(majorAxis/2));

      offsetY3 = (int) Math.sqrt(offsetY2);

      bVal = 0;
      gVal = 0;
      rVal = 255-x*255/majorAxis;

      gc.setColor(new Color(rVal, gVal, bVal));

      gc.fillOval(basePointX+x,
                  basePointY-offsetY3,
                  2*offsetY3,
```

```
                      eWidth);

        if( x % hBandCount == 0 )
        {
           gc.setColor(ellipseColors[x%5]);

           gc.drawOval(basePointX+x,
                       basePointY-offsetY3,
                       2*offsetY3,
                       eWidth);
        }
    }

} // drawEllipses

public void updateCoordinates()
{
    majorAxis += xDelta*xDirection;
    if( majorAxis < minInnerEWidth )
    {
       majorAxis = minInnerEWidth;
       xDirection *= -1;
    }

    if( majorAxis > maxInnerEWidth )
    {
       majorAxis = maxInnerEWidth;
       xDirection *= -1;
    }

    innerEWidth += xDelta*xDirection;

    if( innerEWidth < minInnerEWidth )
    {
       innerEWidth = minInnerEWidth;
       xDirection *= -1;
    }

    if( innerEWidth > maxInnerEWidth )
    {
       innerEWidth = maxInnerEWidth;
       xDirection *= -1;
    }

   } // updateCoordinates

} // EllipticLava2
```

The HTML file *EllipticLava2.html* (Listing 14.6) contains the code for launching *EllipticLava1.class*.

LISTING 14.6 EllipticLava2.html

```
<HTML>
<HFAD></HEAD>
<BODY>
<APPLET CODE=EllipticLava2.class WIDTH=800 HEIGHT=500></APPLET>
</BODY>
</HTML>
```

REMARKS

The previous example, which adds conditional logic in order to create a multi-colored effect, is a variation of the code in *EllipticLava1.java*. Notice that the technique in this example resembles the wire frame technique. Instead of drawing a subset of ellipses to create an outline effect, this example draws all the ellipses and then superimposes them with an additional subset of ellipses.

As in previous examples, the key method in this example is *drawEllipses()*, which draws multiple adjacent ellipses based on the value of the variable majorAxis during a given iteration. This method contains a loop that modifies the "base point" and the width of each ellipse. The loop is controlled by the value of the variable majorAxis, which oscillates between a minimum and maximum allowable value in order to create the illusion of motion.

Notice how the coloring in this example creates a more pronounced lava-like image. Did you also notice the set of vertical parallel line segments? (See if you can figure out why they are rendered.) When the rightmost image is fully drawn, it flickers briefly before receding upward. Since this flickering effect occurs at a different rate from the rate of motion, the graphics image has a more interesting effect.

CONCEPT: ELLIPTIC FLOW LAVA AND COLORS

The next object (Figure 14.5) consists of the following building blocks:

- An ellipse for curvilinear shading
- A set of ellipses

FIGURE 14.5 An oval-shaped "lava" pattern.

The Java class *EllipticColoredLava3.java* contains the following methods:

drawEllipseGradient()
drawEllipses()
updateCoordinates()

The method *drawEllipseGradient()* draws a set of ellipses by means of a loop that invokes *drawEllipses()* which then calculates the y-coordinate of each point on a fixed ellipse.

The method *updateCoordinates()* updates the length of the horizontal axis of the fixed ellipse and ensures that its value lies between a minimum and maximum allowable value.

ON THE CD

The Java class *EllipticColoredLava3.java* (Listing 14.7) demonstrates how to draw a colored lava-like pattern based on a set of ellipses.

LISTING 14.7 EllipticColoredLava3.java

```
import java.awt.Color;
import java.awt.Graphics;
import java.awt.Image;

import java.io.Serializable;

public class EllipticColoredLava3 extends
        java.applet.Applet implements Serializable
{
    private Graphics offScreenBuffer = null;
    private Image    offScreenImage  = null;

    private int width  = 800;
    private int height = 500;
```

```
private int basePointX = 100;
private int basePointY = 200;

private int eHeight = 128;
private int eWidth  = 100;

private int minEWidth  = 10;
private int maxEWidth  = 100;

private int maxCount = 1000;

private int hBandCount = 8;

private Color[] ellipseColors = {
   Color.red, Color.green,
   Color.blue, Color.yellow, Color.white
};

private int rVal = 0;
private int gVal = 0;
private int bVal = 0;

// variables for ellipse...
private double offsetY1 = 0;
private double offsetY2 = 0;
private int    offsetY3 = 0;

private int outerEWidth  = 512;
private int outerEHeight = 300;

private int innerEWidth  = outerEWidth/8;
private int innerEHeight = outerEHeight;

private int majorAxis = 0;

private int minInnerEWidth = 0;
private int maxInnerEWidth = 600;

private int xDelta     = 2;
private int xDirection = 1;

public EllipticColoredLava3()
{
}

public void init()
{
   offScreenImage  = this.createImage(width, height);
   offScreenBuffer = offScreenImage.getGraphics();
```

```
} // init

public void update(Graphics gc)
{
   paint(gc);

} // update

public void paint(Graphics gc)
{
   offScreenBuffer.setColor(Color.lightGray);
   offScreenBuffer.fillRect(0, 0, width, height);

   for(int tick=0; tick<maxCount; tick++)
   {
      offScreenBuffer.setColor(Color.lightGray);
      offScreenBuffer.fillRect(0, 0, width, height);

      drawEllipseGradient(offScreenBuffer, gc);
   }

} // paint

public void drawEllipseGradient(Graphics gc,
                                Graphics gcMain)
{
   drawEllipses(gc);
   gcMain.drawImage(offScreenImage, 0, 0, this);
   updateCoordinates();

} // drawEllipseGradient

public void drawEllipses(Graphics gc)
{
   for(int x=0; x<majorAxis; x++)
   {
      offsetY1 = (outerEHeight/2)*(outerEHeight/2)*
                 ((majorAxis/2)*(majorAxis/2)-x*x);

      offsetY2 = offsetY1/
                    ((majorAxis/2)*(majorAxis/2));

      offsetY3 = (int) Math.sqrt(offsetY2);

      bVal = 0;
      gVal = 0;
      rVal = x*255/majorAxis;

      gc.setColor(new Color(rVal, gVal, bVal));
```

```
        gc.fillOval(basePointX+x,
                    basePointY-offsetY3,
                    1*offsetY3,
                    2*offsetY3);

        if( x % hBandCount == 0 )
        {
           gc.setColor(ellipseColors[x%5]);
           gc.drawOval(basePointX+x,
                       basePointY-offsetY3,
                       1*offsetY3,
                       2*offsetY3);
        }
     }

  } // drawEllipses

  public void updateCoordinates()
  {
     majorAxis += xDelta*xDirection;
     if( majorAxis < minInnerEWidth )
     {
        majorAxis = minInnerEWidth;
        xDirection *= -1;
     }

     if( majorAxis > maxInnerEWidth )
     {
        majorAxis = maxInnerEWidth;
        xDirection *= -1;
     }

     innerEWidth += xDelta*xDirection;

     if( innerEWidth < minInnerEWidth )
     {
        innerEWidth = minInnerEWidth;
        xDirection *= -1;
     }

     if( innerEWidth > maxInnerEWidth )
     {
        innerEWidth = maxInnerEWidth;
        xDirection *= -1;
     }

  } // updateCoordinates

} // EllipticColoredLava3
```

ON THE CD

The HTML file *EllipticColoredLava3.html* (Listing 14.8) contains the code for launching *EllipticColoredLava3.class*.

LISTING 14.8 EllipticColoredLava3.html

```
<HTML>
<HEAD></HEAD>
<BODY>
<APPLET CODE=EllipticColoredLava3.class WIDTH=800
HEIGHT=500></APPLET>
</BODY>
</HTML>
```

REMARKS

The previous example combines two animation techniques with conditional logic in order to create a multi-colored effect. This technique draws an outer set of large ellipses of diminishing height and also an inner set of small ellipses that expand outward. The conditional logic is used to draw the inner subset of ellipses of which the color is based on a computed index into an array of colors.

As in previous examples, the key method in this example is *drawEllipses()*, which draws multiple adjacent ellipses based on the value of the variable majorAxis during a given iteration. This method contains a loop that modifies the "base point," the width, and the height of each ellipse. The loop is controlled by the value of the variable majorAxis, which oscillates between a minimum and maximum allowable value in order to create the illusion of motion. You can create your own variations by modifying the coefficients of the width and height of each ellipse contained in the loop in the method *drawEllipses()*.

CD LIBRARY

ON THE CD

The CD-ROM for this chapter contains "class" files and HTML files that are needed for viewing the graphics images in the following Java files:

OscillatingEllipse1.

EllipticLava1.

EllipticLava2.

EllipticColoredLava1.

EllipticColoredLava2.

EllipticColoredLava3.

EllipticColoredLava4.

EllipticColoredLava5.

EllipticColoredLava6.

EllipticColoredLavaScreen1.

SUMMARY

This chapter presented Java code for drawing patterns that are based on sets of ellipses. The main techniques in this chapter are based on modifying the width or height of the ellipses in different ways in order to create lava-like graphics images. Despite the simplicity of these techniques, many of the graphics images appear to be complex in nature.

STRIATED ELLIPSES AND ARCS

OVERVIEW

This chapter contains Java code that demonstrates how to draw sets of elliptic arcs (which are partial ellipses) that create unusual effects. You'll see a number of rendering techniques in this chapter. Some of these techniques (such as "Venetian shading") you've seen in previous chapters, while other techniques will be new to you. One such technique involves varying the "span" of the rendered elliptic arcs in order to create a disappearing or erasing effect.

CONCEPT: DRAWING CONES WITH ELLIPTIC ARCS

The next object (Figure 15.1) consists of the following building blocks:

- A set of elliptic arcs

FIGURE 15.1 A striated partial cone.

The Java class *EllipticArcsStriatedCone1.java* contains the method *drawEllipticArcs()* that contains a loop which draws a set of elliptic arcs.

The Java class *EllipticArcsStriatedCone1.java* (Listing 15.1) demonstrates how to draw a set of elliptic arcs.

LISTING 15.1 EllipticArcsStriatedCone1.java

```java
import java.awt.Color;
import java.awt.Graphics;
import java.awt.Image;

import java.io.Serializable;

public class EllipticArcsStriatedCone1 extends
        java.applet.Applet implements Serializable
{
    private Graphics offScreenBuffer = null;
    private Image    offScreenImage  = null;

    private int width     = 800;
    private int height    = 500;

    private int basePointX = 300;
    private int basePointY = 100;

    private int currentX  = basePointX;
    private int currentY  = basePointY;

    private int eWidth    = 200;
    private int eHeight   = 40;

    private int amplitude = 40;
    private int frequency = 1;

    private int coneHeight = 120;
    private int startAngle = 30;

    private int rVal = 0;
    private int gVal = 0;
    private int bVal = 0;

    public EllipticArcsStriatedCone1()
    {
    }

    public void init()
    {
        offScreenImage  = this.createImage(width, height);
```

```
        offScreenBuffer = offScreenImage.getGraphics();

    } // init

    public void update(Graphics gc)
    {
        paint(gc);

    } // update

    public void paint(Graphics gc)
    {
        offScreenBuffer.setColor(Color.lightGray);
        offScreenBuffer.fillRect(0, 0, width, height);

        drawEllipticArcs(offScreenBuffer, gc);
        gc.drawImage(offScreenImage, 0, 0, this);

    } // paint

    public void drawEllipticArcs(Graphics gc,
                                 Graphics gcMain)
    {
        for(int y=0; y<coneHeight; y++)
        {
            rVal = y*255/coneHeight;
            gc.setColor(new Color(rVal, gVal, bVal));

            gc.drawArc(basePointX-y, basePointY+y,
                       eWidth+2*y, eHeight,
                       startAngle+y, 330);

            gc.drawArc(basePointX-y+1, basePointY+y,
                       eWidth+2*y, eHeight,
                       startAngle+y, 330);

            gcMain.drawImage(offScreenImage, 0, 0, this);
        }

        gc.setColor(Color.white);
        gc.drawArc(basePointX-coneHeight,
                   basePointY+coneHeight,
                   eWidth+2*coneHeight,
                   eHeight,
                   startAngle+coneHeight,
                   330);

    } // drawEllipticArcs

} // EllipticArcsStriatedCone1
```

The HTML file *EllipticArcsStriatedCone1.html* (Listing 15.2) contains the code for launching *EllipticArcsStriatedCone1.class*.

LISTING 15.2 EllipticArcsStriatedCone1.html

```
<HTML>
<HEAD></HEAD>
<BODY>
<APPLET CODE=EllipticArcsStriatedCone1.class WIDTH=800
HEIGHT=500></APPLET>
</BODY>
</HTML>
```

REMARKS

The preceding example uses the method *drawEllipticArcs()* in order to draw multiple adjacent elliptic arcs during each invocation of this method. Notice that *drawEllipticArcs()* contains a loop that modifies five quantities: the "base point," the width, the height, and the "angle span" of each elliptic arc. By now you've probably figured out that the elliptic-shaped missing portion is the result of rendering elliptic arcs that span only 330 degrees.

In this example, the end angle and the start angle differ by a constant (i.e., 330). Changing this constant will alter the resultant graphics image in unexpected ways. You'll see other examples that modify the end angle independently of the start angle in order to produce some exotic effects.

In a sense, this code generalizes the techniques in the previous chapter because you can modify as many as six variables that control the rendering of an elliptic arc. In the case of ellipses, you can only modify four variables: the width, the height, and the x- and y-coordinates of the "base point" of the ellipse.

CONCEPT: DRAWING CONES
WITH SWIRLING ELLIPTIC SWATHS

The next object (Figure 15.2) consists of the following building blocks:

- A set of elliptic arcs

The Java class *EllipticArcsStriatedCone3.java* contains the method *drawEllipticArcs()* that contains a loop which draws a set of elliptic arcs.

FIGURE 15.2 A striated partial cone.

ON THE CD

The Java class *EllipticArcsStriatedCone3.java* (Listing 15.3) demonstrates how to draw a set of elliptic arcs.

LISTING 15.3 EllipticArcsStriatedCone3.java

```java
import java.awt.Color;
import java.awt.Graphics;
import java.awt.Image;

import java.io.Serializable;

public class EllipticArcsStriatedCone3 extends
        java.applet.Applet implements Serializable
{
    private Graphics offScreenBuffer = null;
    private Image    offScreenImage  = null;

    private int width       = 800;
    private int height      = 500;

    private int basePointX = 300;
    private int basePointY = 100;

    private int currentX    = basePointX;
    private int currentY    = basePointY;

    private int eWidth      = 160;
    private int eHeight     = 40;

    private int amplitude   = 40;
    private int frequency   = 1;

    private int maxCount    = 200;
    private int coneHeight  = 250;

    private int fixedAngle = 30;
    private int startAngle = 30;
    private int angleSweep = 360-fixedAngle;
```

```
private int angleDelta = 8;

private int rVal = 0;
private int gVal = 0;
private int bVal = 0;

public EllipticArcsStriatedCone3()
{
}

public void init()
{
   offScreenImage  = this.createImage(width, height);
   offScreenBuffer = offScreenImage.getGraphics();

} // init

public void update(Graphics gc)
{
   paint(gc);

} // update

public void paint(Graphics gc)
{
   for(int tick=0; tick<maxCount; tick++)
   {
      offScreenBuffer.setColor(Color.lightGray);
      offScreenBuffer.fillRect(0, 0, width, height);

      drawEllipticArcs(offScreenBuffer, gc);
      gc.drawImage(offScreenImage, 0, 0, this);
      updateCoordinates();
   }

} // paint

public void updateCoordinates()
{
   startAngle += angleDelta;

   if( startAngle > 360 )
   {
      startAngle = 0;
   }

} // updateCoordinates

public void drawEllipticArcs(Graphics gc,
                             Graphics gcMain)
```

```
    {
       for(int y=0; y<coneHeight; y++)
       {
          rVal = y*255/coneHeight;
          gc.setColor(new Color(rVal, gVal, bVal));

          // dithering creates better visual effect...
          gc.drawArc(basePointX-y/2, basePointY+y,
                     eWidth+y, eHeight,
                     startAngle+y, angleSweep);

          gc.drawArc(basePointX-y/2+1, basePointY+y,
                     eWidth+y, eHeight,
                     startAngle+y, angleSweep);

          gc.setColor(new Color(rVal, gVal, 255-rVal));
          gc.drawArc(basePointX-y/2, basePointY+y,
                     eWidth+y, eHeight,
                     startAngle+y+angleSweep, fixedAngle);

          gc.drawArc(basePointX-y/2+1, basePointY+y,
                     eWidth+y, eHeight,
                     startAngle+y+angleSweep, fixedAngle);
       }

       gc.setColor(Color.white);
       gc.drawArc(basePointX-coneHeight/2,
                  basePointY+coneHeight,
                  eWidth+coneHeight,
                  eHeight,
                  startAngle+coneHeight,
                  angleSweep);

    } // drawEllipticArcs

} // EllipticArcsStriatedCone3
```

ON THE CD

The HTML file *EllipticArcsStriatedCone3.html* (Listing 15.4) contains the code for launching *EllipticArcsStriatedCone3.class*.

LISTING 15.4 EllipticArcsStriatedCone3.html

```
<HTML>
<HEAD></HEAD>
<BODY>
<APPLET CODE=EllipticArcsStriatedCone3.class WIDTH=800
HEIGHT=500></APPLET>
</BODY>
</HTML>
```

REMARKS

The preceding example combines elliptic arcs with gradient shading in order to create a bluish elliptic stripe in the graphics image. The method *drawEllipticArcs()* draws multiple adjacent elliptic red arcs, and then draws the bluish stripe during each invocation of this method. You can also add conditional logic in order to create a striped effect with one or more additional colors. As noted in the previous example, changing the constant 330 to a smaller value (such as 180) produces some unexpected and interesting effects.

CONCEPT: DRAWING SWIRLING CONES WITH ELLIPTIC ARCS AND VENETIAN SHADING

The next object (Figure 15.3 and Figure 15.4) consists of the following building blocks:

- A set of elliptic arcs

FIGURE 15.3 A snapshot of a swirling striated partial cone.

FIGURE 15.4 A subsequent snapshot of a swirling striated partial cone.

The Java class *EllipticArcsVenetianSwirlingCone1.java* contains the following methods:

drawEllipticArcs()

updateCoordinates()

The *paint()* method contains a loop that invokes two methods. The first method is *drawEllipticArcs()*, which in turn contains a nested loop that draws a set of elliptic arcs. Notice how the nested loop in *drawEllipticArcs()* creates the Venetian shading effect. The second method is *updateCoordinates()*, which varies the width of the elliptic arcs between a minimum and maximum allowable value.

The Java class *EllipticArcsVenetianSwirlingCone1.java* (Listing 15.5)
demonstrates how to draw a set of elliptic arcs.

LISTING 15.5 EllipticArcsVenetianSwirlingCone1.java

```java
import java.awt.Color;
import java.awt.Graphics;
import java.awt.Image;

import java.io.Serializable;

public class EllipticArcsVenetianSwirlingCone1 extends
        java.applet.Applet implements Serializable
{
   private Graphics offScreenBuffer = null;
   private Image    offScreenImage  = null;

   private int width     = 800;
   private int height    = 500;

   private int basePointX = 300;
   private int basePointY = 100;

   private int currentX   = basePointX;
   private int currentY   = basePointY;

   private int eWidth    = 160;
   private int eHeight   = 40;

   private int amplitude = 40;
   private int frequency = 1;

   private int maxCount   = 200;
   private int coneHeight = 240;

   private int stripCount = 8;
   private int stripHeight= coneHeight/stripCount;

   private int yOffset = 0;

   private int fixedAngle = 30;
   private int startAngle = 30;

   private int angleSweep = 360-fixedAngle;
   private int minAngleSweep = 60;
   private int maxAngleSweep = 360;

   private int sweepDelta     = 4;
   private int sweepDirection = 1;
```

```
private int angleDelta = 8;

private int rVal = 0;
private int gVal = 0;
private int bVal = 0;

public EllipticArcsVenetianSwirlingCone1()
{
}

public void init()
{
   offScreenImage  = this.createImage(width, height);
   offScreenBuffer = offScreenImage.getGraphics();

} // init

public void update(Graphics gc)
{
   paint(gc);

} // update

public void paint(Graphics gc)
{
   for(int tick=0; tick<maxCount; tick++)
   {
      offScreenBuffer.setColor(Color.lightGray);
      offScreenBuffer.fillRect(0, 0, width, height);

      drawEllipticArcs(offScreenBuffer, gc);
      gc.drawImage(offScreenImage, 0, 0, this);
      updateCoordinates();
   }

} // paint

public void updateCoordinates()
{
   startAngle += angleDelta;

   if( startAngle > 360 ) { startAngle = 0; }

   angleSweep += sweepDelta*sweepDirection;

   if( angleSweep > maxAngleSweep )
   {
      angleSweep = maxAngleSweep;
      sweepDirection *= -1;
   }
```

```
   if( angleSweep < minAngleSweep )
   {
      angleSweep = minAngleSweep;
      sweepDirection *= -1;
   }

} // updateCoordinates

public void drawEllipticArcs(Graphics gc,
                            Graphics gcMain)
{
   for(int strip=0; strip<stripCount; strip++)
   {
      for(int h=0; h<stripHeight; h++)
      {
         yOffset = strip*stripHeight+h;

         rVal = h*255/stripHeight;
         gc.setColor(new Color(rVal, gVal, bVal));

         // dithering creates better visual effect...
         gc.drawArc(basePointX-yOffset/2,
                    basePointY+yOffset,
                    eWidth+yOffset, eHeight,
                    startAngle+yOffset, angleSweep);

         gc.drawArc(basePointX-yOffset/2+1,
                    basePointY+yOffset,
                    eWidth+yOffset, eHeight,
                    startAngle+yOffset, angleSweep);
      }
   }

} // drawEllipticArcs

} // EllipticArcsVenetianSwirlingCone1
```

ON THE CD

The HTML file *EllipticArcsVenetianSwirlingCone1.html* (Listing 15.6) contains the code for launching *EllipticArcsVenetianSwirlingCone1.class*.

LISTING 15.6 EllipticArcsVenetianSwirlingCone1.html

```
<HTML>
<HEAD></HEAD>
<BODY>
<APPLET CODE=EllipticArcsVenetianSwirlingCone1.class WIDTH=800
HEIGHT=500></APPLET>
</BODY>
</HTML>
```

REMARKS

The preceding example combines elliptic arcs, Venetian "band" shading, and a new technique in order to create a self-erasing effect in the graphics image. This new technique involves varying the variable `angleSweep` which controls the angle span of each elliptic arc. One variation of the preceding example involves conditional logic that creates a striped effect with other colors. Another possibility is to increase the maximum allowable value of `angleSweep` (e.g., another multiple of 360), or to allow for negative values. Whatever changes you decide to make, the results will undoubtedly surprise you!

CONCEPT: DRAWING SWIRLING CONES WITH MULTI-COLORED ELLIPTIC ARCS

The next object (Figure 15.5) consists of the following building blocks:

- A set of elliptic arcs

The Java class *EllipticArcsVenetianSwirlingCone2.java* contains the following methods:

drawEllipticArcs()
updateCoordinates()

The *paint()* method contains a loop that invokes two methods. The first method is *drawEllipticArcs()*, which in turn contains a nested loop that draws a set of elliptic arcs. Notice how the nested loop in *drawEllipticArcs()* creates the Venetian shading effect. The second method is *updateCoordinates()*, which varies the width of the elliptic arcs between a minimum and maximum allowable value.

FIGURE 15.5 A colored swirling striated partial cone.

The Java class *EllipticArcsVenetianSwirlingCone2.java* (Listing 15.7) demonstrates how to draw a set of elliptic arcs.

LISTING 15.7 EllipticArcsVenetianSwirlingCone2.java

```java
import java.awt.Color;
import java.awt.Graphics;
import java.awt.Image;

import java.io.Serializable;

public class EllipticArcsVenetianSwirlingCone2 extends
        java.applet.Applet implements Serializable
{
   private Graphics offScreenBuffer = null;
   private Image    offScreenImage  = null;

   private int width      = 800;
   private int height     = 500;

   private int basePointX = 300;
   private int basePointY = 100;

   private int currentX   = basePointX;
   private int currentY   = basePointY;

   private int eWidth     = 160;
   private int eHeight    = 40;

   private int amplitude  = 40;
   private int frequency  = 1;

   private int maxCount   = 200;
   private int coneHeight = 240;

   private int stripCount = 8;
   private int stripHeight= coneHeight/stripCount;

   private int yOffset = 0;

   private int fixedAngle = 30;
   private int startAngle = 30;

   private int angleSweep = 360-fixedAngle;
   private int minAngleSweep = 60;
   private int maxAngleSweep = 360;

   private int sweepDelta     = 4;
   private int sweepDirection = 1;
```

```
private int angleDelta = 8;

private int rVal = 0;
private int gVal = 0;
private int bVal = 0;

public EllipticArcsVenetianSwirlingCone2()
{
}

public void init()
{
   offScreenImage  = this.createImage(width, height);
   offScreenBuffer = offScreenImage.getGraphics();

} // init

public void update(Graphics gc)
{
   paint(gc);

} // update

public void paint(Graphics gc)
{
   for(int tick=0; tick<maxCount; tick++)
   {
      offScreenBuffer.setColor(Color.lightGray);
      offScreenBuffer.fillRect(0, 0, width, height);

      drawEllipticArcs(offScreenBuffer, gc);
      gc.drawImage(offScreenImage, 0, 0, this);
      updateCoordinates();
   }

} // paint

public void updateCoordinates()
{
   startAngle += angleDelta;

   if( startAngle > 360 ) { startAngle = 0; }

   angleSweep += sweepDelta*sweepDirection;

   if( angleSweep > maxAngleSweep )
   {
      angleSweep = maxAngleSweep;
      sweepDirection *= -1;
   }
```

```
      if( angleSweep < minAngleSweep )
      {
         angleSweep = minAngleSweep;
         sweepDirection *= -1;
      }

} // updateCoordinates

public void drawEllipticArcs(Graphics gc,
                             Graphics gcMain)
{
   for(int strip=0; strip<stripCount; strip++)
   {
      for(int h=0; h<stripHeight; h++)
      {
         yOffset = strip*stripHeight+h;

         rVal = h*255/stripHeight;
         gVal = 0;
         bVal = 0;
         gc.setColor(new Color(rVal, gVal, bVal));

         // dithering creates better visual effect...
         gc.drawArc(basePointX-yOffset/2,
                    basePointY+yOffset,
                    eWidth+yOffset, eHeight,
                    startAngle+yOffset, angleSweep);

         gc.drawArc(basePointX-yOffset/2+1,
                    basePointY+yOffset,
                    eWidth+yOffset, eHeight,
                    startAngle+yOffset, angleSweep);

         rVal = (int)(255*Math.random());
         bVal = (int)(255*Math.random());
         gVal = (int)(255*Math.random());

         gc.setColor(new Color(rVal, gVal, bVal));
         gc.drawArc(basePointX-yOffset/2,
                    basePointY+yOffset,
                    eWidth+yOffset, eHeight,
                    startAngle+yOffset+angleSweep,
                    fixedAngle);

         gc.drawArc(basePointX-yOffset/2+1,
                    basePointY+yOffset,
                    eWidth+yOffset, eHeight,
                    startAngle+yOffset+angleSweep,
                    fixedAngle);
      }
```

```
        }

        gc.setColor(Color.white);
        gc.drawArc(basePointX-coneHeight/2,
                   basePointY+coneHeight,
                   eWidth+coneHeight, eHeight,
                   startAngle+coneHeight, angleSweep);

    } // drawEllipticArcs

} // EllipticArcsVenetianSwirlingCone2
```

ON THE CD

The HTML file *EllipticArcsVenetianSwirlingCone2.html* (Listing 15.8)
contains the code for launching *EllipticArcsVenetianSwirlingCone2.class*.

LISTING 15.8 EllipticArcsVenetianSwirlingCone2.html

```
<HTML>
<HEAD></HEAD>
<BODY>
<APPLET CODE=EllipticArcsVenetianSwirlingCone2.class WIDTH=800
HEIGHT=500></APPLET>
</BODY>
</HTML>
```

REMARKS

The preceding example combines elliptic arcs, Venetian "band" shading,
gradient shading based on random numbers, and the self-erasing tech-
nique described in *EllipticArcsVenetianShadingSwirlingCone1.java*. This ex-
ample uses *dithering* in order to improve the sharpness of the graphics
object. Dithering is achieved by drawing the same thing in two places that
differ by a small offset. In this case, two elliptic arcs are drawn that differ by
one horizontal. You can improve the dithering effect by drawing a third or
fourth elliptic arc that is offset by one horizontal unit. Since the graphics
image is rendered very quickly, the extra code improves the quality without
requiring more time to render the image.

CONCEPT: DRAWING SWIRLING CONES WITH ELLIPTIC ARCS

The next object (Figure 15.6) consists of the following building blocks:

- A set of elliptic arcs

FIGURE 15.6 A Venetian striated partial cone.

The Java class *EllipticArcsVenetianSwirlingCone4.java* contains the following methods:

drawEllipticArcs()

updateCoordinates()

The *paint()* method contains a loop that invokes two methods. The first method is *drawEllipticArcs()*, which in turn contains a nested loop that draws a set of elliptic arcs. Notice how the nested loop in *drawEllipticArcs()* creates the Venetian shading effect. The second method is *updateCoordinates()*, which varies the width and height of the elliptic arcs between a minimum and maximum allowable value.

ON THE CD

The Java class *EllipticArcsVenetianSwirlingCone4.java* (Listing 15.9) demonstrates how to draw a set of elliptic arcs.

LISTING 15.9 EllipticArcsVenetianSwirlingCone4.java

```java
import java.awt.Color;
import java.awt.Graphics;
import java.awt.Image;

import java.io.Serializable;

public class EllipticArcsVenetianSwirlingCone4 extends
        java.applet.Applet implements Serializable
{
    private Graphics offScreenBuffer = null;
    private Image    offScreenImage  = null;

    private int width     = 800;
    private int height    = 500;

    private int basePointX = 300;
    private int basePointY = 100;
```

```
private int currentX   = basePointX;
private int currentY   = basePointY;

private int eWidth     = 160;
private int eHeight    = 40;

private int rectangleWidth  = eHeight;
private int rectangleHeight = eHeight;

private int amplitude  = 40;
private int frequency  = 1;

private int maxCount   = 200;
private int coneHeight = 240;

private int stripCount  = 8;
private int stripHeight = coneHeight/stripCount;

private int minStripHeight = coneHeight/
                              (stripCount*8);
private int maxStripHeight = coneHeight/stripCount;

private int stripDirection = 1;
private int stripDelta     = 2;

private int yOffset = 0;

private int fixedAngle = 30;
private int startAngle = 30;

private int angleSweep = 360-fixedAngle;
private int minAngleSweep = 60;
private int maxAngleSweep = 360;

private int sweepDelta     = 2;
private int sweepDirection = 1;

private int angleDelta = 8;

private int rVal = 0;
private int gVal = 0;
private int bVal = 0;

public EllipticArcsVenetianSwirlingCone4()
{
}

public void init()
{
   offScreenImage  = this.createImage(width, height);
   offScreenBuffer = offScreenImage.getGraphics();
```

```
} // init

public void update(Graphics gc)
{
   paint(gc);

} // update

public void paint(Graphics gc)
{
   for(int tick=0; tick<maxCount; tick++)
   {
      offScreenBuffer.setColor(Color.lightGray);
      offScreenBuffer.fillRect(0, 0, width, height);

      drawEllipticArcs(offScreenBuffer, gc);
      gc.drawImage(offScreenImage, 0, 0, this);
      updateCoordinates();
   }

} // paint

public void updateCoordinates()
{
   startAngle += angleDelta;

   if( startAngle > 360 ) { startAngle = 0; }

   angleSweep += sweepDelta*sweepDirection;

   if( angleSweep > maxAngleSweep )
   {
      angleSweep = maxAngleSweep;
      sweepDirection *= -1;
   }

   if( angleSweep < minAngleSweep )
   {
      angleSweep = minAngleSweep;
      sweepDirection *= -1;
   }

   stripHeight += stripDirection*stripDelta;

   if( stripHeight > maxStripHeight )
   {
      stripHeight = maxStripHeight;
      stripDirection *= -1;
   }
```

```
   if( stripHeight < minStripHeight )
   {
      stripHeight = minStripHeight;
      stripDirection *= -1;
   }

} // updateCoordinates

public void drawEllipticArcs(Graphics gc,
                             Graphics gcMain)
{
   for(int strip=0; strip<stripCount; strip++)
   {
      for(int h=0; h<stripHeight; h++)
      {
         yOffset = strip*stripHeight+h;

         rVal = h*255/stripHeight;
         gVal = 0;
         bVal = 0;
         gc.setColor(new Color(rVal, gVal, bVal));

         // dithering creates better visual effect...
         gc.drawArc(basePointX-yOffset/2,
                    basePointY+yOffset,
                    eWidth+yOffset, eHeight,
                    startAngle+yOffset, angleSweep);

         gc.drawArc(basePointX-yOffset/2+1,
                    basePointY+yOffset,
                    eWidth+yOffset, eHeight,
                    startAngle+yOffset, angleSweep);
      }
   }

} // drawEllipticArcs

} // EllipticArcsVenetianSwirlingCone4
```

ON THE CD

The HTML file *EllipticArcsVenetianSwirlingCone4.html* (Listing 15.10) contains the code for launching *EllipticArcsVenetianSwirlingCone4.class*.

LISTING 15.10 EllipticArcsVenetianSwirlingCone4.html

```
<HTML>
<HEAD></HEAD>
<BODY>
<APPLET CODE=EllipticArcsVenetianSwirlingCone4.class WIDTH=800
```

```
HEIGHT=500></APPLET>
</BODY>
</HTML>
```

REMARKS

The preceding example does not contain a sample of the graphics image because a snapshot does not render the full effect. Like its predecessor, this example combines elliptic arcs, Venetian "band" shading, gradient shading based on random numbers, the self-erasing technique, and variable arc height to create multiple animation effects. The graphics image is drawn so fast that you can easily add more code for improved dithering as well as code for creating a variable-width striped effect. See how much code you can add before the performance suffers from a noticeable degradation.

CD LIBRARY

ON THE CD

The CD-ROM for this chapter contains "class" files and HTML files that are needed for viewing the graphics images in the following Java files:

EllipticArcsStriatedCone1.

EllipticArcsStriatedCone3.

EllipticArcsVenetian
SwirlingCone1.

EllipticArcsVenetian
SwirlingCone2.

EllipticArcsVenetian
SwirlingCone4.

EllipticArcsStriatedCone2.

EllipticArcsStriatedCone4. EllipticArcsVenetian
 SwirlingCone3.

SUMMARY

This chapter presented Java code for drawing so-called striated cones that are based on sets of adjacent elliptic arcs. Elliptic arcs can be leveraged to create exotic graphics images almost effortlessly when you combine elliptic arcs with Venetian shading and animation in order to create a "vanishing" effect. Since an elliptic arc is a partial ellipse, you might assume that it cannot be used as though it were a building block. In actuality, elliptic arcs can be used to achieve visual effects that are sophisticated and also very difficult to reproduce by means of other building blocks.

CHECKERBOARD PATTERNS

OVERVIEW

This chapter contains Java code for drawing a variety of checkerboard patterns that are based on repeating patterns of rectangles and parallelograms. The basic idea for this pattern involves a two-dimensional grid of rectangles or "cells." You can render alternating color patterns simply by computing an index into an array of colors. In addition, you'll also see how easy it is to write Java code for patterns with a three-dimensional effect.

CONCEPT: DRAWING CHECKERBOARD PATTERNS

The next object (Figure 16.1) consists of the following building blocks:

- A grid of squares with alternating colors

The Java class *CheckerBoard1.java* contains the method *drawCheckerBoard()* that draws the checkerboard pattern by means of a pair of nested loops. For each rectangle in the grid, the sum of the row and column value of that rectangle is used in order to compute an index into an array of colors.

FIGURE 16.1 A checkerboard pattern.

The Java class *CheckerBoard1.java* (Listing 16.1) demonstrates how to draw a two-dimensional checkerboard pattern.

LISTING 16.1 CheckerBoard1.java

```java
import java.awt.Color;
import java.awt.Graphics;
import java.awt.Image;

import java.io.Serializable;

public class CheckerBoard1 extends java.applet.Applet
      implements Serializable
{
   private Image offScreenImage    = null;
   private Graphics offScreenBuffer = null;

   private int width            = 800;
   private int height           = 500;

   private int basePointX       = 150;
   private int basePointY       = 50;

   private int rowCount         = 10;
   private int colCount         = 10;

   private int cellWidth        = 40;
   private int cellHeight       = 40;

   private Color[] cellColors = {
      Color.red, Color.blue, Color.green, Color.yellow,
      Color.pink, Color.magenta
   };

   public CheckerBoard1()
   {
   }

   public void init()
   {
      offScreenImage  = this.createImage(width, height);
      offScreenBuffer = offScreenImage.getGraphics();
   }

   public void paint(Graphics gc)
   {
      offScreenBuffer.setColor(Color.lightGray);
      offScreenBuffer.fillRect(0, 0, width, height);
```

```
      drawCheckerBoard(offScreenBuffer);

      gc.drawImage(offScreenImage, 0, 0, this);

   } // paint

   public void drawCheckerBoard(Graphics gc)
   {
      for(int row=0; row<rowCount; row++)
      {
         for(int col=0; col<colCount; col++)
         {
            gc.setColor(cellColors[(row+col)%2]);

            gc.fill3DRect(basePointX+col*cellWidth,
                          basePointY+row*cellHeight,
                          cellWidth,
                          cellHeight,
                          true);
         }
      }

   } // drawCheckerBoard

} // CheckerBoard1
```

The HTML file *CheckerBoard1.html* (Listing 16.2) contains the code for launching *CheckerBoard1.class*.

ON THE CD

LISTING 16.2 CheckerBoard1.html

```
<HTML>
<HEAD></HEAD>
<BODY>
<APPLET CODE=CheckerBoard1.class WIDTH=800 HEIGHT=500></APPLET>
</BODY>
</HTML>
```

REMARKS

The preceding graphics image requires a simple nested loop in order to draw a grid of rectangles. The color of each rectangle is determined by calculating an index into an array of colors. Instead of using red and blue, experiment with other color combinations. Alternatively, try using gradient shading with pre-defined RGB components for shades of green and yellow.

CONCEPT: DRAWING 3D CHECKERBOARD PATTERNS

The next object (Figure 16.2) consists of the following building blocks:

- A grid of 3D squares with alternating colors

FIGURE 16.2 A three-dimensional checkerboard pattern.

The Java class *Checkerboard2.java* contains the method *drawChecker-Board()* that consists of a nested pair of loops for drawing the three-dimensional cells. For each rectangle in the grid, the sum of the row and column value of that rectangle is used in order to compute an index into an array of colors. Gradient shading for the bottom row and right-hand column creates a three-dimensional effect.

ON THE CD

The Java class *CheckerBoard2.java* (Listing 16.3) demonstrates how to draw a three-dimensional checkerboard pattern.

LISTING 16.3 CheckerBoard2.java

```java
import java.awt.Color;
import java.awt.Graphics;
import java.awt.Image;

import java.io.Serializable;

public class CheckerBoard2 extends java.applet.Applet
        implements Serializable
{
    private Image offScreenImage      = null;
    private Graphics offScreenBuffer = null;

    private int width          = 800;
    private int height         = 500;

    private int basePointX         = 150;
    private int basePointY         = 50;
```

```
private int thickness        = 20;

private int rowCount         = 10;
private int colCount         = 10;

private int cellWidth        = 40;
private int cellHeight       = 40;

private Color[] cellColors = {
   Color.red, Color.blue, Color.green, Color.yellow,
   Color.pink, Color.magenta
};

public CheckerBoard2()
{
}

public void init()
{
   offScreenImage  = this.createImage(width, height);
   offScreenBuffer = offScreenImage.getGraphics();
}

public void paint(Graphics gc)
{
   offScreenBuffer.setColor(Color.lightGray);
   offScreenBuffer.fillRect(0, 0, width, height);

   drawCheckerBoard(offScreenBuffer);

   gc.drawImage(offScreenImage, 0, 0, this);

} // paint

public void drawCheckerBoard(Graphics gc)
{
   for(int row=0; row<rowCount; row++)
   {
      for(int col=0; col<colCount; col++)
      {
         gc.setColor(cellColors[(row+col)%2]);

         for(int z=thickness; z>=0; z-)
         {
            gc.fill3DRect(basePointX+col*cellWidth+z,
                          basePointY+row*cellHeight+z,
                          cellWidth,
                          cellHeight,
                          true);
         }
```

```
        }
    }

} // drawCheckerBoard

} // CheckerBoard2
```

ON THE CD

The HTML file *CheckerBoard2.html* (Listing 16.4) contains the code for launching *CheckerBoard2.class*.

LISTING 16.4 CheckerBoard2.html

```
<HTML>
<HEAD></HEAD>
<BODY>
<APPLET CODE=CheckerBoard2.class WIDTH=800 HEIGHT=500></APPLET>
</BODY>
</HTML>
```

REMARKS

The preceding code enhances the class *CheckerBoard1.java* by creating a three-dimensional effect in a very simple manner: the inner-most loop uses simple gradient shading in order to create the illusion of depth. The loop for creating depth can be restricted to just the bottom row and right-most row of squares in the grid instead of invoking the loop for every square in the grid. This redundancy does not cause a problem because there is no animation in this graphics image.

CONCEPT: DRAWING A CHECKERBOARD OF GRADIENT CELLS

The next object (Figure 16.3) consists of the following building blocks:

- A grid of striped squares with alternating colors

The Java class *CheckerBoardGradient1.java* contains the method *drawCheckerBoard()* that draws a grid of cells, each of which is drawn via gradient shading.

FIGURE 16.3 A gradient checkerboard pattern.

The Java class *CheckerBoardGradient1.java* (Listing 16.5) demonstrates how to draw a two-dimensional checkerboard pattern in which each cell within the grid of cells is colored by means of a color gradient.

LISTING 16.5 CheckerBoardGradient1.java

```java
import java.awt.Color;
import java.awt.Graphics;
import java.awt.Image;

import java.io.Serializable;

public class CheckerBoardGradient1 extends
        java.applet.Applet implements Serializable
{
   private Image offScreenImage     = null;
   private Graphics offScreenBuffer = null;

   private int width          = 800;
   private int height         = 500;

   private int basePointX     = 150;
   private int basePointY     = 50;

   private int rowCount       = 10;
   private int colCount       = 10;

   private int cellWidth      = 40;
   private int cellHeight     = 40;

   private int rVal = 0;
   private int gVal = 0;
   private int bVal = 0;

   private Color[] cellColors = {
      Color.red, Color.blue, Color.green, Color.yellow,
      Color.pink, Color.magenta
   };
```

```
public CheckerBoardGradient1()
{
}

public void init()
{
   offScreenImage  = this.createImage(width, height);
   offScreenBuffer = offScreenImage.getGraphics();
}

public void paint(Graphics gc)
{
   offScreenBuffer.setColor(Color.lightGray);
   offScreenBuffer.fillRect(0, 0, width, height);

   drawCheckerBoard(offScreenBuffer);

   gc.drawImage(offScreenImage, 0, 0, this);

} // paint

public void drawCheckerBoard(Graphics gc)
{
   for(int row=0; row<rowCount; row++)
   {
      for(int col=0; col<colCount; col++)
      {
         for(int z=0; z<cellWidth; z++)
         {
            if( (row+col) % 2 == 0 )
            {
               rVal = z*255/cellWidth;
               gVal = 0;
               bVal = 0;
            }
            else
            {
               rVal = 0;
               gVal = 0;
               bVal = z*255/cellWidth;
            }

            gc.setColor(new Color(rVal, gVal, bVal));

            gc.drawLine(basePointX+col*cellWidth+z,
                        basePointY+row*cellHeight,
                        basePointX+col*cellWidth+z,
                        basePointY+
                           row*cellHeight+cellHeight);
         }
```

```
            }
        }

    } // drawCheckerBoard

} // CheckerBoardGradient1
```

ON THE CD

The HTML file *CheckerBoardGradient1.html* (Listing 16.6) contains the code for launching *CheckerBoardGradient1.class*.

LISTING 16.6 CheckerBoardGradient1.html

```
<HTML>
<HEAD></HEAD>
<BODY>
<APPLET CODE=CheckerBoardGradient1.class WIDTH=800
HEIGHT=500></APPLET>
</BODY>
</HTML>
```

REMARKS

The preceding example shows how a bit of imagination can produce a richly textured image! The key idea for this graphics image involves the use of color weighting that replaces the red and blue squares with squares of which the colors range from black to red and from black to blue. Each square is rendered by means of a set of adjacent parallel line segments. The juxtaposition of these "alternating" squares creates a pleasing contrasting pattern.

CONCEPT: DRAWING VERTICAL BLINDS

The next object (Figure 16.4) consists of the following building blocks:

- A grid of vertically-striped rectangles with gradient shading

The Java class *CheckerBoardVBlinds1.java* contains the method *drawCheckerBoard()* that draws a set of vertical rectangles with gradient shading in order to create an image that resembles a set of Venetian blinds.

FIGURE 16.4 A Venetian checkerboard pattern.

The Java class *CheckerBoardVBlinds1.java* (Listing 16.7) demonstrates how to draw a set of "vertical blinds" with a checkerboard pattern.

LISTING 16.7 CheckerBoardVBlinds1.java

```java
import java.awt.Color;
import java.awt.Graphics;
import java.awt.Image;

import java.io.Serializable;

public class CheckerBoardVBlinds1 extends
      java.applet.Applet implements Serializable
{
   private Image offScreenImage     = null;
   private Graphics offScreenBuffer = null;

   private int width           = 800;
   private int height          = 500;

   private int basePointX      = 150;
   private int basePointY      = 50;

   private int thickness       = 20;

   private int rowCount        = 10;
   private int colCount        = 10;

   private int cellWidth       = 40;
   private int cellHeight      = 40;

   private int rVal = 0;
   private int gVal = 0;
   private int bVal = 0;

   private Color[] cellColors = {
      Color.red, Color.blue, Color.green, Color.yellow,
      Color.pink, Color.magenta
```

```
};

public CheckerBoardVBlinds1()
{
}

public void init()
{
   offScreenImage  = this.createImage(width, height);
   offScreenBuffer = offScreenImage.getGraphics();
}

public void paint(Graphics gc)
{
   offScreenBuffer.setColor(Color.lightGray);
   offScreenBuffer.fillRect(0, 0, width, height);

   drawCheckerBoard(offScreenBuffer);

   gc.drawImage(offScreenImage, 0, 0, this);

} // paint

public void drawCheckerBoard(Graphics gc)
{
   for(int row=0; row<rowCount; row++)
   {
      for(int col=0; col<colCount; col++)
      {
         for(int z=0; z<cellWidth; z++)
         {
            if( (row+col) % 2 == 0 )
            {
               rVal = z*255/cellWidth;
               gVal = 0;
               bVal = 0;
            }
            else
            {
               rVal = 0;
               gVal = 0;
               bVal = z*255/cellWidth;
            }

            gc.setColor(new Color(rVal, gVal, bVal));

            gc.drawLine(
                  basePointX+col*cellWidth+z,
                  basePointY+row*cellHeight+z,
                  basePointX+col*cellWidth+z,
```

```
                        basePointY+
                            row*cellHeight+cellHeight+z);
            }

         }
      }

   } // drawCheckerBoard

} // CheckerBoardVBlinds1
```

ON THE CD

The HTML file *CheckerBoardVBlinds1.html* (Listing 16.8) contains the code for launching *CheckerBoardVBlinds1.class*.

LISTING 16.8 CheckerBoardVBlinds1.html

```
<HTML>
<HEAD></HEAD>
<BODY>
<APPLET CODE=CheckerBoardVBlinds1.class WIDTH=800
HEIGHT=500></APPLET>
</BODY>
</HTML>
```

REMARKS

The key idea for rendering this graphics image is similar to that of the *CheckerBoardGradient1.java*, with one additional variation: the inner-most loop with the code for color weighting draws a parallelogram instead of a square. The coordinates of this parallelogram are extremely easy to calculate: the x-coordinate and the y-coordinate of the lower-right vertex increase at the same rate and both are equal to the loop variable z. (Similarly for the upper-right vertex.) This technique avoids the need for calculating trigonometric quantities based on the *sine* and *cosine* functions, and consequently it keeps the code clean and simple!

CONCEPT: DRAWING A CHECKERBOARD GRID PATTERN

The next object (Figure 16.5) consists of the following building blocks:

- A grid pattern of cells
- A grid pattern of diagonals

FIGURE 16.5 A grey-and-white checkerboard pattern.

The Java class *CheckerBoardGrid1.java* contains the following methods:

drawCheckerBoard()
drawDiagonals()

The method *drawCheckerBoard()* contains a nested loop in order to draw a two-dimensional checkerboard pattern. The method *drawDiagonals()* draws two diagonal line segments for each cell of the checkerboard grid.

ON THE CD

The Java class *CheckerBoardGrid1.java* (Listing 16.9) demonstrates how to draw a grid of white cells with inter-cell shading and diagonal shading to create a three-dimensional effect.

LISTING 16.9 CheckerBoardGrid1.java

```java
import java.awt.Color;
import java.awt.Graphics;
import java.awt.Image;

import java.io.Serializable;

public class CheckerBoardGrid1 extends java.applet.Applet
        implements Serializable
{
    private Image offScreenImage    = null;
    private Graphics offScreenBuffer = null;

    private int width      = 800;
    private int height     = 500;

    private int basePointX      = 150;
    private int basePointY      = 50;

    private int thickness      = 20;
```

```
private int rowCount       = 10;
private int colCount       = 10;

private int cellWidth      = 40;
private int cellHeight      = 40;

private Color[] cellColors = {
   Color.red, Color.blue, Color.green, Color.yellow,
   Color.pink, Color.magenta
};

public CheckerBoardGrid1()
{
}

public void init()
{
   offScreenImage  = this.createImage(width, height);
   offScreenBuffer = offScreenImage.getGraphics();
}

public void paint(Graphics gc)
{
   offScreenBuffer.setColor(Color.lightGray);
   offScreenBuffer.fillRect(0, 0, width, height);

   drawCheckerBoard(offScreenBuffer);

   gc.drawImage(offScreenImage, 0, 0, this);

} // paint

public void drawCheckerBoard(Graphics gc)
{
   for(int row=0; row<rowCount; row++)
   {
      for(int col=0; col<colCount; col++)
      {
         for(int z=thickness; z>=0; z-)
         {
            gc.fill3DRect(basePointX+col*cellWidth+z,
                          basePointY+row*cellHeight+z,
                          cellWidth,
                          cellHeight,
                          true);

            // draw diagonals on current cell...
            drawDiagonals(gc,
                          basePointX+col*cellWidth,
                          basePointY+row*cellHeight);
```

```
        }
      }
    }

  } // drawCheckerBoard

  public void drawDiagonals(Graphics gc,
                            int xCoord, int yCoord)
  {
    gc.setColor(Color.white);

    // draw main diagonal...
    gc.drawLine(xCoord,
                yCoord,
                xCoord+cellWidth,
                yCoord+cellHeight);

    // draw off diagonal...
    gc.drawLine(xCoord+cellWidth,
                yCoord,
                xCoord,
                yCoord+cellHeight);

  } // drawDiagonals

} // CheckerBoardGrid1
```

ON THE CD

The HTML file *CheckerBoardGrid1.html* (Listing 16.10) contains the code for launching *CheckerBoardGrid1.class*.

LISTING 16.10 CheckerBoardGrid1.html

```
<HTML>
<HEAD></HEAD>
<BODY>
<APPLET CODE=CheckerBoardGrid1.class WIDTH=800 HEIGHT=500></APPLET>
</BODY>
</HTML>
```

REMARKS

The preceding example is a departure from all the other examples in this book because it does not use multiple color gradients or indexes into an array of colors. In fact, it uses but one color—white—and relies on a subtle interplay with the method *fill3DRect()* that is available in Java.

This example can give you ideas for using this technique with other geometric objects combined with animation.

CD LIBRARY

The CD-ROM for this chapter contains "class" files and HTML files that are needed for viewing the graphics images in the following Java files:

CheckerBoard1.

CheckerBoard2.

CheckerBoardGradient1.

CheckerBoardVBlinds1.

CheckerBoardGrid1.

CheckerBoardChart1.

CheckerBoardChart2.

CheckerBoardCircles1.

CheckerBoardCircles2.

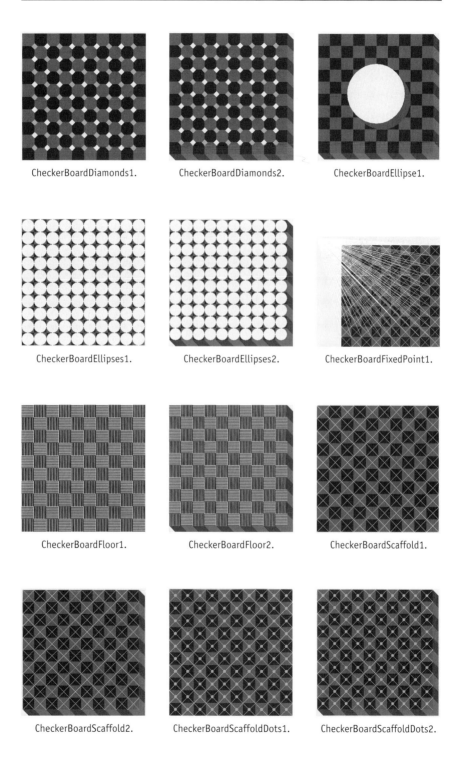

CheckerBoardDiamonds1.

CheckerBoardDiamonds2.

CheckerBoardEllipse1.

CheckerBoardEllipses1.

CheckerBoardEllipses2.

CheckerBoardFixedPoint1.

CheckerBoardFloor1.

CheckerBoardFloor2.

CheckerBoardScaffold1.

CheckerBoardScaffold2.

CheckerBoardScaffoldDots1.

CheckerBoardScaffoldDots2.

Summary

The Java code in this chapter demonstrated how to use rectangles and parallelograms as building blocks in order to draw the following types of patterns:

- Standard two-dimensional checkerboards
- Standard three-dimensional checkerboards
- Vertical blinds

RECURSION

OVERVIEW

Recursion can be a source of great joy and pain simultaneously. There is an intrinsic elegance, due to its compactness, associated with a function that is defined in recursive form. In theory, every recursive algorithm has a corresponding iterative (i.e., non-recursive) algorithm, but some problems are so well-suited to elegant recursive algorithms that it doesn't make much sense to search for that non-recursive algorithm. On the other hand, recursion can be intensive in terms of memory and computation.

If you store intermediate results in an array, you can use iteration instead of recursion. In some cases you don't even need to use an array! For instance, a common introduction to recursion involves the *factorial* function for non-negative integers. The recursive definition is something like this:

```
factorial(n) = n*factorial(n-1) for n > 0, and
factorial(0) = 1.
```

The following non-recursive algorithm is equivalent to the recursive definition for this function, with the added benefit of being simple and efficient in terms of time and memory.

```
public int factorial(int n)
{
    int result = 1;

    if(n > 1)
    {
        for(int k=2; k<=n; k++)
        {
            result *= k;
        }
    }
    return(result);
```

```
} // factorial
```

This function generates huge numbers because it is exponential. Here's a short list of values:

```
factorial(1) = 1
factorial(2) = 2*1 = 2
factorial(3) = 3*2*1 = 6
….
factorial(10) = 10*9*8*….*2*1 = 3,628,800
…
factorial(15) = 1,307,674,368,000
```

CONCEPT: FIBONACCI NUMBERS

This is another popular function, first discovered by the Italian mathematician Fibonacci, that occurs in natural phenomena, such as the pattern of sunflower seeds. Here's the definition of the Fibonacci function:

```
Fib(0) = 0
Fib(1) = 1
Fib(n) = Fib(n-1)+Fib(n-2) for n>=2
```

Without using an array, the computation of the values of this function is very inefficient because each calculation requires two additional calculations that require recursion. However, if you pre-allocate an array of size n and store each value after it has been calculated, then the complexity involves linear time.

CONCEPT: DRAWING LINES VIA RECURSION

The next object (Figure 17.1) consists of the following building blocks:

- A set of line segments

FIGURE 17.1 A set of lines drawn via recursion.

The Java class *RecursiveLine1.java* contains the method *drawSegment()* that recursively invokes itself in order to draw line segments.

The Java class *RecursiveLine1.java* (Listing 17.1) demonstrates how to draw connected line segments by recursion.

LISTING 17.1 RecursiveLine1.java

```java
import java.awt.Color;
import java.awt.Graphics;
import java.awt.Image;
import java.awt.Polygon;

public class RecursiveLine1 extends java.applet.Applet
{
   public Graphics offScreenBuffer = null;
   public Image    offScreenImage  = null;

   private int width        = 800;
   private int height       = 500;

   private int basePointX   = 100;
   private int basePointY   = 250;

   private int lineLength = 300;
   private int maxCount   = 10;

   private int vertexCount   = 4;
   private int theta         = 360/vertexCount;
   private int rotationAngle = theta/2;

   private Color[] lineColors = {
       Color.red, Color.blue, Color.green,
       Color.white, Color.yellow
   };

   public RecursiveLine1()
   {
   }

   public void init()
   {
      offScreenImage  = this.createImage(width, height);
      offScreenBuffer = offScreenImage.getGraphics();
   }

   public void update(Graphics gc)
   {
      paint(gc);
```

```
   } // update

   public void paint(Graphics gc)
   {
      offScreenBuffer.setColor(Color.lightGray);
      offScreenBuffer.fillRect(0, 0, width, height);

      offScreenBuffer.setColor(Color.white);

      offScreenBuffer.drawLine(basePointX,
                               basePointY,
                               basePointX+lineLength,
                               basePointY);

      drawSegment(offScreenBuffer,
                  basePointX+lineLength,
                  basePointY,
                  lineLength/2,
                  theta,
                  0);

      gc.drawImage(offScreenImage, 0, 0, this);

   } // paint

   public void drawSegment(Graphics gc, int xCoord,
                           int yCoord,  int lineLength,
                           int angle, int count)
   {
      int offsetX = (int)(lineLength*
                          Math.cos(angle*Math.PI/180));
      int offsetY = (int)(lineLength*
                          Math.sin(angle*Math.PI/180));

      if( count < maxCount )
      {
         gc.setColor(lineColors[count%5]);
         gc.drawLine(xCoord, yCoord,
                     xCoord+offsetX, yCoord+offsetY);

         drawSegment(offScreenBuffer,
                     xCoord+offsetX,
                     yCoord+offsetY,
                     lineLength/2,
                     angle+rotationAngle,
                     count+1);
      }

   } // drawOuterCircle

} // RecursiveLine1
```

The HTML file *RecursiveLine1.html* (Listing 17.2) contains the code for launching the Java class *RecursiveLine1.class*.

ON THE CD

LISTING 17.2 RecursiveLine1.html

```
<HTML>
<HEAD></HEAD>
<BODY>
<APPLET CODE=RecursiveLine1.class WIDTH=800 HEIGHT=500></APPLET>
</BODY>
</HTML>
```

REMARKS

Notice how the method *drawSegment()* calls itself recursively. Each time this method is invoked, it draws a line segment that starts from the "current" base point. The other end-point of the line segment is based on the values of the horizontal and vertical offsets `offsetX` and `offsetY`, which are calculated by the sine and cosine of the angle `rotationAngle`. Each time this method invokes itself, the new length is half of the current length and the new value of `rotationAngle` is a rotation of its current value.

The preceding example may seem somewhat trivial because the recursion is simple, but don't be deceived! This example shows you the basic concept for recursion that can be used for creating exotic graphics images.

CONCEPT: DRAWING LINES VIA RECURSION TO CREATE TREE-LIKE PATTERNS

The next object (Figure 17.2) consists of the following building blocks:

- A set of line segments

The Java class *RecursiveLine2.java* contains the method *drawSegment()* that recursively invokes itself in order to draw line segments. Note that the resulting graphics image is dramatically different from that of the previous example. This effect is created by means of two recursive invocations of this method in order to produce a tree-like pattern.

The Java class *RecursiveLine2.java* (Listing 17.3) demonstrates a more sophisticated example of drawing line segments. This graph resembles the branches of a symmetric tree.

ON THE CD

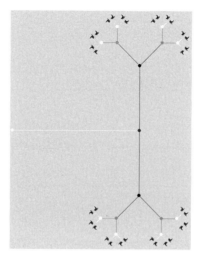

FIGURE 17.2 A tree-like pattern of line segments.

LISTING 17.3 RecursiveLine2.java

```java
import java.awt.Color;
import java.awt.Graphics;
import java.awt.Image;
import java.awt.Polygon;

public class RecursiveLine2 extends java.applet.Applet
{
    public Graphics offScreenBuffer = null;
    public Image    offScreenImage  = null;

    private int width        = 800;
    private int height       = 600;

    private int basePointX = 100;
    private int basePointY = 300;

    private int lineLength = 300;
    private int maxCount   = 10;

    private int vertexCount    = 4;
    private int theta          = 360/vertexCount;
    private int rotationAngle = theta/2;

    private int circleRadius = 8;

    private Color[] lineColors = {
        Color.red, Color.blue, Color.green,
        Color.white, Color.yellow
    };
```

```
public RecursiveLine2()
{
}

public void init()
{
   offScreenImage  = this.createImage(width, height);
   offScreenBuffer = offScreenImage.getGraphics();
}

public void update(Graphics gc)
{
   paint(gc);

} // update

public void paint(Graphics gc)
{
   offScreenBuffer.setColor(Color.lightGray);
   offScreenBuffer.fillRect(0, 0, width, height);

   offScreenBuffer.setColor(Color.white);

   offScreenBuffer.drawLine(basePointX,
                            basePointY,
                            basePointX+lineLength,
                            basePointY);

   offScreenBuffer.fillOval(basePointX-circleRadius/2,
                            basePointY-circleRadius/2,
                            circleRadius,
                            circleRadius);

   drawSegment(offScreenBuffer,
               basePointX+lineLength,
               basePointY,
               lineLength/2,
               theta,
               0);

   drawSegment(offScreenBuffer,
               basePointX+lineLength,
               basePointY,
               lineLength/2,
               -theta,
               0);

   gc.drawImage(offScreenImage, 0, 0, this);

} // paint
```

```
public void drawSegment(Graphics gc, int xCoord,
                        int yCoord, int lineLength,
                        int angle, int count)
{
   int offsetX = (int)(lineLength*Math.cos(angle*
                                  Math.PI/180));

   int offsetY = (int)(lineLength*Math.sin(angle*
                                  Math.PI/180));

   if( count < maxCount )
   {
      gc.setColor(lineColors[count%5]);
      gc.drawLine(xCoord, yCoord,
                  xCoord+offsetX, yCoord+offsetY);

      gc.fillOval(xCoord-circleRadius/2,
                  yCoord-circleRadius/2,
                  circleRadius,
                  circleRadius);

      drawSegment(offScreenBuffer,
                  xCoord+offsetX,
                  yCoord+offsetY,
                  lineLength/2,
                  angle+rotationAngle,
                  count+1);

      drawSegment(offScreenBuffer,
                  xCoord+offsetX,
                  yCoord+offsetY,
                  lineLength/2,
                  angle-rotationAngle,
                  count+1);
   }

} // drawOuterCircle

} // RecursiveLine2
```

ON THE CD

The HTML file *RecursiveLine2.html* (Listing 17.4) contains the code for launching the Java class *RecursiveLine2.class.*

LISTING 17.4 RecursiveLine2.html

```
<HTML>
<HEAD></HEAD>
<BODY>
```

```
<APPLET CODE=RecursiveLine2.class WIDTH=800 HEIGHT=600></APPLET>
</BODY>
</HTML>
```

REMARKS

Notice how the method *drawSegment()* calls itself recursively. Each time this method is invoked, it draws a line segment that starts from the "current" base point. The other end-point of the line segment is based on the values of the horizontal and vertical offsets `offsetX` and `offsetY`, which are calculated by the sine and cosine of the angle `rotationAngle`. Each time this method invokes itself, the new length is half of the current length and then the new value of `rotationAngle` is computed in two ways: one involves a clockwise rotation and the other is a counter-clockwise rotation of its current value.

CONCEPT: DRAWING LINES VIA RECURSION TO CREATE TENDRIL-LIKE PATTERNS

The next object (Figure 17.3) consists of the following building blocks:

- A set of line segments

The Java class *RecursiveLine3.java* contains the method *drawSegment()* that recursively invokes itself in order to draw line segments. Notice that

FIGURE 17.3 A tendril-like pattern of line segments.

there are two recursive invocations of this method, with differing angles of rotations, that produce a much richer tree-like pattern.

The Java class *RecursiveLine3.java* (Listing 17.5) demonstrates a more sophisticated example of drawing line segments. This graph resembles the branches of a symmetric tree.

LISTING 17.5 RecursiveLine3.java

```java
import java.awt.Color;
import java.awt.Graphics;
import java.awt.Image;
import java.awt.Polygon;

public class RecursiveLine3 extends java.applet.Applet
{
    public Graphics offScreenBuffer = null;
    public Image    offScreenImage  = null;

    private int width       = 800;
    private int height      = 600;

    private int basePointX = 100;
    private int basePointY = 300;

    private int lineLength = 100;
    private int maxCount    = 10;

    private int vertexCount   = 8;
    private int theta         = 360/vertexCount;
    private int rotationAngle = theta/2;

    private Color[] lineColors = {
        Color.red, Color.blue, Color.green,
        Color.white, Color.yellow
    };

    public RecursiveLine3()
    {
    }

    public void init()
    {
        offScreenImage  = this.createImage(width, height);
        offScreenBuffer = offScreenImage.getGraphics();
    }

    public void update(Graphics gc)
```

```
{
   paint(gc);

} // update

public void paint(Graphics gc)
{
   offScreenBuffer.setColor(Color.lightGray);
   offScreenBuffer.fillRect(0, 0, width, height);

   offScreenBuffer.setColor(Color.white);

   offScreenBuffer.drawLine(basePointX,
                            basePointY,
                            basePointX+lineLength,
                            basePointY);

   drawSegment(offScreenBuffer,
               basePointX+lineLength,
               basePointY,
               3*lineLength/4,
               theta,
               0);

   drawSegment(offScreenBuffer,
               basePointX+lineLength,
               basePointY,
               3*lineLength/4,
               -theta,
               0);

   gc.drawImage(offScreenImage, 0, 0, this);

} // paint

public void drawSegment(Graphics gc, int xCoord,
                        int yCoord, int lineLength,
                        int angle, int count)
{
   int offsetX = (int)(lineLength*
                       Math.cos(angle*Math.PI/180));
   int offsetY = (int)(lineLength*
                       Math.sin(angle*Math.PI/180));

   if( count < maxCount )
   {
      gc.setColor(lineColors[count%5]);
      gc.drawLine(xCoord, yCoord,
                  xCoord+offsetX, yCoord+offsetY);
```

```
        drawSegment(offScreenBuffer,
                    xCoord+offsetX,
                    yCoord+offsetY,
                    3*lineLength/4,
                  //lineLength/2,
                    angle+rotationAngle,
                    count+1);

        drawSegment(offScreenBuffer,
                    xCoord+offsetX,
                    yCoord+offsetY,
                    3*lineLength/4,
                  //lineLength/2,
                    angle-rotationAngle,
                    count+1);
    }

  } // drawOuterCircle

} // RecursiveLine3
```

ON THE CD

The HTML file *RecursiveLine3.html* (Listing 17.6) contains the code for launching the Java class *RecursiveLine3.class*.

LISTING 17.6 RecursiveLine3.html

```
<HTML>
<HEAD></HEAD>
<BODY>
<APPLET CODE=RecursiveLine3.class WIDTH=800 HEIGHT=600></APPLET>
</BODY>
</HTML>
```

REMARKS

Notice how the method *drawSegment()* calls itself recursively. Each time this method is invoked, it draws a line segment that starts from the "current" base point. The other endpoint of the line segment is based on the values of the horizontal and vertical offsets offsetX and offsetY, which are calculated by the sine and cosine of the angle rotationAngle. Each time this method invokes itself, the new length is half of the current length and then the new value of rotationAngle is computed in two ways: one involves a clockwise rotation and the other is a counter-clockwise rotation of its current value.

CONCEPT: DRAWING SQUARES VIA RECURSION

The next object (Figure 17.4) consists of the following building blocks:

- A set of squares

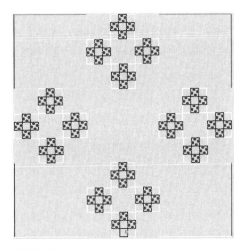

FIGURE 17.4 A set of squares drawn via recursion.

The Java class *RecursiveSquare1.java* contains the following methods:

initializeOuterRectangle()
drawRecursiveEdge()
computeBaseAngle()

The method *initializeOuterRectangle()* initializes the coordinates of the initial outer rectangle.

The method *drawRecursiveEdge()* recursively invokes itself in order to draw a set of line segments.

The method *computeBaseAngle()* determines the new angle of rotation for the next line segment, and is invoked by the preceding method.

ON THE CD

The Java class *RecursiveSquare1.java* (Listing 17.7) demonstrates how to draw self-replicating nested squares using recursion.

LISTING 17.7 RecursiveSquare1.java

```
import java.awt.Color;
import java.awt.Graphics;
```

```java
import java.awt.Image;
import java.awt.Polygon;

public class RecursiveSquare1 extends java.applet.Applet
{
   public Graphics offScreenBuffer = null;
   public Image    offScreenImage  = null;

   private int width     = 800;
   private int height    = 600;

   private int basePointX   = 400;
   private int basePointY   = 400;

   private int offsetX      = 0;
   private int offsetY      = 0;

   private int deltaX       = 0;
   private int deltaY       = 0;

   private int vertexCount  = 4;
   private int[] outerXPts   = new int[vertexCount];
   private int[] outerYPts   = new int[vertexCount];

   private Polygon polygon  = null;

   private int sideLength   = 300;

   private double baseAngle = 0.0;
   private int rotateAngle  = 360/vertexCount;

   private Color[] lineColors = {
       Color.red, Color.green, Color.blue,
       Color.white, Color.yellow
   };

   public RecursiveSquare1()
   {
   }

   public void init()
   {
      offScreenImage  = this.createImage(width, height);
      offScreenBuffer = offScreenImage.getGraphics();

      initializeOuterRectangle();

   } // init

   public void initializeOuterRectangle()
```

```
{
   double offsetX = 0.0;
   double offsetY = 0.0;

   // counter clockwise from lower-left vertex...
   outerXPts[0] = basePointX;
   outerYPts[0] = basePointY;

   for(int v=1; v<vertexCount; v++)
   {
      offsetX = sideLength*Math.cos(
                   (v*rotateAngle)*Math.PI/180);

      offsetY = sideLength*Math.sin(
                   (v*rotateAngle)*Math.PI/180);

      outerXPts[v] = outerXPts[v-1]+(int)offsetX;
      outerYPts[v] = outerYPts[v-1]-(int)offsetY;
   }

} // initializeOuterRectangle

public void update(Graphics gc)
{
   paint(gc);

} // update

public double computeBaseAngle(int x1, int y1,
                              int x2, int y2)
{
   double bAngle=0.0;
   int diffX=0,diffY=0;

   diffX  = x2-x1;
   diffY  = y2-y1;

   deltaX = Math.abs(diffX);
   deltaY = Math.abs(diffY);

   if(deltaX == 0)
   {
      if     (diffY < 0) { bAngle = 90;  }
      else if(diffY > 0) { bAngle = 270; }
      else               { bAngle = 0;   }
   }
   else if(deltaY == 0)
   {
      if     (diffX < 0) { bAngle = 180; }
      else if(diffX > 0) { bAngle = 0; }
```

```
      else                  { bAngle = 0;  }
   }
   else
   {
      bAngle = Math.atan(deltaY/deltaX);
      bAngle *= 180/Math.PI;

      if( (diffX > 0) && (diffY < 0) )      // Q1
      {
         // no change...
      }
      else if( (diffX < 0) && (diffY < 0) ) // Q2
      {
         bAngle = 180-bAngle;
      }
      else if( (diffX < 0) && (diffY > 0) ) // Q3
      {
         bAngle = 180+bAngle;
      }
      else if( (diffX > 0) && (diffY > 0) ) // Q4
      {
         bAngle = 360-bAngle;
      }
   }

   return(bAngle);

} // computeBaseAngle

public void paint(Graphics gc)
{
   offScreenBuffer.setColor(Color.lightGray);
   offScreenBuffer.fillRect(0, 0, width, height);

   for(int v=0; v<vertexCount; v++)
   {
      offScreenBuffer.setColor(lineColors[v%5]);
      offScreenBuffer.drawLine(
                  outerXPts[v],
                  outerYPts[v],
                  outerXPts[(v+1)%vertexCount],
                  outerYPts[(v+1)%vertexCount]);

      drawRecursiveEdge(gc,
                  outerXPts[v],
                  outerYPts[v],
                  outerXPts[(v+1)%vertexCount],
                  outerYPts[(v+1)%vertexCount],
                  4);
   }
```

```
        gc.drawImage(offScreenImage, 0, 0, this);

} // paint

public void drawRecursiveEdge(Graphics gc,
                              int x1, int y1,
                              int x2, int y2,
                              int level)
{
    double sideLength = 0.0;
    double offsetX    = 0.0;
    double offsetY    = 0.0;

    int[] xpts = new int[vertexCount];
    int[] ypts = new int[vertexCount];

    baseAngle  = computeBaseAngle(x1, y1, x2, y2);

    sideLength = Math.sqrt((x1-x2)*(x1-x2)+
                           (y1-y2)*(y1-y2))/3;

    xpts[0] = x2-(x2-x1)/3;
    ypts[0] = y2-(y2-y1)/3;

    for(int v=1; v<vertexCount; v++)
    {
        offsetX = sideLength*Math.cos(
                    (baseAngle+v*rotateAngle)*
                    Math.PI/180);

        offsetY = sideLength*Math.sin(
                    (baseAngle+v*rotateAngle)*
                    Math.PI/180);

        xpts[v] = xpts[v-1]+(int)offsetX;
        ypts[v] = ypts[v-1]-(int)offsetY;
    }

    polygon = new Polygon(xpts, ypts, vertexCount);

    offScreenBuffer.setColor(lineColors[level%5]);
    offScreenBuffer.drawPolygon( polygon );

    gc.drawImage(offScreenImage, 0, 0, this);

    if( level > 0 )
    {
        for(int v=0; v<vertexCount; v++)
        {
```

```
                    drawRecursiveEdge(gc,
                                      xpts[v],
                                      ypts[v],
                                      xpts[(v+1)%vertexCount],
                                      ypts[(v+1)%vertexCount],
                                      level-1);
          }
      }

    } // drawRecursiveEdge

} // RecursiveSquare1
```

ON THE CD

The HTML file *RecursiveSquare1.html* (Listing 17.8) contains the code for launching the Java class RecursiveSquare1.class.

LISTING 17.8 RecursiveSquare1.html

```
<HTML>
<HEAD></HEAD>
<BODY>
<APPLET CODE=RecursiveSquare1.class WIDTH=800 HEIGHT=600></APPLET>
</BODY>
</HTML>
```

REMARKS

When you see the graphics image in the preceding example, you'll see how quickly the nested squares are rendered, despite the fact that recursion is involved. The level of nesting is limited to a small number because the squares quickly become too small. This differs from the class *Recursive-Line3.java*, in which more levels increase the membrane effect. Variations of this example include changing the color pairs for each rectangle, adding animation effects, and drawing multiple sets of recursive squares.

CONCEPT: DRAWING TRIANGLES VIA RECURSION

The next object (Figure 17.5) consists of the following building blocks:

- A set of triangles

The Java class *RecursiveTriangle1.java* contains the following methods:

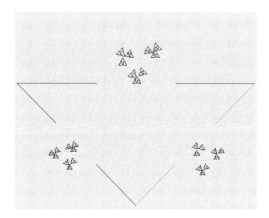

FIGURE 17.5 A set of triangles drawn via recursion.

initializeOuterTriangle()

drawRecursiveEdge()

computeBaseAngle()

The method *initializeOuterTriangle()* initializes the coordinates of the initial outer triangle.

The method *drawRecursiveEdge()* recursively invokes itself in order to draw a set of line segments.

The method *computeBaseAngle()* determines the new angle of rotation for the next line segment, and is invoked by the preceding method.

ON THE CD

The Java class *RecursiveTriangle1.java* (Listing 17.9) demonstrates how to draw self-replicating nested triangles using recursion.

LISTING 17.9 RecursiveTriangle1.java

```java
import java.awt.Color;
import java.awt.Graphics;
import java.awt.Image;
import java.awt.Polygon;

public class RecursiveTriangle1
       extends java.applet.Applet
{
   public Graphics offScreenBuffer = null;
   public Image    offScreenImage  = null;

   private int width     = 800;
   private int height    = 600;
```

```
private int basePointX    = 200;
private int basePointY    = 150;

private int offsetX       = 0;
private int offsetY       = 0;

private int deltaX        = 0;
private int deltaY        = 0;

private double previousX = 0;
private double currentX  = 0.5;

private double previousY = 0;
private double currentY  = 0;

private int lineX         = 0;
private int lineY         = 0;

private int oldLineX      = 0;
private int oldLineY      = 0;

private int vertexCount   = 3;
private int[] outerXPts   = new int[vertexCount];
private int[] outerYPts   = new int[vertexCount];

private double seedValue = -1.5;
private double epsilon    = 0.05;

private Polygon polygon   = null;

private int bWidth        = 400;
private int bHeight       = 400;
private int sideLength    = 160;

private double baseAngle = 0.0;
private int rotateAngle   = 360/vertexCount;

private int intPortion    = 0;

private Color[] lineColors = {
    Color.red, Color.green, Color.blue,
    Color.white, Color.yellow
};

public RecursiveTriangle1()
{
}

public void init()
{
```

```
    offScreenImage  = this.createImage(width, height);
    offScreenBuffer = offScreenImage.getGraphics();

    initializeOuterTriangle();

} // init

public void initializeOuterTriangle()
[
    // counter clockwise from upper-left vertex...
    outerXPts[0] = basePointX;
    outerYPts[0] = basePointY;

    outerXPts[1] = basePointX+bWidth;
    outerYPts[1] = basePointY;

    outerXPts[2] = basePointX+bWidth/2;
    outerYPts[2] = basePointY+bHeight/2;

} // initializeOuterTriangle

public void update(Graphics gc)
{
    paint(gc);

} // update

public double computeBaseAngle(int x1, int y1,
                               int x2, int y2)
{
    double bAngle=0.0;
    int diffX=0,diffY=0;

    diffX = x2-x1;
    diffY = y2-y1;

    deltaX = Math.abs(diffX);
    deltaY = Math.abs(diffY);

    if(deltaX == 0)
    {
        if     (diffY < 0) { bAngle = 90;  }
        else if(diffY > 0) { bAngle = 270; }
        else               { bAngle = 0;   }
    }
    else if(deltaY == 0)
    {
        if     (diffX < 0) { bAngle = 180; }
        else if(diffX > 0) { bAngle = 0;   }
        else               { bAngle = 0;   }
```

```
   }
   else
   {
      bAngle = Math.atan(deltaY/deltaX);
      bAngle *= 180/Math.PI;

      if( (diffX > 0) && (diffY < 0) )        // Q1
      {
         // no change...
      }
      else if( (diffX < 0) && (diffY < 0) ) // Q2
      {
         bAngle = 180-bAngle;
      }
      else if( (diffX < 0) && (diffY > 0) ) // Q3
      {
         bAngle = 180+bAngle;
      }
      else if( (diffX > 0) && (diffY > 0) ) // Q4
      {
         bAngle = 360-bAngle;
      }
   }

   return(bAngle);

} // computeBaseAngle

public void paint(Graphics gc)
{
   offScreenBuffer.setColor(Color.lightGray);
   offScreenBuffer.fillRect(0, 0, width, height);

   for(int v=0; v<vertexCount; v++)
   {
      offScreenBuffer.setColor(lineColors[v%5]);
      offScreenBuffer.drawLine(
                     outerXPts[v],
                     outerYPts[v],
                     outerXPts[(v+1)%vertexCount],
                     outerYPts[(v+1)%vertexCount]);

      drawRecursiveEdge(offScreenBuffer,
                     outerXPts[v],
                     outerYPts[v],
                     outerXPts[(v+1)%vertexCount],
                     outerYPts[(v+1)%vertexCount],
                     4);
   }
```

```
      gc.drawImage(offScreenImage, 0, 0, this);

} // paint

public void drawRecursiveEdge(Graphics gc,
                              int x1, int y1,
                              int x2, int y2,
                              int level)
{
   double sideLength = 0.0;
   double offsetX    = 0.0;
   double offsetY    = 0.0;

   int[] xpts = new int[vertexCount];
   int[] ypts = new int[vertexCount];

   baseAngle  = computeBaseAngle(x1, y1, x2, y2);

   sideLength = Math.sqrt((x1-x2)*(x1-x2)+
                          (y1-y2)*(y1-y2))/3;

   xpts[0] = x2-(x2-x1)/3;
   ypts[0] = y2-(y2-y1)/3;

   for(int v=1; v<vertexCount; v++)
   {
      offsetX = sideLength*Math.cos(
                   (baseAngle+v*rotateAngle)*
                   Math.PI/180);

      offsetY = sideLength*Math.sin(
                   (baseAngle+v*rotateAngle)*
                   Math.PI/180);

      xpts[v] = xpts[v-1]+(int)offsetX;
      ypts[v] = ypts[v-1]-(int)offsetY;
   }

   polygon = new Polygon(xpts, ypts, vertexCount);

   gc.setColor(lineColors[level%5]);
   gc.drawPolygon( polygon );

   if( level > 0 )
   {
      for(int v=0; v<vertexCount; v++)
      {
         drawRecursiveEdge(gc,
```

```
                                xpts[v],
                                ypts[v],
                                xpts[(v+1)%vertexCount],
                                ypts[(v+1)%vertexCount],
                                level-1);
                }
        }

    } // drawRecursiveEdge

} // RecursiveTriangle1
```

The HTML file *RecursiveTriangle1.html* (Listing 17.10) contains the code for launching the Java class *RecursiveTriangle1.class*.

LISTING 17.10 RecursiveTriangle1.html

```
<HTML>
<HEAD></HEAD>
<BODY>
<APPLET CODE=RecursiveTriangle1.class WIDTH=800
HEIGHT=600></APPLET>
</BODY>
</HTML>
```

REMARKS

The preceding example is slightly different from *RecursiveSquares1.java* in that the triangles are slightly skewed from their "parent" triangle. This example only renders the final graphics image. Try adding the code for creating an animation effect, along with changing the colors scheme.

CONCEPT: DRAWING HEXAGONS VIA RECURSION

The next object (Figure 17.6) consists of the following building blocks:

- A set of hexagons

The Java class *RecursiveHexagon1.java* contains the following methods:

initializeOuterHexagon()
drawFractalEdge()
computeBaseAngle()

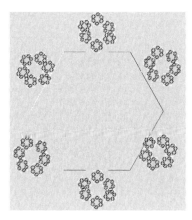

FIGURE 17.6 A set of hexagons drawn via recursion.

The method *initializeOuterHexagon()* initializes the coordinates of the initial outer hexagon.

The method *drawFractalEdge()* recursively invokes itself in order to draw a set of line segments.

The method *computeBaseAngle()* determines the new angle of rotation for the next line segment, and is invoked by the preceding method.

ON THE CD
The Java class *RecursiveHexagon1.java* (Listing 17.11) demonstrates how to draw self-replicating nested hexagons using recursion.

LISTING 17.11 RecursiveHexagon1.java

```java
import java.awt.Color;
import java.awt.Graphics;
import java.awt.Image;
import java.awt.Polygon;

public class RecursiveHexagon1 extends java.applet.Applet
{
   public Graphics offScreenBuffer = null;
   public Image    offScreenImage  = null;

   private int width     = 800;
   private int height    = 600;

   private int basePointX  = 400;
   private int basePointY  = 400;

   private int offsetX    = 0;
   private int offsetY    = 0;
```

```
private int deltaX       = 0;
private int deltaY       = 0;

private int vertexCount  = 6;
private int[] outerXPts  = new int[vertexCount];
private int[] outerYPts  = new int[vertexCount];

private double baseAngle = 0.0;
private int rotateAngle  = 360/vertexCount;

private Polygon polygon  = null;

private int bWidth       = 200;
private int bHeight      = 200;
private int sideLength   = 160;

private Color[] lineColors = {
    Color.red, Color.blue, Color.green,
    Color.white, Color.yellow
};

public RecursiveHexagon1()
{
}

public void init()
{
   offScreenImage  = this.createImage(width, height);
   offScreenBuffer = offScreenImage.getGraphics();

   initializeOuterHexagon();

} // init

public void initializeOuterHexagon()
{
   double offsetX = 0.0;
   double offsetY = 0.0;

   // counter clockwise from lower-left vertex...
   outerXPts[0] = basePointX;
   outerYPts[0] = basePointY;

   for(int v=1; v<vertexCount; v++)
   {
      offsetX = sideLength*Math.cos(
                   (baseAngle-v*rotateAngle)*
                    Math.PI/180);

      offsetY = sideLength*Math.sin(
```

```
                      (baseAngle-v*rotateAngle)*
                      Math.PI/180);

      outerXPts[v] = outerXPts[v-1]+(int)offsetX;
      outerYPts[v] = outerYPts[v-1]+(int)offsetY;
   }

} // initializeOuterHexagon

public void update(Graphics gc)
{
   paint(gc);

} // update

public double computeBaseAngle(int x1, int y1,
                              int x2, int y2)
{
   double bAngle=0.0;
   int diffX=0,diffY=0;

   diffX  = x2-x1;
   diffY  = y2-y1;

   deltaX = Math.abs(diffX);
   deltaY = Math.abs(diffY);

   if(deltaX == 0)
   {
      if     (diffY < 0) { bAngle = 90; }
      else if(diffY > 0) { bAngle = 270; }
      else               { bAngle = 0;  }
   }
   else if(deltaY == 0)
   {
      if     (diffX < 0) { bAngle = 180; }
      else if(diffX > 0) { bAngle = 0; }
      else               { bAngle = 0;  }
   }
   else
   {
      bAngle = Math.atan(deltaY/deltaX);
      bAngle *= 180/Math.PI;

      if( (diffX > 0) && (diffY < 0) )      // Q1
      {
         // no change...
      }
      else if( (diffX < 0) && (diffY < 0) ) // Q2
      {
```

```
                bAngle = 180-bAngle;
            }
            else if( (diffX < 0) && (diffY > 0) ) // Q3
            {
                bAngle = 180+bAngle;
            }
            else if( (diffX > 0) && (diffY > 0) ) // Q4
            {
                bAngle = 360-bAngle;
            }
        }

        return(bAngle);

    } // computeBaseAngle

    public void paint(Graphics gc)
    {
        offScreenBuffer.setColor(Color.lightGray);
        offScreenBuffer.fillRect(0, 0, width, height);

        for(int v=0; v<vertexCount; v++)
        {
            offScreenBuffer.setColor(lineColors[v%5]);
            offScreenBuffer.drawLine(
                        outerXPts[v],
                        outerYPts[v],
                        outerXPts[(v+1)%vertexCount],
                        outerYPts[(v+1)%vertexCount]);

            drawFractalEdge(offScreenBuffer,
                        outerXPts[v],
                        outerYPts[v],
                        outerXPts[(v+1)%vertexCount],
                        outerYPts[(v+1)%vertexCount],
                        4);
        }

        gc.drawImage(offScreenImage, 0, 0, this);

    } // paint

    public void drawFractalEdge(Graphics gc,int x1,int y1,
                                int x2, int y2, int level)
    {
        double sideLength = 0.0;
        double offsetX    = 0.0;
        double offsetY    = 0.0;
```

```
    int[] xpts = new int[vertexCount];
    int[] ypts = new int[vertexCount];

    baseAngle  = computeBaseAngle(x1, y1, x2, y2);

    sideLength = Math.sqrt((x1-x2)*(x1-x2)+
                           (y1-y2)*(y1-y2))/3;

    xpts[0] = x2-(x2-x1)/3;
    ypts[0] = y2-(y2-y1)/3;

    for(int v=1; v<vertexCount; v++)
    {
       offsetX = sideLength*Math.cos(
                    (baseAngle-v*rotateAngle)*
                    Math.PI/180);

       offsetY = sideLength*Math.sin(
                    (baseAngle-v*rotateAngle)*
                    Math.PI/180);

       xpts[v] = xpts[v-1]+(int)offsetX;
       ypts[v] = ypts[v-1]-(int)offsetY;
    }

    polygon = new Polygon(xpts, ypts, vertexCount);

    gc.setColor(lineColors[level%5]);
    gc.drawPolygon( polygon );

    if( level > 0 )
    {
       for(int v=0; v<vertexCount; v++)
       {
          drawFractalEdge(gc,
                          xpts[v],
                          ypts[v],
                          xpts[(v+1)%vertexCount],
                          ypts[(v+1)%vertexCount],
                          level-1);
       }
    }

  } // drawFractalEdge

} // RecursiveHexagon1
```

ON THE CD

The HTML file *RecursiveHexagon1.html* (Listing 17.12) contains the code for launching the Java class *RecursiveHexagon1.class*.

LISTING 17.12 RecursiveHexagon1.html

```
<HTML>
<HEAD></HEAD>
<BODY>
<APPLET CODE=RecursiveHexagon1.class WIDTH=800 HEIGHT=600></APPLET>
</BODY>
</HTML>
```

REMARKS

By this point you're probably comfortable with drawing nested sets of polygons, so here are some more challenging suggestions. Can you think of a way to make the nested hexagons rotate in the same place? Perhaps you can find a simple way to link the center of all the hexagons at the same nested level with line segments that are drawn with color weighting or some other type of shading. Try connecting subsets of the hexagons so that you create sub-triangles with their own design patterns.

CD LIBRARY

ON THE CD

The CD-ROM for this chapter contains "class" files and HTML files that are needed for viewing the graphics images in the following Java files:

RecursiveLine1. RecursiveLine2. RecursiveLine3.

RecursiveSquare1.

RecursiveTriangle1.

RecursiveHexagon1.

RecursiveEllipse1.

RecursiveEllipse2.

RecursiveEllipse3.

RecursiveEllipse4.

RecursiveLine4.

RecursiveOval1.

RecursivePolygons1.

RecursivePolygons2.

RecursivePolygons3.

RecursiveSquareEllipse1. RecursiveSquareEllipse2.

Summary

This chapter introduces recursion and presented Java code that uses recursion for rendering the following types of graphics objects:

- Line segments
- Tree-like patterns
- Triangles
- Squares
- Hexagons

The Java code in this chapter serves as a starting point for the use of recursion and you can combine these examples with your own techniques in order to produce graphics images.

18

CIRCLES AND COMMON OBJECTS

OVERVIEW

This chapter contains Java code with various color shading techniques for drawing a variety of commonplace objects. The first example shows you how to combine circles with dithering in order to create clock-like graphics images. This technique can be used in conjunction with various other geometric objects. The second example shows you how to draw a large slab of cheese. If you look closely, you'll see that the code in that example can easily be modified in order to draw exploding pie charts.

CONCEPT: DRAWING CLOCK-LIKE IMAGES

The next object (Figure 18.1) consists of the following building blocks:

- A set of ellipses

FIGURE 18.1 A clock based on ellipses and gradient shading.

The Java class *Clock1.java* contains the following methods:

drawNewSphere()
drawHours()

The method *drawNewSphere()* uses gradient shading in order to draw a set of circles that create the appearance of a spherical clock.
The method *drawHours()* draws the hours on the clock.

ON THE CD

The Java class *Clock1.java* (Listing 18.1) demonstrates how to draw a simple sphere-like object.

LISTING 18.1 Clock1.java

```java
import java.awt.Color;
import java.awt.Graphics;
import java.awt.Image;

import java.io.Serializable;

public class Clock1 extends java.applet.Applet
        implements Serializable
{
   private Image     offScreenImage  = null;
   private Graphics offScreenBuffer = null;

   private int width  = 800;
   private int height = 500;

   private double theta  = (-30)*Math.PI/180;

   private double currSphereMinuteR;

   private int sphereRadius    =  90;
   private int sphereThickness =  40;

   private int oneSphereFrameWidth = 150;
   private int sphereCount =    1;

   private int basePointX =   80;
   private int basePointY = 150;

   private int minuteSign = 1;
   private int hourSign   = 1;

   private int currSphereX = 0;
   private int currSphereY = 0;
```

```
private int rVal = 228;
private int gVal = 228;
private int bVal = 228;

private String[] Headings = {" ", " ", " ", " ", " "};

private String[] hourStr = {
        " ","4","5","6","7","8","9",
        "10","11","12","1","2","3"
};

public Clock1()
{
}

public void init()
{
   offScreenImage  = this.createImage(width, height);
   offScreenBuffer = offScreenImage.getGraphics();

} // init

public void paint(Graphics gc)
{
   offScreenBuffer.setColor(Color.lightGray);
   offScreenBuffer.fillRect(0, 0, width, height);

   for(int count=0; count<sphereCount; count++)
   {
       currSphereX = basePointX+
                    count*oneSphereFrameWidth;
       currSphereY = basePointY;

       offScreenBuffer.setColor(new
                    Color(240, 240, 240));
       drawNewSphere(offScreenBuffer,
                    currSphereX,
                    currSphereY,
                    sphereRadius,
                    Headings[count],
                    count);
   }

   gc.drawImage(offScreenImage, 0, 0, this);

} // paint

public void drawNewSphere(Graphics gc, int currX,
                    int currY, int sphereRadius,
                    String heading, int index)
```

```
{
   int xCoord, yCoord, centerX, centerY;
   int labelXHour, labelYHour;

   centerX = currX + sphereRadius/2;
   centerY = currY + sphereRadius/2;

   gc.fillOval(currX,   currY,
               sphereRadius, sphereRadius);

   gc.fillOval(currX-1, currY,
               sphereRadius, sphereRadius);

   gc.fillOval(currX,   currY-1,
               sphereRadius, sphereRadius);

   gc.fillOval(currX-1, currY-1,
               sphereRadius, sphereRadius);

   // dithering effect for smoother image...
   for(int z=1; z<sphereThickness; z++)
   {
      rVal = 255-z*255/sphereThickness;
      gVal = 255-z*255/sphereThickness;

      gc.setColor(new Color(rVal, gVal, bVal));

      gc.drawOval(currX-z,
                  currY-(z-1),
                  sphereRadius+(int)(z*Math.sqrt(2)),
                  sphereRadius+(int)(z*Math.sqrt(2)));

      gc.drawOval(currX-(z-1),
                  currY-z,
                  sphereRadius+(int)(z*Math.sqrt(2)),
                  sphereRadius+(int)(z*Math.sqrt(2)));

      gc.drawOval(currX-z,
                  currY-z,
                  sphereRadius+(int)(z*Math.sqrt(2)),
                  sphereRadius+(int)(z*Math.sqrt(2)));
   }

   for(int hour=1; hour<=12; hour++)
   {
      xCoord = centerX+(int)(sphereRadius/2*
                         Math.cos(hour*theta));
      yCoord = centerY-(int)(sphereRadius/2*
                         Math.sin(hour*theta));
```

```
        gc.drawString(hourStr[hour], xCoord, yCoord);
    }

  } // drawNewSphere

} // Clock1
```

The HTML file *Clock1.html* (Listing 18.2) contains the code for launching *Clock1.class*.

LISTING 18.2 Clock1.html

```
<HTML>
<HEAD></HEAD>
<BODY>
<APPLET CODE=Clock1.class WIDTH=500 HEIGHT=450></APPLET>
</BODY>
</HTML>
```

REMARKS

The preceding example contains the method *drawSphere()* in which a set of circles are drawn. This method uses a combination of dithering and color weighting while drawing the circles in order to create the graphics image. Note that the digits 1 through 12 are stored in the array hourStr. The hours are drawn in a clockwise manner, starting from the positive horizontal axis, which represents zero degrees. Why does this array start with a blank? The answer is that this simplifies the logic in the loop: it iterates through the array hourStr, displaying each element and then rotating clockwise by 30 degrees. The first iteration involves a rotation of $0*30 = 0$ degrees, so we need to print a blank space. When we reach the end of the loop, the digit three is displayed in the correct position.

CONCEPT: DRAWING WEDGE-LIKE OBJECTS

The next object (Figure 18.2) consists of the following building blocks:

- A set of elliptic sectors

The Java class *CheeseSlab1.java* contains the method *drawSlice()* that draws a set of vertically stacked "large" elliptic wedges in order to create a three-dimensional effect.

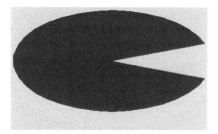

FIGURE 18.2 A wedge pattern.

ON THE CD

The Java class *CheeseSlab1.java* (Listing 18.3) demonstrates how to draw a figure that resembles a slab of cheese.

LISTING 18.3 CheeseSlab1.java

```java
import java.awt.Color;
import java.awt.Graphics;
import java.awt.Image;

import java.io.Serializable;

public class CheeseSlab1 extends java.applet.Applet
      implements Serializable
{
   private Graphics offScreenBuffer = null;
   private Image    offScreenImage  = null;

   private int width      = 800;
   private int height     = 500;

   private int startAngle = 20;
   private int angleSpan   = 320;

   private int sliceHeight = 30;

   private int outerRadius = 400;

   private int basePointX = 100;
   private int basePointY = 100;

   private double offsetX = 0.0;
   private double offsetY = 0.0;

   private Color[] circleColors = {
       Color.red, Color.blue, Color.green,
       Color.white, Color.yellow
   };
```

```java
public CheeseSlab1()
{
}

public void init()
{
   offScreenImage  = this.createImage(width, height);
   offScreenBuffer = offScreenImage.getGraphics();

} // init

public void update(Graphics gc)
{
   paint(gc);

} // update

public void paint(Graphics gc)
{
   offScreenBuffer.setColor(Color.lightGray);
   offScreenBuffer.fillRect(0, 0, width, height);

   drawCheeseSlice(offScreenBuffer);

   gc.drawImage(offScreenImage, 0, 0, this);

} // paint

public void drawCheeseSlice(Graphics gc)
{
   for(int z=sliceHeight; z>=0; z−)
   {
     if(z > 0) { gc.setColor(circleColors[4]); }
     else      { gc.setColor(circleColors[0]); }

     gc.fillArc(basePointX,
                basePointY+z,
                outerRadius,
                outerRadius/2,
                startAngle,
                angleSpan);
   }

   gc.setColor(Color.white);
   gc.drawArc(basePointX,
              basePointY,
              outerRadius,
              outerRadius/2,
              startAngle,
              angleSpan);
```

```
} // drawCheeseSlice
```

```
} // CheeseSlab1
```

The HTML file *CheeseSlab1.html* (Listing 18.4) contains the code for launching *CheeseSlab1.class.*

LISTING 18.4 CheeseSlab1.html

```
<HTML>
<HEAD></HEAD>
<BODY>
<APPLET CODE=CheeseSlab1.class WIDTH=800 HEIGHT=500></APPLET>
</BODY>
</HTML>
```

REMARKS

The preceding example contains the method *drawCheeseSlice()*, which contains a loop that draws three objects. First, it invokes the *fillArc()* method available in Java in order to draw a set of filled-in red elliptic arcs. During the last iteration of the loop, it draws a filled-in blue arc. Finally, it draws the outline of a white elliptic arc for emphasis. You can enhance this example by adding color weighting instead of using an index into an array of colors. Try adding conditional logic for creating a striped effect, or replace the set of red elliptic arcs with an alternating pattern of colors.

CONCEPT: DRAWING 3D TRAFFIC LIGHTS

The next object (Figure 18.3) consists of the following building blocks:

- An outer rectangle
- Three colored circles

The Java class *TrafficLights2.java* contains the following methods:

drawOuterRectangle()

drawLights()

The method *drawOuterRectangle()* uses diagonal shading to draw an outer rectangle with a three-dimensional effect. The method *drawLights()*

FIGURE 18.3 A set of traffic lights.

draws three colored circles (red, yellow, and green) that represent the traffic lights.

ON THE CD

The Java class *TrafficLights2.java* (Listing 18.5) demonstrates how to draw a pattern of traffic lights with a three-dimensional shading effect.

LISTING 18.5 TrafficLights2.java

```java
import java.awt.Color;
import java.awt.Graphics;
import java.awt.Image;

import java.io.Serializable;

public class TrafficLights2 extends java.applet.Applet
        implements Serializable
{
    private Image offScreenImage    = null;
    private Graphics offScreenBuffer = null;

    private int width     = 800;
    private int height    = 500;

    private int basePointX = 100;
    private int basePointY = 100;

    private int eWidth    = 120;
    private int eHeight   = 120;

    private int eCount     = 3;
    private int eThickness = eWidth/eCount;

    private Color[] ellipseColors = {
        Color.red, Color.yellow,
        Color.green, Color.blue, Color.white
    };

    public TrafficLights2()
```

```
{
}

public void init()
{
   offScreenImage  = this.createImage(width, height);
   offScreenBuffer = offScreenImage.getGraphics();

} // init

public void drawOuterRectangle(Graphics gc)
{
   gc.setColor(new Color(80, 80, 80));

   for(int z=eThickness; z>=0; z—)
   {
      gc.fill3DRect(basePointX+z,
                    basePointY-z,
                    eWidth,
                    eCount*eHeight,
                    true);
   }

} // drawOuterRectangle

public void drawLights(Graphics gc)
{
   for(int k=0; k<eCount; k++)
   {
      gc.setColor(ellipseColors[k]);
      gc.fillOval(basePointX,
                  basePointY+k*eHeight,
                  eWidth,
                  eHeight);
   }

} // drawLights

public void update(Graphics gc)
{
   paint(gc);

     } // update

public void paint(Graphics gc)
{
   offScreenBuffer.setColor(Color.lightGray);
   offScreenBuffer.fillRect(0, 0, width, height);

   drawOuterRectangle(offScreenBuffer);
```

```
    drawLights(offScreenBuffer);

    gc.drawImage(offScreenImage, 0, 0, this);

  } // paint

} // TrafficLights2
```

ON THE CD

The HTML file *TrafficLights2.html* (Listing 18.6) contains the code for launching *TrafficLights2.class*.

LISTING 18.6 TrafficLights2.html

```
<HTML>
<HEAD></HEAD>
<BODY>
<APPLET CODE=TrafficLights2.class WIDTH=800 HEIGHT=500></APPLET>
</BODY>
</HTML>
```

REMARKS

The preceding class demonstrates how to create a traffic light by drawing three circles in the method *drawLights()* and a sliding set of rectangles in the method *drawOuterRectangle()*. The latter method uses diagonal shading in conjunction with the fixed color (80, 80, 80), which is a dark shade of gray.

CONCEPT: DRAWING IRON GATES

The next object (Figure 18.4) consists of the following building blocks:

- An outer rectangle
- An upper outer half-circle
- An upper inner half-circle
- A set of radial line segments
- A set of vertical line segments
- Two diagonal line segments

FIGURE 18.4 An iron gate.

The Java class *Gate1.java* contains the following methods:

drawGateArch()

drawBorders()

drawBars()

The method *drawGateArch()* draws the upper arch of the gate, which includes the upper half-circle as well as the spoke-like radial line segments.

The method *drawBorders()* draws the outer frame for the gate.

The method *drawBars()* draws the vertical and diagonal bars of the gate.

ON THE CD

The Java class *Gate1.java* (Listing 18.7) demonstrates how to draw a figure that resembles an iron gate.

LISTING 18.7 Gate1.java

```java
import java.awt.Color;
import java.awt.Graphics;
import java.awt.Image;
import java.awt.Polygon;

import java.io.Serializable;

public class Gate1 extends java.applet.Applet
        implements Serializable
{
    private Image offScreenImage      = null;
    private Graphics offScreenBuffer = null;

    private int width      = 800;
    private int height     = 500;

    private int basePointX = 150;
    private int basePointY = 200;
```

```
private int wWidth       = 200;
private int wHeight      = 200;

private double offsetX1  = 0.0;
private double offsetY1  = 0.0;

private double offsetX2  = 0.0;
private double offsetY2  = 0.0;

private int outerRadius  = wWidth/2;
private int innerRadius  = wWidth/6;

private int radialLineCount = 24;
private int baseAngle       = 360/radialLineCount;

private int ditherX      = 4;
private int colCount      = 16;

private int cellWidth    = wWidth/colCount;
private int cellHeight   = wHeight/colCount;

private int hBorderWidth  = wWidth;
private int hBorderHeight = wHeight/16;

private int vBorderWidth  = wWidth/16;
private int vBorderHeight = wHeight/16;

private Color[] cellColors = {
    Color.red, Color.green, Color.blue,
    Color.white, Color.yellow
};

public Gate1()
{
}

public void init()
{
   offScreenImage  = this.createImage(width, height);
   offScreenBuffer = offScreenImage.getGraphics();
}

public void drawGateArch(Graphics gc)
{
   // draw radial lines...
   gc.setColor(Color.red);
   for(int k=1; k<radialLineCount/2; k++)
   {
      offsetX1 =innerRadius*
                Math.cos(k*baseAngle*Math.PI/180);
```

```
        offsetY1 =innerRadius*
                    Math.sin(k*baseAngle*Math.PI/180);

        offsetX2 =outerRadius*
                    Math.cos(k*baseAngle*Math.PI/180);
        offsetY2 =outerRadius*
                    Math.sin(k*baseAngle*Math.PI/180);

        gc.drawLine(basePointX+wWidth/2+(int)offsetX1,
                    basePointY-(int)offsetY1,
                    basePointX+wWidth/2+(int)offsetX2,
                    basePointY-(int)offsetY2);
    }

    // draw outer arch...
    gc.setColor(Color.blue);
    for(int z=vBorderWidth; z>=0; z—)
    {
        gc.drawArc(basePointX-vBorderWidth+z,
                    basePointY-outerRadius+z,
                    2*outerRadius+2*vBorderWidth-2*z,
                    2*outerRadius-2*z,
                    0,
                    180);
    }

    // draw inner arch...
    gc.setColor(Color.blue);
    for(int z=vBorderWidth/2; z>=0; z—)
    {
        gc.drawArc(
                basePointX+(outerRadius-innerRadius)+z,
                basePointY-innerRadius+z-ditherX,
                2*innerRadius-2*z,
                2*innerRadius-2*z,
                0,
                180);
    }

} // drawGateArch

public void drawBorders(Graphics gc)
{
    gc.setColor(Color.blue);

    // fill top border...
    gc.fillRect(basePointX-vBorderWidth,
                basePointY-hBorderHeight,
                wWidth+2*vBorderWidth,
                hBorderHeight);
```

```
   // fill bottom border...
   gc.fillRect(basePointX-vBorderWidth,
               basePointY+wHeight,
               wWidth+2*vBorderWidth,
               hBorderHeight);

   // fill left border...
   gc.fillRect(basePointX-vBorderWidth,
               basePointY-hBorderHeight,
               vBorderWidth,
               wHeight+2*hBorderHeight);

   // fill right border...
   gc.fillRect(basePointX+wWidth,
               basePointY-hBorderHeight,
               vBorderWidth,
               wHeight+2*hBorderHeight);

} // drawBorders

public void drawBars(Graphics gc)
{
   for(int z=4; z>=0; z--)
   {
      if(z > 0 ) { gc.setColor(cellColors[0]); }
      else       { gc.setColor(cellColors[3]); }

      for(int col=0; col<colCount; ++col)
      {
         gc.drawRect(basePointX+col*cellWidth+z,
                     basePointY-z,
                     cellWidth,
                     colCount*cellHeight);
      }
   }

   // draw main diagonal...
   gc.setColor(Color.red);
   gc.drawLine(basePointX,
               basePointY,
               basePointX+colCount*cellWidth,
               basePointY+colCount*cellHeight);

   // draw off diagonal...
   gc.drawLine(basePointX,
               basePointY+colCount*cellHeight,
               basePointX+colCount*cellWidth,
               basePointY);

} // drawBars
```

```
    public void update(Graphics gc)
    {
        paint(gc);

    } // update

    public void paint(Graphics gc)
    {
        offScreenBuffer.setColor(Color.lightGray);
        offScreenBuffer.fillRect(0, 0, width, height);

        drawBars(offScreenBuffer);
        drawBorders(offScreenBuffer);
        drawGateArch(offScreenBuffer);

        gc.drawImage(offScreenImage, 0, 0, this);

    } // paint

} // Gate1
```

ON THE CD

The HTML file *Gate1.html* (Listing 18.8) contains the code for launching *Gate1.class*.

LISTING 18.8 Gate1.html

```
<HTML>
<HEAD></HEAD>
<BODY>
<APPLET CODE=Gate1.class WIDTH=800 HEIGHT=500></APPLET>
</BODY>
</HTML>
```

REMARKS

The preceding example demonstrates how to produce a surprisingly detailed graphics image with only three pages of code. The method *draw-GateArch()* contains a pair of loops that invoke the method *drawArc()* in order to draw the two curved pieces. The method *drawBars()* contains a loop in which gradient shading combined with diagonal shading to draw the vertical bars. This method is a good example of how to combine the right elements in order to create finely-detailed images.

Concept: Drawing Umbrellas

The next object (Figure 18.5) consists of the following building blocks:

- A set of horizontal elliptic arcs
- A set of horizontal ellipses
- A vertical rectangle
- A triangle

FIGURE 18.5 A parasol table.

The Java class *ParasolTable1.java* contains the following methods:

drawBase()

drawTable()

drawVerticalStand()

drawArcs()

The method *drawBase()* draws the upper arch of the gate, which includes the upper half-circle as well as the spoke-like radial line segments.

The method *drawTable()* draws set of horizontal ellipses for the table top.

The method *drawVerticalStand()* draws a vertical rectangle for the stem of the table.

The method *drawArcs()* draws the horizontal elliptic arcs for the umbrella.

ON THE CD

The Java class *ParasolTable1.java* (Listing 18.9) demonstrates how to draw a figure that resembles a parasol over a table.

LISTING 18.9 ParasolTable1.java

```
import java.awt.Color;
import java.awt.Graphics;
import java.awt.Image;
```

```java
import java.awt.Polygon;

import java.io.Serializable;

public class ParasolTable1 extends java.applet.Applet
      implements Serializable
{
   private Graphics offScreenBuffer = null;
   private Image    offScreenImage  = null;

   private int width      = 800;
   private int height     = 500;

   private int rWidth     = 400;
   private int rHeight    = 300;

   private int basePointX = 100;
   private int basePointY = 100;

   private int arcCount   = 10;
   private int arcWidth   = rWidth/arcCount;
   private int arcHeight  = rHeight/2;
   private int arcShadingHeight = arcWidth/2;

   private int vStemWidth  = 16;
   private int vStemHeight = 2*arcHeight;

   private int tableWidth     = 3*arcCount*arcWidth/4;
   private int tableHeight    = tableWidth/12;
   private int tableThickness = 10;

   private int triangleHeight = 2*arcWidth;
   private int triangleWidth  = 2*arcWidth;

   private int vertexCount    = 3;
   private int[] triangleXPts = new int[vertexCount];
   private int[] triangleYPts = new int[vertexCount];

   private Polygon triangle    = null;

   private Color[] ellipseColors = {
      Color.red, Color.green, Color.blue, Color.yellow,
      Color.red, Color.green
   };

   public ParasolTable1()
   {
   }

   public void init()
   {
```

```
   offScreenImage  = this.createImage(width, height);
   offScreenBuffer = offScreenImage.getGraphics();
}

public void paint(Graphics gc)
{
   offScreenBuffer.setColor(Color.lightGray);
   offScreenBuffer.fillRect(0, 0, width, height);

   drawArcs(offScreenBuffer);
   drawVerticalStand(offScreenBuffer);
   drawTable(offScreenBuffer);
   drawBase(offScreenBuffer);

   gc.drawImage(offScreenImage, 0, 0, this);

} // paint

public void drawBase(Graphics gc)
{
   // counter clockwise from lower-left vertex...
   triangleXPts[0] = basePointX+(arcCount*arcWidth)/2-
                                       triangleWidth/2;
   triangleYPts[0] = basePointY+vStemHeight+
                                         arcHeight/2;

   triangleXPts[1] = basePointX+(arcCount*arcWidth)/2+
                                       triangleWidth/2;
   triangleYPts[1] = basePointY+vStemHeight+
                                         arcHeight/2;

   triangleXPts[2] = basePointX+(arcCount*arcWidth)/2;
   triangleYPts[2] = basePointY+vStemHeight-
                            triangleHeight+arcHeight/2;

   triangle = new Polygon(triangleXPts,
                          triangleYPts,
                          vertexCount);

   gc.setColor(Color.blue);
   gc.fillPolygon(triangle);

} // drawBase

public void drawTable(Graphics gc)
{
   int tableX = basePointX+
                  (arcCount*arcWidth-tableWidth)/2;
   int tableY = vStemHeight;

   for(int z=tableThickness; z>=0; z−)
```

```
    {
       if(z > 0 ) { gc.setColor(Color.darkGray); }
       else        { gc.setColor(Color.red); }

       gc.fillOval(tableX,
                   tableY+z,
                   tableWidth,
                   tableHeight);
    }

    // draw vertical piece that intersects the table...
    gc.setColor(Color.blue);
    gc.fill3DRect(basePointX+arcWidth*arcCount/2-
                      vStemWidth/2,
                  tableY-tableHeight/2,
                  vStemWidth,
                  tableHeight,
                  true);

} // drawTable

public void drawVerticalStand(Graphics gc)
{
    // draw vertical stand...
    gc.setColor(Color.blue);
    gc.fill3DRect(basePointX+arcWidth*arcCount/2-
                      vStemWidth/2,
                  basePointY+arcHeight/2,
                  vStemWidth,
                  vStemHeight,
                  true);

} // drawVerticalStand

public void drawArcs(Graphics gc)
{
    for(int arc=0; arc<arcCount/2; arc++)
    {
       // draw outer elliptic arcs...
       gc.setColor(ellipseColors[arc%5]);

       gc.fillArc(basePointX+arc*arcWidth,
                  basePointY,
                  (arcCount-2*arc)*arcWidth,
                  arcHeight,
                  0,
                  180);
    }
```

```
    // draw vertical middle line...
    gc.setColor(Color.white);
    gc.fill3DRect(basePointX+arcWidth*arcCount/2,
                  basePointY,
                  4,
                  arcHeight/2,
                  true);

    // draw lower shading arcs...
    gc.setColor(Color.darkGray);
    for(int arc=0; arc<arcCount; arc++)
    {
        gc.fillArc(basePointX+arc*arcWidth,
                basePointY+
                  arcHeight/2-arcShadingHeight/2,
                arcWidth,
                arcShadingHeight,
                0,
                180);
    }

  } // drawArcs

} // ParasolTable1
```

ON THE CD

The HTML file *ParasolTable1.html* (Listing 18.10) contains the code for launching *ParasolTable1.class*.

LISTING 18.10 ParasolTable1.html

```
<HTML>
<HEAD></HEAD>
<BODY>
<APPLET CODE=ParasolTable1.class WIDTH=800 HEIGHT=500></APPLET>
</BODY>
</HTML>
```

REMARKS

The preceding example uses a combination of elliptic arcs and half ellipses in order to create the upper portion of the umbrella in the method *drawArcs()*. This method computes an index into an array of colors for drawing the "branches" of the umbrella and then uses dark-gray half ellipses to create a sense of depth.

CD LIBRARY

The CD-ROM for this chapter contains "class" files and HTML files that are needed for viewing the graphics images in the following Java files:

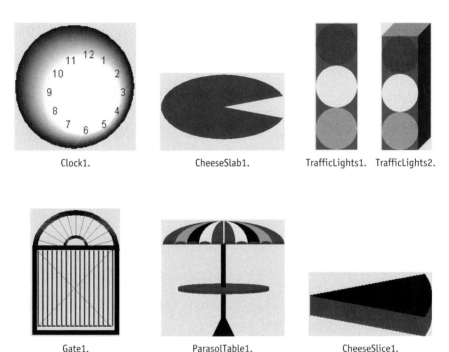

Clock1. CheeseSlab1. TrafficLights1. TrafficLights2.

Gate1. ParasolTable1. CheeseSlice1.

SUMMARY

This chapter contained Java code for drawing the following objects:

- Wedge-like objects
- Cheese slabs
- Three-dimensional traffic lights
- Iron gates
- Umbrellas
- Tables with parasols

These examples provide a variety of techniques that you can leverage in order to write Java code for creating other common-place objects.

LOADING IMAGES

OVERVIEW

Although you can use Java to generate a tremendous variety of graphics images, sometimes it's more convenient to display images that have been saved as GIF files. Many HTML pages often contain images such as GIF files or "jpeg" files, and they are easy to use because HTML has tags that support them. You can also read GIF files from the file system and store them in suitable objects where you can manipulate them in a variety of ways before rendering them. You can use a combination of GIF files, as well as your own images, and display them according to your preferences.

CONCEPT: DISPLAYING A GIF FILE

The next object (Figure 19.1) consists of the following building blocks:

- A GIF file

The Java class *Image1.java* locates the image of a red ball in the *init()* method and then displays it in the *paint()* method.

ON THE CD

The Java class *Image1.java* (Listing 19.1) is a simple program that demonstrates how to read and display a GIF file.

FIGURE 19.1 Displaying a GIF file.

LISTING 19.1 Image1.java

```
import java.awt.Graphics;
import java.awt.Image;

import java.io.Serializable;

public class Image1 extends java.applet.Applet
        implements Serializable
{
   private Image redBall = null;

   public void Image1()
   {
   }

   public void init()
   {
      redBall = getImage(getDocumentBase(),
                    "images/red-ball.gif");
   }

   public void paint(Graphics gc)
   {
      gc.drawImage(redBall, 25, 25, this);

   } // paint

} // Image1
```

ON THE CD

The HTML file *Image1.html* (Listing 19.2) contains the code for launching the Java class *Image1.class*.

LISTING 19.2 Image1.html

```
<HTML>
<HEAD></HEAD>
<BODY>
<APPLET CODE=Image1.class WIDTH=600 HEIGHT=500></APPLET>
</BODY>
</HTML>
```

REMARKS

This Java class displays one GIF file, so it has extremely limited visual appeal, but this example will be used as a basis for creating more interesting examples of displaying GIF files.

If you use the *appletviewer* utility in order to launch the HTML page, then you need an "images" sub-directory containing the necessary GIF files under the directory where you launch *appletviewer*. If you view this HTML page from your browser, then the "images" sub-directory must be located under the directory that contains your HTML files.

CONCEPT: DISPLAYING MULTIPLE GIF FILES

The next object (Figure 19.2) consists of the following building blocks:

- A set of GIF files

FIGURE 19.2 Displaying a set of GIF files.

The Java class *Image2.java* locates the image of a set of balls in the *init()* method and then displays them in the *paint()* method.

ON THE CD

The Java class *Image2.java* (Listing 19.3) is a simple program that demonstrates how to read and display a set of GIF files.

LISTING 19.3 Image2.java

```java
import java.awt.Graphics;
import java.awt.Image;

import java.io.Serializable;

public class Image2 extends java.applet.Applet
      implements Serializable
{
   private Image[] coloredBalls   = new Image[3];
   private int[][] ballCoordinates = new int[3][2];

   public void Image2()
```

```
    {
    }

    public void init()
    {
        coloredBalls[0] = getImage(getDocumentBase(),
                            "images/red-ball.gif");

        coloredBalls[1] = getImage(getDocumentBase(),
                            "images/green-ball.gif");

        coloredBalls[2] = getImage(getDocumentBase(),
                            "images/blue-ball.gif");

        ballCoordinates[0][0] =  50;
        ballCoordinates[0][1] =  50;

        ballCoordinates[1][0] = 100;
        ballCoordinates[1][1] = 300;

        ballCoordinates[2][0] = 300;
        ballCoordinates[2][1] = 150;

    } // init

    public void paint(Graphics gc)
    {
        for(int i=0; i<ballCoordinates.length; i++)
        {
            gc.drawImage(coloredBalls[i],
                        ballCoordinates[i][0],
                        ballCoordinates[i][1],
                        this);
        }

    } // paint

} // Image2
```

ON THE CD

The HTML file *Image2.html* (Listing 19.4) contains the code for launching the Java class *Image2.class*.

LISTING 19.4 Image2.html

```
<HTML>
<HEAD></HEAD>
<BODY>
<APPLET CODE=Image2.class WIDTH=600 HEIGHT=500></APPLET>
</BODY>
</HTML>
```

REMARKS

This Java class is also straightforward, just like *Image1.java*. This class reads a set of GIF files and then displays them on the screen at pre-determined coordinates. Despite its simplicity, you possess the knowledge for creating animation effects with GIF files. When you think about it, you can render GIF files on the screen in much the same way that you've rendered every other object!

CONCEPT: DISPLAYING GRIDS OF GIF FILES

The next object (Figure 19.3) consists of the following building blocks:

- A set of GIF files

FIGURE 19.3 A rectangular outline of GIF files.

The Java class *Image3.java* draws the perimeter of a rectangle with a set of different colored balls in the *paint()* method.

The Java class *Image3.java* (Listing 19.5) is a simple program that demonstrates how to read and display a set of GIF files.

ON THE CD

LISTING 19.5 Image3.java

```
import java.awt.Graphics;
import java.awt.Image;

import java.io.Serializable;
public class Image3 extends java.applet.Applet
        implements Serializable
{
   private int basePointX = 100;
   private int basePointY = 100;
```

```
private int pWidth    = 144;
private int pHeight   = 144;

private int deltaX    = 16;
private int deltaY    = 16;

private int ballCount = 9;
private Image[] coloredBalls = new Image[ballCount];

public void Image3()
{
}

public void init()
{
   for(int i=0; i<ballCount; i++)
   {
      if( i % 3 == 0 )
      {
         coloredBalls[i] = getImage(getDocumentBase(),
                              "images/red-ball.gif");
      }
      else if( i % 3 == 1 )
      {
         coloredBalls[i] = getImage(getDocumentBase(),
                              "images/green-ball.gif");
      }
      else
      {
         coloredBalls[i] = getImage(getDocumentBase(),
                              "images/blue-ball.gif");
      }
   }

} // init

public void update(Graphics gc)
{
   paint(gc);

} // update

public void paint(Graphics gc)
{
   // top border...
   for(int i=0; i<ballCount; i++)
   {
      gc.drawImage(coloredBalls[i],
                  basePointX+i*deltaX,
                  basePointY,
                  this);
   }
```

```
    // bottom border...
    for(int i=0; i<ballCount; i++)
    {
        gc.drawImage(coloredBalls[i],
                     basePointX+i*deltaX,
                     basePointY+pHeight,
                     this);
    }

    // left border...
    for(int i=0; i<ballCount; i++)
    {
        gc.drawImage(coloredBalls[i],
                     basePointX,
                     basePointY+i*deltaX,
                     this);
    }

    // right border...
    for(int i=0; i<ballCount+1; i++)
    {
        gc.drawImage(coloredBalls[i%ballCount],
                     basePointX+pWidth,
                     basePointY+i*deltaX,
                     this);
    }

  } // paint

} // Image3
```

ON THE CD

The HTML file *Image3.html* (Listing 19.6) contains the code for launching the Java class *Image3.class*.

LISTING 19.6 Image3.html

```
<HTML>
<HEAD></HEAD>
<BODY>
<APPLET CODE=Image3.class WIDTH=600 HEIGHT=500></APPLET>
</BODY>
</HTML>
```

REMARKS

This Java class contains the code for drawing the outline of a rectangle. Although you could create a similar effect by drawing a set of suitably colored circles, the GIF files have a richer visual effect. In fact, they can be drawn

very fast, which means that you can use them in order to create very smooth animation effects.

If you decide to create more sophisticated visual effects, you can achieve much better modularization by moving the Java code from the *paint()* method into other methods that are invoked from *paint()*.

CONCEPT: DISPLAYING PATTERNS OF GIF FILES

The next object (Figure 19.4) consists of the following building blocks:

- A grid of GIF files

FIGURE 19.4 Displaying an arrow GIF files.

The Java class *Image4.java* draws the outline of an arrow-shaped image with a set of colored balls in the *paint()* method.

The Java class *Image4.java* (Listing 19.7) is a simple program that demonstrates how to read and display a grid of GIF files.

ON THE CD

LISTING 19.7 Image4.java

```
import java.awt.Graphics;
import java.awt.Image;

import java.io.Serializable;

public class Image4 extends java.applet.Applet
        implements Serializable
{
    private int basePointX = 300;
    private int basePointY = 100;

    private int pWidth    = 144;
    private int pHeight    = 144;
```

```
private int deltaX    = 16;
private int deltaY    = 16;

private int ballCount = 9;

private Image[] coloredBalls = new Image[ballCount];
private Image   yellowBall   = null;

public void Image4()
{
}

public void init()
{
   yellowBall = getImage(getDocumentBase(),
                   "images/yellow-ball.gif");

   for(int i=0; i<ballCount; i++)
   {
      if( i % 3 == 0 )
      {
         coloredBalls[i] = getImage(getDocumentBase(),
                           "images/red-ball.gif");
      }
      else if( i % 3 == 1 )
      {
         coloredBalls[i] = getImage(getDocumentBase(),
                           "images/green-ball.gif");
      }
      else
      {
         coloredBalls[i] = getImage(getDocumentBase(),
                           "images/blue-ball.gif");
      }
   }

} // init

public void update(Graphics gc)
{
   paint(gc);

} // update

public void paint(Graphics gc)
{
   // left side...
   for(int i=0; i<ballCount; i++)
   {
      gc.drawImage(coloredBalls[i],
                basePointX-i*deltaX,
```

```
                         basePointY+i*deltaX,
                         this);
        }

        // right side...
        for(int i=0; i<ballCount; i++)
        {
           gc.drawImage(coloredBalls[i],
                        basePointX+i*deltaX,
                        basePointY+i*deltaX,
                        this);
        }

        // bottom side...
        for(int i=-ballCount; i<ballCount+1; i++)
        {
           gc.drawImage(coloredBalls[(i+ballCount)%2],
                        basePointX+i*deltaX,
                        basePointY+pHeight,
                        this);
        }

        // base...
        for(int j=0; j<3*ballCount/4; j++)
        {
           gc.drawImage(coloredBalls[j],
                        basePointX-deltaX/2,
                        basePointY+pHeight+(j+1)*deltaY,
                        this);

           gc.drawImage(coloredBalls[j],
                        basePointX+deltaX/2,
                        basePointY+pHeight+(j+1)*deltaY,
                        this);
        }

   } // paint

} // Image4
```

ON THE CD

The HTML file *Image4.html* (Listing 19.8) contains the code for launching the Java class *Image4.class*.

LISTING 19.8 Image4.html

```
<HTML>
<HEAD></HEAD>
<BODY>
<APPLET CODE=Image4.class WIDTH=600 HEIGHT=500></APPLET>
```

```
</BODY>
</HTML>
```

REMARKS

The *paint()* method in the preceding example contains all the rendering code. As in the previous example, it's probably better to move the code from the *paint()* method into other methods that are invoked from *paint()*.

One thing to notice about the graphics image is that you will encounter difficulties when trying to create the same effect without GIF files. The explanation is simple: a GIF file can contain many embedded shading effects that are difficult to discern without the aid of a paint tool.

CONCEPT: RESIZING AND DISPLAYING GIF FILES

The next object (Figure 19.5) consists of the following building blocks:

- A GIF file

FIGURE 19.5 A resized GIF file.

The Java class *ResizeImage.java* resizes an image and then draws it in the *paint()* method.

ON THE CD The Java class *ResizeImage.java* (Listing 19.9) demonstrates how to resize an image. The sharpness of the image degrades noticeably when the image is magnified by a factor of four.

LISTING 19.9 ResizeImage.java

```
import java.awt.Graphics;
import java.awt.Image;
import java.io.Serializable;

public class ResizeImage1 extends java.applet.Applet
       implements Serializable
```

```
{
   private int basePointX  = 50;
   private int basePointY  = 50;

   private int imageWidth  = 50;
   private int imageHeight = 50;

   private Image redBall  = null;

   public void ResizeImage1()
   {
   }

   public void init()
   {
      redBall = getImage(getDocumentBase(),
                 "images/red-ball.gif");
   }

   public void paint(Graphics gc)
   {
      imageWidth  = redBall.getWidth(this);
      imageHeight = redBall.getHeight(this);

      // half-size image...
      gc.drawImage(redBall,
                 basePointX,     basePointY,
                 imageWidth/2,   imageHeight/2,
                 this);

      // regular size image...
      gc.drawImage(redBall,
                 basePointX+75,  basePointY,
                 this);

      // double size image...
      gc.drawImage(redBall,
                 basePointX+150, basePointY,
                 imageWidth*2,   imageHeight*2,
                 this);

      // 2.5 size image...
      gc.drawImage(redBall,
                 basePointX+225, basePointY,
                 (int)(imageWidth*2.5),
                 (int)(imageHeight*2.5),
                 this);

      // triple size image...
      gc.drawImage(redBall,
```

```
                    basePointX+300, basePointY,
                    imageWidth*3,   imageHeight*3,
                    this);

      // quadruple size image...
      gc.drawImage(redBall,
                    basePointX+375, basePointY,
                    imageWidth*4,   imageHeight*4,
                    this);

  } // paint

} // ResizeImage1
```

ON THE CD

The HTML file *ResizeImage1.html* (Listing 19.10) contains the code for launching the Java class *ResizeImage1.class*.

LISTING 19.10 ResizeImage1.html

```
<HTML>
<HEAD></HEAD>
<BODY>
<APPLET CODE=ResizeImage1.class WIDTH=600 HEIGHT=500></APPLET>
</BODY>
</HTML>
```

REMARKS

The preceding example demonstrates that the GIF files are actually at their optimal size. Shrinking them does not add any sharpness and expanding them—even if it's only a factor of two—reveals jagged edges from rectangular-shaped pixels.

CONCEPT: DISPLAYING GIF FILES AS CONNECTED CIRCLES

The next object (Figure 19.6) consists of the following building blocks:

■ A set of GIF files

The Java class *ConnectedCircles2.java* contains the following methods:

initializeImages()
initializeCircles()

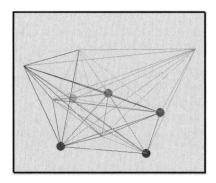

FIGURE 19.6 A set of connected circles.

updateCircleColors()

drawCircles()

drawConnectingLines()

drawBorder()

The methods *initializeImages()* and *initializeCircles()* specify the coordinates of the images and circles, respectively.

The method *updateCircleColors()* updates the color components of the circles and ensures that those values lie between 0 and 255.

The method *drawCircles()* draws the set of circles and images.

The method *drawConnectingLines()*draws the lines that connect each pair of circles and images.

The method *drawBorder()* draws a blue border around the set of circles and images.

ON THE CD

The Java class *ConnectedCircles2.java* (Listing 19.11) uses images in order to demonstrate how to draw interconnected circles.

LISTING 19.11 ConnectedCircles2.java

```
import java.awt.Color;
import java.awt.Graphics;
import java.awt.Image;
import java.io.Serializable;

public class ConnectedCircles2 extends
        java.applet.Applet implements Serializable
{
    private Image offScreenImage     = null;
    private Graphics offScreenBuffer = null;
```

```
private int width  = 800;
private int height = 500;

private int pWidth     = 400;
private int pHeight    = 300;

private int basePointX = 100;
private int basePointY =  50;

private int currentX   = basePointX;
private int currentY   = basePointY;

private int ballX      = basePointX;
private int ballY      = basePointY;

private int pause      = 50;
private int clockTicks = 20*1000/pause;

private int ballRadius    = 20;
private int currBallColor = 0;

private int imageWidth  = 0;
private int imageHeight = 0;

private Color[] ballColors  = {
   Color.red, Color.green, Color.blue,
   Color.yellow, Color.pink
};

private Image[] ballImages = new Image[4];

private int maxCircles = 10;

private int[][] circleColors   =
                    new int[maxCircles][3];
private int[][] colorIncrement =
                    new int[maxCircles][3];
private int[][] circleCenters  =
                    new int[maxCircles][2];

private int thickness  = 4;

public void ConnectedCircles2()
{
}

public void init()
{
   offScreenImage  = this.createImage(width, height);
   offScreenBuffer = offScreenImage.getGraphics();
```

```
        initializeImages();
        initializeCircles();

    } // init

    public void initializeImages()
    {
        ballImages[0] = getImage(getDocumentBase(),
                            "images/red-ball.gif");

        ballImages[1] = getImage(getDocumentBase(),
                            "images/green-ball.gif");

        ballImages[2] = getImage(getDocumentBase(),
                            "images/blue-ball.gif");

        ballImages[3] = getImage(getDocumentBase(),
                            "images/yellow-ball.gif");

        imageWidth  = ballImages[0].getWidth(this);
        imageHeight = ballImages[0].getHeight(this);

    } // initializeImages

    public void initializeCircles()
    {
        for(int i=0; i<maxCircles; i++)
        {
            circleCenters[i][0] = currentX+
                            (int)(pWidth*Math.random());

            circleCenters[i][1] = currentY+
                            (int)(pHeight*Math.random());
        }

        for(int i=0; i<maxCircles; i++)
        {
            circleColors[i][0] = (int)(255*Math.random());
            circleColors[i][1] = (int)(255*Math.random());
            circleColors[i][2] = (int)(255*Math.random());
        }

        for(int i=0; i<3; i++)
        {
            for(int j=0; j<3; j++)
            {
                colorIncrement[i][j] = 8;
            }
        }
```

```
} // initializeCircles

public void update(Graphics gc)
{
   paint(gc);

} // update

public void paint(Graphics gc)
{
   for(int tick=0; tick<clockTicks; ++tick)
   {
      offScreenBuffer.setColor(Color.lightGray);
      offScreenBuffer.fillRect(0, 0, width, height);

      updateCircleColors();
      drawCircles(offScreenBuffer);
      drawConnectingLines(offScreenBuffer);
      drawBorder(offScreenBuffer);

      gc.drawImage(offScreenImage, 0, 0, this);
   }

} // paint

public void drawCircles(Graphics gc)
{
   for(int i=0; i<maxCircles; i++)
   {
      if(i % 2 == 0)
      {
         gc.drawImage(ballImages[i%4],
                      circleCenters[i][0],
                      circleCenters[i][1],
                      this);
      }
      else
      {
         gc.setColor(new Color(circleColors[i][0],
                               circleColors[i][1],
                               circleColors[i][2]));

         gc.fillOval(circleCenters[i][0],
                     circleCenters[i][1],
                     ballRadius,
                     ballRadius);
      }
   }

} // drawCircles
```

```
public void updateCircleColors()
{
   for(int i=0; i<maxCircles; i++)
   {
      for(int j=0; j<3; j++)
      {
         circleColors[i][j] += colorIncrement[i][j];

         if( circleColors[i][j] > 255 )
         {
            circleColors[i][j] = 255;
            colorIncrement[i][j] *= -1;
         }

         if( circleColors[i][j] < 1 )
         {
            circleColors[i][j] = 0;
            colorIncrement[i][j] *= -1;
         }
      }
   }

} // updateCircleColors

public void drawConnectingLines(Graphics gc)
{
   int dX1=0, dY1=0, dX2=0, dY2=0;

   for(int i=0; i<maxCircles-1; i++)
   {
      for(int j=i+1; j<maxCircles; j++)
      {
         if( i % 2 == 0 )
         {
            dX1 = imageWidth/2;
            dY1 = imageHeight/2;
         }
         else
         {
            dX1 = ballRadius/2;
            dY1 = ballRadius/2;
         }

         if( j % 2 == 0 )
         {
            dX2 = imageWidth/2;
            dY2 = imageHeight/2;
         }
         else
         {
            dX2 = ballRadius/2;
```

```
                dY2 = ballRadius/2;
            }

        gc.setColor(new Color(circleColors[i][0],
                              circleColors[i][1],
                              circleColors[i][2]));

        gc.drawLine(circleCenters[i][0]+dX1,
                    circleCenters[i][1]+dY1,
                    circleCenters[j][0]+dX2,
                    circleCenters[j][1]+dY2);
        }
    }

} // drawConnectingLines

public void drawBorder(Graphics gc)
{
    gc.setColor(Color.blue);

    for(int i=0; i<thickness; i++)
    {
        gc.drawRect(basePointX-ballRadius+i,
                    basePointY-ballRadius+i,
                    pWidth+2*ballRadius,
                    pHeight+3*ballRadius);
    }

} // drawBorder

public void shortPause()
{
    try {
        Thread.sleep(pause);
    }
    catch(Exception e){};

} // shortPause

} // ConnectedCircles2
```

ON THE CD

The HTML file *ConnectedCircles2.html* (Listing 19.12) contains the code for launching the Java class *ConnectedCircles2.class*.

LISTING 19.12 ConnectedCircles2.html

```
<HTML>
<HEAD></HEAD>
<BODY>
```

```
<APPLET CODE=ConnectedCircles2.class WIDTH=600 HEIGHT=500></APPLET>
</BODY>
</HTML>
```

REMARKS

The preceding examples show you how to draw a combination of circles and GIF files representing balls. A nested pair of loops in the method *draw-ConnectingLines()* connects every pair of circles and GIF files with line segments. The line segments do not intersect the center of each circle; you'll need to make a small adjustment to the code to achieve this effect. When you view this class via *appletviewer* or with a browser, you'll also see how the color weighting changes the colors of the line segments in order to create a nice visual effect. You could also add motion to each of the circles and GIF files. After all the examples that you've seen thus far, you could probably add that code in virtually no time at all!

CONCEPT: DISPLAYING DIGITAL DATES WITH GIF FILES

The next object (Figure 19.7) consists of the following building blocks:

- A set of GIF files

FIGURE 19.7 A digital date based on GIF files.

The Java class *DigitalDates1.java* contains the following methods:

initializeDigits()
drawDigits()
drawDash()

The method *initializeDigits()* initializes an array of coordinates for ten digits.
The method *drawDigits()* draws the current digit.
The method *drawDash()* draws a dash mark that separates the digital month, day, and year.

The *paint()* method invokes the preceding methods in order to draw a digital date.

The Java class *DigitalDates1.java* (Listing 19.13) demonstrates how to use images in order to draw a digital year.

ON THE CD

LISTING 19.13 DigitalDates1.java

```java
import java.awt.Color;
import java.awt.Graphics;
import java.awt.Image;
import java.io.Serializable;

public class DigitalDates1 extends java.applet.Applet
        implements Serializable
{
    private Image offScreenImage       = null;
    private Graphics offScreenBuffer  = null;

    private int width  = 900;
    private int height = 400;

    private int basePointX =  20;
    private int basePointY = 100;

    private int currentX   = basePointX;
    private int currentY   = basePointY;

    private int rowCount   = 7;
    private int colCount   = 7;

    private int imageWidth  = 12;
    private int imageHeight = 12;

    private int dashXOffset    =  imageWidth/2;
    private int dashWidth      =  3*imageWidth;
    private int dashXIncrement =  2*dashXOffset+
                                        dashWidth;

    private Image[] coloredBalls = new Image[3];

    private int[][][] digitBitMap = new
                        int[10][rowCount][colCount];

    public void DigitalDates1()
    {
    }

    public void init()
```

```
{
   offScreenImage  = this.createImage(width, height);
   offScreenBuffer = offScreenImage.getGraphics();

   initializeImages();
   initializeDigits();

} // init

public void initializeImages()
{
   coloredBalls[0] = getImage(getDocumentBase(),
                       "images/red-ball.gif");

   coloredBalls[1] = getImage(getDocumentBase(),
                       "images/green-ball.gif");

   coloredBalls[2] = getImage(getDocumentBase(),
                       "images/blue-ball.gif");

   initializeDigits();

} // initializeImages

public void initializeDigits()
{
   // digit 0 (vertical lines)
   for(int row=0; row<rowCount; row++)
   {
      digitBitMap[0][row][0]          = 1;
      digitBitMap[0][row][colCount-1] = 1;
   }

   // digit 0 (horizontal lines)
   for(int col=0; col<colCount; col++)
   {
      digitBitMap[0][0][col]          = 1;
      digitBitMap[0][rowCount-1][col] = 1;
   }

   // digit 1 (vertical lines)
   for(int row=0; row<rowCount; row++)
   {
      digitBitMap[1][row][colCount/2] = 1;
   }

   // digit 1 (horizontal lines)
   digitBitMap[1][rowCount-1][colCount/2-1] = 1;
   digitBitMap[1][rowCount-1][colCount/2+1] = 1;

   // digit 2 (vertical lines)
```

```
for(int row=0; row<rowCount/2; row++)
{
   digitBitMap[2][row][colCount-1]    = 1;
   digitBitMap[2][row+rowCount/2][0] = 1;
}

// digit 2 (horizontal lines)
for(int col=0; col<colCount; col++)
{
   digitBitMap[2][0][col]            = 1;
   digitBitMap[2][rowCount/2][col] = 1;
   digitBitMap[2][rowCount-1][col] = 1;
}

// digit 3 (vertical lines)
for(int row=0; row<rowCount; row++)
{
   digitBitMap[3][row][colCount-1] = 1;
}

// digit 3 (horizontal lines)
for(int col=0; col<colCount; col++)
{
   digitBitMap[3][0][col]            = 1;
   digitBitMap[3][rowCount/2][col] = 1;
   digitBitMap[3][rowCount-1][col] = 1;
}

// digit 4 (vertical lines)
for(int row=0; row<rowCount; row++)
{
   digitBitMap[4][row][colCount-1] = 1;
}

for(int row=0; row<rowCount/2; row++)
{
   digitBitMap[4][row][0]            = 1;
}

// digit 4 (horizontal lines)
for(int col=0; col<colCount; col++)
{
   digitBitMap[4][rowCount/2][col] = 1;
}

// digit 5 (vertical lines)
for(int row=0; row<rowCount/2; row++)
{
   digitBitMap[5][row][0]                        = 1;
   digitBitMap[5][row+rowCount/2][colCount-1] = 1;
}
```

```
// digit 5 (horizontal lines)
for(int col=0; col<colCount; col++)
{
   digitBitMap[5][0][col]            = 1;
   digitBitMap[5][rowCount/2][col] = 1;
   digitBitMap[5][rowCount-1][col] = 1;
}

// digit 6 (vertical lines)
for(int row=0; row<rowCount; row++)
{
   digitBitMap[6][row][0]            = 1;
}

// digit 6 (vertical lines)
for(int row=rowCount/2; row<rowCount; row++)
{
   digitBitMap[6][row][colCount-1] = 1;
}

// digit 6 (horizontal lines)
for(int col=0; col<colCount; col++)
{
   digitBitMap[6][rowCount/2][col] = 1;
   digitBitMap[6][rowCount-1][col] = 1;
}

// digit 7 (diagonal line)
for(int row=0; row<rowCount; row++)
{
   digitBitMap[7][row][colCount-1] = 1;
 //digitBitMap[7][row][colCount-row/2-1] = 1;
}

// digit 7 (horizontal lines)
for(int col=0; col<colCount; col++)
{
   digitBitMap[7][0][col]            = 1;
}

// digit 8 (vertical lines)
for(int row=0; row<rowCount; row++)
{
   digitBitMap[8][row][0]            = 1;
   digitBitMap[8][row][colCount-1] = 1;
}

// digit 8 (horizontal lines)
for(int col=0; col<colCount; col++)
{
   digitBitMap[8][0][col]            = 1;
```

```
        digitBitMap[8][rowCount/2][col] = 1;
        digitBitMap[8][rowCount-1][col] = 1;
    }

    // digit 9 (vertical lines)
    for(int row=0; row<rowCount; row++)
    {
        digitBitMap[9][row][colCount-1] = 1;
    }

    // digit 9 (vertical lines)
    for(int row=0; row<rowCount/2; row++)
    {
        digitBitMap[9][row][0] = 1;
    }

    // digit 9 (horizontal lines)
    for(int col=0; col<colCount; col++)
    {
        digitBitMap[9][0][col]           = 1;
        digitBitMap[9][rowCount/2][col] = 1;
    }

} // initializeDigits

public void update(Graphics gc)
{
    paint(gc);

} // update

public void paint(Graphics gc)
{
    offScreenBuffer.setColor(Color.lightGray);
    offScreenBuffer.fillRect(0, 0, width, height);

    currentX = basePointX;
    currentY = basePointY;
    drawDigit(offScreenBuffer, 0);

    currentX += (colCount+1)*imageWidth;
    drawDigit(offScreenBuffer, 1);

    currentX += (colCount+1)*imageWidth;
    offScreenBuffer.setColor(Color.yellow);
    drawDash(offScreenBuffer);
    currentX += dashXIncrement;

    drawDigit(offScreenBuffer, 0);

    currentX += (colCount+1)*imageWidth;
```

```
    drawDigit(offScreenBuffer, 1);

    currentX += (colCount+1)*imageWidth;
    offScreenBuffer.setColor(Color.yellow);
    drawDash(offScreenBuffer);
    currentX += dashXIncrement;

    drawDigit(offScreenBuffer, 2);

    currentX += (colCount+1)*imageWidth;
    drawDigit(offScreenBuffer, 0);

    currentX += (colCount+1)*imageWidth;
    drawDigit(offScreenBuffer, 0);

    currentX += (colCount+1)*imageWidth;
    drawDigit(offScreenBuffer, 1);

    gc.drawImage(offScreenImage, 0, 0, this);

} // paint

public void drawDash(Graphics gc)
{
    gc.fill3DRect(currentX-imageWidth/2,
                  currentY+rowCount*imageHeight/2,
                  dashWidth,
                  imageHeight,
                  true);

} // drawDash

public void drawDigit(Graphics gc, int digit)
{
    for(int row=0; row<rowCount; row++)
    {
        for(int col=0; col<colCount; col++)
        {
            if( digitBitMap[digit][row][col] == 1 )
            {
                gc.drawImage(coloredBalls[row%3],
                             currentX+col*imageWidth,
                             currentY+row*imageHeight,
                             imageWidth,
                             imageHeight,
                             this);
            }
        }
    }
```

```
    } // drawDigit

} // DigitalDates1
```

ON THE CD

The HTML file *DigitalDates1.html* (Listing 19.14) contains the code for launching the Java class *DigitalDates1.class*.

LISTING 19.14 DigitalDates1.html

```
<HTML>
<HEAD></HEAD>
<BODY>
<APPLET CODE=DigitalDates1.class WIDTH=600 HEIGHT=500></APPLET>
</BODY>
</HTML>
```

REMARKS

The preceding examples show you how to draw a digital date based on a set of GIF files. The method *initializeDigits()* initializes an array that determines which "dots" need to be drawn for the digits 0 through 9. The method for drawing each digits is in the method *drawDigit()*, which is invoked multiple times from *paint()*. You can enhance this example by adding code that changes the colors of the balls in order to create a sparkling effect.

CD LIBRARY

ON THE CD

The CD-ROM for this chapter contains "class" files and HTML files that are needed for viewing the graphics images in the following Java files:

Image1. Image2. Image3.

Image4. ResizeImage1. ConnectedCircles2.

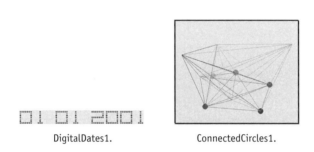

DigitalDates1. ConnectedCircles1.

SUMMARY

This chapter introduces GIF files and presents Java code to display the following:

- GIF files
- Resized GIF files
- GIF files and connected circles
- Digital dates with GIF files

This chapter introduced techniques that will enable you to import ready-made GIF files and combine them in order to create your own graphics images. There are sophisticated filtering techniques available for rotating and manipulating the contents of GIF files, but they are beyond the scope of this chapter.

MISCELLANEOUS GRAPHICS

OVERVIEW

This chapter contains an assortment of graphics images that are based on some shading techniques that you have already seen as well as some techniques that have not been introduced in previous chapters. The Supplemental folder on the CD-ROM contains literally hundreds of *ON THE CD* additional examples that can be used as a starting point from which you can incorporate your own ideas. Try experimenting with the commented lines of code contained in some of the Java classes, or replace them with your own variations.

CommonObjects Folder

This folder contains examples of rendering line segments and rectangles in order to render commonplace objects. For example, the Java class *AnalogColorMeter.java* demonstrates how to render a graph of the RGB components of a colored ball that moves back and forth horizontally. The Java

FIGURE 20.1 An analog color meter.

FIGURE 20.2 An analog fuel meter.

class *Crane1.java* uses rectangles and circles in order to render the image of a crane with a wrecking ball.

FIGURE 20.3 A bar bell.

FIGURE 20.4 A brick wall.

FIGURE 20.5 A crane and wrecking ball.

FIGURE 20.6 A set of gymnasium lockers.

FIGURE 20.7 A nocturnal sky.

FIGURE 20.8 A red sponge.

FIGURE 20.9 A pattern of dots.

FIGURE 20.10 A vase.

FIGURE 20.11 A striped set of ellipses.

FIGURE 20.12 A zig-zag pattern.

FLAGS FOLDER

The examples in this folder contain examples of techniques for rendering line segments, polygons, and elliptic arcs in order to draw flags of various countries. For example, the Java class *AlgeriaFlag.java* uses elliptic arcs to render a lunar-like partial circle and a polygon in order to render a star-like object.

FIGURE 20.13 The Algerian Flag.

FIGURE 20.14 The NATO Flag.

FIGURE 20.15 The Flag of South Africa.

FIGURE 20.16 The Flag of Wallis.

Miscellaneous Folder

This folder contains a mixture of examples that involve ellipses, polygons, and trigonometric functions. For example, the Java class *BlinkingEyes.java* uses two sets of elliptic arcs and two circles to create an image resembling a pair of eyes. The blinking effect is achieved by rapidly drawing a partial ellipse to simulate the moving eyelids.

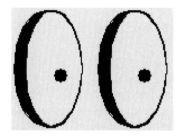

FIGURE 20.17 A pair of blinking eyes.

FIGURE 20.18 Two-sided arrows.

FIGURE 20.19 A swirl pattern.

PlayingCards Folder

This folder contains examples of how to use line segments and elliptic arcs in order to render playing cards.

PolarEquations Folder

This folder contains numerous examples of how to use polar equations in conjunction with rectangles in order to render exotic-looking graphics images. For example, the Java class *TriaxialTritorus1.java* uses a Triaxial equa-

FIGURE 20.20 A playing card.

FIGURE 20.21 A triaxial-based polar graph.

tion with small rectangles to create a graphics image with a strong textural effect.

ASTROIDS FOLDER

This folder contains *Astroid*-based polar equations that are combined with *Limacon* curves, *Deltoids*, and ellipses in order to render images via gradient shading techniques. For example, the Java class *AstroidEllipses.java* combines an *Astroid* curve with ellipses in order to create a tubular effect.

FIGURE 20.22 An *Astroid* curve and ellipses.

PSEUDOFRACTALS FOLDER

This folder contains examples of how to generate graphics images that are based on fractal-like equations combined with rectangles, ellipses, and gradient shading techniques.

FIGURE 20.23 A fractal-like set of ellipses.

FIGURE 20.24 A fractal-like set of ellipses and rectangles.

STRIPES FOLDER

This folder contains a variety of gradient shading techniques that involve rendering polygonal objects by means of line segments, as well as rendering graphics images based on polar equations combined with rectangles.

FIGURE 20.25 A striped polygon.

FIGURE 20.26 A *Toroid*-based graphics image.

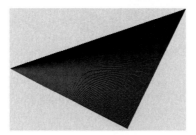

FIGURE 20.27 A striped triangle.

ESSENTIAL MATHEMATICAL CONCEPTS

Overview

This appendix contains a rather eclectic mix of material, a lot of which might be familiar to you. Some topics are short and very simple (which means that you'll be able to read them quickly); other topics involve factoids that are probably long-forgotten, being as the last time you thought of them was probably when you last studied trigonometry. Review these topics, even if it's simply a rapid skim through the material. You'll know where to bookmark individual pages if you ever need to come back to specific topics (e.g., rotating a point in the Euclidean plane).

Several comments must be made regarding the terms in this book and their "definitions." The terms provided in this chapter are intended to be practical and therefore won't be rigorously defined. From a mathematical standpoint, highly-precise definitions are avoided if they make for tedious reading and also make the concepts more difficult to understand. This book contains many graphics images that are based on a traditional geometric object such as a cone. In a sense, these images can be viewed as generalizations of a cone because they "relax" the definition of a cone. You'll see various terms for these images, such as "cone-like" objects and "pseudo-cones." The same holds true for other objects (e.g., cylinders) as well.

For the keen-eyed readers who enjoy finding exceptions, please keep in mind that all geometric properties involving angles and polygons apply specifically to the Euclidean plane. For example, when you read the statement that the sum of the angles of a triangle equals 180, this property is only in the Euclidean plane; for a spherical triangle, though, the sum can be equal to 270. We won't concern ourselves with non-Euclidean geometries,

such as hyperbolic or elliptic geometries. [If you really need to know, they involve variants of Euclid's fifth postulate, and you can delve into a geometry book for more details.]

Most of the time, you'll see common sense derivations or discussions that are based on some simple examples in order to demonstrate a property. Our ultimate goal is to understand how to apply the concepts in order to display pleasing graphics rather than providing formal proofs!

SCALE FACTORS

Some of the graphics images in this book are based on a scaling factor that varies through a range of values in order to render an expanding or shrinking type of graphics image. There are several points to keep in mind regarding the nature of a scaling factor and how a scaling factor is used in the Java code in this book. First, a scaling factor can be greater than, equal to, or less than one. If it's greater than one, you've magnified an object; if it's less than one, you've "shrunken" or compressed the object. Hence, a multiplier can be greater than or less than one.

Second, multiplying by 0.25 produces the same effect as dividing by 4. The latter is simpler in the code because it reduces the number of occurrences of mixing/matching "double" and "int" values and then casting a "double" to an "int" when invoking the standard drawing methods, most of which require integer values. (Incidentally, you can also think of a scale factor of 4 as dividing by 0.25, but that is not the typical manner in which a magnification is performed.)

Many people struggle with decimals, and they find it easier to divide a quantity by five instead of multiplying by 0.2. Since any non-repeating decimal can be expressed as a ratio of two integers, you might find it simpler to work with integers instead of decimals. Which would you rather do— multiply by 0.571 or multiply by 4 and then divide by 7?

ESSENTIAL TRIGONOMETRY

ANGLES

Let's review some terminology regarding three types of angles in the Euclidean plane. An *acute angle* is an angle between 0 and ninety degrees; a *right angle* is a 90 degree angle; and an *obtuse angle* is an angle between 90

and 180 degrees. You can think of a line segment as an angle of 180 degrees. Now consider the pair of angles in Figure A1:

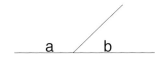

FIGURE A1 A pair of collinear angles.

Since the adjacent angles a and b form a line segment, then the following is true:

 a + b = 180

TRIANGLES

In the Euclidean plane, the sum of the angles of any triangle equals 180 degrees. If one of those angles is 90 degrees, then the sum of the other two angles is 90, which means that those other two angles are acute.

A *right-angled triangle* is a triangle that contains a 90 degree angle. Consider the right-angled triangle in Figure A2:

FIGURE A2 A right-angled triangle.

The *hypotenuse* is the slanted line segment of length r and the *legs* of the triangle are the horizontal segment of length x and vertical line segment of length y. The angle between the two legs is ninety degrees. Let's agree that the hypotenuse r will always be positive; otherwise, we're dealing with the case of r = 0, which means that x = 0 and y = 0, and that's an uninteresting situation.

Sine, cosine, and tangent functions
The trigonometric functions *sine*, *cosine*, and *tangent* are defined as the following ratios:

```
sine a   = y/r
cosine a = x/r
tangent a = y/x
```

where a is the angle between the hypotenuse and the leg of length x. Sine is pronounced "sign" and cosine is pronounced "co-sign." Since r is positive, these ratios are defined. Note that if x = 0, then y/x is not a number; it's actually +(plus infinity.) There's also a short form of the preceding formulas:

```
sin a = y/r
cos a = x/r
tan a = y/x
```

EXAMPLES

a) If a = 3, b = 4, and r = 5, then:

```
sin a = 4/5
cos a = 3/5
tan a = 4/3
```

b) if a = 6, b = 8, and r = 10, then:

```
sin a = 8/10 = 4/5
cos a = 6/10 = 3/5
tan a = 8/6 = 4/3
```

THE PYTHAGOREAN THEOREM

Given a right-angled triangle with legs of length x and y and hypotenuse of length r, the following equation is true:

$$x^2 + y^2 = r^2$$

The converse is also true; in other words, if three numbers x, y, and r satisfy the preceding equation, then the three numbers form a right-angled triangle.

NOTE

In the 17th century, the French mathematician, Fermat, claimed that he had proved that there are no non-trivial (i.e., other than x = y = z = 0) solutions to the equation:

$$x^n + y^n = r^n$$

for n > = 3. Fermat's Theorem remained unproven for more than 350 years.

EXAMPLES

c) since $3^2 + 4^2 = 5^2$

the numbers 3, 4, and 5 form a right-angled triangle.

d) since $6^2 + 8^2 = 10^2$

the numbers 6, 8, and 10 form a right-angled triangle.

If you know the length of two out of three sides of a right-angled triangle, and also the angle between those two sides, then you can determine the value of the unknown side and angle. For example, consider the right-angled triangle in Figure A3:

CALCULATING ANGLE B

Since the three angles have a sum of 180, and one angle is ninety degrees, then

```
a + b = 90
```

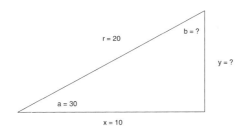

FIGURE A3 A right-angled triangle with unknown quantities.

which means that b = 60.

CALCULATING SIDE Y

Use a calculator to verify that cos 60 = 0.5 and sin 60 = 0.866 (a decimal approximation), and then substitute these values into the ratios for sine and cosine:

```
sin a = y/r and cos a = x/r
```

gives the following:

```
cos 60 = 0.5 = x/r = 10/20 = 0.5
sin 60 = 0.866 = y/20, and so y = 20*(0.866) = 17.32
```

SLOPES OF LINE SEGMENTS

In the Euclidean plane, every non-vertical line has a slope associated with it that can be determined by any distinct pair of points on that line. The slope is defined as the ratio of two numbers:

```
slope = rise/run = (change in altitude)/(horizontal change)
```

For example, the slope of the line segment with endpoints P1(2, 3) and P2(3, 6) is:

```
slope = (6 − 3)/(3 − 2) = 3/1 = 3
```

Notice that the slope can be computed by moving from P2 to P1 as follows:

```
slope = (3 − 6)/(2 − 3) = (−3)/(−1) = 3
```

The slope of a line segment will be useful when drawing line gradients in a subsequent chapter.

TRIGONOMETRIC IDENTITIES

The first identity involves the tangent function:

1) tan a = (sin a)/(cos a)

The preceding formula is true for the following reason:

```
(sin a)/(cos a) = (y/r)/(x/r)
                = (y/r)*(r/x)
                = (y*r)/(r*x)
                = y/x
```

```
Since tan a = y/x, the formula is true.
```

NOTE Division by zero is not permitted, which means that r cannot be zero. Since r represents the hypotenuse of a triangle, it cannot be negative. Hence, r > 0 must be true. We make this assumption because r = 0 implies x^2 +y^2 = 0, which in turn means that x = y = 0. We can safely exclude this uninteresting case.

2) $(\cos a)^2 + (\sin a)^2 = 1$

Since sin a = x/r, then r*sin a = x. Similarly, cos a = y/r implies that r*cos a = y. Substituting these quantities in the formula:

$$x^2 + y^2 = r^2$$

yields:

```
(r*cos a)2 + (r*sin a)2 = r2 and therefore
r2*(cos a)2 + r2*(sin a)2 = r2 which implies
(cos a)2 + (sin a)2 = 1
```

because we know that r > 0.

ADDITIONAL FORMULAS

The following formulas will be needed later in the chapter, and they are presented without derivation:

3) sin(theta1 + theta2) = sin theta1 * sin theta2 + cos theta1 * sin theta2

4) cos(theta1 + theta2) = cos theta1 * cos theta2 – sin theta1 * sin theta2

RADIANS

A *radian* is based on "navigating" the circumference of a circle. Figure A4 depicts a circle of radius r and an angle of one radian.

Imagine yourself standing stationary in a field, and you have a dog on a leash. Your fixed location is the center of a circle and the length of the leash is r units. If the leash is taut, your dog will move in a circular fashion. Initially there is a baseline between you and your dog of length r; then, when he has travelled exactly r units along the circle, he becomes stationary. Since the leash is taut, the second line between you and your

FIGURE A4 A circle of radius r.

dog is also of length r. Consequently, a "wedge" has been created with the following properties: the base line, the circular arc, and the second line all have length r. We can now define one radian as the angle formed between the base line and the second line.

Recall that the circumference C of a circle with radius r can be calculated as follows:

```
C = 2 * PI * r = (2*PI) * r
```

Since PI is approximately 3.14156, then 2*PI is approximately 6.28312. Consequently, if you walk the circumference of a circle, you will have traveled approximately 6.28312 multiples of its radius. Since 2*PI multiples of r are required in order to traverse the circumference of a circle, this means that a circle has 2*PI radians. On the other hand, a circle also has 360 degrees, and therefore 360 degrees equals 2*PI radians.

CONVERTING BETWEEN RADIANS AND DEGREES

We know that the following is true:

```
2*PI radians = 360 degrees, and so
PI radians   = 180 degrees, and so
1 radian     = (180/PI) degrees = 57….. degrees.
```

Here are some other common values:

```
PI/2 radians = 90 degrees
PI/3 radians = 60 degrees
PI/4 radians = 45 degrees
PI/6 radians = 30 degrees
3*PI/4 radians = 135 degrees
5*PI/6 radians = 150 degrees
7*PI/6 radians = 210 degrees
5*PI/4 radians = 225 degrees
3*PI/2 radians = 270 degrees
```

CIRCLES AND ELLIPSES

Figure A5 depicts a circle of which the center is C and the radius is length r. The point P has components x and y, and it's an arbitrary point on the circumference of the circle.

Notice that every point on the preceding circle is the same distance from the center point C: namely, the distance r. Consequently, a typical point P with coordinates (x, y) lies on the circle, then the hypotenuse of length r and the two legs of lengths x and y form a right triangle. According to the Pythagorean Theorem, the following equation must be true for every point P on the circle with radius r:

$$x^2 + y^2 = r^2$$

FIGURE A5 A point on a circle of radius r.

To illustrate this more clearly, try drawing such a circle. Next, draw an arbitrary point (x, y) on the circle and construct the right-angled triangle whose base is length x and whose height is length y. By the Pythagorean Theorem, the preceding formula is true for the triangle. Since the point on the circle was chosen randomly, the equation must be true for all points on the circle. [The preceding discussion is a heuristic argument rather than a formal proof.]

If you shift the circle so that its center is the point (h, k), then the equation of the circle becomes:

$$(x - h)^2 + (y - k)^2 = r^2$$

Figure A6 depicts a circle of radius r of which the center is the point (h, k).

An ellipse can be viewed as the generalization of a circle. (Sometimes a circle is referred to as a *degenerate* case of an ellipse.) In order to construct an ellipse, choose two points on the x-axis that are equidistant from the y-axis. For example, suppose the points are (–1, 0) and (1, 0). Now imagine a string (with length greater than 2) of which the endpoints are "tied" at the two fixed points. Trace a pattern in the plane—while keeping the

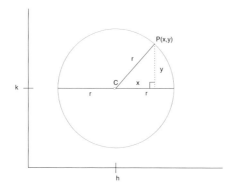

FIGURE A6 A circle of radius r with center (h, k).

string taut—with a pencil. The outline will be an ellipse and its equation is of the form:

$x^2/A^2 + y^2/B^2 = 1$

The center of the ellipse is (0, 0), with a "major axis" of length A and a "minor axis" of length B. Incidentally, the "fixed points" are known as the *foci*. Figure A7 depicts an ellipse with major axis A and minor axis B.

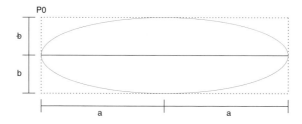

FIGURE A7 An ellipse with major axis a and minor axis b.

Figure A8 displays the preceding ellipse centered at the origin in the x-y plane.

Notice that if you set A = B, the result is a circle of radius A of which the center is (a, b); in this case, the two foci are both equal to the center of the circle.

The next diagram depicts an ellipse that is centered at (h, k), of which the equation is:

$(x - h)^2/A^2 + (y - k)^2/B^2 = 1$

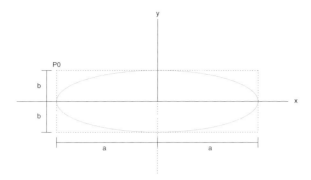

FIGURE A8 An ellipse with center (0,0), major axis a, and minor axis b.

POLAR COORDINATES

A point in the Euclidean plane can be represented by means of different systems. For example, the point (0, 2) in the Cartesian coordinate system represents a point that can be reached by moving two units above the origin. In polar coordinates, the same point can be expressed by (2, 90). The first number is the distance from the origin, and the second number is an angle that is obtained by rotating positive x-axis in a counter-clockwise fashion. By implication, the positive x-axis is zero degrees. Consequently, the point (2, 90) is the point that is two units away from the origin and is a 90-degree counter-clockwise rotation of the positive x-axis. This point is the same as the point (0, 2) in the Cartesian coordinate system.

POLAR COORDINATES TO CARTESIAN

In Figure A9, the point C represents the origin and P is a point in the Euclidean plane with Cartesian coordinates (x, y). Let's use the letter A to represent the angle between the positive x-axis and the hypotenuse of the right-angled triangle below.

Then, based on our previous definitions:

```
sin A = y/r and cos A = x/r, or

y = r*sin A
x = r*cos A
```

In other words, if you have a point P represented by (r, A) in polar coordinates, you can convert that point P to Cartesian coordinates (x, y) by means of the preceding pair of equations.

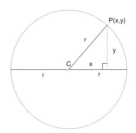

FIGURE A9 Converting from polar to Cartesian coordinates.

CARTESIAN TO POLAR COORDINATES

Consider the point P(x, y) on the circle in the previous diagram. We can determine the polar coordinates of the point P by using the definition of the tangent function to compute angle A:

```
tan A = y/x, so
A = inverse tangent (y/x)
```

We can use the Pythagorean theorem in order to determine the radius r:

```
r² = x² + y², or
```

$$r = \sqrt{x * x + y * y}$$

POLYGONS

A polygon in which all sides are of equal length and all internal angles are equal is called a *regular* polygon. If a regular polygon has n sides, and e represents one of its external angles, then the following is true:

```
e = 360/n
```

Consider the case of a regular octagon (n=8). Suppose you move in a straight line for 10 feet (this number is arbitrary; any distance will serve the same purpose.) Now turn to your left by 45 degrees and travel the same distance, followed by another 45 degree rotation to your left. How many times must you perform this action in order to return to your starting point? Since a circle consists of 360 degrees, the answer is 360/45 = 8 times.

In general, the external angle of an n-sided regular polygon equals 360/n.

Next, an external angle e plus the adjacent internal angle b of an n-sided regular polygon form a straight line:

```
e + b = 180 degrees, and so
b = 180 − e = 180 − 360/n
```

Rotating Points in the Plane

Problem: given a point (x, y) on a circle, how do we express the values of a point (x', y') that is obtained by rotating point (x, y) by an angle of theta2 degrees?

Answer: the following matrix defines how to rotate the point (x, y) through an angle theta in order to produce point (x', y'):

```
x' = cos(theta)*x - sin(theta)*y;
y' = sin(theta)*x + cos(theta)*y;
```

Mapping (x, y, z) Points to (x, y) Values

Suppose that we have an arbitrary three-dimensional point P1 whose co-ordinates are represented by the triple (x, y, z). We're interested in computing the coordinates of the two-dimensional point P2 with coordinates (x', y') that we need in order to draw point P1. In other words, if we treat the three-dimensional point P1 as a two-dimensional point, then P2 contains the horizontal and vertical values required to draw point P1.

Notice the following simple fact: movement along one axis is independent of the other axes. This fact is very useful because we can translate each component of point P into its corresponding effect on a two-dimensional point (x', y'). Let's look at each component separately and figure out how it maps to the two-dimensional plane.

The x coordinate: this component is identical to the x-coordinate.

The y coordinate: this component is identical to the y-coordinate.

The z coordinate: this component affects both the x- and the y-coordinate.

For drawing purposes, 40 degrees is a good value for theta.

The x value of the z coordinate is z*cos(theta) and the y value of the z coordinate is z*sin(theta).

Therefore, the three-dimensional point P1(x, y, z) is mapped to the two-dimensional point P2(x', y') in the following manner:

```
P1 = (x, y, z) → (x + z*cos(theta), y+z*sin(theta))
   = (x', y')
   = P2
```

B

JAVA ESSENTIALS

OVERVIEW

This appendix contains a section that explains the terminology and the naming conventions used in all the Java code contained in this book. *Please read it.* You don't have to memorize its contents. You can skim through it in order to familiarize yourself with the contents and then read it again at a later time. The information will help you understand the code in this book. The naming conventions for variables are fairly consistent throughout the books, which means that you'll see a similar style in the Java classes. Moreover, reading the Java code will reinforce the common techniques in the Java classes, and that will make it easier for you to understand additional examples with less time and effort.

You'll also see the outline of defining and compiling a Java class file. We'll be working almost exclusively with Java applets, which can be launched from the command line via the *appletviewer* utility.

We'll look at common methods that our Java classes will contain so that we can get and set variables whenever necessary. You'll also get a brief discussion on the attributes of some common widgets that are available in the Java window toolkit, which are used in some of the Java classes in this book.

TERMINOLOGY IN THIS BOOK

The following list describes the variables and the respective meanings that you'll find in most of the Java classes. Descriptive names have been used as consistently as possible so that you'll spend less time trying to understand the purpose of the variables. Glance through this list, but don't try to memorize it. If you bookmark these pages you can have them readily available whenever you need to refer to them. After you've finished the first few

chapters, return to this section and read it again. You'll find that the content will start becoming more familiar to you.

As you read the sample code, you'll see the same variables appear many times, which will help you remember their purpose, and that in turn will enable you to read and understand the code faster and with less effort.

REFERENCE POINTS

The point (`basePointX, basePointY`) is the "fixed point" from which every other point or position is derived, and it is usually the lower-left corner of the image.

The integer `minBasePointX` contains the minimum value of `basePointX`.
The integer `maxBasePointX` contains the maximum value of `basePointX`.
The integer `minBasePointY` contains the minimum value of `basePointY`.
The integer `maxBasePointY` contains the maximum value of `basePointY`.
The integer `currentX` contains the current value of `basePointX`.
The integer `currentY` contains the current value of `basePointY`.

RECTANGLES

There are two variables: `rectangleWidth` refers to the width of the rectangle, and `rectangleHeight` refers to the height of the rectangle.

ELLIPSES

There are two variables: `eWidth` refers to the width of the ellipse and `eHeight` refers to the height of the ellipse. Alternate variables are `ellipseWidth` and `ellipseHeight`.

POLYGONS

The letter `v` (for vertex) is usually the loop variable. The variable `vertexCount` is an integer that specifies the number of vertices of a polygon.

Vertices are *labeled*, starting with the integer zero. Vertex zero is usually the lower-left vertex of the polygon (unless indicated otherwise), and the remaining vertices are labeled sequentially by rotating counter clockwise.

DOUBLE BUFFERING

Most applets use double buffering, even if there isn't any animation. The *paint()* method is often treated as a pass-through method in the sense that it is the place from which all your paint-related methods are invoked. This approach makes it easy to quickly grasp the overall purpose of the code and also to easily enhance the code.

The two variables that are always used in double buffering are `off-ScreenBuffer`, which refers to the graphics context, and `offScreenImage`, which refers to the image to which the graphics context belongs.

The *update()* method is required in order to eliminate the well-known flickering effect that occurs whenever the graphics context is refreshed.

The *start()* method is where threads are initialized and started.

The *stop()* method is where threads are stopped.

The *updateCoordinates()* method is defined when the coordinates of a point are incremented or decremented.

MISCELLANEOUS

The integers `rVal`, `gVal`, and `bVal` represent the RGB components of a color.

The integer *thickness* is used for applets that have shading effects, and it refers to the depth of the shading. The letter `z` is usually the loop variable.

The integer `maxCount` refers to the maximum number of iterations through a loop in applets that have animation. The integer `tick` is usually the loop variable.

The integer `pause` refers to the sleep time (in milliseconds) for applets that have animation.

The method *shortPause()* is the method invoked in the "paint" method in order to sleep for pause milliseconds.

The integer `slantLength` refers to the length of the line segment that is used for shading purposes

The integer `slantHeight` refers to the slanted side of a parallelogram, which is also the hypotenuse of a triangle that can be constructed from the parallelogram.

The integer `offsetX` is based on the `slantHeight`, and it is used in order to calculate the horizontal offset for shading.

The integer `offsetY` is based on the `slantHeight`, and it is used in order to calculate the vertical offset for shading.

The integers deltaX and deltaY are used when referring to a line segment of which the endpoints are usually vertices of a polygon.

The integer xDirection refers to the direction of horizontal motion, and it can be -1, 0, or 1, which represent moving toward the left, without any horizontal motion, or moving toward the right, respectively.

The integer yDirection refers to the direction of vertical motion, and it can be -1, 0, or 1, which represent moving upward, no vertical motion, or moving downward, respectively.

The integer xDelta refers to the amount by which the horizontal direction is incremented.

The integer yDelta refers to the amount by which the vertical direction is incremented.

The integer rowCount refers to the number of rows, usually when displaying a grid. The integer row is usually the loop variable.

The integer colCount refers to the number of columns, usually when displaying a grid. The integer col is usually the loop variable.

The integer baseAngle refers to the angle formed by the slanted side of a parallelogram and the positive x-axis. An alternate variable is theta.

The integer sliceCount refers to the number of "slices" or wedges into which a circle will be subdivided.

The integer innerRadius refers to the radius of the inner circle of two or more concentric circles.

The integer outerRadius refers to the radius of the outer circle of two or more concentric circles.

The integer arrays xpts, xPts, xPoints refer to an array of the x-coordinates of a set of points that are usually vertices of a polygon.

The integer arrays ypts, yPts, yPoints refers to an array of the y-coordinates of a set of points that are usually vertices of a polygon.

The integer array rightXPts refers to an array of the x-coordinates for a set of points that are usually vertices of a parallelogram that is drawn to the right of rectangle for shading purposes.

The integer array rightYPts refers to an array of the y-coordinates of a set of points that are usually vertices of a parallelogram that is drawn to the right of rectangle for shading purposes.

The integer array tempXPts refers to an array of the x-coordinates for a set of points that are an offset of a fixed polygon.

The integer array tempYPts refers to an array of the y-coordinates for a set of points that are an offset of a fixed polygon.

The integer array triangleXPts refers to an array of the x-coordinates for a set of points that represent the coordinates of a triangle.

The integer array `triangleYPts` refers to an array of the y-coordinates for a set of points that represent coordinates of a triangle.

BAR GRAPHS

The integer `barCount` refers to the number of vertical bars in a bar graph. The integer `barWidth` refers to the width of a vertical bar in a bar graph. The integer `barHeight` refers to the height of a vertical bar in a bar graph.

CODING STYLE

How do you define style? Even though all programmers have their own idiosyncrasies that are an integral part of their coding style, the answer to that question is not obvious. The programming examples provided will help facilitate your comprehension of my coding style.

A) VARIABLES AND FORMATTING

1. Mixed-case names for variables
2. Curly braces that are aligned under the if/for/while statement.
3. Indent two spaces (no tabs!)
4. Public/private/protected variables at the top of the Java class

B) METHODS AND ORDER OF APPEARANCE

1. Constructor
2. *init()*
3. One or more initialization methods invoked from *init()* (optional)
4. *update()*
5. *start()* (optional)
6. *stop()* (optional)
7. *updateCoordinates()* (optional)
8. *paint()*
9. One or more methods invoked from *paint()* (optional)
10. Mouse-related methods (optional)
11. *shortPause()* (optional)

Defining Java Classes

The file name of a Java class must match the public class listed in the file. The following Java code shows you how to define the Java class *Sample1* in the file *Sample1.java* that draws a string at the point (100, 100).

Sample1.java

```
import java.awt.Graphics;

public class Sample1 extends java.applet.Applet
{
    public Sample1()
    {
    }

    public void init()
    {
    }

    public void paint(Graphics gc)
    {
        gc.drawString("Hello from Sample1", 100, 100);
    }

} // Sample1
```

Let's take a look at the preceding example in more detail. First, there is an import statement:

```
import java.awt.Graphics;
```

This import statement is required by the *paint()* method that uses a "graphics context," which is often represented by the variable *gc*.

Notice that the Java class *Sample1.java* is a subclass of the class java.applet.Applet, and that it contains the following methods:

- An empty constructor named *Sample1()*
- An *init()* method that is automatically executed because *Sample.java* is a subclass of Applet
- A *paint()* method that displays a message string

The Java class java.applet.Applet contains a lot of things that you get for free simply by extending that class. From our standpoint, the most useful thing involves the graphics context that is supplied to the *paint()*

method because you can use it to immediately display text and draw graphics on the screen.

The constructor does nothing because it's empty. From our standpoint, we don't need to worry about its purpose. Suffice it to say that a constructor is invoked during instantiation of an object.

The *init()* method is always executed in a Java applet, and that's where initialization code can be conveniently placed. Almost all the examples in this book contain some initialization code that is executed in *init()*.

The purpose of this class is simple: it draws the string Hello from Sample1 starting from the point with coordinates (100, 100). Don't worry if you don't know about points and their coordinates.

Compiling Java Classes

Make sure that CLASSPATH contains the current directory. Here's how to do it from the Unix command line and from the Windows NT command line.

If you're using Unix C Shell, type the following:

```
setenv CLASSPATH .:${CLASSPATH}
```

If you're using Unix Bourne or Korn Shell, type the following:

```
set CLASSPATH=.:$CLASSPATH
```

If you're using Windows NT, type the following:

```
set CLASSPATH=.:%CLASSPATH%
```

You'll also need to make sure that the directory that contains javac is in your PATH variable.

Now you can compile the class *Sample1.java* as follows:

```
javac Sample1.java
```

If the compilation was successful, then you'll find the file *Sample1.class* in the same directory that contains *Sample1.java*. You can place this file in another directory by using the "-d" switch. Since *Sample1.java* is a subclass of `java.applet.Applet`, you need an HTML page in order to view the output. The HTML file *Sample1.html* contains the code for launching *Sample1.class*:

Sample1.html

```
<HTML>
<HEAD></HEAD>
```

```
<BODY>
<APPLET CODE=Sample1.class WIDTH=400 HEIGHT=200></APPLET>
</BODY>
</HTML>
```

Make sure that the Java utility *appletviewer* appears in your PATH variable (which you can set in a manner similar to that for CLASSPATH.) You can launch the Java applet from the command line by invoking the *appletviewer* utility as follows:

```
appletviewer Sample1.html
```

After a few moments you'll see the following output:

```
Hello from Sample1
```

TEMPLATE FOR JAVA CLASSES

A typical Java class for drawing a rectangle is given below. Focus on the layout of the code. Most of the examples in this book, regardless of their length, will follow a format that is very similar to the following sample.

myTemplate.java

```
import java.awt.Color;
import java.awt.Graphics;
import java.awt.Image;

import java.io.Serializable;

public class myTemplate extends java.applet.Applet
       implements Serializable
{
    private Image offScreenImage    = null;
    private Graphics offScreenBuffer = null;

    private int width = 800;
    private int height = 500;

    private int basePointX = 100;
    private int basePointY = 100;

    private int rectangleWidth   = 200;
    private int rectangleHeight  = 150;

    public myTemplate()
    {
    }
```

```
public void init()
{
    offScreenImage  = this.createImage(width, height);
    offScreenBuffer = offScreenImage.getGraphics();
}

// eliminate flickering effect...
public void update(Graphics gc)
{
    paint(gc);

} // update

public void paint(Graphics gc)
{
  offScreenBuffer.setColor(Color.lightGray);
  offScreenBuffer.fillRect(0, 0, width, height);

  drawRectangle(offScreenBuffer);

  gc.drawImage(offScreenImage, 0, 0, this);

} // paint

public void drawRectangle(Graphics gc)
{
    gc.setColor(Color.red);

    gc.fillRect(basePointX,
                basePointY,
                rectangleWidth,
                rectangleHeight);

} // drawRectangle

} // myTemplate
```

In case you're wondering about the purpose of the preceding Java class, it will fill a red rectangle that has width rectangleWidth and height rectangleHeight. The upper-left corner of the rectangle is located at the point with coordinates (basePointX, basePointY). This Java class uses a technique known as *double-buffering* which is used to render the rectangle. This technique is essential when you need to redraw images very quickly. In the preceding example, double buffering is obviously unnecessary, but I included it so that you'll start getting a feel for how to use this technique.

FAST REDRAWING VIA DOUBLE BUFFERING

Double buffering is a useful technique for redrawing images and then rendering them quickly. In the *paint()* method of an applet, you have access to a graphics context that belongs to the Graphics class. If you want to move an image, you first need to "clear" the graphics context and then redraw the image.

The key idea in double buffering involves refreshing images on an "off screen" buffer that are not visible to users. Instead, users see only the redrawn image. This technique is extremely important for animation effects.

OVERVIEW OF AWT DRAWING METHODS

The main drawing methods used extensively in this book are methods for drawing polygons and ellipses. The set of drawable polygons includes both regular and non-regular polygons with n sides, where n >=3. In the case of n=4, there is also the *drawRect()* method.

Circles are actually a special case of ellipses, so they can be drawn by the same method that is used to draw ellipses.

When reading the signature (the number and type of each parameter) of a method for drawing curved objects, it might help if you keep in mind the following fact: the first pair of values usually represent the x-coordinate and the y-coordinate of the upper-left hand corner of the object that you wish to draw; the next pair of values represent the width and height of the smallest rectangle that encloses the object.

ELLIPSES

The two methods demonstrated for drawing ellipses involve drawing the outline and filling the entire ellipse with a specified color, and they are as follows:

```
1) drawOval(int xCoord, int yCoord, int ellipseWidth, int
   ellipseHeight);
2) fillOval(int xCoord, int yCoord, int ellipseWidth, int
   ellipseHeight);
```

The preceding methods will draw (or fill) an ellipse that is inside a rectangle of which the width is `ellipseWidth` and the height is `ellipseHeight`. The upper-left corner of this rectangle is the point with coordinates (`xCoord`, `yCoord`).

Ellipses are used for drawing many commonplace objects that have curved surfaces. For example, drawing a pair of eyes or a pair of eyeglasses can be accomplished by drawing a set of appropriately sized ellipses. When you learn how to handle mouse-related events, you can even make the eyeballs move around the screen as you move your mouse!

ARCS

There are two methods presented for drawing arcs. One method draws the outline of an arc and the other method fills the whole arc or "wedge." Here are their signatures:

```
1) drawArc(int xCoord, int yCoord, int eWidth, int eHeight, int
   startAngle,int spanAngle);
2) fillArc(int xCoord, int yCoord, int eWidth, int eHeight, int
   startAngle,int spanAngle);
```

Visualize a rectangle with width *ellipseWidth* and height *ellipseHeight* of which the upper-left corner is the point with coordinates (*xCoord, yCoord*). The preceding methods will draw (or fill) an arc that starts from angle *startAngle* and then rotates counterclockwise by *spanAngle* degrees. Note that zero degrees corresponds to a horizontal line segment that points to the right.

CIRCLES AND SEMI-CIRCLES

A circle is an ellipse in which the width and the height are the same. You can draw one by setting eWidth = eHeight in the *drawOval* and *fillOval* methods.

A semi-circle is half of a circle, and can be drawn using the following two steps:

```
1) set eWidth = eHeight
2) endAngle = startAngle+180 in the drawOval and fillOval
   methods.
```

LINES

The method used to draw lines involves specifying the coordinates of the start point and the end point. This method has the following signature:

```
drawLine(int startXCoord, int startYCoord, int endXCoord, int
endYCoord);
```

By the way, if you want to draw a "dashed" line, you can use this method in a simple loop. You can also simulate the drawing of "thick" horizontal or vertical lines by drawing a thin horizontal or thin vertical rectangle.

RECTANGLES

The four drawing methods consist of two "draw" and two "fill" methods that require the coordinates of the upper-left hand corner of the rectangle as well as the width and height of the rectangle. These methods have the following signatures:

```
1) drawRect(int xCoord, int yCoord, int rectangleWidth, int
   rectangleHeight);
2) draw3DRect(int xCoord, int yCoord, int rectangleWidth, int
   rectangleHeight, int boolean);
3) fillRect(int xCoord, int yCoord, int rectangleWidth, int
   rectangleHeight);
4) fill3DRect(int xCoord, int yCoord, int rectangleWidth, int
   rectangleHeight, int boolean);
```

NOTE

The Boolean parameter specifies whether or not to draw a "raised" rectangle.

The preceding methods will draw (or fill) a rectangle with width `rectangleWidth` and height `rectangleHeight`. The upper-left corner of this rectangle is the point with coordinates (`xCoord`, `yCoord`).

POLYGONS

A polygon consists of a set of vertices and line segments that connect those vertices. Each point has an x-coordinate and a y-coordinate. If you know the values of the x-coordinates and the y-coordinates of the points of a particular polygon, you can draw the polygon by doing the following:

1. put all the x-coordinates in one array
2. put all the y-coordinates in another array
3. invoke a method for drawing polygons

Drawing the outline of the polygon or filling the polygon can be done by invoking one of the following methods:

```
drawPolygon(int xpts[], int ypts[], int vertexCount);
fillPolygon(int xpts[], int ypts[], int vertexCount);
```

You can draw static images of polygons, or those that have a relatively small number of polygons, by means of the preceding methods. However, in the case of animation, there is a performance drag (partly involving garbage collection) that is incurred when many instances of a polygon are created during very short time intervals. This is a situation in which you benefit from the use of double-buffering.

Overview of Shading Techniques

This book contains several shading techniques that can be used individually or in combination with each other. The choice of which technique to use is entirely up to you. Generally speaking, the more complex shading techniques produce subtler and richer effects, but such effects can sometimes be achieved with simpler methods.

The terms for the following shading techniques are not standard terms, but simply convenient terminology.

Vertical Shading

This is the simplest shading technique and is used primarily with parallelograms that represent the base of some object. For example, suppose you have a three-dimensional coordinate system. The horizontal plane is actually a parallelogram, and you can give it a sense of depth by drawing a vertical set of parallelograms by drawing a set of "sliding" parallelograms merely changing the vertical component of the points of each parallelogram.

Horizontal Shading

This technique is the same as vertical shading, except that objects are moved horizontally instead of vertically in order to create a three-dimensional effect.

Diagonal Shading

This technique is almost as simple as vertical shading, and it's often used with rectangles. The key idea involves drawing a successive set of "layered" rectangles, each of which is offset by 45 degrees from its predecessor. Usually the last-drawn polygon is a light color that contrasts with all the other polygons, which are usually dark gray, blue, or black.

Since you're moving your objects by a 45 degree angle, it's very easy to calculate the offsets: one unit of movement in both the vertical and horizontal direction. This means you have four possible directions in which you can move the objects diagonally: north-east, north-west, south-east, and south-west. The most common axis of motion for the Java code in this book is the north-east axis, and the next most common is the south-east axis.

DEPTH SHADING

This technique is essentially a generalization of diagonal shading; for example, you would use this technique when you want to draw a set of objects along an axis of which the angle of inclination is not 45 degrees.

The key idea involves the use of the *sine* and *cosine* functions in order to calculate the horizontal and vertical offsets. This technique involves approximations and in some cases you'll see slight imperfections appear in your images. One solution involves *dithering*, which refers to drawing the same object by moving it slightly in a horizontal or vertical direction so that you can eliminate those imperfections.

Instead of using the *drawRect* (or *fillRect*) method, invoke the *drawPolygon* (or *fillPolygon*) method. This method is much more powerful because it can be used to draw an arbitrary polygon.

CURVILINEAR SHADING

This technique provides the best-looking shading effect, and it involves moving a set of objects along the path of a non-linear function, such as a circle or a *sine* function. When drawing a set of polygons, usually the upper-left vertex follows the path of the curve. You can vary the size of the polygons (or whatever objects you wish to draw) as they are drawn along the path of the curve.

POLYGON SHADING

This technique is the most common method of providing shading to bar charts. The key idea involves drawing a dark parallelogram to one side of a rectangle and a light colored parallelogram on top of the same rectangle. If the angle of inclination is 45 degrees, then the same effect can be achieved by diagonal shading. When the angle is not 45 degrees, then you need to calculate the horizontal and vertical offsets by means of the *sine* and *cosine* functions.

Parallel or "Shadow" Shading

This technique involves drawing two objects, one of which is drawn with a darker color in order to create the impression of a shadow. Character-based mode sometimes used this method for creating a three-dimensional effect.

Gradient Shading

This technique involves a gradual change in the weight of one or more of the three components associated with every color. An object—usually a line or polygon—is then drawn by gradually shifting the location of that object. This gradual change in color and location sometimes creates a shadowy three-dimensional effect.

Vertex Shading

This technique also involves a gradual change in the weight of one or more of the three components associated with every color. Unlike gradient shading, the lines that are drawn have a common vertex. This technique is often used for shading a triangle.

Curvilinear Shading

This technique involves drawing a object so that one corner of that object traces the pattern of a non-linear curve. For example, you might draw a set of continuous rectangles whose lower-left vertex is a point on a circle.

Wire Frames

This technique involves drawing a subset of a collection of similar (and usually adjacent) objects. For example, suppose you draw a set of rectangles that are shifted horizontally and vertically by 45 degrees. The resulting image will be continuous; in other words, it will appear smooth. If you draw every other (or every third) rectangle, then gaps will appear between consecutive rectangles.

This simple technique can produce rather surprising visual effects, particularly when you draw a set of objects with varying height and width. This technique is used with gradient shading in order to draw a set of variable-sized ellipses whose upper-left vertex shifts horizontally and vertically. The code is very straightforward and compact. See if you can visualize the generated graphics object and then compare it with the actual image.

NG

This well-known technique is used in many, many animation scenes because it provides a smoother image. Unevenness in an image is due to the integer approximation that occurs when rendering a color at a physical location on your screen.

For example, if you draw a line from a fixed point to every point on an ellipse, the image is a bit ragged in some places. The solution involves drawing each line twice: once in its calculated position and a second line that is directly above the first line. The second line has an offset of one vertical unit. In fact, you can even draw a third line that is directly below the first line, and has a vertical offset of one unit. If you really wanted to make sure the image is smooth, draw two more lines (one on either side of the original line) that have an offset of one horizontal unit.

A second example involves drawing a clock. Look at the Java code in *Clock1.java* and you'll see that the key idea involves drawing four closely aligned circles that have an offset of one unit either up, down, left, or right of the displayed circle.

You can combine one or more of the preceding shading techniques to draw very aesthetic images. Many Java examples that draw sets of polygons often use gradient shading and diagonal shading. The next section describes the three components of every color, and it is used in conjunction with the preceding color shading techniques.

SUMMARY

This appendix presented an overview of the following:

- Defining a Java class
- Compiling a Java class
- Frequently used variable names and coding styles
- A template for many Java classes in these chapters
- AWT graphics methods for drawing objects
- Shading techniques

ABOUT THE CD-ROM

The CD-ROM included with *Java Graphics Programming Library: Concepts to Source Code* contains complete source code for every example presented in the book. It also contains a "Supplemental" folder with complete source code for hundreds of graphic images not included in the book. Many of the graphics on the CD-ROM are animated. The figures in the book will give you a single snapshot of the graphic, but you need to launch these images in a browser (or appletviewer) in order to capture the full quality of the visual effects.

CD FOLDERS

The CD-ROM contains the following folders.

SOURCE CODE

This folder contains all the files covered in the book, arranged by chapter. For example, the folder for Chapter 1 contains the following sub-folders, each representing a graphics image covered in Chapter 1:

- Poly1
- Poly2
- Rect1
- Rect2
- Rect3

The folder **Poly1** contains the files *Poly1.java*, *Poly2.class*, and *Poly3.html*. The remaining folders contain the corresponding three files

associated with the Java class whose name appears as a sub-folder. Similar comments apply to the remaining chapter folders.

SUPPLEMENTAL

This folder contains a number of sub-folders, each of which contains several hundred additional examples of graphics images.

FIGURES

This folder contains the full color version of all of the figures in the book.

SUN JAVA

This folder contains Sun's Java 2 Software Development Kit version 1.3.1 for Windows and Forte for Java, release 3.0, Community Edition, an integrated development environment for creating Java applications.

Note that the code on this CD-ROM will actually run under version 1.02 of the JDK, so you can use an earlier version of the JDK if you already have one. You'll need this folder if you want to compile modified Java files or newly created Java files. Make sure that "javac" is in your CLASSPATH variable. For example, if you have installed Java in the directory d:\JDK13, then in a DOS window you can type something like the following:

```
set CLASSPATH=d:\JDK13\bin;%CLASSPATH%
```

SYSTEM REQUIREMENTS

The programs on the CD-ROM are designed to run on a PC that has Windows 95, Windows 98, or Windows NT. Since the code is portable, you'll be able to run the examples in a Unix environment, provided that you download the Java SDK for Unix. You can find different versions of the SDK for different platforms at the following URL: http://www.javasoft.com.

Additional system requirements depend on the version of the SDK that you install on your PC. If you have version 1.02, then a Pentium PC with 16 megabytes of RAM and either Internet Explorer (version 5.x or higher) or Netscape Navigator (version 4.x or higher) will be sufficient. If you install version 1.3, then you'll need 64 megabytes of RAM and a 300 megahertz processor in order to view the graphics images in this book in a reasonable amount of time. Machines with faster processors will provide even better performance.

INSTALLATION

The images on the CD-ROM can be viewed in a browser simply by double-clicking on an HTML file. For example, if you want to view the graphics image generated by the Java class `Poly1.java,` first navigate to the folder labeled "Source Code," then open the sub-folder "`ch1`," and then double-click on the file `Poly1.html`.

Several factors will affect the rendering time for the graphics images, including:

- The processing power of your PC
- Netscape versus Internet Explorer
- The version of your browser
- Command-line invocation via "appletviewer"

This book focuses on the nuts-and-bolts of creating graphics images, with performance as a secondary consideration. In most cases, the rendering time for the graphics images is close to optimal, but the Java code in some of the animation-based graphics images can be enhanced in order to increase performance.

As a rule, the graphics images have a width and height of 800 and 500, respectively, which means that some code tweaking is required if you want to reduce the size of some images in order to incorporate them into your HTML pages.

INDEX

Sun Microsystems, Inc. Binary Code License Agreement

READ THE TERMS OF THIS AGREEMENT AND ANY PROVIDED SUPPLEMENTAL LICENSE TERMS (COLLECTIVELY "AGREEMENT") CAREFULLY BEFORE OPENING THE SOFTWARE MEDIA PACKAGE. BY OPENING THE SOFTWARE MEDIA PACKAGE, YOU AGREE TO THE TERMS OF THIS AGREEMENT. IF YOU ARE ACCESSING THE SOFTWARE ELECTRONICALLY, INDICATE YOUR ACCEPTANCE OF THESE TERMS BY SELECTING THE "ACCEPT" BUTTON AT THE END OF THIS AGREEMENT. IF YOU DO NOT AGREE TO ALL THESE TERMS, PROMPTLY RETURN THE UNUSED SOFTWARE TO YOUR PLACE OF PURCHASE FOR A REFUND OR, IF THE SOFTWARE IS ACCESSED ELECTRONICALLY, SELECT THE "DECLINE" BUTTON AT THE END OF THIS AGREEMENT.

1. LICENSE TO USE. Sun grants you a non-exclusive and non-transferable license for the internal use only of the accompanying software and documentation and any error corrections provided by Sun (collectively "Software"), by the number of users and the class of computer hardware for which the corresponding fee has been paid.

2. RESTRICTIONS Software is confidential and copyrighted. Title to Software and all associated intellectual property rights is retained by Sun and/or its licensors. Except as specifically authorized in any Supplemental License Terms, you may not make copies of Software, other than a single copy of Software for archival purposes. Unless enforcement is prohibited by applicable law, you may not modify, decompile, or reverse engineer Software. You acknowledge that Software is not designed, licensed or intended for use in the design, construction, operation or maintenance of any nuclear facility. Sun disclaims any express or implied warranty of fitness for such uses. No right, title or interest in or to any trademark, service mark, logo or trade name of Sun or its licensors is granted under this Agreement.

3. LIMITED WARRANTY. Sun warrants to you that for a period of ninety (90) days from the date of purchase, as evidenced by a copy of the receipt, the media on which Software is furnished (if any and if provided by Sun) will be free of defects in materials and workmanship under normal use. Except for the foregoing, Software is provided "AS IS". Your exclusive remedy and Sun's entire liability under this limited warranty will be at Sun's option to replace Software media or refund the fee paid for Software, if any.

4. DISCLAIMER OF WARRANTY. **UNLESS SPECIFIED IN THIS AGREEMENT, ALL EXPRESS OR IMPLIED CONDITIONS, REPRESENTATIONS AND WARRANTIES, INCLUDING ANY IMPLIED WARRANTY OF MERCHANTABILITY, FITNESS FOR A PARTICULAR PURPOSE OR NON-INFRINGEMENT ARE DISCLAIMED, EXCEPT TO THE EXTENT THAT THESE DISCLAIMERS ARE HELD TO BE LEGALLY INVALID.**

5. LIMITATION OF LIABILITY. **TO THE EXTENT NOT PROHIBITED BY LAW, IN NO EVENT WILL SUN OR ITS LICENSORS BE LIABLE FOR ANY LOST REVENUE, PROFIT OR DATA, OR FOR SPECIAL, INDIRECT, CONSEQUENTIAL, INCIDENTAL OR PUNITIVE DAMAGES, HOWEVER CAUSED REGARDLESS OF THE THEORY OF LIABILITY, ARISING OUT OF OR RELATED TO THE USE OF OR INABILITY TO USE SOFTWARE, EVEN IF**

SUN HAS BEEN ADVISED OF THE POSSIBILITY OF SUCH DAMAGES. In no event will Sun's liability to you, whether in contract, tort (including negligence), or otherwise, exceed the amount paid by you for Software under this Agreement. The foregoing limitations will apply even if the above stated warranty fails of its essential purpose.

6. Termination. This Agreement is effective until terminated. You may terminate this Agreement at any time by destroying all copies of Software. This Agreement will terminate immediately without notice from Sun if you fail to comply with any provision of this Agreement. Upon Termination, you must destroy all copies of Software.

7. Export Regulations. All Software and technical data delivered under this Agreement are subject to US export control laws and may be subject to export or import regulations in other countries. You agree to comply strictly with all such laws and regulations and acknowledge that you have the responsibility to obtain such licenses to export, re-export, or import as may be required after delivery to you.

8. U.S. Government Restricted Rights. If Software is being acquired by or on behalf of the U.S. Government or by a U.S. Government prime contractor or subcontractor (at any tier), then the Government's rights in Software and accompanying documentation will be only as set forth in this Agreement; this is in accordance with 48 CFR 227.7201 through 227.7202- 4 (for Department of Defense (DOD) acquisitions) and with 48 CFR 2.101 and 12.212 (for non-DOD acquisitions).

9. Governing Law. Any action related to this Agreement will be governed by California law and controlling U.S. federal law. No choice of law rules of any jurisdiction will apply.

10. Severability. If any provision of this Agreement is held to be unenforceable, this Agreement will remain in effect with the provision omitted, unless omission would frustrate the intent of the parties, in which case this Agreement will immediately terminate.

11. Integration. This Agreement is the entire agreement between you and Sun relating to its subject matter. It supersedes all prior or contemporaneous oral or written communications, proposals, representations and warranties and prevails over any conflicting or additional terms of any quote, order, acknowledgment, or other communication between the parties relating to its subject matter during the term of this Agreement. No modification of this Agreement will be binding, unless in writing and signed by an authorized representative of each party.

For inquiries please contact: Sun Microsystems, Inc. 901 San Antonio Road, Palo Alto, California 94303

JAVATM 2 SOFTWARE DEVELOPMENT KIT STANDARD EDITION VERSION 1.3 SUPPLEMENTAL LICENSE TERMS

These supplemental license terms ("Supplemental Terms") add to or modify the terms of the Binary Code License Agreement (collectively, the "Agreement"). Capitalized terms not defined in these Supplemental Terms shall have the same meanings ascribed to them in the Agreement. These Supplemental Terms shall supersede any inconsistent or conflicting terms in the Agreement, or in any license contained within the Software.

1. Internal Use and Development License Grant. Subject to the terms and conditions of this Agreement, including, but not limited to, Section 2 (Redistributables) and Section 4 (Java Technology Restrictions) of these Supplemental Terms, Sun grants you a non-exclusive, non-transferable, limited license to reproduce the Software for internal use only for the sole purpose of development of your JavaTM applet and application ("Program"), provided that you do not redistribute the Software in whole or in part, either separately or included with any Program.

2. Redistributables. In addition to the license granted in Paragraph 1above, Sun grants you a non-exclusive, non-transferable, limited license to reproduce and distribute, only as part of your separate copy of JAVA(TM) 2 RUNTIME ENVIRONMENT STANDARD EDITION VERSION 1.3 software, those files specifically identified as redistributable in the JAVA(TM) 2 RUNTIME ENVIRONMENT STANDARD EDITION VERSION 1.3 "README" file (the "Redistributables") provided that: (a) you distribute the Redistributables complete and unmodified (unless otherwise specified in the applicable README file), and only bundled as part of the JavaTM applets and applications that you develop (the "Programs:); (b) you do not distribute additional software intended to supersede any component(s) of the Redistributables; (c) you do not remove or alter any proprietary legends or notices contained in or on the Redistributables; (d) you only distribute the Redistributables pursuant to a license agreement that protects Sun's interests consistent with the terms contained in the Agreement, and (e) you agree to defend and indemnify Sun and its licensors from and against any damages, costs, liabilities, settlement amounts and/or expenses (including attorneys' fees) incurred in connection with any claim, lawsuit or action by any third party that arises or results from the use or distribution of any and all Programs and/or Software.

3. Separate Distribution License Required. You understand and agree that you must first obtain a separate license from Sun prior to reproducing or modifying any portion of the Software other than as provided with respect to Redistributables in Paragraph 2 above.

4. Java Technology Restrictions. You may not modify the Java Platform Interface ("JPI", identified as classes contained within the "java" package or any subpackages of the "java" package), by creating additional classes within the JPI or otherwise causing the addition to or modification of the classes in the JPI. In the event that you create an additional class and associated API(s) which (i) extends the functionality of a Java environment, and (ii) is exposed to third party software developers for the purpose of developing additional software which invokes such additional API, you must promptly publish broadly an accurate specification for such API for free use by all developers. You may not create, or authorize your licensees to create additional classes, interfaces, or subpackages that are in any way identified as "java", "javax", "sun" or similar convention as specified by Sun in any class file naming convention. Refer to the appropriate version of the Java Runtime Environment binary code license (currently located at http://www.java.sun.com/jdk/index.html) for the availability of runtime code which may be distributed with Java applets and applications.

5. Trademarks and Logos. You acknowledge and agree as between you and Sun that Sun owns the Java trademark and all Java-related trademarks, service marks, logos and other brand designations including the Coffee Cup logo and Duke logo ("Java Marks"), and you agree to comply with the Sun Trademark and Logo Usage Requirements currently located at http://www.sun.com/policies/trademarks. Any use you make of the Java Marks inures to Sun's benefit.

6. Source Code. Software may contain source code that is provided solely for reference purposes pursuant to the terms of this Agreement.

7. Termination. Sun may terminate this Agreement immediately should any Software become, or in Sun's opinion be likely to become, the subject of a claim of infringement of a patent, trade secret, copyright or other intellectual property right.

License Agreement: Forte for Java, release 3.0, Community Edition, English

To obtain Forte for Java, release 3.0, Community Edition, English, you must agree to the software license below.

Sun Microsystems, Inc. Binary Code License Agreement

READ THE TERMS OF THIS AGREEMENT AND ANY PROVIDED SUPPLEMENTAL LICENSE TERMS (COLLECTIVELY "AGREEMENT") CAREFULLY BEFORE OPENING THE SOFTWARE MEDIA PACKAGE. BY OPENING THE SOFTWARE MEDIA PACKAGE, YOU AGREE TO THE TERMS OF THIS AGREEMENT. IF YOU ARE ACCESSING THE SOFTWARE ELECTRONICALLY, INDICATE YOUR ACCEPTANCE OF THESE TERMS BY SELECTING THE "ACCEPT" BUTTON AT THE END OF THIS AGREEMENT. IF YOU DO NOT AGREE TO ALL THESE TERMS, PROMPTLY RETURN THE UNUSED SOFTWARE TO YOUR PLACE OF PURCHASE FOR A REFUND OR, IF THE SOFTWARE IS ACCESSED ELECTRONICALLY, SELECT THE "DECLINE" BUTTON AT THE END OF THIS AGREEMENT.

1. LICENSE TO USE. Sun grants you a non-exclusive and non-transferable license for the internal use only of the accompanying software and documentation and any error corrections provided by Sun (collectively "Software"), by the number of users and the class of computer hardware for which the corresponding fee has been paid.

2. RESTRICTIONS. Software is confidential and copyrighted. Title to Software and all associated intellectual property rights is retained by Sun and/or its licensors. Except as specifically authorized in any Supplemental License Terms, you may not make copies of Software, other than a single copy of Software for archival purposes. Unless enforcement is prohibited by applicable law, you may not modify, decompile, or reverse engineer Software. You acknowledge that Software is not designed, licensed or intended for use in the design, construction, operation or maintenance of any nuclear facility. Sun disclaims any express or implied warranty of fitness for such uses. No right, title or interest in or to any trademark, service mark, logo or trade name of Sun or its licensors is granted under this Agreement.

3. LIMITED WARRANTY. Sun warrants to you that for a period of ninety (90) days from the date of purchase, as evidenced by a copy of the receipt, the media on which Software is furnished (if any) will be free of defects in materials and workmanship under normal use. Except for the forego-

ing, Software is provided "AS IS". Your exclusive remedy and Sun's entire liability under this limited warranty will be at Sun's option to replace Software media or refund the fee paid for Software.

4. DISCLAIMER OF WARRANTY. UNLESS SPECIFIED IN THIS AGREEMENT, ALL EXPRESS OR IMPLIED CONDITIONS, REPRESENTATIONS AND WARRANTIES, INCLUDING ANY IMPLIED WARRANTY OF MERCHANTABILITY, FITNESS FOR A PARTICULAR PURPOSE OR NON-INFRINGEMENT ARE DISCLAIMED, EXCEPT TO THE EXTENT THAT THESE DISCLAIMERS ARE HELD TO BE LEGALLY INVALID.

5. LIMITATION OF LIABILITY. TO THE EXTENT NOT PROHIBITED BY LAW, IN NO EVENT WILL SUN OR ITS LICENSORS BE LIABLE FOR ANY LOST REVENUE, PROFIT OR DATA, OR FOR SPECIAL, INDIRECT, CONSEQUENTIAL, INCIDENTAL OR PUNITIVE DAMAGES, HOWEVER CAUSED REGARDLESS OF THE THEORY OF LIABILITY, ARISING OUT OF OR RELATED TO THE USE OF OR INABILITY TO USE SOFTWARE, EVEN IF SUN HAS BEEN ADVISED OF THE POSSIBILITY OF SUCH DAMAGES. In no event will Sun's liability to you, whether in contract, tort (including negligence), or otherwise, exceed the amount paid by you for Software under this Agreement. The foregoing limitations will apply even if the above stated warranty fails of its essential purpose.

6. Termination. This Agreement is effective until terminated. You may terminate this Agreement at any time by destroying all copies of Software. This Agreement will terminate immediately without notice from Sun if you fail to comply with any provision of this Agreement. Upon termination, you must destroy all copies of Software.

7. Export Regulations. All Software and technical data delivered under this Agreement are subject to US export control laws and may be subject to export or import regulations in other countries. You agree to comply strictly with all such laws and regulations and acknowledge that you have the responsibility to obtain such licenses to export, re-export, or import as may be required after delivery to you.

8. U.S. Government Restricted Rights. If Software is being acquired by or on behalf of the U.S. Government or by a U.S. Government prime contractor or subcontractor (at any tier), then the Government's rights in Software and accompanying documentation will be only as set forth in this Agreement; this is in accordance with 48 CFR 227.7201 through 227.7202-4 (for Department of Defense (DOD) acquisitions) and with 48 CFR 2.101 and 12.212 (for non-DOD acquisitions).

9. Governing Law. Any action related to this Agreement will be governed by California law and controlling U.S. federal law. No choice of law rules of any jurisdiction will apply.

10. Severability. If any provision of this Agreement is held to be unenforceable, this Agreement will remain in effect with the provision omitted, unless omission would frustrate the intent of the parties, in which case this Agreement will immediately terminate.

11. Integration. This Agreement is the entire agreement between you and Sun relating to its subject matter. It supersedes all prior or contemporaneous oral or written communications, proposals, representations and warranties and prevails over any conflicting or additional terms of any quote, order, acknowledgment, or other communication between the parties relating to its subject matter during the term of this Agreement. No modification of this Agreement will be binding, unless in writing and signed by an authorized representative of each party.

FORTE(TM) FOR JAVA(TM), RELEASE 3.0, COMMUNITY EDITION SUPPLEMENTAL LICENSE TERMS

These supplemental license terms ("Supplemental Terms") add to or modify the terms of the Binary Code License Agreement (collectively, the "Agreement"). Capitalized terms not defined in these Supplemental Terms shall have the same meanings ascribed to them in the Agreement. These Supplemental Terms shall supersede any inconsistent or conflicting terms in the Agreement, or in any license contained within the Software.

1. Software Internal Use and Development License Grant. Subject to the terms and conditions of this Agreement, including, but not limited to Section 4 (Java(TM) Technology Restrictions) of these Supplemental Terms, Sun grants you a non-exclusive, non-transferable, limited license to reproduce internally and use internally the binary form of the Software complete and unmodified for the sole purpose of designing, developing and testing your Java applets and applications intended to run on the Java platform ("Programs").

2. License to Distribute Software. Subject to the terms and conditions of this Agreement, including, but not limited to Section 4 (Java (TM) Technology Restrictions) of these Supplemental Terms, Sun grants you a non-exclusive, non-transferable, limited license to reproduce and distribute the Software in binary code form only, provided that (i) you distribute the Software complete and unmodified and only bundled as part of, and for the sole purpose of running, your Programs, (ii) the Programs add significant and primary functionality to the Software, (iii) you do not distribute additional software intended to replace any component(s) of the Software, (iv) for a particular version of the Java platform, any executable output generated by a compiler that is contained in the Software must (a) only be compiled from source code that conforms to the corresponding version of the OEM Java Language Specification; (b) be in the class file format defined by the corresponding version of the OEM Java Virtual Machine Specification; and (c) execute properly on a reference runtime, as specified by Sun, associated with such version of the Java platform, (v) you do not remove or alter any proprietary legends or notices contained in the Software, (v) you only distribute the Software subject to a license agreement that protects Sun's interests consistent with the terms contained in this Agreement, and (vi) you agree to defend and indemnify Sun and its licensors from and against any damages, costs, liabilities, settlement amounts and/or expenses (including attorneys' fees) incurred in connection with any claim, lawsuit or action by any third party that arises or results from the use or distribution of any and all Programs and/or Software.

3. License to Distribute Redistributables. Subject to the terms and conditions of this Agreement, including but not limited to Section 4 (Java Technology Restrictions) of these Supplemental Terms, Sun grants you a non-exclusive, non-transferable, limited license to reproduce and distribute the binary form of those files specifically identified as redistributable in the Software "RELEASE NOTES" file ("Redistributables")

provided that: (i) you distribute the Redistributables complete and unmodified (unless otherwise specified in the applicable RELEASE NOTES file), and only bundled as part of Programs, (ii) you do not distribute additional software intended to supersede any component(s) of the Redistributables, (iii) you do not remove or alter any proprietary legends or notices contained in or on the Redistributables, (iv) for a particular version of the Java platform, any executable output generated by a compiler that is contained in the Software must (a) only be compiled from source code that conforms to the corresponding version of the OEM Java Language Specification; (b) be in the class file format defined by the corresponding version of the OEM Java Virtual Machine Specification; and (c) execute properly on a reference runtime, as specified by Sun, associated with such version of the Java platform, (v) you only distribute the Redistributables pursuant to a license agreement that protects Sun's interests consistent with the terms contained in the Agreement, and (v) you agree to defend and indemnify Sun and its licensors from and against any damages, costs, liabilities, settlement amounts and/or expenses (including attorneys' fees) incurred in connection with any claim, lawsuit or action by any third party that arises or results from the use or distribution of any and all Programs and/or Software.

4. Java Technology Restrictions. You may not modify the Java Platform Interface ("JPI", identified as classes contained within the "java" package or any subpackages of the "java" package), by creating additional classes within the JPI or otherwise causing the addition to or modification of the classes in the JPI. In the event that you create an additional class and associated API(s) which (i) extends the functionality of the Java platform, and (ii) is exposed to third party software developers for the purpose of developing additional software which invokes such additional API, you must promptly publish broadly an accurate specification for such API for free use by all developers. You may not create, or authorize your licensees to create, additional classes, interfaces, or subpackages that are in any way identified as "java", "javax", "sun" or similar convention as specified by Sun in any naming convention designation.

5. Java Runtime Availability. Refer to the appropriate version of the Java Runtime Environment binary code license (currently located at http://www.java.sun.com/jdk/index.html) for the availability of runtime code which may be distributed with Java applets and applications.

6. Trademarks and Logos. You acknowledge and agree as between you and Sun that Sun owns the SUN, SOLARIS, JAVA, JINI, FORTE, and iPLANET trademarks and all SUN, SOLARIS, JAVA, JINI, FORTE, and iPLANET-related trademarks, service marks, logos and other brand designations ("Sun Marks"), and you agree to comply with the Sun Trademark and Logo Usage Requirements currently located at http://www.sun.com/policies/trademarks. Any use you make of the Sun Marks inures to Sun's benefit.

7. Source Code. Software may contain source code that is provided solely for reference purposes pursuant to the terms of this Agreement. Source code may not be redistributed unless expressly provided for in this Agreement.

8. Termination for Infringement. Either party may terminate this Agreement immediately should any Software become, or in either party's opinion be likely to become, the subject of a claim of infringement of any intellectual property right.

For inquiries please contact: Sun Microsystems, Inc. 901 San Antonio Road, Palo Alto, California 94303 (LFI#91205/Form ID#011801)

License Agreement: Forte for Java, release 3.0, Enterprise Edition Try and Buy, Multi-Language

To obtain Forte for Java, release 3.0, Enterprise Edition Try and Buy, Multi-Language, you must agree to the software license below.

Sun Microsystems Inc. Try and Buy Binary Software License Agreement

SUN IS WILLING TO LICENSE THE ACCOMPANYING BINARY SOFTWARE IN MACHINE- READABLE FORM, TOGETHER WITH ACCOMPANYING DOCUMENTATION (COLLECTIVELY "SOFTWARE") TO YOU ONLY UPON THE CONDITION THAT YOU ACCEPT ALL OF THE TERMS AND CONDITION CONTAINED IN THIS TRY AND BUY LICENSE AGREEMENT. READ THE TERMS AND CONDITIONS OF THIS AGREEMENT CAREFULLY BEFORE OPENING THE SOFTWARE MEDIA PACKAGE. BY OPENING THE SOFTWARE MEDIA PACKAGE, YOU AGREE TO THE TERMS OF THIS AGREEMENT. IF YOU ARE ACCESSING THE SOFTWARE ELECTRONICALLY, INDICATE YOUR ACCEPTANCE OF THESE TERMS BY SELECTING THE "ACCEPT" BUTTON AT THE END OF THIS AGREEMENT. IF YOU DO NOT AGREE TO ALL THESE TERMS, PROMPTLY RETURN THE UNUSED SOFTWARE TO YOUR PLACE OF PURCHASE FOR A REFUND OR, IF THE SOFTWARE IS ACCESSED ELECTRONICALLY, SELECT THE "DECLINE" BUTTON AT THE END OF THIS AGREEMENT.

LICENSE TO EVALUATE (TRY) THE SOFTWARE: If you have not paid the applicable license fees for the Software, the Binary Code License Agreement ("BCL") and the Evaluation Terms ("Evaluation Terms") below shall apply. The BCL and the Evaluation Terms shall collectively be referred to as the Evaluation Agreement ("Evaluation Agreement").

LICENSE TO USE (BUY) THE SOFTWARE: If you have paid the applicable license fees for the Software, the BCL and the Supplemental Terms ("Supplemental Terms") provided following the BCL shall apply. The BCL and the Supplemental Terms shall collectively be referred to as the Agreement ("Agreement").

EVALUATION TERMS

If you have not paid the applicable license fees for the Software, the terms of the Evaluation Agreement shall apply. These Evaluation Terms add to or modify the terms of the BCL. Capitalized terms not defined in these Evaluation Terms shall have the same meanings ascribed to them in the BCL. These Evaluation Terms shall supersede any inconsistent or conflicting terms in the BCL below, or in any license contained within the Software.

1. LICENSE TO EVALUATE. Sun grants to you, a non-exclusive, non-transferable, royalty-free and limited license to use the Software internally for the purposes of evaluation

only for sixty (60) days after the date you install the Software on your system ("Evaluation Period"). No license is granted to you for any other purpose. You may not sell, rent, loan or otherwise encumber or transfer the Software in whole or in part, to any third party. Licensee shall have no right to use the Software for productive or commercial use.

2. TIMEBOMB. Software may contain a timebomb mechanism. You agree to hold Sun harmless from any claims based on your use of Software for any purposes other than those of internal evaluation.

3. TERMINATION AND/OR EXPIRATION. Upon expiration of the Evaluation Period, unless terminated earlier by Sun, you agree to immediately cease use of and destroy Software.

4. NO SUPPORT. Sun is under no obligation to support Software or to provide upgrades or error corrections ("Software Updates") to the Software. If Sun, at its sole option, supplies Software Updates to you, the Software Updates will be considered part of Software, and subject to the terms of this Agreement.

5. NO SUPPLEMENTAL TERMS. The Supplemental Terms following the BCL do not apply to the Evaluation Agreement.

Sun Microsystems, Inc. Binary Code License Agreement

READ THE TERMS OF THIS AGREEMENT AND ANY PROVIDED SUPPLEMENTAL LICENSE TERMS (COLLECTIVELY "AGREEMENT") CAREFULLY BEFORE OPENING THE SOFTWARE MEDIA PACKAGE. BY OPENING THE SOFTWARE MEDIA PACKAGE, YOU AGREE TO THE TERMS OF THIS AGREEMENT. IF YOU ARE ACCESSING THE SOFTWARE ELECTRONICALLY, INDICATE YOUR ACCEPTANCE OF THESE TERMS BY SELECTING THE "ACCEPT" BUTTON AT THE END OF THIS AGREEMENT. IF YOU DO NOT AGREE TO ALL THESE TERMS, PROMPTLY RETURN THE UNUSED SOFTWARE TO YOUR PLACE OF PURCHASE FOR A REFUND OR, IF THE SOFTWARE IS ACCESSED ELECTRONICALLY, SELECT THE "DECLINE" BUTTON AT THE END OF THIS AGREEMENT.

1. LICENSE TO USE. Sun grants you a non-exclusive and non-transferable license for the internal use only of the accompanying software and documentation and any error corrections provided by Sun (collectively "Software"), by the number of users and the class of computer hardware for which the corresponding fee has been paid.

2. RESTRICTIONS. Software is confidential and copyrighted. Title to Software and all associated intellectual property rights is retained by Sun and/or its licensors. Except as specifically authorized in any Supplemental License Terms, you may not make copies of Software, other than a single copy of Software for archival purposes. Unless enforcement is prohibited by applicable law, you may not modify, decompile, or reverse engineer Software. You acknowledge that Software is not designed, licensed or intended for use in the design, construction, operation or maintenance of any nuclear facility. Sun disclaims any express or implied warranty of fitness for such uses. No right, title or interest in or to any trademark, service mark, logo or trade name of Sun or its licensors is granted under this Agreement.

3. LIMITED WARRANTY. Sun warrants to you that for a period of ninety (90) days from the date of purchase, as evidenced by a copy of the receipt, the media on which Software is furnished (if any) will be free of defects in materials and workmanship under normal use. Except for the foregoing, Software is provided "AS IS". Your exclusive remedy and Sun's entire liability under this limited warranty will be at Sun's option to replace Software media or refund the fee paid for Software.

4. DISCLAIMER OF WARRANTY. UNLESS SPECIFIED IN THIS AGREEMENT, ALL EXPRESS OR IMPLIED CONDITIONS, REPRESENTATIONS AND WARRANTIES, INCLUDING ANY IMPLIED WARRANTY OF MERCHANTABILITY, FITNESS FOR A PARTICULAR PURPOSE OR NON-INFRINGEMENT ARE DISCLAIMED, EXCEPT TO THE EXTENT THAT THESE DISCLAIMERS ARE HELD TO BE LEGALLY INVALID.

5. LIMITATION OF LIABILITY. TO THE EXTENT NOT PROHIBITED BY LAW, IN NO EVENT WILL SUN OR ITS LICENSORS BE LIABLE FOR ANY LOST REVENUE, PROFIT OR DATA, OR FOR SPECIAL, INDIRECT, CONSEQUENTIAL, INCIDENTAL OR PUNITIVE DAMAGES, HOWEVER CAUSED REGARDLESS OF THE THEORY OF LIABILITY, ARISING OUT OF OR RELATED TO THE USE OF OR INABILITY TO USE SOFTWARE, EVEN IF SUN HAS BEEN ADVISED OF THE POSSIBILITY OF SUCH DAMAGES. In no event will Sun's liability to you, whether in contract, tort (including negligence), or otherwise, exceed the amount paid by you for Software under this Agreement. The foregoing limitations will apply even if the above stated warranty fails of its essential purpose.

6. Termination. This Agreement is effective until terminated. You may terminate this Agreement at any time by destroying all copies of Software. This Agreement will terminate immediately without notice from Sun if you fail to comply with any provision of this Agreement. Upon termination, you must destroy all copies of Software.

7. Export Regulations. All Software and technical data delivered under this Agreement are subject to US export control laws and may be subject to export or import regulations in other countries. You agree to comply strictly with all such laws and regulations and acknowledge that you have the responsibility to obtain such licenses to export, re-export, or import as may be required after delivery to you.

8. U.S. Government Restricted Rights. If Software is being acquired by or on behalf of the U.S. Government or by a U.S. Government prime contractor or subcontractor (at any tier), then the Government's rights in Software and accompanying documentation will be only as set forth in this Agreement; this is in accordance with 48 CFR 227.7201 through 227.7202-4 (for Department of Defense (DOD) acquisitions) and with 48 CFR 2.101 and 12.212 (for non-DOD acquisitions).

9. Governing Law. Any action related to this Agreement will be governed by California law and controlling U.S. federal law. No choice of law rules of any jurisdiction will apply.

10. Severability. If any provision of this Agreement is held to be unenforceable, this Agreement will remain in effect with the provision omitted, unless omission would frustrate the intent of the parties, in which case this Agreement will immediately terminate.

11. Integration. This Agreement is the entire agreement between you and Sun relating to its subject matter. It supersedes all prior or contemporaneous oral or written communications, proposals, representations and warranties and prevails over any conflicting or additional terms of any quote, order, acknowledgment, or other communication between the parties relating to its subject matter during the term of this Agreement. No modification of this Agreement will be binding, unless in writing and signed by an authorized representative of each party.

FORTE(TM) FOR JAVA(TM), RELEASE 3.0, ENTERPRISE EDITION SUPPLEMENTAL LICENSE TERMS

These supplemental license terms ("Supplemental Terms") add to or modify the terms of the Binary Code License Agreement (collectively, the "Agreement"). Capitalized terms not defined in these Supplemental Terms shall have the same meanings ascribed to them in the Agreement. These Supplemental Terms shall supersede any inconsistent or conflicting terms in the Agreement, or in any license contained within the Software.

1. Software Internal Use and Development License Grant. Subject to the terms and conditions of this Agreement, including, but not limited to Section 3 (Java(TM) Technology Restrictions) of these Supplemental Terms, Sun grants you a non-exclusive, non-transferable, limited license to use internally the binary form of the Software complete and unmodified for the sole purpose of designing, developing and testing your Java applets and applications intended to run on the Java platform.

2. License to Distribute Redistributables. Subject to the terms and conditions of this Agreement, including but not limited to Section 3 (Java Technology Restrictions) of these Supplemental Terms, Sun grants you a non-exclusive, non-transferable, limited license to reproduce and distribute the binary form of those files specifically identified as redistributable in the Software "RELEASE NOTES" file ("Redistributables") provided that: (i) you distribute the Redistributables complete and unmodified (unless otherwise specified in the applicable RELEASE NOTES file), and only bundled as part of Programs, (ii) you do not distribute additional software intended to supersede any component(s) of the Redistributables, (iii) you do not remove or alter any proprietary legends or notices contained in or on the Redistributables, (iv) for a particular version of the Java platform, any executable output generated by a compiler that is contained in the Software must (a) only be compiled from source code that conforms to the corresponding version of the OEM Java Language Specification; (b) be in the class file format defined by the corresponding version of the OEM Java Virtual Machine Specification; and (c) execute properly on a reference runtime, as specified by Sun, associated with such version of the Java platform, (v) you only distribute the Redistributables pursuant to a license agreement that protects Sun's interests consistent with the terms contained in the Agreement, and (v) you agree to defend and indemnify Sun and its licensors from and against any damages, costs, liabilities, settlement amounts and/or expenses (including attorneys' fees) incurred in connection with any claim, lawsuit or action by any third party that arises or results from the use or distribution of any and all Programs and/or Software.

3. Java Technology Restrictions. You may not modify the Java Platform Interface ("JPI", identified as classes contained within the "java" package or any subpackages of the "java" package), by creating additional classes within the JPI or otherwise causing the addition to or modification of the classes in the JPI. In the event that you create an additional class and associated API(s) which (i) extends the functionality of the Java platform, and (ii) is exposed to third party software developers for the purpose of developing additional software which invokes such additional API, you must promptly publish broadly an accurate specification for such API for free use by all developers. You may not create, or authorize your licensees to create, additional classes, interfaces, or subpackages that are in any way identified as "java", "javax", "sun" or similar convention as specified by Sun in any naming convention designation.

4. Java Runtime Availability. Refer to the appropriate version of the Java Runtime Environment binary code license (currently located at http://www.java.sun.com/jdk/index.html) for the availability of runtime code which may be distributed with Java applets and applications.

5. Trademarks and Logos. You acknowledge and agree as between you and Sun that Sun owns the SUN, SOLARIS, JAVA, JINI, FORTE, and iPLANET trademarks and all SUN, SOLARIS, JAVA, JINI, FORTE, and iPLANET-related trademarks, service marks, logos and other brand designations ("Sun Marks"), and you agree to comply with the Sun Trademark and Logo Usage Requirements currently located at http://www.sun.com/policies/trademarks. Any use you make of the Sun Marks inures to Sun's benefit.

6. Source Code. Software may contain source code that is provided solely for reference purposes pursuant to the terms of this Agreement. Source code may not be redistributed unless expressly provided for in this Agreement.

7. Termination for Infringement. Either party may terminate this Agreement immediately should any Software become, or in either party's opinion be likely to become, the subject of a claim of infringement of any intellectual property right.

For inquiries please contact: Sun Microsystems, Inc. 901 San Antonio Road, Palo Alto, California 94303 (LFI#91206/Form ID#011801)